THE TOLEDO MUSEUM OF ART
American Paintings

THE TOLEDO MUSEUM OF ART
American Paintings

Catalogue by Susan E. Strickler
Edited by William Hutton

THE TOLEDO MUSEUM OF ART · TOLEDO · OHIO

Distributed by The Pennsylvania State University Press

Library of Congress Catalog Card Number: 79–66974
ISBN (clothbound): 0–935172–00–9
ISBN (paperbound): 0–935172–01–7

Distributed by The Pennsylvania State University Press,
University Park and London

Designed by Harvey Retzloff
Photography by Raymond S. Sess and Carl J. Schulz
Composition by Typoservice Corporation, Indianapolis, Indiana
Printed in the United States of America by
The Meriden Gravure Company, Meriden, Connecticut

First Printing 1979

This catalogue is supported in part by a grant from
the National Endowment for the Arts, a federal agency.

Contents

List of Color Plates

Foreword

The American paintings catalogue is a welcome addition to literature about the Museum's collection. It represents a considerable effort in planning and research, which we hope will foster greater study of the Museum's rich collection of American painting. Nearly all of this catalogue has been written by Susan E. Strickler, Research Associate under the National Endowment for the Arts grant for this publication. She has carried out this exacting task in an exemplary way, and we are grateful for the knowledge and commitment which she brought to it. William Hutton, Senior Curator and James Moore, Coordinator of the Museum-University of Toledo art history program, also prepared a few entries, and Robert F. Phillips, Chief Curator and Curator of Contemporary Art, advised on entries for paintings since 1945. Mr. Hutton acted as editor of the catalogue, and has been responsible for general guidance of this project. A steering committee consisting of Roger Mandle, Director, William Hutton, James Moore, and Susan Strickler, met regularly during the catalogue's preparation period.

Thanks are due to members of the Museum staff who have made valuable contributions to this project, including Anne O. Reese, Librarian and Joan L. Sepessy, Assistant Librarian, who obtained information not available in the Museum; Patricia Whitesides, Registrar, who managed the many photographic requirements; and Darlene Lindner, Curatorial Secretary, whose meticulous care in typing successive revisions and in organization contributed greatly to the final result. Carol Orser was most helpful in reading proof, as was Joan Sepessy.

Many artists, descendants of artists, museums, libraries, archives, scholars, art dealers, private collectors and others have with great patience and generosity responded to questions and supplied information that has been essential in preparing this catalogue. To these sources we are deeply grateful. In addition to those acknowledged in catalogue entries, the following have given information and advice that has been of particular value: William Gerdts, David C. Huntington, Henry Adams La Farge, Elwood C. Parry, III, Ronald G. Pisano, Allen Staley, James Leo Yarnall, and Robert C. Vose, Jr.

These institutions furnished essential help of many kinds: Midwest Area Center, Archives of American Art, Detroit; Frick Art Reference Library; William Gavin, Art Department, Boston Athenaeum; the libraries of the Cincinnati Art Museum, Art Institute of Chicago, Cleveland Museum of Art, Detroit Institute of Arts, M. Knoedler and Co., Metropolitan Museum of Art, New-York Historical Society, and the Historical Society of Pennsylvania; William L. Clements Library, University of Michigan; New York Public Library; Donald Gallup, Beinecke Library, Yale University; Art Division and Local History and Genealogy Division, Toledo-Lucas County Public Library; Peter H. Hasserick, Buffalo Bill Historical Center; Linn Hardenburgh, Art Institute of Chicago; Costume Institute, Metropolitan Museum of Art; Natalie Spassky, Metropolitan Museum of Art; Albert K. Baragwanath, Museum of the City of New York; Grace M. Mayer, Steichen Archives, Museum of Modern Art; New England Historic Genealogical Society; Newport Historical Society; Mary C. Black and Richard Koke, New-York Historical Society; Rhode Island Historical Society; Sallie Doscher, South Carolina Historical Society; Inventory of American Paintings, Smithsonian Institution; and Clifford M. Nelson, Geological Survey, U.S. Department of the Interior.

Among the many others who have also been helpful are: Gordon K. Allison, Jack Beal, Nicolai Cikovsky, Jr., Don Eddy, Richard Estes, Cal French, The Hon. W. Averell Harriman, Martha Hoppin, Octavia Hughes, Mrs. John C. LeClair, Col. Merl M. Moore, Jr., R. Peter Mooz, Bennard Perlman, Jules Prown, Deborah Remington, Charles Coleman Sellers, Mrs. Frank E. Sprower, Diana Strazdes, Jesse O. Tanner, Sir Ellis Waterhouse, Gabriel Weisberg, and Count Hilarion Woronzoff-Daschkoff.

The preparation and publication of this catalogue has been made possible by a substantial grant from the National Endowment for the Arts, with matching funds provided by the Museum. The catalogue is a summary and a place marker in the development of the American collection, whose history has established a pattern of quality and strength that will guide future acquisitions.

ROGER MANDLE
Director

Introduction

This is the first catalogue of the Museum's collection of American paintings. It is a companion to the catalogue of European paintings published in 1976. Those who use it will find innumerable points of contact between the art of painting as practiced in America and Europe, beginning in the eighteenth century with the colonial painters' emulation of British portraiture and proceeding throughout the nineteenth century to successively more cosmopolitan engagements with the art centers of Europe through artists' study and residence abroad. At the same time, and in counterpoint to these currents, independent national characteristics, especially faithfulness to reality, are clearly apparent. A generation ago this independence and an already rich national school of painting came together with more recent ideas from Europe to form a group of artists who for the first time commanded international leadership in painting.

In his foreword to the catalogue of the spectacular inaugural exhibition of the Museum's new building in January 1912, George W. Stevens, director from 1903 to 1926, declared the leading place this country's art was to have in the Museum's program, concluding: "Our loyalty to American art will be made fully manifest as time progresses." This loan exhibition, which also included European painting, American sculpture and Japanese painting, contained no less than 112 pictures by American painters, nearly all contemporaries.

Immediately after the close of the exhibition, Florence Scott Libbey (plate 162), the wife of the Museum's founder and principal benefactor, Edward Drummond Libbey (plate 163), initiated the Maurice A. Scott Gallery to present the historical development of painting in this country. The original group comprised pictures by Benjamin West, Gilbert Stuart, George Inness, Childe Hassam, Thomas Dewing, Henry W. Ranger, Birge Harrison, Dwight Tryon, Edward Steichen and Frederic Remington, though the most important was Winslow Homer's *Sunlight on the Coast*. The gallery was named in honor of Mrs. Libbey's father, whose house had stood on the site of the new building. During her lifetime Mrs. Libbey acquired paintings for this gallery by such leading artists as Sargent, Eastman Johnson, Ryder, Whistler and Beaux, among others, and at her death in 1938 she bequeathed funds for future ac-

quisitions of American painting and sculpture, as well as for both European and American decorative arts and the Museum's music program. Works bought with these funds are designated as gifts of Florence Scott Libbey.

The Museum had shown a close interest in American painting well before 1912, even though it owned very few pictures. Indeed, while most of its early exhibitions were of conservative artists, it is interesting to find that in October 1908 the remarkably crowded schedule at the Museum's early home, a remodelled house at 1216 Madison Avenue, included a selection from the controversial exhibition of paintings by The Eight. Ever since its first showing in New York that February this exhibition has been regarded as a milestone in the development of American realism.

Four years later, just after the 1912 inaugural exhibition, Mr. Libbey gave *The Bridge, Blackwell's Island* by George Bellows, an artist closely associated with The Eight, though not actually one of them. Earlier, Mr. Libbey had sent this powerful canvas to George Stevens from New York with the words, "You need not hang this canvas unless you care to. I feel that someday it will be important, for the painter shows greats promise." This was the second picture by Bellows to enter a museum collection. Late in 1912 the pictures Bellows had assembled for his first exhibition in his native Columbus were also shown here. That same year the Museum received an important group of 51 watercolors and drawings which Mr. Libbey had bought in 1911 at the estate sale of John La Farge, and which reflects the range of this many-sided and influential artist.

In 1916 Mr. Libbey paid a record price of $20,000 at auction for Ralph Blakelock's masterpiece, *Brook by Moonlight,* which the artist had found difficult to sell in the early 1890s. This was then the highest price yet paid for a work by a living artist, and the second highest price for any American painting. Shortly after its purchase, this painting formed part of a traveling benefit exhibition organized to raise money for the destitute artist, who had suffered a mental breakdown.

Among the principal benefactors of the American collection was Arthur J. Secor (plate 165), the Museum's second president, who between 1922 and 1933 gave the Museum his important collection of 75 paintings. While largely European, the collection included some pictures by Americans working in the last half of the nineteenth century, chiefly those influenced by the French Barbizon school, including Hunt, Inness, Wyant, Chase, Sargent, Blakelock and Daingerfield.

From 1914 to 1954 the Museum made acquisitions from its annual summer exhibitions of contemporary American painting. In earlier years, pictures for the Toledo showings were taken from the national juried annuals of the Pennsylvania Academy, Corcoran Gallery, National Academy and Carnegie Institute; later, they were selected directly from the art market. The Toledo annuals were generally conservative in character, accounting for the collection's relatively small representation of early modern and abstract art. Among the diverse works acquired in this way are paintings by John Carroll, Georgia O'Keeffe, Walter Murch, Lyonel Feininger, I. Rice Pereira, John Koch, Charles Sheeler and Ad Reinhardt.

The collection developed during the directorship of Blake-More Godwin from 1926 to

1959 with the acquisition of pictures by Feke, Rembrandt Peale, Kensett, Eakins, Luks, Sloan, Speicher and Corbino. The bequest in 1943 of Elizabeth C. Mau, a Toledo school teacher, enabled the Museum to acquire several American pictures, among them works by Reginald Marsh, Henry Mattson, Alexander Brook and Andrew Wyeth.

After World War II the American collection grew substantially under the guidance of Otto Wittmann, associate director from 1946, and director from 1959 to 1976. Many of the principal eighteenth and nineteenth century pictures were acquired at this time, with colonial portraits by Smibert, Greenwood and Copley, and paintings of the Federal and Romantic periods by Earl, Trumbull, Allston, Stuart, Raphaelle Peale, Morse, Krimmel, Jarvis, Waldo and Heade. A distinguished group of Hudson River School landscapes, acquired at a time when these painters were relatively neglected, includes Doughty, Cropsey and two of Sanford Gifford's principal works. In 1949 Thomas Cole's *The Architect's Dream*, undoubtedly the most famous American picture in the Toledo collection, was acquired from the artist's descendants. The art of later generations is admirably represented with major pictures by Hassam, Chase, Prendergast, Thayer and Lawson. A painting of distinguished aesthetic quality that also has particular historical meaning for Toledo is William Harnett's *Still Life with the* TOLEDO BLADE, given by Mr. and Mrs. Roy Rike, as was Bierstadt's view of the Yosemite Valley.

In the last ten years the collection has grown largely in the field of post-war American painting represented by such major artists as Hans Hofmann, Willem de Kooning, Mark Rothko, Richard Estes, Frank Stella and Ilya Bolotowsky. The Museum has also received significant contemporary works by gift such as the Evergood and Kitaj from Dr. and Mrs. Joseph A. Gosman, and from the Woodward Foundation paintings by Gottlieb, Rauschenberg, Frankenthaler and Okada. In addition, the Toledo Modern Art Group and the National Endowment for the Arts have helped make possible the acquisition of other contemporary works.

The Toledo collection may be characterized as broadly representative of the main trends in American painting since the mid-1700s, with notable strength from 1800 to 1900, especially in that century's most characteristic subject, the landscape. Realism and the academic tradition after 1900 are present in depth, but there are relatively few substantial examples of the overtly modern styles which American painters based upon the radical departures that took place in European art in this century's early years. On the other hand, the great developments since 1945 surrounding the rise of abstract expressionism may be found here in excellent examples.

Painting is but one aspect of American art in this Museum, where the art of this country in printmaking, photography, sculpture and the decorative arts—notably glass—may also be seen in collections which exemplify the changing ideals of American artists, and of the ever-mobile society in which they have worked for more than two centuries.

WILLIAM HUTTON
Senior Curator

Explanatory Notes

This catalogue provides in succinct form the essential information on all paintings that were in the collection by August 1979. Where indicated, there is a brief discussion of attribution, iconography, dating, provenance or related works.

CATALOGUE ENTRIES: Entries in the first section of the catalogue are arranged alphabetically according to the surnames or commonly used names of artists. Where there are two or more works by the same artist, entries appear in chronological order, or in order of accession numbers.

ILLUSTRATIONS: All paintings are illustrated and each catalogue entry indicates the plate number. Plates are arranged chronologically, with minor exceptions.

MEDIA: This catalogue includes works in oil, tempera, watercolor and pastel.

ACCESSION NUMBERS: The first two digits indicate the year of acquisition; the last digits, the serial number within the year (e.g. 79.1 indicates the first work of art acquired in 1979).

DIMENSIONS: The measurements represent support or image size (if on paper) unless otherwise indicated. These are given in inches, followed by centimeters in parentheses. Height precedes width.

SIGNATURES AND INSCRIPTIONS: Transcribed as accurately as possible, virgules indicating breaks between lines. Cited inscriptions other than on the faces of paintings are those believed to be in the artist's hand unless otherwise noted.

RIGHT AND LEFT: Unless otherwise stated, these terms indicate the spectator's right and left.

COLLECTIONS: Known owners are listed chronologically. Dealer's names and auction sales appear in parentheses. Inclusive dates indicate known periods of ownership.

EXHIBITIONS: Only those significant for their subject, scholarship, evidence of dating, early ownership or other documentary value are listed. Cities are omitted if clearly contained in museum names.

REFERENCES: These are selective. In general, entries include early references, standard *catalogues raisonnés* and monographs, specialized studies and critical commentaries or analyses.

SOURCES: Unless otherwise indicated, all paintings accessioned through 1938 were given by Florence Scott Libbey, while those accessioned after 1938, unless otherwise indicated, were acquired by the Museum with funds bequeathed by her. Following her wishes, such acquisitions are designated as gifts

of Florence Scott Libbey. Works acquired with funds bequeathed by Edward Drummond Libbey are designated as his gifts.

ABBREVIATIONS: These bibliographical and other abbreviations have been used:

ANA: Associate, National Academy of Design

ASL: Art Students League, New York

Cowdrey, *NAD*: M. B. Cowdrey, *National Academy of Design Exhibition Record, 1826–1860,* New York, 1943.

Knoedler: M. Knoedler and Co., Inc., New York

Macbeth: William Macbeth, Inc., New York

NA: Academician, National Academy of Design

NAD: National Academy of Design, New York

PAFA: Pennsylvania Academy of the Fine Arts, Philadelphia

Toledo Museum of Art Annual refers to the Annual Exhibition of Contemporary Paintings held from 1914 to 1954

Vose: Vose Galleries, Boston

Catalogue

ISRAEL ABRAMOFSKY

1888–1975. Born near Kiev, Russia. After serving in a Siberian prison camp, in 1909 came to Toledo to join two brothers. Worked as a welder, studying art evenings. 1914, 1920 and 1925 in Paris, where he studied with J. P. Laurens and Lucien Simon at Académie Julian; met many artists of School of Paris, who influenced his work. 1934 settled permanently in Toledo.

The Fountain PL. 184

[1921] Oil on canvas
21⅛ x 25½ in. (53.7 x 64.8 cm.)
Signed lower left: ABRAMOFSKY

Acc. no. 23.3157
Gift of Dr. and Mrs. L. A. Levison

EXHIBITIONS: Sylvania (Ohio), Congregation Shomer Emunin, *Homage to Israel Abramofsky*, 1975, no. 34.

This is a view of the Luxembourg Gardens in Paris with the dome of the Panthéon in the background.

Pont-Croix, Brittany PL. 183

[1931] Oil on canvas
36½ x 29 in. (92.7 x 73.6 cm.)
Signed lower left: I. ABRAMOFSKY

Acc. no 32.21
Gift of Aaron B. Cohn

COLLECTIONS: (Mohr Art Galleries, Toledo).

EXHIBITIONS: Paris, *Salon des Artistes Français*, 1931; Toledo, Mohr Art Galleries, *Recent Paintings by I. Abramofsky*, 1931, repr. on cover (as *Pont-Croix*); New York, Babcock Galleries, *Recent Paintings by I. Abramofsky,* 1932, no. 16, repr.; Sylvania (Ohio), Congregation Shomer Emunin, *Homage to Israel Abramofsky,* 1975, no. 48.

Breton villages were among Abramofsky's favorite subjects. This view of Pont-Croix near Quimper on the south coast of Brittany shows the tall tower of the Romanesque church of Notre-Dame de Roscadon.

WASHINGTON ALLSTON

1779–1843. Born in Georgetown, S.C. Schooled in Newport, R.I. 1800 B.A. Harvard College. 1801 studied in London at the Royal Academy and with West. 1805 settled in Rome, where he met Washington Irving, Samuel Coleridge and many European artists. 1808–11 in Boston. 1811 returned to England. 1818 settled in Boston. While in Europe Allston achieved an international reputation as a leading romantic painter, poet and art theorist. In America he was widely influential despite the limited public for imaginative subjects. Many younger American artists followed his example and went abroad to study.

Italian Landscape PL. 16

[1814] Oil on canvas
44 x 72 in. (111.8 x 183 cm.)
Signed lower right: W. ALLSTON/1814

Acc. no. 49.113

COLLECTIONS: Elias Vanderhorst, Bristol, England, 1814–16; Mary Vanderhorst Taylor, Bristol; by descent to Miss E. I. M. Duncombe, Bristol, to 1946; Bristol Museum and Art Gallery, to 1949; (Macbeth, 1949).

EXHIBITIONS: London, Royal Academy of Arts, 1814, no. 248 (as *A Landscape: Italian Scenery*); Detroit Institute of Arts and Toledo Museum of Art, *Travelers in Arcadia: American Artists in Italy 1830–1875,* 1951, no. 2, repr.; New York, Wildenstein, *Landmarks in American Art 1670–1950,* 1953, no. 10, repr.; Boston, Museum of Fine Arts, *"A Man of Genius": The Art of Washington Allston,* 1979, no. 31, repr. (color).

REFERENCES: A. Jameson, "Washington Allston," *Atheneum,* London, 1844, p. 16; E. Richardson, *Washington Allston,* Chicago, 1948, pp. III, 199, no. 85; W. Gerdts, "Washington Allston and the German Romantic Classicists in Rome," *Art Quarterly,* XXXII, Summer 1969, p. 192, fig. 26; E. Johns, "Washington Allston: The Artist as Philosopher," in *The Paintings of Washington Allston* (exh. cat.), Lowe Art Museum, Miami, Fla., 1974, p. 14; K. Bolton, "The Drawings of Washington Allston, A Catalogue Raisonné," unpublished Ph.D. dissertation, Harvard University, 1977, in nos. 155, 156.

This canvas was painted in Bristol while Allston was recovering his health after the strain of painting the vast *The Dead Man Revived by Touching the Bones of the Prophet Elisha* (1811–14; PAFA). It was bought by Allston's uncle, Elias Vanderhorst, then American consul at Bristol.

Although landscapes did not predominate in Allston's subsequent work, in Rome he painted a group of them which increasingly reflected the classically ordered compositions of Nicolas Poussin, Claude Lorrain and certain of Allston's German contemporaries in Rome. Gerdts considers the Toledo picture transitional both in style and mood between the early Roman paintings and Allston's later works such as *Landscape* (1835; Bos-

ton, Museum of Fine Arts), which are still classical in concept, but imbued with a romantic spirit of reverie.

There are two preparatory drawings, one for the landscape and architecture, the other for the seated figure (Cambridge, Fogg Art Museum; Bolton, cat. nos. 155, 156).

ANONYMOUS
Camp in the Adirondacks
PL. 69

Oil on wood panel
9-13/16 x 12 in. (25 x 30.5 cm.)
Signed lower left: G. Inness

Acc. no. 22.35
Gift of Arthur J. Secor

COLLECTIONS: Frederick S. Gibbs, New York (sold, New York, American Art Association, Feb. 24, 1904, lot 146, repr.); Henry Smith (sold, New York, Fifth Avenue Art Galleries, Feb. 23–24, 1905); J. R. Andrews, Bath, Me.; (Vose); Arthur J. Secor, 1912–22.

REFERENCES: L. Ireland, *The Works of George Inness, An Illustrated Catalogue Raisonné*, Austin and London, 1965, no. 247, repr. (by Inness, ca. 1862–64).

From at least 1904 until recently this picture was attributed to George Inness (1825–1894), and it was catalogued among his authentic works by Ireland.

However, since 1965 it has become evident that the picture is not by Inness. The Inness scholar Nicolai Cikovsky, Jr. has observed that both the intimate character of the sporting subject and characteristics of style are alien to Inness' work, and he has also pointed out that the provenance cannot be traced back to Inness' lifetime (letter, Apr. 27, 1979).

When the picture was cleaned in 1977 the signature was found to be thinly painted and sensitive to solvents that did not affect other dark pigments in the painting. It thus appears the Inness signature was added at a later date to a work by another artist.

ANONYMOUS
Emma Gordon Shields
PL. 27

[Ca. 1840–43] Oil on canvas
30-1/16 x 25 in. (76.3 x 63.5 cm.)
Acc. no. 45.15

COLLECTIONS: Mrs. Levi Pierce, New Orleans; Pierce family, New Orleans; Private collection, ca. 1900; (Eunice Chambers, Hartsville, S.C., 1945).

The sitter has been traditionally identified as Emma Gordon Shields of New Orleans. According to the dealer Eunice Chambers, she was the daughter of Ellen Blanchard Keer and Thomas Shields, U.S.N., who married Hezekiah O'Callaghan and moved to Philadelphia. Although there are records for a Mrs. Emma G. Shields (d. 1850, age 30) in New Orleans, none has been found for the O'Callaghans in Philadelphia.

Until recently, the portrait was attributed to Samuel F. B. Morse and thought to have been painted during his 1818–21 stay in Charleston, S.C., where Emma Shields allegedly had relatives. However, the costume and hairstyle are typical of the early 1840s. By this time Morse had largely given up painting in favor of scientific interests. As well, the smooth, linear treatment of the face, and awkwardly stylized figure are uncharacteristic of Morse's fluid, painterly brushwork and firm grasp of form.

ANONYMOUS
Florence Scott Libbey
PL. 164

Oil on canvas
30 x 25¼ in. (76.2 x 64.1 cm.)
Acc. no. 38.23

Biographical data on the sitter appears in the entry for her portrait by Jean MacLane

ANDREY AVINOFF

1884–1949. Born in Tulchin, Russia. 1905 law degree, University of Moscow. 1917 settled in U.S.; worked as advertising illustrator and portraitist. His long-time interest in entomology led to his appointment as assistant curator and from 1926–45 as director of the Carnegie Museum, Pittsburgh. As an artist, Avinoff specialized in watercolors of flowers.

White Orchid with Pale Yellow Throat
PL. 236

[Ca. 1947–49] Watercolor on paper
20 x 15¼ in. (50.8 x 38.7 cm.)
Species name inscribed on reverse: C. Sousan

Acc. no. 59.35
Gift of Mr. and Mrs. John D. Biggers

COLLECTIONS: (Nicholas Shoumatoff, Bedford, N.Y.).

White Orchids with Pale-Green Yellow Throats PL. 237

[Ca. 1947–49] Watercolor on paper
21⅞ x 15 in. (55.5 x 38 cm.)
Species names inscribed on reverse: L.C. Louis
 Georgiana/X.C. Intermedia Alba/L.C. Louis Sandero
Acc. no. 59.36
Gift of Mr. and Mrs. John D. Biggers
COLLECTIONS: (Nicholas Shoumatoff, Bedford, N.Y.).

Yellow Orchids with Red-Orange Throats PL. 238

[Ca. 1947–49] Watercolor on paper
21⅞ x 15 in. (55.5 x 38 cm.)
Species names inscribed on reverse: C. Dowiana/XC.C.
 Prinic. Royal
Acc. no. 59.37
Gift of Mr. and Mrs. John D. Biggers
COLLECTIONS: (Nicholas Shoumatoff, Bedford, N.Y.).

Pale Yellow Orchids with Magenta Throats PL. 239

[Ca. 1947–49] Watercolor on paper
20⅜ x 14⅞ in. (51.8 x 37.8 cm.)
Species names inscribed on reverse: C. No Nom Yet
 (sic)/C. Auria/XC. Sylvia
Acc. no. 59.38
Gift of Mr. and Mrs. John D. Biggers
COLLECTIONS: (Nicholas Shoumatoff, Bedford, N.Y.).

WALTER DARBY BANNARD

1934–. Born in New Haven, Conn. 1956 B.A. Princeton
University; began to paint seriously while at Princeton.
Lived in New York and in Europe. 1958 settled in
Princeton, N.J. Ca. 1966 began writing criticism, chiefly
on contemporary art. 1968 visiting critic at Columbia
University. 1968–69 Guggenheim Foundation Fellow-
ship. As a painter Bannard has developed within the
color field movement.

Summer Joys #2 PL. 271

[1970] Alkyd resin on canvas
65⅞ x 98⅞ in (167.7 x 251.2 cm.)
Signed, dated and inscribed on the stretcher: "Summer
 Joys #2" 1970/W. D. BANNARD
Acc. no. 72.11

Gift of Edward Drummond Libbey
COLLECTIONS: (Tibor de Nagy Galleries, Inc., New York).
According to the artist, the title was taken from a poem
by George Meredith, *Modern Love* (1862):

> We saw the swallows gathering in the sky
> And in the osier-isle we heard them noise.
> We had not to look back on summer joys,
> Or forward to a summer of bright dye. . . .

The *Summer Joys* series belongs to a larger group of
works for which Bannard used cardboard templates to
produce faint overall grid patterns, and a cloth on a
handle to apply the paint (letter, Mar. 21, 1979). The six
canvases in this series were painted simultaneously using
the same colors.

ELINOR M. BARNARD

1872–1942. Born in London, England. Member, Na-
tional Academy of Women Painters and Sculptors.
Specialized in watercolor portraits.

Flower Arrangement PL. 179

Watercolor on paper
20 x 26⅜ in (50.8 x 66.7 cm.)
Signed lower left: E. M. Barnard
Acc. no. 27.318
Gift of Athena Society and Friends

WILLIAM BAZIOTES

1912–1963. Born in Pittsburgh, raised in Reading, Pa.
1933 to New York; studied with Leon Kroll at NAD
until 1936. 1936–41 artist and instructor for WPA Fed-
eral Art Project. During late 1930s met Surrealists in
New York and began to experiment with automatism.
1948 a founder of Subjects of the Artist School and
The Club. From 1949 taught at several New York
schools. Of all the New York School painters, Baziotes
remained closest to Surrealism in his imagery and mood.

Scorpion PL. 255

[1952] Oil on canvas
50⅛ x 24⅞ in. (127.3 x 63.3 cm.)
Signed lower right: Baziotes
Signed and dated on reverse: Scorpion W. Baziotes 1952
Acc. no. 52.98
Museum Purchase Fund
COLLECTIONS: (Kootz Gallery, New York).

EXHIBITIONS: New York, Kootz Gallery, *Baziotes, New Paintings,* 1952, no. 9; Toledo Museum of Art, *39th Annual,* 1952, no. 3.

JACK BEAL

1931–. Born in Richmond, Va. Studied at William and Mary College, Norfolk, Va., and at the Art Institute of Chicago and University of Chicago. Since 1967 has been a visiting artist at many college and universities. Lives in New York City and upstate New York. As a painter of figures and interior subjects and as a printmaker, Beal is a leading figure among the realist artists who came to maturity in the 1960s.

Still Life Painter PL. 278

(1978–79) Oil on canvas
49¾ x 60 in. (126.3 x 152.5 cm.)

Acc. no. 79.77
Gift of Edward Drummond Libbey

EXHIBITIONS: New York, Allan Frumkin Gallery, *The Big Still Life,* 1979, repr. (color); Philadelphia, PAFA, *Seven on the Figure,* 1979, p. 23, repr. p. 21.

This picture was painted in response to an invitation by the dealer Allan Frumkin in the summer of 1978 to several artists to paint a large still life for an exhibition to take place in the winter of 1979.

Beal has said he decided to paint the back of a still life arrangement that had already been set up by his wife, the painter Sondra Freckelton, for the canvas she was painting for the same Frumkin show, though he added the large begonia plant through which his wife is seen working on her canvas. The artist has also pointed out that the theme of people at work has been of particular interest to him for some time, and that he has often shown his wife and other family members working in the garden or studio.

CECILIA BEAUX

1855–1942. Born in Philadelphia. Studied privately 1872–73, and 1881–83 with William Sartain. 1877 enrolled PAFA. By mid-1880s an established portraitist in Philadelphia. 1888–90 studied in Paris at Académies Julian and Colarossi. 1890 returned to Philadelphia. 1893 member of Society of American Artists. 1895–1916 first woman instructor at PAFA. 1896 in Paris and England; met Monet. Mid-1890s moved to New York. 1903 N.A.

1930 published autobiography, *Background with Figures.*

After the Meeting PL. 161

[1914] Oil on canvas
40-15/16 x 28⅛ in. (104 x 71.5 cm.)
Signed lower left: Cecilia Beaux

Acc. no. 15.163

COLLECTIONS: Bought from the artist, 1915.

EXHIBITIONS: Pittsburgh, Carnegie Institute, *18th Annual Exhibition,* 1914, no. 13, repr.; New York, NAD, 1914, no. 270; Syracuse Museum of Fine Arts, *Portraits by Cecilia Beaux,* 1931, no. 10; New York, American Academy of Arts and Letters, *Paintings by Cecilia Beaux,* 1935, no. 7; Philadelphia, PAFA, *150th Anniversary Exhibition,* 1955, no. 124; Philadelphia, PAFA, *Cecilia Beaux: Portrait of an Artist,* 1974, no. 67, repr. (color) (cat. by F. Goodyear and E. Bailey).

REFERENCES: H. Drinker, *The Paintings and Drawings of Cecilia Beaux* (exh. cat.), PAFA, Philadelphia, 1955, p. 59, repr. p. 60.

The artist's closest friend, Dorothea Gilder McGrew (1882–1920), daughter of Richard Watson Gilder, poet and editor of *Century Magazine,* posed for this canvas, painted in Beaux's Gramercy Park studio. The two women met in Paris in 1896. The Gilders introduced Beaux to many distinguished American artists and writers in their New York home, and she painted several portraits of Dorothea, her parents, and sisters (Rosamond Gilder, the sitter's sister, letter, Nov. 25, 1978).

This painting is unusual in Beaux's work both for its richly decorative patterns and because it was not intended as a portrait (Beaux, letter, 1915). Unlike many of Beaux's sitters, this figure is animated, conversing with someone outside the composition.

GEORGE WESLEY BELLOWS

1882–1925. Born in Columbus, Ohio. 1901–04 attended Ohio State University, developing interests in athletics, music and art. 1904–06 studied with Robert Henri. 1909 A.N.A., the youngest in the Academy's history; 1913 N.A. 1910 exhibited in Independent Artists Exhibition, and in 1913 Armory Show, which he helped stage. From 1910 taught at ASL. 1916 began lithography. 1917 a founding member of Society of Independent Artists. Although younger than The Eight, with whom he was closely associated, Bellows achieved early success with boldly conceived and brilliantly executed city and boxing subjects, as well as portraits.

The Bridge, Blackwell's Island PL. 156

[1909] Oil on canvas
34-1/16 x 44-1/16 in. (86.5 x 112 cm.)
Signed lower right: Geo Bellows

Acc. no. 12.506
Gift of Edward Drummond Libbey

COLLECTIONS: Edward Drummond Libbey, Toledo, ca. 1911.

EXHIBITIONS: Berlin, Königliche Akademie der Künste, *Ausstellung Amerikanischer Kunst,* 1910, no. 26; Munich Royal Society, 1910; New York, NAD, 1910, no. 258; New York, Metropolitan Museum of Art, *George Bellows Memorial Exhibition,* 1925, no. 9, repr.; New York, Whitney Museum of American Art, *New York Realists, 1900–1914,* 1937, no. 2; Art Institute of Chicago, *George Bellows,* 1946, no. 7, repr. p. 16.

REFERENCES: *George Bellows' Private Diary of Paintings,* unpublished MS. on deposit at H. V. Allison & Co., New York, Book A, p. 70 (dated Dec. 1909); E. Bellows, *The Paintings of George Bellows,* New York, 1929, pl. 19; P. Boswell, *George Bellows,* New York, 1942, p. 16, repr. p. 59; C. Morgan, *George Bellows, Painter of America,* New York, 1965, pp. 102, 104, 125, repr. p. 319; D. Braider, *George Bellows and the Ashcan School of Painting,* Garden City, 1971, pp. 54, 56, repr. pl. 9; M. Young, *The Paintings of George Bellows,* New York, 1973, p. 40, repr. (color) p. 41.

This is one of several New York river subjects Bellows painted between 1908–13, and is a view from 59th Street in Manhattan of the Queensboro Bridge spanning the East River and Welfare Island, formerly called Blackwell's Island. Bellows was fascinated by the constant construction in New York; he painted this canvas in December 1909, shortly after completion of the bridge.

When Edward Drummond Libbey bought this painting, he wrote to the Museum's director, George W. Stevens, "You need not hang this canvas now unless you care to. I feel that some day it will be important, for the painter shows great promise." (quoted from *Toledo Museum of Art Museum News,* No. 48, Mar. 1926, p. 603).

EUGENE BERMAN

1899–1972. Born in St. Petersburg, Russia; younger brother of Leonid (q.v.), 1914 first studied art and architecture. 1918–39 chiefly in Paris. 1919 studied with Edouard Vuillard, Paul Sérusier and Maurice Denis.

1925 first exhibited with the Neo-Romantic group. 1930s increasingly active as a theatrical designer and illustrator. 1940 settled in California. 1944 U.S. citizen. 1956 moved to Rome. Strongly influenced by De Chirico, Picasso and the Surrealists.

La Puerta de los Milagros PL. 229

[1948] Oil on canvas
36⅛ x 29-3/16 in. (91.8 x 74.2 cm.)
Signed and dated bottom center: EB/1948
Inscribed by artist on reverse of canvas: E. Berman/ Hollywood. Dec. 1947/Jan. 1948/La Puerta de los Milagros

Acc. no. 50.6
Gift of an Anonymous Donor

COLLECTIONS: (Macbeth).

The Gate of Miracles is from a series of paintings inspired by studies of Mexican colonial architecture made on two trips funded by Guggenheim Foundation Fellowships in 1945 and 1947.

LOUIS BETTS

1873–1961. Born in Little Rock, Ark.; raised in Chicago. Studied with his father, Edwin D. Betts, landscape painter, and with W. M. Chase at PAFA and at Shinnecock, Long Island. 1902 to Europe. 1912 N.A. Chiefly a portraitist; worked mostly in New York.

Elizabeth Betts of Wortham PL. 170

[1923] Oil on canvas
90⅛ x 60⅜ in. (229 x 153.3 cm.)
Signed and dated lower left: Louis Betts/1923

Acc. no. 23.3137

COLLECTIONS: (Chester Johnson, Chicago).

EXHIBITIONS: New York, NAD, 1923, no. 368, repr. (Altman Prize).

REFERENCES: L. Betts, "Experiences of a Portrait Painter, part II: Working on Portrait Canvases," *Artist,* LII, Feb. 1957, p. 144.

In his article, Betts stated he painted this canvas in his New York studio at a time he no longer did portraits. The title is unclear, as Florence D. Shea of New York later identified herself as the model (letter, Apr. 8, 1929).

ALBERT BIERSTADT

1830–1902. Born in Solingen, Germany. Raised in New Bedford, Mass. 1853 to Germany; studied at Düsseldorf, where he met Leutze and Whittredge; traveled with them to Italy 1856–57. 1859 settled in New York. 1860 N.A. Trips to western U.S. 1858–59, 1863, 1871–73. Continued to travel in U.S. and Europe. Bierstadt achieved international acclaim for vast canvases reflecting the grandeur of the American West, and in the 1860s and 70s his landscapes brought record prices for an American artist.

El Capitan, Yosemite Valley, California PL. 43

[1875] Oil on canvas
32-3/16 x 48⅛ in. (81.7 x 122.3 cm.)
Signed lower left: ABierstadt (AB in monogram)
Inscribed on reverse of wood fill stretcher: El Capitan
 Yosemite Valley/1875/El Capitan Yosemite Valley
 Cal./painted 1875/A. Bierstadt

Acc. no. 59.18
Gift of Mr. and Mrs. Roy Rike

COLLECTIONS: Matthew T. Gay, Newark and East Orange, N.J.; given by Herbert S. Gay to Zeta Psi, Williams College, Williamstown, Mass., 1920s–1959; (Vose, 1959).

EXHIBITIONS: Santa Barbara Museum of Art, *Work of Albert Bierstadt*, 1964, no. 63 (cat. by G. Hendricks); Toledo Museum of Art, *Heritage and Horizon: American Painting 1776–1976*, 1976, no. 14, repr.

REFERENCES: R. Trump, "Life and Works of Albert Bierstadt," unpublished Ph.D. dissertation, Ohio State University, 1963, no. 70; G. Hendricks, "The First Three Western Journeys of Albert Bierstadt," *The Art Bulletin*, XLVI, Sep. 1964, p. 359, no. 147; E. Cock, *The Influence of Photography on American Landscape Painting, 1839–1880*, New York, 1977 (Garland reprint of Ph.D. dissertation, New York University, 1967), I, pp. 94–5; II, pl. 17; E. Lindquist-Cock, "Stereo-scopic Photography and the Western Paintings of Albert Bierstadt," *Art Quarterly*, XXXIII, No. 4, 1970, pp. 374–75, fig. 16; G. Hendricks, *Albert Bierstadt: Painter of the American West*, New York, 1974, p. 242, fig. 182, no. CL-191; J. Sweeney, "The Artist-Explorers of the American West: 1860–1880," unpublished Ph.D. dissertation, Indiana University, 1975, pp. 246–51, illus. 54, 55 (detail), 56 (detail).

Bierstadt visited Yosemite Valley in the Sierra Nevadas in 1863 and 1872–73. On both trips he made sketches from which he later composed finished works.

This is one of his most topographically accurate views

of the steep granite cliffs of El Capitan rising above the meadows by the Merced River. By 1875 it had become the most celebrated site in Yosemite, largely due to Bierstadt's earlier depictions of it.

Two of Eadweard Muybridge's 1873 stereoscopic views of El Capitan may have served as studies (Bradley and Rulofson, *Catalogue of Photographic Views Illustrating the Yosemite, etc. by Muybridge*, San Francisco, 1873, nos. 1415 and 1462). As Lindquist-Cock notes, both the painting and photographs show the contrast of sharply focused foreground objects—clumps of grass, rocks, trees and highly reflective water surfaces—against the distant hazy mountains, creating a sense of depth and drama.

RALPH ALBERT BLAKELOCK

1847–1919. Born in New York. Chiefly self-taught. 1864 attended Free Academy (now City University of New York). 1865 began painting landscapes. 1867 first exhibited NAD. 1869–72 traveled extensively in the West sketching Indians. 1876 married and settled in New York. During 1880s his financial resources worsened and led to a series of mental breakdowns. After 1899 largely confined to sanitariums. 1912–16 rediscovery of his work brought high prices and led to many forgeries. Blakelock is one of the chief landscape painters of late nineteenth century romanticism.

Brook by Moonlight PL. 70

[Before 1891] Oil on canvas
72⅛ x 48-1/16 in. (183.2 x 122.1 cm.)
Signed lower left: Ralph Albert Blakelock (within
 arrowhead)

Acc. no. 16.4
Gift of Edward Drummond Libbey

COLLECTIONS: Bought from the artist by Catholina Lambert, Paterson, N.J., 1891 (sold, New York, American Art Association, Feb. 21, 1916, no. 182, repr.); Edward Drummond Libbey.

EXHIBITIONS: New York, Henry Reinhardt, *Loan Exhibition of Paintings by Ralph Albert Blakelock*, 1916, no. 40.

REFERENCES: C. Caffin, *Story of American Painting*, New York, 1907, repr. p. 215; E. Daingerfield, *Ralph Albert Blakelock*, New York, 1914, pp. 35–6, repr. opp. p. 33 (partially reprinted in *Art in America*, II, 1914, p. 68, fig. 4; LI, No. 4, 1963, repr. p. 83); "Blakelock's Moonlight," *Toledo Museum of Art Museum News*, No.

29, Feb. 1917, pp. 1–2, repr.; F. F. Sherman, *Landscape and Figure Painters of America*, New York, 1917, pp. 28–9; L. Goodrich, *Ralph Albert Blakelock Centenary Exhibition* (exh. cat.), New York, Whitney Museum of American Art, 1947, pp. 15, 29, 35, 37; V. Barker, *American Painting*, New York, 1950, p. 606, pl. 87; W. Garrett, ed., *The Arts in America, The Nineteenth Century*, New York, 1969, repr. p. 277; W. Adelson, D. and S. Blakelock and J. Tanzer, *Ralph Albert Blakelock* (exh. cat.), New York, Knoedler, 1973, pp. 2–3; N. Geske, *Ralph Albert Blakelock* (exh. cat.), Lincoln, Neb., Sheldon Memorial Art Gallery, 1975, p. 19, fig. 6; Nebraska Blakelock Inventory, University of Nebraska, Lincoln, no. NBI-703.

Blakelock painted numerous variations of the moonlight landscape, which the Blakelock scholar, Norman Geske has characterized as "the artist's central and definitive image . . . expressive of the solitary vision of the painter himself" (Geske, 1975, p. 18), and his most romantic and poetic theme.

Goodrich recounts the sale in 1891 of this painting, then considered one of Blakelock's major pictures, to the collector and silk manufacturer, Catholina Lambert, who paid only half of the asking price of $1,000. Such disappointments contributed to the mental breakdown of the financially pressed artist. Ironically, this picture was sold at auction in 1916 to Edward Drummond Libbey for $20,000, up to that time the highest price paid for a work by a living American artist, and the second highest price paid for any American painting.

The Setting Sun PL. 71

[Probably 1890s] Oil on canvas
18⅛ x 32 in. (46 x 81.2 cm.)
Signed lower left: R. A. Blakelock (in arrowhead)

Acc. no. 22.17
Gift of Arthur J. Secor

COLLECTIONS: Bought from the artist before 1899 by Colonel William P. Roome, New York; Frederick S. Gibbs, New York, by 1901; Thomas R. Ball, New York, 1903 (sold, American Art Association, Mar. 14, 1919, lot 142, repr.); (Vose, 1919); Arthur J. Secor, Toledo, 1919–22.

EXHIBITIONS: New York, Lotus Club, *Paintings by Ralph Albert Blakelock in the Collection of Frederick S. Gibbs*, 1901, n.p., repr. (with verse, "Like some high spirit summoned from our sight, the sun steps down into the unknown night"); New York, Whitney Museum of American Art, *Ralph Albert Blakelock Centenary Exhibition*, 1947, no. 22.

REFERENCES: Nebraska Blakelock Inventory, University of Nebraska, Lincoln, no. NBI-704.

FRITZ BOEHMER

1875–1942. Born in Falknau, Bohemia. Studied painting on glass at Haida, Bohemia and at Dresden. Worked as porcelain painter in Austria, Hungary and Germany. In 1923 settled in Toledo, where he worked as a glass and china painter for DeVilbiss Manufacturing Company and later for Dura Company. Boehmer specialized in miniature portraits on ivory.

Gertrud Boehmer PL. 142

[Ca. 1895] Oil on ivory
5 x 3½ in (12.7 x 9 cm.)
Signed lower left: F. BOEHMER

Acc. no. 52.101
Museum Purchase Fund

Gertrud Boehmer was the artist's wife.

Head of a Girl PL. 140

Oil on academy board
16 x 12 in. (40.7 x 30.5 cm.)
Signed lower left: F. BOEHMER

Acc. no. 54.4
Gift of Mrs. Fritz Boehmer

ILYA BOLOTOWSKY

1907–. Born in St. Petersburg, Russia. 1923 to New York; 1924–30 studied at NAD. 1929 U.S. citizen. 1933 first saw works by Mondrian and Miró which directly affected his work. 1936 a founder of American Abstract Artists group. Mid-1930s worked for WPA Federal Art Project. 1946–48 acting head of art department at Black Mountain College, N.C. From 1948 has taught at several universities. Since the 1940s Bolotowsky has been the major American exponent of geometric abstraction influenced by neoplasticism and suprematism.

Blue Ellipse PL. 270

[1976] Acrylic on canvas
68 x 40¼ in (172.7 x 102.2 cm.)
Signed lower right edge: Ilya Bolotowsky 76
Inscribed on stretcher: "BLUE ELLIPSE" Nov. 1976/
 68″ x 40″ by Ilya Bolotowsky

Acc. no. 77.44

Gift of Edward Drummond Libbey

COLLECTIONS: (Grace Borgenicht Gallery, New York).

GEORGE HENRY BOUGHTON

1833–1905. Born in Norwich, England. Ca. 1837 family emigrated to Albany, N.Y. Chiefly self-taught. 1856 briefly in London. 1858 first exhibited NAD; 1871 N.A. 1860–62 studied with Edouard Frère and Edouard May in Paris. 1862 settled permanently in London. 1879 Associate, Royal Academy; 1896 Academician. Boughton is best known for historical and literary subjects.

Early Puritans of New England Going to PL. 44
Worship

[1872] Oil on canvas
14-3/16 x 25¼ in (36.1 x 64.2 cm.)
Signed lower right: GHB
Inscribed on paper glued to stretcher: New England
 Pilgrims Going to Church-/The Early Settlers of New
 England were/obliged to go armed on their way to
 Church/in order to protect themselves against the/
 hostile Indians and the Wild Beasts of the/forests—
 Painted by George H. Boughton/London 1872

Acc. no. 57.30

COLLECTIONS: Bennett, London; Capt. Gerard Crutchley, London; (Gerald C. Paget, New York, 1957).

REFERENCES: *G. H. Boughton Paintings,* bound collection of photographs, New York Public Library, n.d., III, pl. 46.

Colonial history was a popular theme in late nineteenth century literature and art, and Boughton's Puritan subject was the first in a series of pictures by him illustrating early New England history and romance. Like many of his contemporaries, Boughton was inspired by the poetry and prose of such writers as Longfellow, Hemans and Hawthorne. The Toledo canvas is a half-size replica of a painting exhibited at the Royal Academy in 1867 (New York Public Library; on permanent loan to the New-York Historical Society), and was inspired by a passage in William Henry Bartlett's *Pilgrim Fathers* (London, 1853):

> Except in the vicinity of the larger towns, the whole country was still overspread with a dense forest, the few villages were almost isolated, being connected only by long miles of blind pathway through the tangled wood The calvalcade proceeding to the church . . . was often interrupted by the sudden death-shot from some invisible enemy (pp. 236–37).

The larger version of 1867 has often been illustrated, and this composition is the most famous of Boughton's works.

ROBERT BRACKMAN

1898–. Born in Odessa, Russia. Ca. 1908 emigrated to New York. Ca. 1915 studied with Robert Henri and George Bellows at the Modern School at the Ferrer Center, New York. Ca. 1921 studied with Charles Curran at NAD. Since 1934 has taught at ASL and at his own summer school in Noank, Conn., where he lives. Chiefly a portrait and figure painter.

In a Mid-day Light PL. 218

[1949] Oil on canvas
50 x 28-1/16 in. (127 x 71.2 cm.)
Signed lower right: Brackman
Inscribed by artist on reverse of canvas: IN A MID-DAY
 LIGHT/Robert Brackman/Noank, Conn.

Acc. no. 50.267
Museum Purchase Fund

COLLECTIONS: (Grand Central Galleries, New York).

EXHIBITIONS: New York, NAD, *124th Annual,* 1949, no. 88; Toledo Museum of Art, *37th Annual,* 1950, no. 7.

REFERENCES: K. Bates, *Brackman: His Art and Teaching,* Noank, Conn., 1951, fig. 11.

ALEXANDER BROOK

1898–. Born in Brooklyn, N.Y. 1915–19 studied at ASL. 1924–27 assistant director of Whitney Studio Club. In late 1920s active as art critic. Has lived mostly in New York. Taught at ASL. Chiefly a still life and figure painter.

Amalia PL. 199

[1942] Oil on canvas
35⅞ x 27-15/16 in. (91.2 x 71 cm.)
Signed lower right: A. Brook

Acc. no. 43.64
Elizabeth C. Mau Bequest Fund

COLLECTIONS: (Frank K. M. Rehn, New York).

EXHIBITIONS: New York, Whitney Museum of American Art, *Annual Exhibit of Contemporary American Art,* 1942, no. 9a; Toledo Museum of Art, *30th Annual,* 1943; New York, Knoedler, *Recent Works of Alexander Brook,* 1952, no. 4.

REFERENCES: American Artists Group, *Alexander Brook,* New York, 1945, repr.

The artist has identified the sitter as Amalia Prendergast, a New York friend who lived on Washington Square (letter, Jan. 30, 1979).

JAMES BROWN

Ca. 1820-after 1859. Born in New York State. Ca. 1835 moved with his family to New York City. In 1840s partner in lithography firm of E. & J. Brown, which published several lithographs after his designs. About 1850 active as a painter of genre, portrait and marine subjects. Exhibited NAD, 1850–55; American Art Union, 1850. Last recorded in St. Louis, 1859.

The Young Pedlar PL. 32

[1850] Oil on canvas
24 x 19⅝ in (61 x 50 cm.)
Signed and dated lower left: James Brown 1850/N.Y.
Inscribed on old label attached to stretcher: The Young
 Pedlar/James Brown 181 Broadway, B14 White Str./
 For Sale.
Old printed label attached to stretcher: No. 227/Amer-
 ican Art Union,/The Young Pedlar/Painted by James
 Brown/Distributed December 20, 1850

Acc. no. 59.20
Museum Purchase Fund

COLLECTIONS: Dr. William L. Johnson, Exeter, N.H., 1850; (Charles D. Childs, Boston, 1959).

EXHIBITIONS: New York, NAD, 1850, no. 80; New York, American Art Union, 1850, no. 222.

REFERENCES: M. B. Cowdrey, *NAD,* I, p. 54; M. B. Cowdrey, *American Academy of Fine Arts and American Art Union, Exhibition Record, 1816–1852,* New York, 1953, p. 47.

Little is known about Brown. Although he was active in New York City when he painted *The Young Pedlar,* the park and buildings cannot be identified with a specific location there, nor is it apparently a view in Philadelphia, Baltimore, Boston or London.

JOHN GEORGE BROWN

1831–1913. Born in Durham, England. Served seven-year apprenticeship as glasscutter and studied art at Newcastle-on-Tyne. Studied at Royal Scottish Academy,

Edinburgh and Royal Academy, London. 1853 emigrated to New York. 1853–55 studied painting with Thomas Seir Cummings. 1858 first exhibited NAD. 1863 N.A. 1899–1904 vice-president, NAD. Chiefly known for popular sentimental paintings of city urchins, Brown was one of the most successful genre painters of the late nineteenth century.

The Country Gallants PL. 54

[1876] Oil on canvas
30-1/16 x 46 in. (76.4 x 116.8 cm.)
Signed and dated lower right: J. G. Brown, N.A./N.Y.
 1876

Acc. no. 49.23

COLLECTIONS: Crocker Collection, San Francisco; G. N. Blanding; (Albert K. Schneider, New York).

EXHIBITIONS: New York, NAD, 1876, no. 384.

WILLIAM MASON BROWN

1828–1898. Born in Troy, N.Y. Studied in New York. 1850–58 active as landscape painter in Newark, N.J. 1858 moved to Brooklyn. 1859–91 exhibited regularly at NAD. By 1865 specialized in still lifes. Although he began his career as a landscapist in the romantic tradition of Cole, Brown established his reputation as a painter of precise, almost photographic still lifes.

Landscape with Two Indians PL. 34

[Ca. 1855] Oil on canvas
45⅞ x 69⅜ in. (116.5 x 176.2 cm.)
Signed lower right: WM Brown (WM in monogram)

Acc. no. 22.109
Gift of Arthur J. Secor

COLLECTIONS: D. G. Geddes, to 1899(?); L. A. Lanthier(?); (Clapp and Graham, New York, 1919); (Vose, to 1922).

EXHIBITIONS: Art Institute of Chicago, *The Hudson River School,* 1945, no. 53 (cat. by F. Sweet; as *Dream of Arcadia* by Thomas Cole).

REFERENCES: F. Mather, "The Hudson River School," *American Magazine of Art,* XXVII, June 1934, repr. p. 298 (as *Dream of Arcadia* by Cole); P. Lesley, "Thomas Cole and the Romantic Sensibility," *The Art Quarterly,* V, Summer 1942, pp. 218, 219, repr. p. 221 (as *An Evening in Arcady* by Cole).

Until 1978 this painting was attributed to Thomas Cole

because of its Cole-like style and the inscription *T. Cole* at lower right. As it became apparent that the style was inconsistent with Cole's established works and that the Cole inscription concealed another, this later addition was removed to reveal Brown's characteristic signature, which is technically consistent with the rest of the paint surface and similar to those on other landscapes by him.

The date is based on the similar dated landscape by Brown, *Summer Time* (1853; Hanover, N.H., Dartmouth College Museum and Galleries), and on the fact that in the mid-1850s he was chiefly painting landscapes.

GEORGE ELMER BROWNE

1871–1946. Born in Gloucester, Mass. Studied at the Boston Museum School, and worked as an illustrator. Later studied in Paris at the Académie Julian with Jules Lefebvre and Tony Robert-Fleury. 1928 N.A. Lived in Paris, Provincetown, Mass. and New York. Chiefly a landscape painter.

The White Cloud PL. 135

(1910) Oil on canvas
32 x 39 in. (81.2 x 99.1 cm.)
Signed lower left: GEO. ELMER BROWNE.

Acc. no. 12.7

COLLECTIONS: (Henry Reinhardt, New York).

According to the artist, this was painted at Étaples (Pas de Calais), France.

Edge of the Grove PL. 136

[Ca. 1916] Oil on canvas
39½ x 39½ in. (100.5 x 100.5 cm.)
Signed lower left: Geo. Elmer Browne

Acc. no. 16.49
Museum Purchase Fund

COLLECTIONS: Bought from the artist.

REFERENCES: *American Art Annual*, XIII, 1916, repr.

GEORGE DE FOREST BRUSH

1855–1941. Born in Shelbyville, Tenn.; raised in Connecticut. Studied at NAD, and 1874–80 with Gérôme in Paris. Traveled in western U.S. and Canada to study Indian subjects. 1880 member Society of American Artists. 1887–1914 several trips to Europe. Brush retained a conservative style influenced by the Italian Renaissance in

the paintings of Indians and of idealized women for which he is best known.

Portrait of a Child PL. 171

[1922] Oil on panel
15⅝ x 13¾ in (39.7 x 35 cm.)
Signed and dated upper right: Geo. De Forest Brush/
 1922

Acc. no. 23.3135

EMIL CARLSEN

1853–1932. Born in Copenhagen, Denmark. Studied architecture before emigration to U.S. in 1872. Studied painting in Chicago and taught at Art Institute of Chicago. Ca. 1875–77 in Paris. 1887–91 director of San Francisco Art School. 1891 settled in New York. Spent summers in New England. 1908 and 1912 in Europe. While also a landscape and marine painter, Carlsen is best known for still lifes.

The Leeds Jug PL. 169

[1920] Oil on canvas mounted on board
15-15/16 x 14 in. (40.5 x 35.6 cm.)
Signed and dated lower left: Emil Carlsen 1920

Acc. no. 31.53

COLLECTIONS: (Macbeth).

JOHN FABIAN CARLSON

1874–1945. Born in Kolsebro, Sweden. 1884 family settled in Buffalo, N.Y. 1902–03 studied with Birge Harrison. 1911–18 director of Woodstock (N.Y.) Summer School. 1920 co-founder Broadmoor Art Academy, Colorado Springs. 1922 founded John F. Carlson School of Landscape Painting at Woodstock. 1925 N.A. 1928 published *Elementary Principles of Landscape Painting*. He was an influential teacher of landscape painting.

Woodland Repose PL. 174

[1915] Oil on canvas
30 x 39⅞ in. (76.1 x 101.4 cm.)
Signed lower right: John F. Carlson
Inscribed in paint on stretcher: John F. Carlson/Woodland Repose

Acc. no. 16.61
Gift of Dr. and Mrs. Julius H. Jacobson

JOHN CARROLL

1892–1959. Born in Wichita, Kan. 1913–15 studied engineering at University of California. Studied painting in San Francisco, and with Frank Duveneck in Cincinnati. Exhibited at Whitney Studio Club, New York. Summers at Woodstock, N.Y. Taught at ASL, 1926, 1944–59, and at Society of Arts and Crafts, Detroit, 1930–44. Figure, portrait and landscape painter; frescoes for Detroit Institute of Arts, 1935–36.

White Lace PL. 192

[1935] Oil on canvas
40⅛ x 29-15/16 in. (102 x 76 cm.)
Signed and dated lower right: John Carroll 35

Acc. no. 36.71
Museum Purchase Fund

COLLECTIONS: (Frank K. M. Rehn, New York).

EXHIBITIONS: Toledo Museum of Art, *23rd Annual*, 1936, no. 11, repr.; Brooklyn Museum, *Revolution and Tradition*, 1951, no. 136; Albany Institute of History and Art, *John Carroll Retrospective Exhibition*, 1963, no. 9.

REFERENCES: J. I. H. Baur, *Revolution and Tradition in American Art*, New York, 1951, fig. 186.

The model was Georgia F. Carroll, the artist's wife.

Spring Bonnet PL. 193

[Ca. 1948] Oil on canvas
22 x 18 in. (55.9 x 45.7 cm.)
Signed lower right: John Carroll

Acc. no. 51.312
Gift of Harold Boeschenstein

COLLECTIONS: (Frank K. M. Rehn, New York).

A three-quarters length figure with a similar head and the same title is illustrated in the catalogue of *Painting in the United States*, Carnegie Institute, Pittsburgh, 1948, pl. 7.

CLARENCE HOLBROOK CARTER

1904–. Born in Portsmouth, Ohio. 1923–27 studied at Cleveland School of Art. 1927–28 in Italy; summer study in 1927 with Hans Hofmann. Taught at Cleveland Museum of Art, 1930–37; Carnegie Institute, 1938–44; and elsewhere. 1948 moved to New Jersey. Carter's earlier landscape and figure subjects have been modified under the influence of surrealism in the direction of abstract, geometrical motifs.

Tobacco Barn, Adams County, Ohio PL. 209

[1936] Watercolor on paper
14 x 21 in. (35.6 x 53.3 cm.)
Signed and dated lower right: Clarence H. Carter 36

Acc. no. 36.5
Museum Purchase Fund

COLLECTIONS: (Ferargil, New York).

Stew PL. 213

[1939] Oil on canvas
45 x 36-3/16 in. (114.3 x 92 cm.)
Signed and dated lower left: CLARENCE H. CARTER 39

Acc. no. 46.23
Elizabeth C. Mau Bequest Fund

COLLECTIONS: (Ferargil, New York).

EXHIBITIONS: Pittsburgh, Carnegie Institute, *Exhibition of Paintings by Clarence H. Carter*, 1940, no. 9; Toledo Museum of Art, *33rd Annual*, 1946, no. 8; Cleveland School of Art, *Clarence Carter in Review*, 1948; Trenton, New Jersey State Museum, *A Retrospective Exhibition of Paintings and Constructions by Clarence Holbrook Carter*, 1974, no. 20, repr.

CARLTON THEODORE CHAPMAN

1860–1925. Born in New London, Ohio; raised in Toledo. Studied at NAD and ASL, and in Paris at Académie Julian. Correspondent for *Harper's Weekly* in Spanish-American War. 1914 N.A. Marine and landscape painter.

A Rocky Coast PL. 125

Oil on canvas
20⅛ x 30¼ in. (51 x 76.7 cm.)
Signed lower left: Carlton T. Chapman

Acc. no. 06.258

The Maumee River PL. 138

[1921] Oil on canvas
30 x 40¼ in. (76.2 x 102.2 cm.)
Signed lower left: Carlton Chapman/1921
Inscribed on reverse: The Maumee River/C. T. Chapman/58 W. 57th St.

Acc. no. 23.10
Gift of National Academy of Design, Ranger Fund

WILLIAM MERRITT CHASE

1849–1916. Born in Williamsburgh, Ind. Studied portraiture in Indianapolis. 1870 to New York; studied at NAD. 1871 still life painter in St. Louis. 1872–79 studied in Munich, where he met Duveneck and achieved considerable recognition. 1878 settled in New York; began teaching at ASL. 1880, 1886, president, Society of American Artists. From the 1880s often in Europe; met Whistler in 1885. 1890 N.A. 1891–1902 held summer classes at Shinnecock, Long Island. Continued to teach at Chase School, New York School of Art and PAFA. 1902 member of The Ten American Painters. Chase was a leading painter and tastemaker, and a highly influential teacher.

The Open Air Breakfast [COLOR PL. IV] PL. 92

[Ca. 1888] Oil on canvas
37-7/16 x 56¾ in (95.1 x 144.3 cm.)
Signed lower left: Wᵐ M. Chase

Acc. no. 53.136

COLLECTIONS: The artist, to 1916; Mrs. William Merritt Chase (Chase sale, New York, American Art Galleries, May 14–17, 1917, lot 375, as *The Back Yard: Breakfast Out-of-Doors);* Gabriel Weiss, New York, 1917-at least 1949; J. A. Hoffman, Charleston, S.C.; (Victor Spark, New York).

EXHIBITIONS: Art Institute of Chicago, *28th Annual Exhibition of American Oil Paintings and Sculpture,* 1915, no. 73, repr. (as *Open Air Breakfast);* New York, Metropolitan Museum of Art, *Loan Exhibition of Paintings by William M. Chase,* 1917, no. 15 (as *The Backyard; Breakfast Out-of-Doors);* Philadelphia, PAFA, *150th Anniversary Exhibition,* 1955, no. 56, repr.; New York, Metropolitan Museum of Art, *19th Century America, Painting and Sculpture,* 1970, no. 173, repr.; Washington, National Gallery of Art, *American Impressionist Painting,* 1973, no. 17, repr. (cat. by M. Domit); New York, Whitney Museum of American Art, *The Painters' America: Rural and Urban Life, 1810–1910,* 1974, no. 24, repr. (cat. by P. Hills).

REFERENCES: W. Peat, "Checklist of Known Work by William M. Chase," in *Chase Centennial Exhibition* (exh. cat.), John Herron Art Museum, Indianapolis, 1949, n.p. (as *The Back Yard: Breakfast Out-of-Doors);* R. Boyle, *American Impressionism,* Boston, 1974, p. 205, repr. p. 190; R. Pisano, *William Merritt Chase,* New York, 1979, p. 48, pl. 15.

Set in the Chases' backyard, *Open Air Breakfast* was probably painted in the summer of 1888, when they were living near Prospect Park in Brooklyn. Chase's family often posed for him, and in this picture his wife is seated at the table next to their oldest child, Alice, in the high chair. Virginia Gerson, Mrs. Chase's sister, reclines in the hammock. Ronald G. Pisano, who is preparing a catalogue raisonné of Chase's work, has identified the girl wearing a seventeenth century Dutch-style hat and standing before a Japanese screen as the artist's sister, Hattie (letter, Aug. 7, 1978). One of Chase's Russian hounds naps by the fence. The variety of accessories reveals Chase's well known taste for the kind of exotic objects which decorated his famous Tenth Street studio.

Near the Beach, Shinnecock PL. 93

[Ca. 1895] Oil on canvas
30 x 48⅛ in (76.2 x 122.3 cm.)
Signed lower left: Wᵐ M. Chase

Acc. no. 24.58
Gift of Arthur J. Secor

COLLECTIONS: (John Levy Galleries, New York, by 1918); (Vose); Arthur J. Secor, Toledo, by 1924.

EXHIBITIONS: New York, John Levy Galleries, *A Group of Paintings by Murphy, Tyron, Walker and Wyant,* 1918, no. 31, repr.; Indianapolis, John Herron Art Institute, *Chase Centennial Exhibition,* 1949, no. 36, repr.; Southhampton (N.Y.), Parrish Art Museum, *William Merritt Chase, A Retrospective Exhibition,* 1957, no. 50, repr.; New York, American Academy of Arts and Letters, *The Impressionist Mood in American Painting,* 1959, no. 33; Memphis, Dixon Gallery and Gardens, *Mary Cassatt and the American Impressionists,* 1976, no. 8, repr.

REFERENCES: D. Hoopes, *The American Impressionists,* New York, 1972, p. 44, repr. p. 45 (color).

In 1891 Chase opened a summer school at Shinnecock, Long Island, the first in which painting was taught outdoors. The coastal meadows, expansive horizon and bright clear skies of Shinnecock inspired landscapes which are among Chase's most impressionistic works. The figures in this canvas are Mrs. Chase and two of their daughters.

THOMAS COLE

1801–1848. Born Bolton-le-Moor, Lancashire, England. 1818 family emigrated to Philadelphia. Ca. 1820 active as portraitist in Ohio and Pennsylvania. Ca. 1823–25 turned to landscape painting; brief study at PAFA. 1825 to New York, where his work was discovered by Trumbull, Dunlap and Durand. 1826 elected to second group

of founding members of NAD. 1829–31 and 1841–42 European trips. Cole was a founder of the Hudson River School. Through his associationist aesthetic he brought the beautiful, sublime and picturesque qualities of the American landscape to the attention of the public and succeeding generations of painters.

The Architect's Dream [COLOR PL. II] PL. 23

[1840] Oil on canvas

53 x 84-1/16 in. (134.7 x 213.6 cm.)

Signed and dated on capital: PAINTED BY T. COLE/FOR
 I. TOWN ARCH^t./1840.

Acc. no. 49.162

COLLECTIONS: Thomas Cole, Catskill, N.Y., to 1848; Sarah Cole (daughter), Catskill; Mrs. Florence H. Cole Vincent, Catskill, Mrs. Mary Cole VanLoan and Thomas Cole, III, New York (grandchildren), to 1949.

EXHIBITIONS: New York, NAD, 1840, no. 93 (as *The Architect's Dream*, owned by Ithiel Town); New York, *Exhibition of the Paintings of the late Thomas Cole at the Gallery of the American Art Union*, 1848, no. 37 (owned by Sarah Cole); Hartford, Wadsworth Atheneum, *Thomas Cole, 1801–1848, One Hundred Years Later*, 1948, no. 36, pl. XI (cat. by E. Seaver); Detroit Institute of Arts and Toledo Museum of Art, *Travelers in Arcadia: American Artists in Italy 1830–1875*, 1951, no. 34, repr. and cover (detail); Detroit Institute of Arts, *Painting in America*, 1957, no. 79; New York, Metropolitan Museum of Art, *19th Century America, Painting and Sculpture*, 1970, no. 49, repr. (cat. by J. Howat and N. Spassky); London, Royal Academy, *The Age of Neo-Classicism*, 1972, no. 1058.

REFERENCES: Cole Papers: Correspondence between Cole and Town, Manuscripts and History Division, New York State Library, Albany (on microfilm, Archives of American Art); "The Fine Arts," *The Knickerbocker*, XVII, July 1840, p. 81; "Our Landscape Painters," *The New-York Mirror*, XVIII, July 7, 1840, p. 29; W. C. Bryant, *A Funeral Oration Occasioned by the Death of Thomas Cole, Delivered before the National Academy of Design, New-York, May 4, 1848*, pp. 27–8; L. Noble, *The Course of Empire*, New York, 1853, pp. 285–86; Cowdrey, *NAD*, p. 89 (owned by Ithiel Town); C. Tunnard, "Reflections on 'The Course of Empire' and other Architectural Fantasies of Thomas Cole," *Architectural Review*, CIV, Dec. 1948, pp. 291, 294, repr. (detail); J. Soby, "T. Cole," *Art News*, XLVII, Jan. 1949, p. 29, repr. p. 27; O. Larkin, *Art and Life in America*, New York, 1949, p. 175; L. Hawes, "A Sketchbook by Thomas Cole," *Record of the Art Museum*, Princeton University, XV, No. 1, 1956, pp. 9–11, repr.; E. P. Richardson, *Paint-*

ing in America, The Story of 450 Years, New York, 1956, p. 168, pl. IX; B. Novak Deutsch, "Cole and Durand: Criticism and Patronage," unpublished Ph.D. dissertation, Radcliffe College, 1957, pp. 48–51; A. Gowans, *Images of American Living*, New York, 1964, p. 291, fig. 96; L. Noble, *The Life and Works of Thomas Cole* (E. Vessell, ed.), Cambridge, 1964, pp. 212–13, 321 n.2, pl. 20; "The Artist Speaks: Part Two," *Art in America*, LIII, Aug.-Sep. 1965, pp. 43–6, repr. (detail) p. 52; W. Gerdts, "Egyptian Motifs in Nineteenth Century American Painting and Sculpture," *Antiques*, XC, Oct. 1966, p. 493, repr.; R. Rosenblum, *Transformations in Late Eighteenth Century Art*, Princeton, 1970, p. 107, fig. 113; W. Feaver, *The Art of John Martin*, Oxford, 1974, pp. 109–10, pl. 80; E. Parry, "Gothic Elegies for an American Audience, Thomas Cole's Repackaging of Imported Ideas," *American Art Journal*, VIII, Nov. 1976, pp. 38, 40, 41, fig. 11; J. Lipman and H. Franc, *Bright Stars: American Painting and Sculpture Since 1776*, New York, 1976, p. 70, repr. (color); W. H. Pierson, Jr., *American Buildings and Their Architects: Technology and the Picturesque*, Garden City, 1978, pp. 127–29, fig. 87; E. Parry, "Thomas Cole's Imagination at Work in *The Architect's Dream*," *American Art Journal*, XII, 1, Winter 1980.

In 1839 the New Haven architect Ithiel Town (1784–1844) commissioned a painting from Cole which resulted in *The Architect's Dream*. Both men had met as early members of the National Academy of Design. Town, a leading architect working in both Greek Revival and Gothic styles, amassed one of the largest art and architectural libraries in the country, to which he granted ready access to artists and architects.

The circumstances of the commission can be pieced together through surviving correspondence between Cole and Town. Originally Town had suggested that Cole and Asher B. Durand paint companion pictures, one of ancient Athens and the other of modern Athens (letter, Town to Cole, May 20, 1840, Cole Papers). Cole objected to this choice of subjects because, never having been to Athens, he felt he would have to rely too heavily on prints (letter, Cole to Town, May 25, 1840, Cole Papers). Like many of Cole's patrons, Town let the artist choose the specific subject within the guidelines of the commission.

Cole was to be paid partly with books and engravings from Town's library, the remainder in cash, for a total of $500 (receipt, Mar. 6, 1839, Cole Papers). At the outset Cole took only part of the books he was entitled to receive. A second, undated memorandum by Cole states he was to enlarge the composition for an additional

$150; on this receipt Cole first called the painting *The Architect's Dream*.

The finished picture was exhibited in 1840 at the NAD, where Town probably first saw it. Almost immediately he wrote Cole of his displeasure with the subject (letter, May 20, 1840, Cole Papers). Although Town liked "the mixture of different ages and styles in the same imaginary picture," he wanted the landscape to dominate the architecture. Refusing to accept the canvas, he asked Cole to paint instead a view of Athens, as he had first proposed.

Enraged by Town's criticism, Cole complained to his friend Durand, "I have received a letter from Town telling me that neither he nor his friends like the picture I have painted for him, and desiring (expecting) me to paint another for him in place of it . . . he expects me again to spend weeks and weeks after the uncertain shadow of his approbation. I will not do it and I have written him to say that I would rather give him his Books back and consider the commission as null rather than paint on such precarious terms" (letter, Cole to Durand, May 26, 1840, Cole Papers).

After much bickering between artist and patron, a new agreement was reached by which Cole would paint a small landscape in return for the books he already had received from Town, plus $250 (letters, Town to Cole, June 12, July 4, July 22 and Aug. 1, 1840; Cole to Town, June 19 [?], July 13 and July 24, 1840, Cole Papers). Whether this agreement was ever honored is not certain from the surviving correspondence. As late as October 1840 Cole was still complaining about the incident to his friend William Adams (letter, Cole to Adams, Oct. 4, 1840, Cole Papers).

The correspondence does not explain the discrepancy between what Town commissioned and the subject Cole painted. Apparently Cole did not advise Town about the painting as it progressed, as was his custom with other patrons. Perhaps Cole intended the picture as a tribute to Town's success. Town may have rejected *The Architect's Dream* because he felt self-conscious about accepting a romantic allegorical portrait of himself, or he may have preferred a more conventional composition, and perhaps had envisioned that Cole and Durand would paint companion pictures closer in composition to Cole's recent series such as *The Departure* and *The Return* (1837; Washington, Corcoran Gallery of Art) or *The Past* and *The Present* (1838; Amherst College, Mass.). As the Cole scholar Ellwood Parry suggests, Cole probably conceived this painting to stand out in Town's art collection and to complement the bookcases in Egyptian, Grecian and Gothic styles housing Town's architectural library (Parry, 1976, p. 41). This was not uncommon for Cole, who had planned, for example, the exact placement of his series *The Course of Empire* (1833–36; New-York Historical Society) in the picture gallery of the New York collector Luman Reed.

In the painting Cole arranged the various styles of architecture in historical sequence by placing the Egyptian pyramid and hypostyle hall in the distance, the classical buildings in the middle distance, and the Gothic cathedral in the left foreground. Within this sequence, Cole distinguished between the classical orders by placing the earlier Doric temple in the background, the Ionic temple at near right, and the Roman temple, reminiscent of Temple of Vesta at Tivoli with its Corinthian order and the aqueduct above. Cole also used light not only to organize the composition but also to distinguish further between the classical architecture of the Mediterranean bathed in sunlight and the northern Gothic cathedral cast in shadow.

Cole himself had a strong interest in architecture and had submitted designs in the 1838 competition for the Ohio State Capitol. Architectural books like those in Town's library were sources of the architectural details in his paintings. Parry has pointed out that the Gothic cathedral was inspired by a plate of the east end of Salisbury Cathedral in John Britton's *Cathedral Antiquities* (1815), and that the capitals of the colonettes framing the composition were derived from another plate in Britton of details in the Chapter House at Salisbury. The giant column on which the architect reclines may have been derived, as Parry suggests, from Roman columns, such as the Column of Trajan (Parry, 1976, p. 41), or possibly from the capitals of the Erectheum caryatids depicted in several plates in Stuart and Revett's *Antiquities of Athens* (1762), a source which Cole used for *The Consummation* in *The Course of Empire*.

While Cole showed his scholarly knowledge of architectural detail, the overall composition of *The Architect's Dream* not only recalls *The Consummation* and *The Destruction* of his earlier series but also the work of his English contemporaries John Martin and J. M. W. Turner, both of whom Cole had met on his first European trip. The deep space, exaggerated perspective and fanciful architecture peopled by tiny figures suggests Martin's *The Seventh Plague of Egypt* (1823) or *The Fall of Babylon* (1831), which Cole knew firsthand or from engravings. During his visit on Dec. 12, 1829 to Turner's Gallery, he commented, in particular, on *The Building of Carthage*: "Magnificent piles of architecture fill the sides, while in the middle of the picture an arm of the sea or bay comes into the foreground. . . . The figures, vessels, etc. are all very appropriate. . . . The composition resembles very closely some of Claude's"

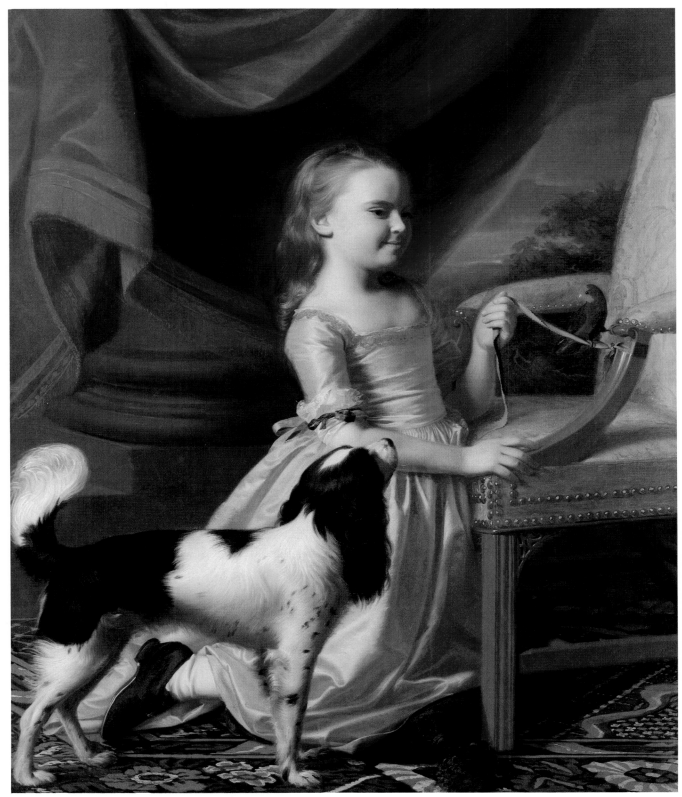

1. John Singleton Copley, *Young Lady with a Bird and Dog*, 1767

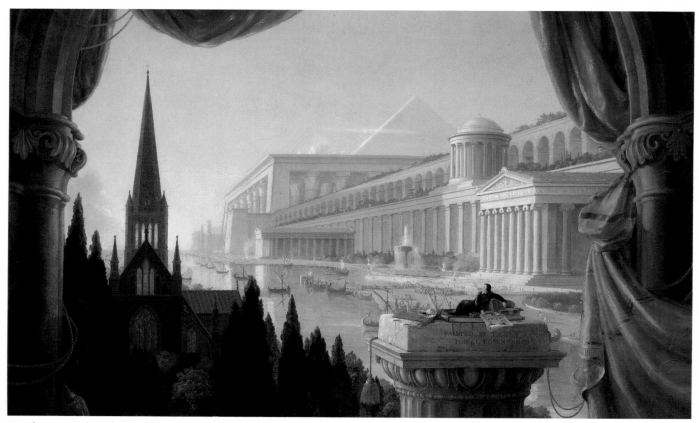

11. Thomas Cole, *The Architect's Dream,* 1840

(quoted by Noble, *Life and Works*, p. 81). Cole drew not only on all those specific elements from Turner's picture but also, as Turner had, from the harbor scenes by Claude Lorrain, whose work he greatly admired. The ecclecticism of Cole's choice of sources is characteristic not only of his own method of composing imaginary pictures but also of much of the aesthetics of art and architecture of the mid-nineteenth century.

As Pierson points out, Cole's painting carries three primary messages: 1) the importance of past architecture as sources for contemporary buildings; 2) the clarity of classical architecture versus the mystery of the gothic; 3) the importance of books as references to the styles of the past. Both Cole in his painting and Town in his architectural designs shared this approach; thus, Town's rejection of this canvas is all the more perplexing.

An undated pen and ink drawing (Detroit Institute of Arts, acc. no. 39.354) showing piled up architectural elements is probably one of Cole's earliest conceptions for the painting. A pencil drawing in a sketchbook begun in 1839 (Princeton University Art Museum) is closer to the painting's composition, but shows a lion atop the column in place of the architect (Hawes, fig. 2). In a letter of July 13, 1840 to Town, Cole mentioned an oil sketch; this is now unlocated.

Landscape, The Vesper Hymn: An Italian Twilight PL. 24

[1841] Oil on canvas
34¼ x 46-3/16 in. (87 x 117.3 cm.)
Signed and dated lower right: T. COLE/1841

Acc. no. 54.76

COLLECTIONS: Thomas Hall Faile, New York, 1841–73; Jane R. Faile, to 1954; (Knoedler, New York, 1954).

EXHIBITIONS: New York, NAD, 1841, no. 110; New York, *Exhibition of the Paintings of the late Thomas Cole at the Gallery of the American Art-Union*, 1848, no. 5 (as *Evening Vespers*, with verse).

REFERENCES: Cole Papers: Correspondence between Cole and Durand, Manuscripts and History Division, New York State Library, Albany (on microfilm, Archives of American Art); "The Fine Arts, National Academy of Design," *The Knickerbocker*, XVIII, July 1841, p. 87; W. C. Bryant, *A Funeral Oration Occasioned by the Death of Thomas Cole, Delivered Before the National Academy of Design, New York, May 4, 1848*, pp. 26–7; Cowdrey, *NAD*, I, p. 89; Kennedy Galleries, *Thomas Cole, N.A. (1801–1848)* (exh. cat.), New York, 1964, pp. 13, 22.

The Vesper Hymn was painted in 1841, before Cole left for England that August, as the result of an 1837 commission from the New York collector and merchant Thomas Hall Faile (*Commissions for Pictures*, entry dated Dec. 2, 1837, Cole Papers, Box 6, folder 2). Faile (1803–1873) was a patron of Durand, a friend of the leading New York patrons and collectors Luman Reed and Jonathan Sturges, and a co-founder of the short-lived New-York Gallery of Fine Arts.

Correspondence about the commission shows that Cole and Faile at first disagreed on the subject. Like certain other educated patrons of his time, Faile wanted an imaginary composition which would reflect his elevated taste, in this case an episode of Medora and Conrad from Byron's *Corsair*. Cole, however, preferred a subject from Coleridge's *Ballad of the Dark Ladie* (letter to Durand, Jan. 31, 1838, Cole Papers). From his Catskill home, Cole complained to his friend Durand in New York that Faile wanted the landscape to be subordinate to the figures. Acting on Cole's behalf, Durand persuaded Faile to accept another subject. Although the remainder of the correspondence about this commission is incomplete, Cole apparently changed the subject at least once more (letters, Cole to Durand, Feb. 12, 1838; Mar. 20, 1838; May 28, 1838; Cole Papers). In the end, Cole evidently selected a verse from Felicia Hemans' *Spanish Evening Hymn* (first published 1832) to appear in the 1848 American Art-Union catalogue entry for the painting:

> Ave! Now let prayer and music
> Meet in love on earth and sea;
> Now, sweet mother! may the weary
> Turn from this cold world to thee!

Although the poem and picture are not identical in subject, they share a common Romantic mood. Felicia Hemans (1793–1835) was an English poet well-known in England and America, and Cole knew her work.

Completion of the commission was delayed until 1841 by Cole's entry of a design in the 1838 competition for the Ohio State Capitol, by Samuel Ward's commission of *The Voyage of Life* (1839) and, in 1840, by Ithiel Town's commission which resulted in *The Architect's Dream*, also in the Toledo collection.

There is a related but undated drawing in the sketchbook from Cole's first European trip of 1829–31 (Detroit Institute of Arts, acc. no. 39.422).

WILLIAM CONGDON

1912–. Born in Providence, R.I. 1934 B.A. Yale University. 1934–36 studied painting with Henry Hensche at Provincetown, Mass. Studied sculpture at PAFA, 1935;

with George Demetrious, 1936–39. After 1945 in New York; worked in abstract expressionist style. 1948 settled in Venice. Lives in Assisi, Italy.

The Church of the Redeemer, Venice　　　PL. 235

[1952] Lacquer and oil on masonite
48¾ x 56⅛ in. (124 x 142.5 cm.)
Signed and dated on reverse: Congdon Redentore—
　　Venice '52

Acc. no. 53.148
Museum Purchase Fund

COLLECTIONS: (Betty Parsons Gallery, New York).

EXHIBITIONS: New York, Betty Parsons Gallery, *William Congdon*, 1953; Toledo Museum of Art, *40th Annual*, 1953, no. 13.

JOHN SINGLETON COPLEY

1738–1815. Probably born in Boston. Stepson of engraver-painter Peter Pelham (ca. 1699–1751). Self-taught, but influenced by Smibert, Feke, Greenwood, Blackburn, and by English engravings. Established as the leading colonial portraitist by the 1760s. Worked chiefly in Boston. 1771 in New York and Philadelphia. 1774 sailed for England and toured Italy. 1776 Associate, Royal Academy; 1779 Academician. By the combination of his innate talent, keen powers of perception and honest characterization of his sitters, Copley set a new standard for American portraiture.

Young Lady with a Bird
and Dog　　　[COLOR PL. I] PL. 4

[1767] Oil on canvas
48 x 39¾ in. (122 x 101 cm.)
Signed and dated lower left: Jnº Singleton Copley/
　　pinx 1767

Acc. no. 50.306

COLLECTIONS: Descended in the Harrel family to Sir David Harrel, Harrel, Ireland, to 1910; (Blakeslee Gallery, New York, 1910); Mrs. Edward H. Harriman, New York, 1910–32; W. Averell Harriman, New York, 1932; (Maynard Walker, New York); (John Levy Galleries, New York, 1950).

EXHIBITIONS: London, Society of Artists of Great Britain, 1767, no. 28 (as *Portrait of a Young Lady with a Bird and Dog*; whole length; by William Copeley [sic]); New York, Blakeslee Galleries, *Two Famous Portraits by John Singleton Copley*, 1910, n.p. (as *Mary Warner*);

Detroit Institute of Arts, *Painting in America*, 1957, no. 29, repr.; New York, Hirschl and Adler, *American Portraits by John Singleton Copley*, 1975, no. 28, repr.

REFERENCES: C. Adams, G. Jones and W. Ford, ed., "Letters and Papers of John Singleton Copley and Henry Pelham 1739–1776," *The Massachusetts Historical Society Collections*, LXXI, 1914, pp. 52–60; F. Bayley, *Life and Works of John Singleton Copley*, Boston, 1915, p. 250; T. Bolton and H. Binsse, "John Singleton Copley," *The Antiquarian*, XV, Dec. 1930, p. 80, repr. p. 82; B. Parker and A. Wheeler, *John Singleton Copley*, Boston, 1930, pp. 198–99, pl. 73; J. Flexner, *America's Old Masters*, New York, 1939, p. 124, repr.; J. Flexner, *First Flowers of our Wilderness*, Boston, 1947, pp. 231, 234, 236, 238, 346, repr. p. 231; J. Flexner, *John Singleton Copley*, Cambridge, 1948, pp. 41–2, 54, 131, pl. 14; E. Richardson, *Painting in America*, New York, 1956, p. 75; J. Prown, *John Singleton Copley, 1738–1815* (exh. cat.), National Gallery of Art, Washington, 1965, p. 42; J. Prown, *John Singleton Copley*, Cambridge, 1966, I, pp. 31, 40n, 50, 51, 54 and n., 55, 58, 59, 81, pl. 164; II, pp. 318, 387; A. Frankenstein, *The World of Copley 1738–1815*, New York, 1970, p. 62, repr.; L. Andrus, *Measure and Design in American Painting*, New York, 1977, pp. 106–07, fig. 36 (Garland reprint, Ph.D. dissertation, Columbia University, 1976).

As a test of how well his work would be received in London, Copley sent *Boy with a Squirrel (Henry Pelham)* (Boston, Museum of Fine Arts) to the 1766 exhibition of the Society of Artists of Great Britain in London. The reception was generally favorable. Joshua Reynolds was impressed with Copley's skill, but criticized his use of flat local color and hard outlines. Benjamin West wrote Copley encouraging him to enter another portrait in the following year's exhibition, and suggesting the composition include two children. He further advised that Copley soften the outlines but that he continue to paint directly from nature (*Letters*, pp. 44–5). In 1767 Copley sent the Toledo picture, explaining that he did not have enough time to include two figures (*Letters*, p. 50). Although in this work he tried to improve his style according to Reynold's and West's advice, this second picture was much less favorably received. Criticism focused on the unattractive child, excessive peripheral detail, crowded composition, strong color, and opaque shadows (*Letters*, pp. 53–4, 56–8). Copley, downhearted by his failure, sent no more paintings to England. He realized that although his skill was considerable he would have to go to Europe to improve his art; he finally went in 1774.

The sitter was not identified when the painting was exhibited in London, and she remains unknown. How-

ever, for some fifty years after it came on the art market in 1910, the portrait was identified as Mary Warner of Portsmouth, N.H. As Copley's subject is a child of five or six, and Mary Warner, who was baptized in 1749, would have been about sixteen, there is no reason to associate her with this portrait.

JON CORBINO

1905–1964. Born in Vittoria, Sicily. 1913 to New York. Ca. 1922–25 studied at ASL and PAFA with George Luks, Frank DuMond and Daniel Garber. Summers from ca. 1930 at Rockport, Mass. First active as sculptor; in mid-1930s turned largely to painting. 1936 and 1937 Guggenheim Fellow. 1938–55 taught at ASL. 1940 N.A. Ca. 1960 moved to Sarasota, Fla.

Stampeding Bulls PL. 194

[1937] Oil on canvas
27-15/16 x 41-15/16 in. (71 x 106.5 cm.)
Signed lower left: Jon Corbino

Acc. no. 37.19
Museum Purchase Fund

COLLECTIONS: (Macbeth).

EXHIBITIONS: Toledo Museum of Art, *24th Annual*, 1937, no. 15, repr.; Macbeth, *Jon Corbino*, 1938, no. 9, repr.; Pittsburgh, Carnegie Institute, *Exhibition of Paintings and Drawings by Jon Corbino*, 1939, no. 19, repr. (lists oil study on paper [unlocated]); Art Institute of Chicago, *Half A Century of American Art*, 1939, no. 39, pl. XLVIII; New York, Museum of Modern Art, *Romantic Painting in America*, 1943, no. 58, repr. (cat. by D. Miller).

REFERENCES: E. Brace, "Jon Corbino," *Magazine of Art*, XXX, Dec. 1937, p. 706, repr. p. 708; M. Baigell, *The American Scene*, New York, 1974, repr. p. 85.

RALSTON CRAWFORD

1906–1978. Born in St. Catharine's, Ontario; raised in Buffalo, N.Y. 1926–27 studied at Otis Art Institute, Los Angeles; 1927–30 at PAFA and Barnes Foundation; and 1930–32 in Paris. After 1950 visiting artist at several universities and art schools. Many trips to New Orleans to paint and photograph its jazz life, and to Spain. Painter, lithographer and photographer; best known for abstract renderings of the industrial landscape and urban life.

Mountain Bird Maru PL. 249

[1947–49] Oil on canvas
28 x 36 in. (71.1 x 91.5 cm.)
Signed center left: RALSTON/CRAWFORD/1947–49

Acc. no. 50.265
Museum Purchase Fund

COLLECTIONS: (Downtown Gallery, New York).

EXHIBITIONS: St. Paul, University of Minnesota Gallery, *Ralston Crawford*, 1949, no. 41; Baton Rouge, Louisiana State University, *Ralston Crawford*, 1950, no. 11; Toledo Museum of Art, *37th Annual*, 1950, no. 13; Duluth, Tweed Gallery, University of Minnesota, *Ralston Crawford Retrospective Exhibition*, 1961, no. 14, repr.; Champaign, Krannert Art Museum, University of Illinois, *Ralston Crawford*, 1961, no. 14, repr.

REFERENCES: R. Freeman, *Ralston Crawford*, University of Alabama, 1953, p. 45.

JASPER FRANCIS CROPSEY

1823–1900. Born on Staten Island, N.Y. Began to paint while apprenticed to an architect 1837–42. 1847–49 in England, France and chiefly Rome. 1848 A.N.A. 1851 N.A. 1856–63 London. After 1863 took occasional architectural commissions. 1867 a founder of American Watercolor Society. Cropsey was one of the strongest draftsmen among the Hudson River School painters. He was influenced by Cole, and is best known for autumnal landscapes.

Starrucca Viaduct, Pennsylvania PL. 41

[1865] Oil on canvas
22⅜ x 36⅜ in. (56.8 x 92.4 cm.)
Signed and dated lower right: J. F. Cropsey/1865

Acc. no. 47.58

COLLECTIONS: Brig. General H. Clifton-Browne, London, 1947 (sold, Sotheby, London, Feb. 26, 1947, lot 128); (M. Bernard, London); (Frank T. Sabin, London); (Scott & Fowles, New York, and Macbeth, 1947).

EXHIBITIONS: Detroit Institute of Arts and Toledo Museum of Art, *Travelers in Arcadia: American Artists in Italy 1830–1875*, 1951, no. 39; Montreal Museum of Fine Arts, *The Painter and the New World*, 1967, no. 344; New York, Paul Rosenberg and Co., *The American Vision, Painting 1825–1875*, 1968, no. 101, repr.; Washington, National Collection of Fine Arts, *Jasper F. Cropsey 1823–1900*, 1970, no. 46, repr. (cat. by W. Talbot); Grand Rapids (Mich.) Art Museum, *Themes in Amer-*

ican Painting, 1977, no. 10, pp. 29, 31, repr. p. 303 (cat. by J. G. Sweeney).

REFERENCES: H. Tuckerman, *Book of the Artists*, New York, 1882, p. 538; P. Bermingham, *Jasper F. Cropsey 1823–1900, A Retrospective View of America's Painter of Autumn* (exh. cat.), College Park, University of Maryland Art Gallery, 1968, p. 30, fig. 6; N. Cikovsky, Jr., "George Inness and the Hudson River School, The Lackawanna Valley," *American Art Journal*, II, Fall 1970, pp. 54, 56, repr. p. 55; J. Wilmerding, *American Art*, Harmondsworth, 1976, pp. 85, 86, 153, 259n. 21, pl. 97; W. Talbot, *Jasper F. Cropsey 1823–1900*, New York, 1977 (Garland reprint, Ph.D. dissertation, New York University, 1972), pp. 180–83, 428–31, fig. 127.

Starrucca Viaduct, built in 1847–48 by the New York and Erie Railroad (now the Erie Lackawanna), was among the great American engineering feats of its time. After three unsuccessful attempts, James P. Kirkwood erected the stone structure (1220 feet long, 110 feet high, with 17 arches and 18 piers) spanning the Susquehanna Valley near Lanesboro in northeastern Pennsylvania. Cropsey shows an Erie train crossing the viaduct with the village of Lanesboro at the right, nestled below the mountains.

In nineteenth century landscape painting the railroad was often seen as a symbol of industrial progress, or of man's destruction of nature. In this autumnal view Cropsey formed a harmony between nature and industrial advancement by the reflective attitude of the figures, the juxtaposition of the new viaduct with the old wooden truss bridge across the river, and by the dominance of the foreground wilderness undisturbed by the distant train.

Cropsey's earliest drawing of Starrucca dates from 1853 (Boston, Museum of Fine Arts, Karolik Collection); in 1856 he made drawings for the foreground figures (Cropsey Studio, Hastings-on-Hudson, N.Y.) and a small oil sketch (Newington Collection, Greenwich, Conn.).

Talbot (1977, pp. 324–25, 428) lists four finished versions of this subject as noted in Cropsey's account book for 1864–65: November 1864, *Starrucca Vale, N.Y. & E.R.R.*, a study sold to Charles Isham; April 12, 1865, *N.Y. & E.R.R.*, an engraver's copy; June 7, 1865, *N.Y. & E.R.R.*, sold to James Brown; and the largest version, November 23, 1865, *Starrucca Vale—Erie Railroad*, to H. W. Derby. The Toledo painting is either the small version sold to Brown or the engraver's copy from which a chromolithograph was made by William Dresser and printed by Thomas B. Sinclair (an example is in the TMA collection). Talbot also notes a fifth version dated 1896 (Kenneth Chorley Collection).

CHARLES COURTNEY CURRAN

1861–1942. Born in Hartford, Ky.; raised in Norwalk, Ohio. Ca. 1879 studied at NAD, ASL and in Paris at Académie Julian. 1901 Assistant Director of Fine Arts, Pan-American Exposition, Buffalo. 1904 N.A. Landscape and figure painter.

The Swimming Hole　　　　PL. 122

[Ca. 1894] Oil on canvas
22 x 18 in. (55.9 x 45.7 cm.)
Signed and dated lower left: CHAS C CURRAN/189(4?)
Acc. no. 08.82
Gift of C. S. Ashley, Toledo

The Jungfrau, Afternoon Sunlight　　PL. 119

[1900] Oil on canvas
22⅛ x 18 in. (56.2 x 45.7 cm.)
Inscribed on stretcher: The Jungfrau/Afternoon Sunlight/Price $150⁰⁰/Charles C. Curran/16 W. 61st St.
Acc. no. 05.3
Gift of the Art Study Club
REFERENCES: *Toledo Museum of Art Museum News*, III, Nov. 1909, p. 1.

This is the Jungfrau as seen from Interlaken, one of several views Curran painted of the famous Swiss Alpine peak.

ELLIOTT DAINGERFIELD

1859–1932. Born in Harpers Ferry, W. Va.; raised in Fayetteville, N.C. 1880 first exhibited NAD. 1906 N.A. 1911 published *George Inness, The Man and His Art*. 1911 and 1913 traveled in the West. 1924 in Europe. A follower of Inness, Daingerfield was both a religious and landscape painter, as well as a prolific writer and art critic.

Storm Breaking Up　　　PL. 172

[Ca. 1912] Oil on canvas
30¼ x 36⅛ in. (76.8 x 91.8 cm.)
Signed lower right: Elliott Daingerfield
Acc. no. 12.8
COLLECTIONS: Bought from the artist, 1912.
EXHIBITIONS: Toledo Museum of Art, *Inaugural Exhibition*, 1912, no. 21, repr.

Westglow PL. 173

[Ca. 1920] Oil on canvas
36-1/16 x 48-3/16 in. (91.7 x 122.5 cm.)
Signed lower right: Elliott Daingerfield

Acc. no. 33.18
Gift of Arthur J. Secor

COLLECTIONS: Butler Art Institute, Youngstown, Ohio, to 1922; (Vose, 1922); Arthur J. Secor, Toledo, 1922–33.

According to a letter from the artist (July 3, 1922), this is a view from Westglow, the house which Daingerfield built at Blowing Rock, North Carolina in 1916.

FELIX OCTAVIUS CARR DARLEY

1822–1888. Born in Philadelphia. Ca. 1843 began book and magazine illustration. 1848 to New York. 1853 N.A. 1859 settled in Claymont, Del. 1867–68 in Europe. Darley made designs for bank notes, lithographs, and steel and wood engravings. Famous for his illustrations of Irving's and Cooper's novels, Darley is the best known early American illustrator.

A Street Scene in Rome PL. 48

[1867] Watercolor and pencil on paper
7⅝ x 9⅝ in. (19.3 x 24.5 cm.)
Signed lower right: F. O. C. Darley
Inscribed in ink on reverse: A Street Scene in Rome/
 Quatro (*sic*) Fontane March 1867/by/F.O.C. Darley

Acc. no. 10.17
Gift of Mrs. Warren J. Colburn

COLLECTIONS: Mrs. Warren J. Colburn, Toledo (sister-in-law of the artist).

EXHIBITIONS: New York, Whitney Museum of American Art, *A History of American Watercolor Painting*, 1942, no. 59.

Darley's letters to his family from his European tour of 1867–68, illustrated with picturesque or humorous subjects of this kind, were published as *Sketches Abroad with Pen and Pencil* (New York, 1869). The Via del Quattro Fontane in Rome is near the Barberini and Quirinal Palaces.

The Camp PL. 49

[1876] Watercolor on paper
8⅝ x 11¾ in. (21.8 x 30 cm.)
Signed and dated lower left: F. O. C. Darley 1876

Acc. no. 10.16
Gift of Mrs. Warren J. Colburn

WILDER M. DARLING

1855–1933. Born in Sandusky, Ohio. First studied art with Henry Mosler in Cincinnati; ca. 1875 with F. Duveneck in Munich; later with J. P. Laurens in Paris and with W. M. Chase in New York. Ca. 1900 had a studio at Laren, Holland for several years. 1917–29 in Toledo. 1931 last trip to Europe. Darling specialized in Dutch and Breton genre subjects.

Helping Mother PL. 100

[1900] Oil on canvas
18⅛ x 12¾ in (46 x 32.5 cm.)
Signed lower left: Wilder Darling

Acc. no. 21.90
Gift of a Group of Members of the Museum

EXHIBITIONS: Paris, *U.S. Commission to the Paris Exposition*, 1900 (3rd prize bronze medal).

REFERENCES: *Toledo Museum of Art Museum News*, Oct. 1921, no. 39, n.p.

Head of a Dutch Peasant PL. 97

Oil on panel
13⅞ x 10 in. (35.3 x 25.4 cm.)
Signed lower right: W. M. Darling

Acc. no. 24.4
Gift of The Art Klan

ARTHUR BOWEN DAVIES

1862–1928. Born in Utica, N.Y. 1878 family moved to Chicago; studied at Chicago Academy of Design. 1882 studied at Art Institute of Chicago. 1886 enrolled ASL and Gotham Art School in New York. 1887 worked as magazine illustrator. 1893 to Europe. 1908 exhibited with The Eight. 1911 elected President of Association of American Painters and Sculptors, which organized the 1913 Armory Show. While Davies worked in the tradition of late nineteenth century romantic visionaries, he was also an important promoter of modernism in the early twentieth century.

The Redwoods PL. 152

[1905] Oil on canvas
26 x 40 in. (66 x 101.5 cm.)

Acc. no. 38.9
Gift of an Anonymous Donor

COLLECTIONS: Stephen C. Clark, New York.

EXHIBITIONS: Buffalo, Albright Art Gallery, *Exhibition of Paintings by Arthur B. Davies*, 1923, no. 1 (as *The Redwoods)*; Macbeth, *The Eight of 1908, Thirty Years After*, 1938, no. 2; Utica, Munson-Williams-Proctor Institute, *Arthur Bowen Davies, Distinguished American Painter*, 1941, no. 23.

REFERENCES: J. Czestochowski, *The Works of Arthur B. Davies*, Chicago, expected 1979, no. 5E7.

On a trip to the West Coast in 1905, Davies was particularly impressed by the grandeur of the Sierra Nevadas and the redwood forests. This is from a group of paintings done after his California trip which shows greater monumentality in style and which employs these imposing landscape motifs.

WILLEM DE KOONING

1904–. Born in Rotterdam, Holland. 1916–24 attended Rotterdam Academy of Arts and Techniques; became familiar with art of De Stijl. 1926 to U.S.; worked as house painter. 1927 settled in New York, met John Graham, and in 1929 Arshile Gorky, both strong influences on his art. Worked as commercial artist through the 1930s. 1935–36 member mural and easel divisions of WPA Federal Art Project. Although his work has been essentially figurative, de Kooning emerged in the early 1950s as the leading gestural Abstract Expressionist, who has strongly influenced the second generation of the New York School.

Lily Pond PL. 262

[1959] Oil on canvas
70-5/16 x 80⅛ in. (178.7 x 203.5 cm.)
Signed upper left: de Kooning

Acc. no. 72.32
Gift of Edward Drummond Libbey

COLLECTIONS: Robert Rowan, Calif.; Pasadena Art Museum, Calif.; (Knoedler, New York); (Allan Stone Gallery, New York).

EXHIBITIONS: New York, Sidney Janis Gallery, *Willem de Kooning*, 1959; Beverly Hills (Calif.), Paul Kantor Gallery, *De Kooning*, 1961, repr; Pittsburgh, Carnegie Institute, *Willem de Kooning*, 1979, no. 29, repr.

REFERENCES: T. Hess, *Willem de Kooning*, New York, 1959, fig. 155 (as *Untitled;* incorrect dimensions); R. Phillips, "Abstract Expressionists," *Toledo Museum of Art Museum News*, XIX, No. 4, 1977, pp. 92, 95, pl. II (color).

Originally untitled, *Lily Pond* was later named by de Kooning for a lane in East Hampton where he once considered buying a house. It belongs to a group of non-figurative paintings from the late 50s and early 60s composed of a few broad bold brushstrokes and inspired by the open expanses and sunlight of Long Island seen by de Kooning on frequent trips between New York and Long Island.

CHARLES HENRY DEMUTH

1883–1935. Born in Lancaster, Pa. 1901–04 studied at Drexel Institute, Philadelphia; 1904 in Paris. 1905–06 and 1908–11 at PAFA. 1907 in Paris; met Matisse and the Fauves. 1912–14 again in Paris to study painting; met Gertrude and Leo Stein. From 1915 lived chiefly in Lancaster and New York, where he met Stieglitz and his circle. 1916–17 work first reflected Cézanne and cubism. Demuth is among the twentieth century American masters of watercolor.

The Bay, Provincetown PL. 159

[Ca. 1914] Watercolor on paper
10⅛ x 14⅛ in (25.7 x 36 cm.)
Signed in left margin: C. Demuth-

Acc. no. 38.13
Museum Purchase Fund

COLLECTIONS: (Daniel Gallery, New York); (C. W. Kraushaar, New York).

EXHIBITIONS: New York, Museum of Modern Art, *Charles Demuth*, 1950, no. 18 (cat. by A. Ritchie); Harrisburg, William Penn Memorial Museum, *Charles Demuth of Lancaster*, 1966, no. 15.

REFERENCES: E. Farnham, "Charles Demuth: His Life, Psychology and Works," unpublished Ph.D. dissertation, 1959, Ohio State University, II, pp. 442–43; E. Farnham, *Charles Demuth: Behind a Laughing Mask*, Norman, Okla., 1970, pp. 88, 111, 199.

In 1914–15, during his first two summers at Provincetown on Cape Cod, Demuth painted several watercolors of the shoreline in bright Fauvist colors. All are titled *The Bay;* in this one the Pilgrim Monument appears at the left. The Toledo painting may have been in Demuth's first one-man exhibition, twenty-five watercolors nearly all of the Provincetown neighborhood, shown at the Daniel Gallery, New York in October-November 1914.

THOMAS WILMER DEWING

1851–1938. Born in Boston. Studied at the Boston Museum School; 1876–79 in Paris at Académie Julian with Gustave Boulanger and Jules Lefebvre. 1880 settled in New York; elected to Society of American Artists and began teaching at ASL. 1888 N.A. Ca. 1891 met Charles Freer, who became his friend and patron. 1895 a founding member of The Ten American Painters. Dewing was a leading figure of late nineteenth century aestheticism, strongly influenced by Whistler and by Oriental art.

The Letter PL. 112

[1908] Oil on panel
19⅝ x 24 in. (49.8 x 60.9 cm.)
Signed lower left: T. W. Dewing

Acc. no. 12.6

COLLECTIONS: (Montross, New York, 1910); Florence Scott Libbey, 1911.

EXHIBITIONS: City Art Museum of St. Louis, *Third Annual Exhibition of Selected Paintings by American Artists,* 1908, repr. no. 50; Seattle, Alaska-Yukon-Pacific Exposition, 1909, no. 365; San Francisco, M. H. de Young Memorial Museum and California Palace of the Legion of Honor, *The Color of Mood, American Tonalism 1880–1910,* 1972, no. 14; Toledo Museum of Art, *Heritage and Horizon: American Painting 1776–1976,* 1976, no. 34, repr.

The Letter, painted for the 1908 St. Louis exhibition, is the most spatially ambitious work of a group painted in 1907–08 which shows a new concern in Dewing's paintings with defining interior space without disturbing his characteristic atmosphere of reverie (letter, Claudia Kern, May 17, 1973). According to the Dewing scholar Claudia Kern, the subject depicts Dewing's New York studio at 12 West 8th Street. The mantle vases are Korean celadon ware, and the simple flower arrangement is Oriental in inspiration. Dewing seated one figure in a late Federal chair at a Chippendale desk, reflecting the revival of interest in early American decorative arts at the turn of the century.

PRESTON DICKINSON

1889–1930. Born in New York. Ca. 1906–10 studied at ASL with Lawson, Bellows and George Bridgman. 1910–14 chiefly in Paris, where he studied the old masters, Cézanne, the Cubists and Japanese prints. 1914 returned to New York. 1925–26 and 1929 in Canada. 1930 to Spain, where he died. His work was strongly influenced by Cézanne and Cubism.

Spanish Landscape PL. 187

[1930] Pastel on paper
12⅝ x 19⅛ in (32.2 x 48.5)

Acc. no. 39.79
Museum Purchase Fund

COLLECTIONS: (Downtown Gallery, New York).

EXHIBITIONS: Lincoln, Sheldon Memorial Art Gallery, University of Nebraska, *Preston Dickinson,* 1979, no. 70, repr.

Done in the fall before Dickinson died in Spain in November 1930, this pastel shows both the Cubist influence more evident earlier in his career, and the calligraphic line and transparent tones derived from Japanese art which pervade his later work.

PAUL DOUGHERTY

1877–1947. Born in Brooklyn, N.Y. 1898 received law degree. Ca. 1900–05 studied art in Europe; chiefly self-taught. 1905 member Society of American Artists. 1907 N.A. Several trips to Cornwall, England and to the Maine coast. Ca. 1920–27 had studios in New York and Paris. 1932 settled in Carmel, Calif. Chiefly a marine painter.

Moonlit Cove PL. 131

[1908] Oil on canvas
36 x 34 in. (91.4 x 86.4 cm.)
Signed and dated lower left: Paul Dougherty/1908

Acc. no. 12.9

COLLECTIONS: (Henry Reinhardt, New York).

EXHIBITIONS: Portland (Me.) Museum of Art, *Paul Dougherty, A Retrospective Exhibition,* 1978, no. 19b.

THOMAS DOUGHTY

1793–1856. Born in Philadelphia. Chiefly self-taught. By 1816 began painting landscapes and exhibited at PAFA. 1830–32 editor of *The Cabinet of Natural History and American Rural Sports.* Sketched near Philadelphia, in the White Mountains, and on the New England coast. 1837 in London. After 1838 worked in New York and along the Hudson River. 1845–47 in London and Paris.

1848 settled in New York. Doughty was among the earliest American specialists in landscape painting.

View near Cornwall-on-Hudson PL. 19

[Ca. 1839] Oil on canvas
28⅜ x 36⅜ in. (72.1 x 92.5 cm.)
Signed lower right: T. Doughty
Stenciled on reverse of canvas before relining: The Tayloe Collection

Acc. no. 52.104

COLLECTIONS: Benjamin Ogle Tayloe, Washington; Phebe Warren Tayloe (wife), to 1892; Corcoran Gallery of Art, Washington, 1892–1902; returned to Warren family, Troy, N.Y.; by descent to Henry Warren, Troy, 1951; Mary Rogers Warren (daughter), Manchester, Vt., 1951–52; (Macbeth, 1952).

EXHIBITIONS: PAFA, *Thomas Doughty, 1793–1856, An American Pioneer in Landscape Painting,* 1973, no. 42, repr. (as ca. 1841; cat. by F. Goodyear).

REFERENCES: Corcoran Gallery of Art, *Catalogue of the Tayloe Collection,* Washington, 1892, no. 63 (as *View on the Hudson, Looking Towards West Point*); F. Goodyear, "The Life and Art of Thomas Doughty," unpublished M.A. thesis, University of Delaware, 1969, no. 135.

This view was taken looking south toward the northern opening of the Highlands of the Hudson River. At the right, on the west bank, Storm King Mountain rises above the village of Cornwall Landing, opposite the cliff of Breakneck Mountain on the east shore.

Doughty probably painted this canvas in 1839 when he was living nearby at Newburgh. Another undated version is known (J. Howat, *The Hudson River and Its Painters,* New York, 1972, pl. 48; *View of Highlands from Newburgh, New York,* private collection). This or the Toledo picture may be the *Opening of the Highlands, from below Newburgh, Looking down the Hudson,* shown at the Apollo Association, New York in October 1839, no. 72.

According to Robert MacIntyre of Macbeth Galleries, the original canvas, now covered by the relining, bears the stencil of the Tayloe Collection; this indicates it once belonged to Benjamin Ogle Tayloe (1796–1868) of Virginia. His wife, Phebe Warren Tayloe of Troy, New York, presented the collection to the Corcoran Gallery of Art with the provision that if a separate exhibition room were not provided the collection be returned to the family. As this proviso was not met, the collection, including this painting, was returned to the family.

FRANK DUVENECK

1848–1919. Born in Covington, Ky. 1860s worked as church decorator. 1870–73 studied in Munich; influenced by the realist Wilhelm Leibl. 1878 returned to Munich and opened a painting school there. 1879–88 chiefly in Florence and Venice. 1890 began teaching at school of Cincinnati Art Museum. Painted little during his last thirty years. Duveneck was a leading American exponent of the Munich school of bravura brushwork, and a widely influential teacher.

Head of an Old Man PL. 63

[Ca. 1883] Oil on canvas
22-1/16 x 18 in. (56 x 45.8 cm.)
Signed lower left: FD (in monogram)

Acc. no. 23.19

COLLECTIONS: Given by the artist to G. W. Pierpont; (Chester H. Johnson, Chicago, 1923).

REFERENCES: W. Siple, *Exhibition of the Work of Frank Duveneck* (exh. cat.), Cincinnati Art Museum, 1936, p. 70 (listed under "Portraits and Studies of Heads, Subjects Unknown").

Duveneck painted many bust-length studies of anonymous studio models; few are dated. According to the dealer Chester Johnson, this one was painted in 1883 at Florence. The plausibility of this date is confirmed by the artist's son, Frank B. Duveneck (letter, Aug. 16, 1978), and by evidence of style, as the bold brushwork and dark palette of Duveneck's earlier style apparent here were replaced after the mid-1880s by a lighter palette and less broadly painted surfaces.

THOMAS COWPERTHWAIT EAKINS

1844–1916. Born in Philadelphia. 1862 enrolled PAFA. 1864–65 attended anatomy classes at Jefferson Medical College. 1866–70 chiefly in Paris; studied with Gérome at Ecole des Beaux Arts, and with Léon Bonnat and Augustin Dumont. 1869 in Spain where he studied the work of Velázquez and Ribera. 1870 returned to Philadelphia. 1876 instructor at PAFA. 1882 director of PAFA School. 1884 worked with Muybridge recording motion by photography. 1886 resigned PAFA directorship and organized ASL of Philadelphia. From the mid-1880s increasingly concentrated on portraiture. One of the great nineteenth century realists, Eakins based his art on dispassionate observation and on scientific study of the human figure.

B. J. Blommers PL. 72

[1904] Oil on canvas
24 x 20 in. (61 x 50.8 cm.)
Signed, inscribed and dated on reverse: TO HIS FRIEND/
 B. J. BLOMMERS/THOMAS EAKINS/1904/PHILADELPHIA

Acc. no. 37.16

COLLECTIONS: B. J. Blommers, 1904–14; Charles P. Gruppe, New York, 1936.

EXHIBITIONS: Art Club of Philadelphia, *Sixteenth Annual Exhibition,* 1904, no. 89; Venice, *XXI Biennale di Venezia,* 1938, no. 113.

REFERENCES: "Catalogue of the Works of Thomas Eakins," *The Pennsylvania Museum Bulletin,* XXV, Mar. 1930, p. 32 (as unlocated); L. Goodrich, *Thomas Eakins, His Life and Works,* New York, 1933, p. 200, no. 412 (as unlocated); R. McKinney, *Thomas Eakins,* New York, 1942, repr. p. 77; G. Hendricks, *The Life and Works of Thomas Eakins,* New York, 1974, p. 336, no. 203, repr.; T. Siegl, *The Thomas Eakins Collection, Philadelphia Museum of Art,* Philadelphia, 1978, in no. 109.

The landscapes and genre subjects of the Dutch Hague School painter Bernardus Johannes Blommers (1845–1914) reflect the influence of his friends the Maris brothers, and particularly that of Jozef Israels. Although Blommers never achieved the same recognition as these colleagues, his work attained considerable popularity in the decade 1900–10, particularly in England, Scotland and America.

According to Goodrich, Blommers was visiting the Philadelphia collector and painter Edward Taylor Snow when Eakins painted his portrait. The inscription on the Blommers portrait indicates that, like many of Eakins' paintings, it was a gift rather than a commissioned work.

The portrait was acquired in Holland by Charles P. Gruppe (1860–1940), an American landscape and marine painter who knew Blommers. Eakins also painted portraits in or about 1904 of both Gruppe and Edward Taylor Snow, as well as of Blommers' wife; the portrait of Mrs. Blommers is now unlocated. The three-quarters view, bust-length format and canvas size are characteristic of many of Eakins' portraits from the 1890s until his death.

RALPH EARL

1751–1801. Born in Worcester County, Mass. 1773 active in New Haven. A loyalist, he fled to England in 1778, remaining until 1785. Studied with Benjamin West. 1783 Member, Royal Academy, where he exhibited 1783–85. 1785 returned to America and worked as portraitist primarily in New England and New York. The leading Connecticut Valley painter, Earl influenced a generation of New England itinerant portraitists.

The Taylor Children PL. 5

[1796] Oil on canvas
48⅜ x 48-7/16 in. (122.8 x 123.1 cm.)
Signed and dated lower left: R. Earl/Pinxt/1796

Acc. no. 65.1

COLLECTIONS: John Taylor, New Milford, Conn.; Charlotte Taylor Huntington (Mrs. Enoch Huntington), New Milford, by 1882; Mrs. J. F. K. Alexander, by 1936; Grace Goodhue Huntington (Mrs. Harwood Huntington) and Charles Goodhue Huntington (son), Los Angeles, by 1939–52; Miss Harriet Huntington, Los Angeles, 1952–64; (Kennedy Galleries, New York, 1965).

EXHIBITIONS: New York, Whitney Museum of American Art, *Ralph Earl, 1751–1801,* 1945, no. 40, repr.

REFERENCES: S. Orcutt, *History of the Towns of New Milford and Bridgewater, Connecticut, 1703–1882,* Hartford, 1882, p. 775; F. Sherman, "An Early and a Late Portrait by Ralph Earl," *Art in America,* XXIV, Apr. 1936, p. 86, repr. p. 87; F. Sherman, "The Painting of Ralph Earl," *Art in America,* XXVIII, Oct. 1939, pp. 173, 178, no. 67; R. Wunderlich, "Recorders, Deceivers and Dreamers," *The Kennedy Quarterly,* V, Jan. 1965, p. 88, repr. p. 89; L. Goodrich, *Ralph Earl, Recorder for an Era,* New York, 1967, p. 80, repr. p. 81.

The subjects, children of Colonel Nathaniel Taylor and Ann Northrup of New Milford, Conn., are (left to right): John (1777–?), later a New Milford merchant; Charlotte (1782–1846), who married David Sherman Boardman, a prominent Litchfield County judge; and Nathaniel William (1786–1858), who graduated from Yale in 1807, studied theology under Timothy Dwight, and later taught at Yale Divinity School. Earl also painted the portraits of Col. Taylor and his wife (New Milford Historical Society) while he was in New Milford in 1796.

The canvas has been pieced on the right side. This is a technical peculiarity characteristic of many large paintings by Earl.

DON EDDY

1944–. Born in Long Beach, Calif. Worked in family auto body shop. 1967 B.F.A. and 1969 M.F.A., University of

Hawaii. 1969–70 studied at University of California, Santa Barbara. During the 1960s supported himself by various occupations, including commercial photography. 1972 moved to New York. Although Eddy, like most Photo Realists, uses photographs to compose his paintings, his work shows an increasing concern with color and light as active spatial elements.

Jewelry PL. 276

[1974] Acrylic on canvas
40 x 52⅛ in. (101.6 x 132.4 cm.)
Signed on reverse: Don Eddy

Acc. no. 75.7
Purchased with funds provided by the National Endowment for the Arts and an Anonymous Donor

COLLECTIONS: (Nancy Hoffman Gallery, New York).

EXHIBITIONS: Toledo Museum of Art, *Image, Color and Form: Paintings by Eleven Americans,* 1975, no. 11, repr. (cat. by R. Phillips); Williamstown (Mass.), Williams College Museum of Art, *Don Eddy,* 1975, repr. (cat. by J. Neff).

The composition is based on several color photographs Eddy made of DuBoff's jewelry store at 42nd Street and Fifth Avenue in New York. The artist has given the Museum three of these photographs, one of which is masked to show the edges of the composition as painted.

Eddy has said that *Jewelry* is a crucial painting in the development of his work:

> *Jewelry* is particularly interesting to me because of the relationship between image sizes, color, and the whole matrix of spatial tensions in the painting. Progressing from the ideas in the shoe paintings, I began looking for images that were very small, numerous, widely dispersed in an area, and were not necessarily readily identified with any particular color. The jewelry in that window . . . allowed me to further break down the color units and thus explore an alternate way of understanding the spatial impact of color. The next step seemed to be further atomization of color shapes. . . . At the time, it seemed logical to turn to silverware as imagery because it accumulated little pieces of color/light from its surroundings that were even smaller than the pieces of jewelry. Understood from this point of view, *Jewelry* takes on significance as a pivotal painting (letter, Apr. 1979).

OLIVER TARBELL EDDY

1799–1868. Born in Greenbush, Vt. Taught copper plate printing by his father. 1826–27 listed as a miniature and portrait painter in New York. 1827 exhibited NAD. By 1831 in Elizabeth, N.J. 1835–41 portraitist in Newark, and 1842–50 in Baltimore. 1851 moved to Philadelphia, where he worked chiefly on mechanical inventions and died in poverty.

Henrietta Ten Broeck Day PL. 26

[Ca. 1835] Oil on panel
36½ x 28-15/16 in. (92.7 x 73.6 cm.)

Acc. no. 43.4
Museum Purchase Fund

COLLECTIONS: Matthias Ward Day, Jr. (son of the sitter), Toledo, to 1911; Edward P. Day, Toledo, 1911–20; Mrs. Edward P. Day, Toledo, 1920–42; (Mohr Art Galleries, Toledo, 1943).

Henrietta Ten Broeck (1804–1837) married Matthias Ward Day (1802–1863) on June 7, 1829 in New York. She and her husband lived in Newark, N.J. This portrait was inherited by their son, Matthias W. Day, Jr., who came to Toledo by 1858.

The attribution to Eddy is based on style and on the fact that in 1838 he is known to have painted portraits of the elder Day and his second wife, Alice Colie (Newark, New Jersey Historical Society).

When Eddy was in Elizabeth and Newark in the 1830s, his work was uneven in quality, and he seems to have been influenced by more accomplished portraitists such as Henry Inman and Rembrandt Peale. The portrait of Henrietta Day shows several of Eddy's characteristics, particularly the placement of a half-length figure before a curtained window with a landscape vista, and awkwardly rendered hands. The pose resembles Eddy's *Mrs. Albert Alling* (ca. 1839, New Jersey Historical Society), which includes a similar marble-top table with two books. Pentimenti in the Alling portrait show the left arm was originally raised to the waist in a position like that of Mrs. Day. The Toledo portrait, like all Eddy's New Jersey portraits, is painted on a wood panel.

Dating is based on the evident age of the sitter, her death in 1837 and the arrival of Eddy in Newark in 1835.

STUART CARSON EDIE

1908–1974. Born in Wichita Falls, Texas. Studied with T. H. Benton at the Kansas City Art Institute, and with Boardman Robinson at ASL. 1933–42 WPA Federal Art Project. Lived in New York City and Woodstock, N.Y. Taught at the University of Iowa from 1944 until 1971, when he moved to Mexico. Figure, landscape and still life painter.

Red, White, Blue　　　　　　　　　PL. 226

[1946] Oil on canvas
25 x 45-3/16 in (63.5 x 114.8 cm.)
Signed lower right: EDIE
Inscribed on reverse of canvas: "RED, WHITE, BLUE"/
　　STUART EDIE/1946

Acc. no. 47.51
Museum Purchase Fund
COLLECTIONS: (Associated American Artists, Inc., New York).

EXHIBITIONS: Toledo Museum of Art, *34th Annual*, 1947, no. 24; Iowa City, University of Iowa Museum of Art, *Stuart Edie, A Retrospective Exhibition*, 1979, no. 10, repr.

CHARLES LORING ELLIOTT

1812–1868. Born in Scipio, Cayuga County, N.Y. Worked for his father, an architect-farmer. 1829 in New York; studied briefly with John Trumbull and John Quidor. For ten years worked as a portraitist near Skaneateles, N.Y. 1839 returned to New York. 1845 A.N.A.; 1846 N.A. Elliott was a leading New York portraitist in the 1850s and 1860s; his clients included merchants, governors, fellow artists and literary figures.

Samuel Rhoades, Jr.　　　　　　　　PL. 22

[1836] Oil on canvas
34-11/16 x 28-5/16 in. (88.2 x 71.9 cm.)

Acc. no. 52.139
Gift of Edward H. and William H. Rhoades in memory
　　of Mr. and Mrs. Edward H. Rhoades, Jr.

COLLECTIONS: Samuel and Electa Cleaveland Rhoades, Jr., Skaneateles, N.Y., 1836–63(?); Lewis Hunt Rhoades; Edward H. Rhoades, Toledo, by 1909; Mr. and Mrs. Edward H. Rhoades, Jr., Toledo; William H. and Edward H. Rhoades, III, New York and Toledo, 1952.

REFERENCES: C. Elliott, "A List of Pictures painted by Chas. L. Elliott, commencing on the 1st day of May in the year Eighteen Hundred and Thirty four," autograph MS., NAD Archives, New York; J. Barrow, *Elliott in Skaneateles: A Paper Read Before the Onondaga Historical Association, Feb. 7, 1897*, Syracuse, 1897, p. 5; T. Bolton, "Charles Loring Elliott, An Account of his Life and Work," *Art Quarterly*, v, Winter 1942, p. 64.

Samuel Rhoades, Jr. (1776–1850), born in Chesterfield, Mass., settled in Skaneateles, N.Y. in 1806. He served as

lieutenant in the 159th Regiment of the New York State militia during the War of 1812.

In a letter of March 1909, Cornelia Rhoades Edwards, daughter of the sitters, wrote that the portraits of her parents were painted by Elliott in April and May 1836 at Skaneateles. She recalled the price was $20 for each painting, and that her father was portrayed "clasping his watch chain as he always did when busy talking."

Electa Cleaveland Rhoades　　　　　PL. 21

[1836] Oil on canvas
34¾ x 28-5/16 in. (88.3 x 72 cm.)

Acc. no. 52.138
Gift of Edward H. and William H. Rhoades in memory
　　of Mr. and Mrs. Edward H. Rhoades, Jr.

COLLECTIONS: Samuel and Electa Cleaveland Rhoades, Jr., Skaneateles, N.Y. 1836–63(?); Lewis Hunt Rhoades; Edward H. Rhoades, Toledo, by 1909; Mr. and Mrs. Edward H. Rhoades, Jr., Toledo; William H. and Edward H. Rhoades, III, New York and Toledo, 1952.

REFERENCES: C. Elliott, "A List of Pictures painted by Chas. L. Elliott, commencing on the 1st day of May in the year Eighteen Hundred and Thirty four," autograph MS., NAD Archives, New York.

Electa Cleaveland Rhoades (1782–1863) was the second wife of Samuel Rhoades, Jr. They were married at Skaneateles in 1813, and had four children.

JIMMY ERNST

1920–. Born in Cologne, Germany; son of the Surrealist painter Max Ernst. Attended Arts and Crafts School, Altoona, Germany, and served three years printing and typography apprenticeship before emigration to New York in 1938. Began to paint in mid-1940s. Chiefly self-taught. Has taught widely since mid-1950s. His work is strongly influenced by surrealism.

Cirque d'Hiver　　　　　　　　　　PL. 259

[1952] Oil on canvas
25 x 35⅞ in. (63.5 x 91.2 cm.)
Signed and dated lower right: Jimmy Ernst '52

Acc. no. 53.149
Museum Purchase Fund
COLLECTIONS: (Grace Borgenicht Gallery, New York).

EXHIBITIONS: Toledo Museum of Art, *40th Annual*, 1953, no. 20; Des Moines Art Center, *Jimmy Ernst*, 1966, no. 2.

RICHARD ESTES

1936–. Born in Kewanee, Ill.; raised in Evanston. 1952–56 studied at Art Institute of Chicago. 1959 settled in New York. 1956–66 publishing and advertising illustrator and layout designer; thereafter turned to painting full-time. Estes is a leading Photo-Realist; his subjects are most often the unpeopled streets and buildings of New York.

Helene's Florist PL. 275

[1971] Oil on canvas
48 x 72 in. (121.9 x 182.8 cm.)
Signed and dated center left (on menu): RICHARD ESTES 71

Acc. no. 76.34
Gift of Edward Drummond Libbey

COLLECTIONS: (Allan Stone Gallery, New York); Mr. and Mrs. Merrill Berman, Scarsdale, N.Y., 1972–75; (Acquavella Galleries, New York, 1976).

EXHIBITIONS: New York, Whitney Museum of American Art, *1972 Annual Exhibition, Contemporary American Painting,* 1972, no. 34; Venice, American Pavilion, *XXXVI International Biennial Exhibition of Art,* 1972, no. 17, repr.; Hartford, Wadsworth Atheneum, *New Photo Realism, Painting and Sculpture of the 1970's,* 1974, p. 15, repr. p. 30; Boston, Museum of Fine Arts, *Richard Estes: The Urban Landscape,* 1978, no. 10, repr. cover (color detail) and pp. 28, 29 (cat. by J. Arthur).

REFERENCES: L. Chase, *Hyper-Realism,* New York, 1975, repr. p. 17.

Helene's Florist is located at 267a Columbus Avenue at 72nd Street in Manhattan. The composition is based on a photograph of the site, and is characteristic of the close-up, frontal views in Estes' paintings before his change about 1972 to long vistas of New York streets.

STEPHEN MORGAN ETNIER

1903–. Born in York, Pa. Attended Yale and Haverford Colleges. Studied at PAFA, and with Rockwell Kent and John Carroll. In 1920s settled in Maine; worked many winters in Caribbean region.

Vieux Carré PL. 220

[1946] Oil on masonite
23-13/16 x 32-3/16 in. (60.5 x 81.7 cm.)
Signed and dated lower right: Stephen Etnier 46

Acc. no. 50.269
Museum Purchase Fund

COLLECTIONS: (E. & A. Milch, Inc., New York).

EXHIBITIONS: Toledo Museum of Art, *37th Annual,* 1950, no. 18; Rockland (Me.), William A. Farnsworth Library and Art Gallery, *Paintings by Stephen Etnier,* 1953, repr.

PHILIP EVERGOOD

1901–1973. Born Philip Evergood Blashki in New York. Educated in England. 1921 left Cambridge University to study art at Slade School in London. 1923–24 studied in New York at ASL with George Luks, and at Educational Alliance School. 1924 briefly studied in Paris with Jean Paul Laurens and André Lhote. Through WPA and progressive artists' groups in 1930s, became increasingly interested in the artist's role in society. Evergood's work is topically related to social realism and contains satirical and often autobiographical symbolism.

The Enigma of the Collective American Soul PL. 260

[1959] Oil on canvas
70 x 36 in. (178 x 91.6 cm.)
Signed lower left: Philip Evergood

Acc. no. 72.85
Gift of Dr. and Mrs. Joseph A. Gosman

COLLECTIONS: (A.C.A. Gallery, New York); Dr. and Mrs. Joseph A. Gosman, Toledo, 1959.

EXHIBITIONS: New York, Whitney Museum of American Art, *Philip Evergood Retrospective,* 1960, repr. pl. 88 (cat. by J. I. H. Baur); Hartford, Wadsworth Atheneum, *Doris Caesar, Philip Evergood,* 1960, no. 78; University of Pittsburgh, Department of Fine Arts Gallery, *The Gosman Collection,* 1969, no. 20, repr.

REFERENCES: J. I. H. Baur, *Philip Evergood,* New York, 1975, pp. 65, 72, fig. 20; K. Taylor, "Philip Evergood and the Humanist Intention," unpublished Ph.D. dissertation, Syracuse University, 1979, p. 138.

Evergood's work frequently deals with the ironic dichotomy of American life.

The center figure is probably film star Marilyn Monroe dressed as a Miss America beauty queen, wearing a crown reminiscent of the Statue of Liberty and holding a trophy capped with a missle head. Evergood knew Monroe, and shortly after her death he painted *Look Homeward Marilyn* (1963; collection of Mr. and Mrs. Joseph James Akston, Palm Beach, Fla.). The Evergood scholar Kendall Taylor has suggested that the baby wear-

ing a watch paces time from birth to death and, at the same time forecasts the motherhood and eventual death of the young beauty queen (letter, Feb. 11, 1979).

At the right is Dwight D. Eisenhower, then President of the United States. Beside him is Sir Winston Churchill, former British Prime Minister. As a young man applying to the Royal Naval Training College at Osborne, Philip Evergood Blashki found his admission was held up by the committee of admirals. The artist's father, suspecting ethnic discrimination, wrote a letter of protest to Churchill, then First Lord of the Admiralty. Churchill advised that the Blashkis change the family name to avoid further discrimination; Churchill's advice was followed.

The couple at the left have not been specifically identified by Baur, Taylor or Julia Evergood, the artist's widow. Taylor has suggested that they represent middle-class America pondering the future. Taylor also pointed out that the two street urchins at the left foreground were inspired by a newspaper photograph, and, that in contrast to the false optimism evoked by the surrounding figures, they represent harsh reality.

JERRY FARNSWORTH

1895–. Born in Dalton, Ga. Studied at Corcoran Art School and with C. W. Hawthorne at Provincetown, Mass. Ca. 1925 settled at North Truro, Mass., where he later opened the Farnsworth Art School. Also taught at ASL and Grand Central Art School. Author of three books on painting techniques. Chiefly a figure and portrait painter.

The Amateur PL. 216

[1943] Oil on canvas
42⅛ x 36¼ in. (107 x 92 cm.)
Signed lower right: Farnsworth
Inscribed on stretcher: Painted/Summer 1943/"The Amateur"/by Jerry Farnsworth/Price $250.00

Acc. no. 44.44
Elizabeth C. Mau Bequest Fund

COLLECTIONS: (E. & A. Milch, New York).

EXHIBITIONS: Toledo Museum of Art, *31st Annual,* 1944.

DEAN FAUSETT

1913–. Born in Price, Utah. Studied at Brigham Young University and at ASL with Kenneth Hayes Miller and Boardman Robinson. A painter, muralist, printmaker and sculptor.

Vermont Landscape PL. 207

[1941] Watercolor on paper
21⅞ x 28 in. (55.6 x 71.1 cm.)
Signed lower left: Dean Fausett/1941

Acc. no. 46.10
Museum Purchase Fund

COLLECTIONS: (C. W. Kraushaar Art Galleries, New York).

LYONEL CHARLES ADRIAN FEININGER

1871–1956. Born in New York. 1887 to Germany to study music, but turned to art. 1887–92 studied in Hamburg, Berlin and Paris. 1893–1907 active as illustrator-cartoonist. 1911 saw cubist works in Paris. 1913 exhibited with the Blaue Reiter group in Berlin. 1919–33 teacher and artist-in-residence at the Bauhaus at Weimar and Dessau. 1924 formed the Blaue Vier group with Kandinsky, Klee and Jawlensky. 1936 settled in New York. Feininger developed in the mainstream of European modernism, drawing on cubism, futurism and German expressionism.

Gothic Church I PL. 191

[1942] Ink and watercolor on paper
18⅞ x 13⅞ in. (48 x 35.2 cm.)
Signed, inscribed and dated in lower margin: Feininger Gothic Church I 6.ix. 42.

Acc. no. 43.39
Gift of Art Additions Group

COLLECTIONS: (Buchholz Gallery, New York).

EXHIBITIONS: Cleveland Museum of Art, *Work of Lyonel Feininger,* 1951, no. 73.

Baltic, A Recollection PL. 190

[1947] Oil on canvas
20 x 34⅞ in. (50.8 x 88.6 cm.)
Signed upper right: Feininger
Inscribed on stretcher: Lyonel Feininger, 1947/Baltic: a Recollection

Acc. no. 48.69
Museum Purchase Fund

COLLECTIONS: (Lilienfeld Galleries, New York).

EXHIBITIONS: New York, Buchholz Gallery, *Feininger, Recent Work 1945–1947,* 1948, no. 9; Toledo Museum of Art, *35th Annual,* 1948, no. 19; Cleveland Museum of Art, *Work of Lyonel Feininger,* 1951, no. 41, pl. XI.

REFERENCES: H. Hess, *Lyonel Feininger*, New York, 1961, no. 477, repr.

The subject was inspired by a summer Feininger spent at Deep on the German Baltic coast.

ROBERT FEKE

1706/07–1752. Born in Oyster Bay, Long Island. Little is known about his training. In early 1740s emerged as a leading portraitist in Boston and Newport, R.I., where Feke married and settled. 1746 and 1749–50 in Philadelphia. 1748 active in Boston. 1750 left Newport for Barbados, where he died. Important as the first gifted native-born American artist. His portraits particularly influenced Greenwood, Hesselius and Copley.

John Banister PL. 2

[1748] Oil on canvas
50-9/16 x 40-9/16 in. (128.5 x 103 cm.)
Acc. no. 45.16

COLLECTIONS: John Banister, Newport, 1748–67; John Banister II, Newport, ca. 1767–1803; Thomas and Rachel Martin Banister, Lawrence, L.I., 1803–15; Alice Hermione Pelham Banister McNeill, Lawrence, 1815–23; Thomas Hewlett, Lawrence, 1823–41; Mary Hewlett, Lawrence; James Hewlett, Lawrence, 1870–90; Mary Sanderson Hewlett, Lawrence, 1890–1917; George Hewlett, Brooklyn, 1917-at least 1931; Stephen C. Clark, to ca. 1944; (Macbeth, 1945).

EXHIBITIONS: New York, Whitney Museum of American Art, *Robert Feke*, 1946, no. 17; Huntington (N.Y.), Heckscher Art Museum, *Robert Feke, Native Colonial Painter*, 1946, repr, opp. p. 11; New York, Wildenstein Gallery, *Landmarks in American Art, 1670–1950*, 1953, no. 3, repr.

REFERENCES: J. Banister, *Waste Book 1746–1749*, entry dated Dec. 22, 1748, p. 369 (MS., Rhode Island Historical Society, Providence); H. Foote, *Robert Feke*, Cambridge, 1930, pp. 66, 164–65, repr. opp. p. 164; T. Bolton and H. Binsse, "Robert Feke, First Painter to Colonial Aristocracy," *The Antiquarian*, XV, Oct. 1930, p. 37, repr.; C. Burroughs, "Mrs. Josiah Martin," *Bulletin of the Detroit Institute of Arts*, XXIV, Dec. 1945, pp. 64–5; J. Flexner, "Robert Feke," *Art Bulletin*, XXVIII, Sep. 1946, p. 199; J. Flexner, "Chronology of Feke's Pictures," *Magazine of Art*, XL, Jan. 1947, p. 36; R. Mooz, "The Art of Robert Feke," unpublished Ph.D. dissertation, University of Pennsylvania, 1970, pp. 146–47, 148n., 161 and n. 213, 229, pl. 68.

John Banister (1707–1767), who came to Newport from Boston about 1735, married Hermione Pelham, granddaughter of Governor Benedict Arnold of Rhode Island. Banister was a landowner, merchant, shipbuilder, and slave trader who prospered in the triangle trade and imported glassware, pottery, and textiles into Newport. His circle of friends there included Feke, from whom Banister commissioned portraits as early as 1745 (Mooz, p. 41).

From 1803 until the mid-1930s this portrait and its companion (Detroit Institute of Arts) hung in Rock Hall, the home of Josiah Martin (1699–1778) at Lawrence, Long Island. The Martin family's traditional identification of the sitters as Josiah Martin and his wife was accepted by scholars until 1970, when Mooz first suggested these portraits might be John and Hermione Pelham Banister of Newport. Mooz shows that John Banister's account book records payment to Feke in December 1748 for portraits of himself and his wife, paintings considered lost by earlier scholars. Mooz also noted that the Martin and Banister families intermarried in the late eighteenth or early nineteenth centuries, thus accounting for the portraits' passage from Newport to Long Island.

More recently, the identification and provenance of the portraits has been confirmed by the will of John Banister Jr. (City Hall, Newport), son of the sitters, who left the portraits of his parents to his brother Thomas, then living on Long Island, and who had married Rachel Martin, daughter of Josiah Martin, about 1792.

The Toledo portrait clearly fits in with Feke's work of 1748, and is almost identical in pose and landscape background to the portrait of *Isaac Winslow* (Boston, Museum of Fine Arts), which Feke painted in Boston in 1748.

VAUGHN FLANNERY

1898–1955. Born in Kentucky. Studied at the Art Institute of Chicago. After posts as art director of two advertising firms, in 1941 he settled in Maryland and engaged in race horse breeding, farming and newspaper publishing, as well as painting. Specialized in racing subjects and landscapes.

Swan Island PL. 198

[1942] Oil on canvas
30 x 40 in. (76.2 x 101.6 cm.)
Signed lower center: Vaughn Flannery
Inscribed on the reverse: Swan Island, Maryland/Vaughn Flannery
Acc. no. 44.46

Elizabeth C. Mau Bequest Fund

COLLECTIONS: (C. W. Kraushaar, New York).

EXHIBITIONS: Pittsburgh, Carnegie Institute, *Painting in the United States, 1943;* Toledo Museum of Art, *31st Annual,* 1944; Baltimore Museum of Art, *Vaughn Flannery Memorial Exhibition,* 1959, repr.

JOSEPH FLOCH

1895–1977. Born in Vienna, Austria. Studied at State Academy of Fine Arts, Vienna. 1921–23 in Holland. 1925 settled in Paris. 1941 emigrated to New York; later became U.S. citizen. 1964–67 taught at New School for Social Research. Chiefly a figure and interior painter.

Seated Figure PL. 210

[Ca. 1936] Oil on canvas
36⅜ x 25⅝ in. (92.5 x 65 cm.)
Signed lower right: Floch

Acc. no. 42.1
Gift of Art Additions Group

BEN FOSTER

1852–1926. Born in North Anson, Me. Studied painting in New York with Abbott Thayer, and in Paris with Luc Olivier Merson and Aimé Merot. 1904 N.A. Worked in New York and Cornwall, Conn. Landscape painter.

Early Moonlight PL. 130

[Ca. 1912] Oil on canvas
36 x 30 in. (91.4 x 76.2 cm.)
Signed lower left: Ben Foster

Acc. no. 12.919
Gift of Charlotte Scott Chapin

COLLECTIONS: Bought from the artist.

EXHIBITIONS: Toledo Museum of Art, *Inaugural Exhibition,* 1912, no. 34, repr.

HELEN FRANKENTHALER

1928–. Born in New York. Studied with Rufino Tamayo, 1945; with Paul Feeley at Bennington College, 1946; with Vaclav Vytlacil at ASL, 1947; with Hans Hofmann, 1950. 1952 developed a soak-stain technique on unprimed canvas derived from Pollock's gestural application of paint. 1958 married Robert Motherwell. 1961–69 summers at Provincetown, Mass. Frankenthaler is an important second generation New York School painter whose technique influenced Morris Louis, Kenneth Noland and Jules Olitski, among others.

Blue Jay PL. 264

[1963] Oil on canvas
44-3/16 x 64⅛ in. (112.2 x 162.8 cm.)
Signed lower right: Frankenthaler

Acc. no. 77.52
Gift of the Woodward Foundation

COLLECTIONS: Woodward Foundation, Washington, D.C.

REFERENCES: B. Rose, *Helen Frankenthaler,* New York, (1971), fig. 122.

AUGUST FRANZEN

1863–1938. Born in Norrköping, Sweden. Studied in Sweden with Carl Larsson and in Paris with Dagnan-Bouveret. 1882 to America, and from 1891 lived in New York. 1920 N.A. Portrait and genre painter.

Arthur J. Secor PL. 165

[Ca. 1913] Oil on canvas
33 x 25¾ in. (83.8 x 65.4 cm.)
Signed center right: Aug. Franzen

Acc. no. 22.16
Gift of Arthur J. Secor

COLLECTIONS: Arthur J. Secor, Toledo, ca. 1913–22.

REFERENCES: "The Arthur J. Secor Collection," *Toledo Museum of Art Museum News,* Sep. 1941, no. 95A, repr. (cover).

Arthur Joseph Secor (1857–1941) was a Toledo native. He attended Swarthmore College and returned to Toledo to join the Secor-Berdan Company, a wholesale grocery firm founded by his father. A trustee of the Museum from 1904 until his death, he served as President in 1926–27, 1931 and 1933, and as Chairman of the Board 1934–41. His collection of seventeenth century Dutch, eighteenth century British and nineteenth century French, Dutch and American painting, in which the French Barbizon and Dutch Hague School artists are especially well represented, was given to the Museum in 1922, 1926 and 1933. These gifts rank him among the Museum's chief benefactors.

Edward Drummond Libbey PL. 163

[1914] Oil on canvas
36 x 28 in. (91.4 x 71.1 cm.)
Signed and dated lower left: Aug. Franzen/1914 N.Y.

Acc. no. 33.15

Edward Drummond Libbey (1854–1925) brought the glass industry to Toledo in 1888. He organized the Libbey Glass Company, and with other associates developed the processes for automatic bottle blowing and production of sheet glass which formed the basis for later development of the Toledo glass industry.

He founded the Museum in 1901, and served as its president until his death, after which the Museum received his own art collection, as well as funds for both future art acquistions and general operations.

FREDERICK CARL FRIESEKE

1874–1939. Born in Owosso, Mich. Studied briefly at Art Institute of Chicago and ASL. 1898 studied at Académie Julian, Paris; settled permanently in France. His reputation became international by early 1900s. 1906 bought summer house at Giverny. Chiefly a figure painter, his style and subjects reflect the influence of French impressionism.

Silhouette PL. 178

[1933] Oil on canvas
36-5/16 x 28⅞ in. (92.2 x 73.4 cm.)
Signed and dated lower left: F. C. Frieseke –33
Colorman's stencil stamped on reverse of canvas:
 Lefebvre—Foinet, Paris

Acc. no. 37.3
Museum Purchase Fund

COLLECTIONS: (Macbeth).

EXHIBITIONS: New York, Grand Central Art Galleries, *Retrospective Exhibition of Paintings by Frederick C. Frieseke, N.A.*, 1939, no. 17.

REFERENCES: A. Weller, "Frederick Carl Frieseke: The Opinions of an American Impressionist," *The Art Journal*, XXVIII, Winter 1968/69, repr. p. 165.

The subject is the artist's daughter Frances (b. 1914), a favorite model.

GEORGE FULLER

1822–1884. Born in Deerfield, Mass. 1841 itinerant portraitist in northern New York. 1847 studied at NAD, and worked chiefly in New York. 1859 in Europe, where he met the English Pre-Raphaelites. 1860 returned to Deerfield to manage family farm. In 1875 a Boston exhibition of his work met with great success, and he resumed active painting. At his death Fuller was ranked as a leading romantic visionary.

Head of a Boy PL. 76

Oil on panel
17¼ x 14½ in. (43.9 x 36.8 cm.)
Signed lower left: G.F./G. Fuller

Acc. no. 23.3136

COLLECTIONS: James W. Ellsworth, New York; (Knoedler, New York, 1923); (Chester Johnson, Chicago, 1923).

EXHIBITIONS: Art Institute of Chicago, *Catalogue of the Art Collections, Loaned by James W. Ellsworth*, 1890, no. 31 (as *An Ideal Head*).

REFERENCES: W. Homer and D. Robb, Jr., "Paintings by George Fuller in American Museums and Public Collections," *Art Quarterly*, XXIV, Autumn 1961, p. 290.

FREDERICK FRARY FURSMAN

1874–1943. Born in El Paso, Ill. Studied at Art Institute of Chicago, and at Académie Julian, Paris. 1910–38 taught at Art Institute of Chicago. Ca. 1934 founder and director of art school at Saugatuck, Mich., modelled after Chase's plein-air landscape school at Shinnecock.

In the Garden PL. 123

[1909] Oil on canvas
31⅞ x 25¾ in. (81 x 65.5 cm.)
Signed and dated lower right: Frederick F. Fursman '09

Acc. no. 13.80
Gift of Cora Baird Lacey, in memory of Henry Allen
 Lacey

COLLECTIONS: Bought from the artist.

EXHIBITIONS: Art Institute of Chicago, *Exhibition of Paintings of Frederick Frary Fursman*, 1909, no. 20; Art Institute of Chicago, *24th Annual Exhibition*, 1911, no. 20 (as *Summertime;* Martin C. Cahn Prize); Toledo Museum of Art, *17th Annual Exhibition of the Society of Western Artists*, 1913; Art Institute of Chicago, *Half a Century of American Art*, 1939, no. 62, pl. XVII; St. Louis Art Museum, *Currents of Expansion: Painting in the Midwest, 1820–1940*, 1977, no. 83, repr.

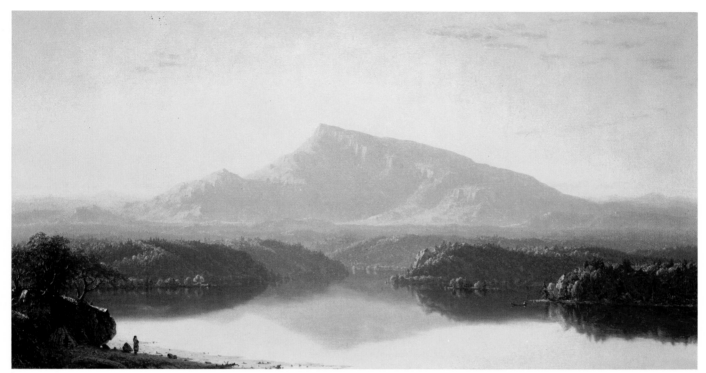

III. Sanford Robinson Gifford, *The Wilderness*, 1860

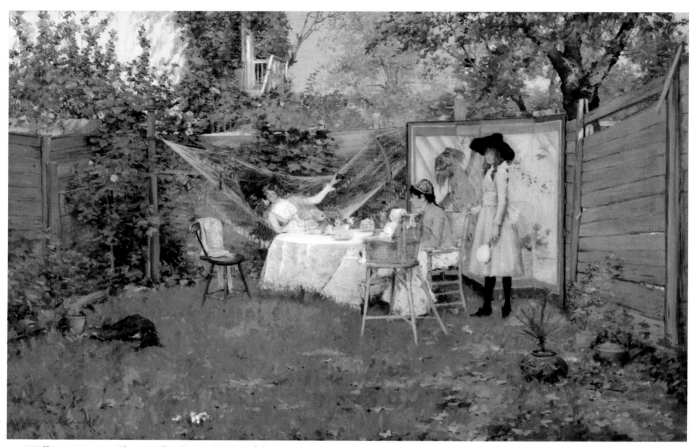

IV. William Merritt Chase, *The Open Air Breakfast*, ca. 1888

CARL FREDERICK GAERTNER

1898–1952. Born in Cleveland. 1918 studied at Western Reserve University and Cleveland School of Art. 1920–23 taught painting at John Carroll University and 1925–52 at Cleveland Institute of Art and Western Reserve University School of Architecture. 1947–49 instructor, Toledo Museum of Art School of Design. Specialized in landscapes and industrial subjects, particularly of the Cleveland region.

Covert's Old Pasture PL. 244

[1947] Tempera on masonite panel
21½ x 29½ in. (54.6 x 75 cm.)
Signed and dated lower right: CARL GAERTNER/1947

Acc. no. 47.31
Gift of the artist

Landscape PL. 245

[1948] Gouache on beaverboard
21⅞ x 30 in. (55.6 x 76.5 cm.)
Signed and dated lower right: CARL GAERTNER/1948

Acc. no. 48.44
Gift of the artist

Collision Bend PL. 247

[1952] Oil on masonite panel
24 x 44-3/16 in. (61 x 112 cm.)
Signed and dated lower right: CARL GAERTNER/1952
Inscribed on reverse: +315/COLLISION BEND/CARL
 GAERTNER/1952

Acc. no. 53.1
Museum Purchase Fund

COLLECTIONS: (Macbeth).

EXHIBITIONS: Macbeth, *Carl Gaertner*, 1952, no. 2; Toledo Museum of Art, *40th Annual*, 1953, no. 25; Cleveland Museum of Art, *Carl Gaertner Memorial Exhibition*, 1953, no. 91.

The Museum's records include a photograph and a small pencil sketch Gaertner used in developing this composition.

SAMUEL LANCASTER GERRY

1813–1891. Born in Boston. Chiefly self-taught. 1837–40, 1850–54 and 1873–75 in Europe. Worked mostly in New England; studio in Boston. Exhibited at Boston Atheneum, PAFA, NAD and American Art-Union. 1854 charter member of Boston Art Club. A prolific portrait,

genre and landscape painter, Gerry was influenced by the Hudson River School painters, particularly Durand and Cole, and later by some of the lesser Barbizon painters.

Artists' Brook, North Conway, PL. 35
New Hampshire

[Ca. 1857] Oil on canvas
26⅜ x 40⅜ in. (67 x 102.7 cm.)

Acc. no. 47.55

COLLECTIONS: (John Levy, New York, to 1947); Knoedler, New York, 1947).

EXHIBITIONS: Montclair (N.J.) Art Museum, *A.B. Durand 1796–1886*, 1971, no. 74, repr. (as *Landscape, Artist Sketching* by Durand; cat. by D. Lawall).

REFERENCES: D. Lawall, "Asher Brown Durand: His Art and Art Theory in Relation to his Times," unpublished version Ph.D. dissertation, Princeton University, 1966, appendix, p. 171, no. 338, fig. 156 (as by Durand, 1858).

This is almost certainly a view from the once-noted Artists' Brook looking across the Conway meadows toward Mount Washington in the Presidential Range of the White Mountains. This stream, a tributary of the Saco River, was a favorite painting site, especially in the 1850s. Benjamin Champney, a leading member of the White Mountain group of landscape painters, reminisced, "North Conway and the neighborhood of Artists' Brook at one time became almost as famous as Barbison (sic) and the Forest of Fontainebleau. . . . Dozens of umbrellas were dotted about under which sat artists from all sections of the country." (*Sixty Years' Memories of Art and Artists,* 1899; Garland reprint, 1977, p. 160).

The Toledo painting was formerly attributed to Asher B. Durand (1796–1886). However, there is no evidence for the Durand attribution before 1947, and the dry brushwork and thin application of paint do not resemble Durand's characteristic style. Although the Durand scholar David Lawall included the picture in his 1966 dissertation on Durand, and in his 1971 Durand exhibition catalogue, he subsequently questioned Durand's authorship on grounds of style (letter, May 11, 1978). The attribution to Gerry is based upon a half-size version of the Toledo picture, signed by Gerry and dated 1857 (Henry M. Fuller Collection, New York), which differs only in the omission or simplification of some details. The attribution is further supported by the close similarity of style of the Toledo landscape to signed works by Gerry such as *The Valley of the Pemigewasset* (1858; University of Michigan Museum of Art, Ann Arbor).

Although unsigned, the Toledo canvas may be reason-

ably attributed to Gerry. It is dated about 1857 on the basis of the smaller version, and on the fact that Gerry was especially active in the White Mountains in the 1850s.

SANFORD ROBINSON GIFFORD

1823–1880. Born in Greenfield, N.Y. After attending Brown University 1842–44, turned to painting. 1845 studied with John Rubens Smith and at NAD. Inspired by Cole and the scenery of the Catskills and Berkshires, he focused on landscape painting about 1846. 1851 A.N.A.; 1854 N.A. 1855–57 in Europe. 1868–69 in Europe and Middle East. Summer 1870 in Colorado Rockies and Wyoming with Whittredge and Kensett. 1874 traveled on West Coast. Gifford was a leading figure in the second generation of the Hudson River School and a principal painter of American luminism.

Lake Nemi PL. 38

[1856–57] Oil on canvas
39⅝ x 60⅜ in. (101.8 x 153.3 cm.)
Signed and dated on reverse (covered by relining canvas):
 Nemi/S. R. Gifford/Rome 1856–57

Acc. no. 57.46

COLLECTIONS: C. C. Alger, by 1858; Mrs. M. L. Alger, New London, Conn., by 1881; Hoysardt family, Hudson, N.Y.; Dr. Rossman, Hudson, N.Y.; (Vose, 1957).

EXHIBITIONS: New York, Century Club, *Inaugural Exhibition*, 1858; New York, NAD, 1858, no. 460; New Haven, Yale College, Works of art exhibited in Alumni Building, 1858; New York, Metropolitan Museum of Art, *19th Century America, Paintings and Sculpture*, 1970, no. 100, repr.

REFERENCES: S. Gifford, *European Letters*, II, pp. 122, 129, 136, 139 (MSS. in Archives of American Art); "Foreign Correspondence," *The Crayon*, IV, 1857, No. 7, p. 219; "Sketchings," V, 1858, No. 1, p. 25; V, No. 2, p. 57; V, No. 4, p. 117; "Art in New Haven," V, No. 9, p. 268; "Address by W. Whittredge," *Gifford Memorial Meeting of The Century Association*, New York, 1880, p. 37; *A Memorial Catalogue of the Paintings of Sanford Robinson Gifford, N.A.*, Metropolitan Museum of Art, New York, 1881, no. 107; Worthington Whittredge, *Autobiography*, 1905 (reprinted in *Brooklyn Museum Journal*, I, 1942, p. 57); Cowdrey, *NAD*, I, p. 182; R. Boyle, *American Impressionism*, Boston, 1974, repr. p. 50; I. Weiss, *Sanford Gifford (1823–1880)*, New York, 1977, pp. 145–50, pl. V.E.1 (Garland reprint of Ph.D. dissertation, Co-

lumbia University, 1968); W. Talbot, *Jasper Cropsey, 1823–1900*, New York, 1977, p. 60 (Garland reprint of Ph.D. dissertation, New York University, 1972).

Lake Nemi, in the Alban Hills southeast of Rome, was a famous site often painted in the eighteenth and nineteenth centuries. Gifford first visited it in 1856, when he made two pencil drawings, one of which is dated October 6 (in Gifford sketchbook dated 1856–57, Dr. Sanford Gifford Collection, Cambridge, Mass.), and an oil sketch (*Memorial Catalogue*, no. 99). His second visit is documented by two more oil studies dated October 23, 1856 (*Memorial Catalogue*, no. 101, now Julian Ganz Collection, Los Angeles; and no. 102). Gifford's impressions of the site are in his *European Letters* (II, p. 122; quoted by Weiss, p. 146). Except for the time of day, Gifford describes almost exactly the canvas he painted that winter, which is his largest work:

> We were high up above the lake. On one side in the foreground were some picturesque houses and ruined walls—a tall dark cypress, rising out of a rich mass of foliage, cut strongly against the lake, distance and sky. Far below, the still lake reflected the full moon, and the heights of the further shore, which crested by the walls and campanile of Gensano, were relieved richly against the light and misty expanse of the campagna, while still further beyond, a long line of silver light, the reflection of the moon, told where the sea was.

The Wilderness [COLOR PL. III] PL. 39

[1860] Oil on canvas
30 x 54-5/16 in. (76.2 x 138 cm.)
Signed and dated lower left: S. R. Gifford 1860

Acc. no. 51.403

COLLECTIONS: Harrison Maynard, Boston, 1860; Pittman family, Boston; Mrs. Morton C. Bradley, Boston; (Vose, 1951).

EXHIBITIONS: New York, NAD, 1860, no. 561 (as *The Wilderness*); Detroit Institute of Arts, *Painting in America*, 1957, no. 111; New York, Whitney Museum of American Art, *The American Frontier: Images and Myths*, 1973, no. 30, fig. 4; Toledo Museum of Art, *Heritage and Horizon: American Painting 1776–1976*, 1976, no. 11, repr.

REFERENCES: Metropolitan Museum of Art, *A Memorial Catalogue of the Paintings of Sanford Gifford*, New York, 1881, no. 204 (as *In the Wilderness*); Cowdrey, *NAD*, I, p. 183, no. 561; E. Richardson, *Painting in America*, New York, 1956, p. 227, fig. 103; P. Bermingham, *American Art in the Barbizon Mood* (exh. cat.), National Collection of Fine Arts, Washington, 1975, p. 52, fig. 37; I. Weiss, *Sanford Gifford (1823–1880)*, New York, 1977,

pp. 195–205, pl. VI H.I. (Garland reprint of Ph.D. dissertation, Columbia University, 1968); J. Sweeney, "The Artist-Explorers of the American West: 1860–1880," unpublished Ph.D. dissertation, Indiana University, 1975, pp. 16, 18, illus. 10.

While this composition was almost certainly inspired by the mountain scenery of New England, Gifford developed it from studies made at several locations to form an idealized rather than topographical landscape. Still, it is quite possible the motif of a vast and solitary peak rising above the forests may have been suggested by Mt. Katahdin in Maine. While there is no evidence that he actually visited Katahdin at this time, Gifford's sketchbooks show that in July and August 1859 he traveled in surrounding areas of Nova Scotia, Maine and New Hampshire.

Gifford's title reinforces the idealizing mood, as does the line which followed it in the catalogue of the 1860 National Academy exhibition: "home of the red brow'd hunter race." This verse, whose source has not been found, refers to the Indian family as a symbol of man living in harmony with nature, a theme which Gifford treated several times in the 1860s.

While the general composition was composed from drawings of New England views showing a similar balanced symmetry, the Indians in the canoe and the family in the foreground were taken from studies of the Mic Macs of Halifax Basin, Nova Scotia dated July 15, 1859 (Gifford sketchbooks, Vassar College Art Gallery).

Although no oil study for this picture is known, there is a related oil sketch dated 1861 which shows the same mountain from a closer viewpoint (Andover, Mass., Addison Gallery of American Art). As the Gifford scholar Ila Weiss noted, this study and the Toledo painting may have been derived from the same pencil drawing (letter, July 31, 1978).

SAM GILLIAM

1933–. Born in Tupelo, Miss.; raised in Louisville, Ky. 1961 M.A. University of Louisville. 1962 settled in Washington, D.C. First worked in hard-edged color field painting. In 1968 Gilliam turned to stained, draped canvases related to gestural abstract expressionism.

Untitled PL. 269

[1968] Watercolor and enamel on paper
23⅝ x 18 in. (60 x 45.7 cm.)
Signed and dated lower right (recto and verso): Sam Gilliam '68

Acc. no. 73.23
Frederick B. Shoemaker Fund
COLLECTIONS: (Fendrick Gallery, Washington, D.C.)
REFERENCES: E. McCready, "Tanner and Gilliam: Two American Black Painters," *Negro American Literature Forum*, VIII, Winter 1974, pp. 279–81, fig. 2.

ARTHUR CLIFTON GOODWIN

1864–1929. Born in Portsmouth, N.H.; raised in Chelsea, Mass. Ca. 1902 began to paint. Chiefly self-taught. 1902–21 worked in Boston. 1921–23 studio in New York. 1923–29 lived on farm at Old Chatham, N.Y. Best known for views of Boston and New York, Goodwin was influenced by the subject matter and style of The Ten American Painters.

On South Boston Pier PL. 116

[Ca. 1904] Oil on canvas
15⅞ x 20 in. (40.4 x 50.7 cm.)
Signed lower left: A. C. Goodwin

Acc. no. 50.307

COLLECTIONS: Bought from the artist by the Elwel family, Melrose, Mass.; (Giovanni Castano, Boston).

EXHIBITIONS: Andover (Mass.), Addison Gallery of American Art, *Arthur Clifton Goodwin*, 1946, no. 8, repr.

South Boston Pier was built in 1885 as part of Marine Park at City Point and included Castle Island, visible at the left of the canvas. A popular spot for summer amusement at the turn of the century, it no longer exists.

The date is based on style, and on a signed and dated pastel of the same view (1904; repr. *Antiques*, LXXXVIII, Nov. 1965, p. 634).

LUTHER EMERSON VAN GORDER

1857–1931. Born in Warren, Ohio. When young worked for a Toledo newspaper. Studied painting in New York with W. M. Chase and C. Y. Turner; 1894–96 in Paris at Ecole des Beaux Arts with Carolus-Duran. Lived in Paris five years, then in New York. By 1903 settled in Toledo. Illustrator and painter of landscapes and street scenes.

Quai aux Fleurs, Paris PL. 105

Oil on canvas
36 x 48 in. (91.4 x 121.9 cm.)

Signed lower right: L. E. VAN GORDER.

Acc. no. 11.25

Gift of The Tile Club, Toledo

Flower Market, Paris PL. 106

Oil on canvas

22¼ x 28⅛ in. (56.5 x 71.4 cm.)

Signed lower left: L E VAN GORDER

Acc. no. 12.916

Gift of the artist

ADOLPH GOTTLIEB

1903–1974. Born in New York. 1920 studied with John Sloan and Robert Henri at ASL. 1921 in Europe. 1923 studied at Parsons School of Design. 1935–40 exhibited with The Ten. 1936 easel painter for WPA Federal Art Project. 1937–39 in Tucson, Ariz. In the late 1930s with his friend Mark Rothko, he developed an interest in mythology and primitive art. While his pictographs of the 1940s were influenced by surrealism, Gottlieb's mature work united the attitudes of color field painting and gestural abstract expressionism.

Summer PL. 263

[1964] Oil on canvas

48 x 36 in. (121.9 x 91.4 cm.)

Signed and dated on reverse: Adolph Gottlieb/
 "SUMMER"/48 x 36"/1964 6404

Acc. no. 77.9

Gift of the Woodward Foundation

COLLECTIONS: Woodward Foundation, Washington, D.C., 1964–77.

REFERENCES: R. Phillips, "Abstract Expressionists," *Toledo Museum of Art Museum News*, XIX, No. 4, 1977, p. 106, repr. pl. IV (color).

WALTER GRANVILLE-SMITH

1870–1938. Born in South Granville, N.Y. Studied with James Carroll Beckwith, Willard Metcalf, at ASL, and in Europe. 1916 N.A. Chiefly a landscape painter.

Southaven Mill PL. 175

[1926] Oil on canvas

40½ x 50½ in. (102.9 x 128.3 cm.)

Signed and dated lower left: W. Granville-Smith 1926

Acc. no. 26.143

National Academy of Design, Ranger Fund Purchase

EXHIBITIONS: New York, NAD, 1926, no. 257 (Carnegie Prize); Toledo Museum of Art, *14th Annual*, 1926, no. 20.

JOHN GREENWOOD

1727–1792. Born in Boston. 1742 apprenticed to Thomas Johnston, japanner, engraver and sign painter. 1745–52 active as engraver and painter in Boston until he went to Surinam, where he painted many portraits. 1758–62 engraver in Holland. Settled in London as art dealer. 1765 elected to Society of Artists of Great Britain. Greenwood was influenced by the more accomplished style of his contemporary, Robert Feke.

Sarah Kilby PL. 3

[Ca. 1752] Oil on canvas

49-13/16 x 40 in. (126.5 x 101.6 cm.)

Acc. no. 51.296

COLLECTIONS: Mrs. Alexander S. Porter, Boston, by 1879 to 1939; Miss Frances R. Porter, Boston, 1939–43; Mrs. William E. Groff and Miss Katharine Robins, Boston, 1943–51; (Richard C. Morrison, Concord, 1951).

EXHIBITIONS: Boston, Museum of Fine Arts, *One Hundred Colonial Portraits*, 1930, no. 23, repr.; Andover (Mass.), Addison Gallery of American Art, *John Greenwood in America*, 1942.

REFERENCES: C. Bolton, ed., *American Portraits 1620–1825 in Massachusetts*, Boston, 1929, I, p. 100, no. 530; A. Burroughs, *Limners and Likenesses*, Cambridge, 1936, p. 54 (as Mrs. Cunningham); A. Burroughs, *John Greenwood in America, 1745–1752*, Andover, 1943, pp. 27–9, 34, 59, 66–7, 72, fig. 18; O. Larkin, *Art in America*, New York, 1949, p. 53 (as Mrs. Cunningham); R. Mooz, "The Art of Robert Feke," unpublished Ph.D. dissertation, University of Pennsylvania, 1970, p. 192.

The sitter is identified by family tradition as Sarah Kilby (1736–?), daughter of William and Sarah Clark Kilby of Boston. In 1754 she married Nathaniel Cunningham, Jr. (died 1756), whose mother's portrait by John Smibert is also in the collection of The Toledo Museum of Art (48.19). In 1757 Sarah Kilby Cunningham married Capt. Gilbert McAdam, a Scotsman from Ayrshire who fought in the French and Indian Wars. At the close of the war, the McAdams returned to Scotland. This portrait was probably painted shortly before Greenwood left Boston in 1752.

Greenwood made changes in developing the composition: the shadow of a column base is visible in the left corner of the landscape vista, and the sitter's left hand probably at first rested in her lap as the outline of a hand can be seen below the folds of the skirt.

WILLIAM HARNETT

1848–1892. Born in Clonakilty, County Cork, Ireland. Raised in Philadelphia. Ca. 1865–75 worked as engraver of table silver. 1871 studied at the NAD and Cooper Union in New York. By 1875 a still life specialist. 1880–86 in Europe, chiefly in Munich. From 1886 lived in New York. Harnett revived the table-top still life format established by the Peale family, and introduced the trompe l'oeil tradition that was carried on by Peto, Haberle, and others after 1900.

Still Life with the Toledo Blade PL. 56

[1886] Oil on canvas
22⅛ x 26-3/16 in. (56.1 x 66.5 cm.)
Signed and dated lower left: W. M. HARNETT./1886
Inscribed on reverse: PAINTED TO ORDER/FOR I. N.
 REED./of TOLEDO./OHIO./1886/Wᵐ. M. Harnett

Acc. no. 62.2
Gift of Mr. and Mrs. Roy Rike

COLLECTIONS: Isaac N. Reed, Toledo, 1886–91; Mrs. Isaac N. Reed, Toledo, 1891–1914; Marian Reed Kirtland (Mrs. Harry B. Kirtland), Toledo; Harry B. Kirtland, Toledo, to 1961; (Victor D. Spark, New York, 1961).

EXHIBITIONS: Toledo Museum of Art, *Heritage and Horizon: American Painting 1776–1976*, 1976, no. 23, repr.

REFERENCES: A. Frankenstein, *After the Hunt*, Berkeley, 1953, pp. 7, 9, 73, 171, no. 105, repr. pl. 66.

This canvas was painted a few months after Harnett's return from Europe for Isaac N. Reed, a Toledo druggist whose business often took him to New York. The folded newspaper was a device Harnett often used—it is the September 17, 1886 issue of the *Toledo Blade*; renamed *The Blade,* it is still Toledo's daily paper.

Pentimenti, more clearly visible under infra-red light, show that Harnett changed the composition during the course of execution: he replaced a large jug with the present stoneware pitcher, painted out a jar once behind the open book, and altered the profiles of the drapery and newspaper.

Harnett employed many of the same objects—the opened book, pipe, pitcher, violin and bow—in an al-

most identical composition with the October 20, 1886 issue of the *Philadelphia Times* (New Britain [Conn.] Museum of American Art).

BIRGE HARRISON

1854–1929. Born in Philadelphia. Studied at PAFA and in Paris with Carolus-Durand. 1883 member Society of American Artists. 1889–93 extensive travel in Australia, South Seas, and western U.S. 1904 founder of Woodstock (N.Y.) School of Landscape Painting of ASL, which he directed until 1910. 1909 published *Landscape Painting*. 1910 N.A. Harrison was an influential teacher and a leading figure in the development of Woodstock as an art colony.

Woodstock Meadows in Winter PL. 129

[1909] Oil on canvas
46 x 40¼ in. (117 x 102.2 cm.)
Signed and dated lower left: Birge Harrison/1909

Acc. no. 12.1266
Gift of Cora Baird Lacey in memory of Mary A. Dustin

COLLECTIONS: Bought from the artist.

EXHIBITIONS: Buffalo Fine Arts Academy and Albright Art Gallery, *Two Retrospective Exhibitions of Paintings by Alexander Harrison and Birge Harrison*, 1913, no. 1, repr.; New York, American Academy of Arts and Letters, *An Exhibition of Paintings and Sculpture Commemorating the Armory Show of 1913*, 1955, no. 39; Poughkeepsie (N.Y.), Vassar College Art Gallery, *Woodstock: An American Art Colony, 1902–1977*, 1977, no. 12, repr.

REFERENCES: B. Harrison, *Landscape Painting*, New York, 1909, repr. opp. p. 216; A. Hoeber, "Birge Harrison, N.A., Landscape Painter," *International Studio*, LXIV, July 1911, repr. p. VII.

This shows the stream which joins Tannery Brook. In the center background is Wide Clove, with Mead's Mountain to the left and Overlook Mountain to the right.

WILLIAM STANLEY HASELTINE

1835–1900. Born in Philadelphia, where he studied with Paul Weber. 1854 B.A. Harvard College. 1855 studied with Andreas Achenbach at Düsseldorf, where he met Bierstadt, Whittredge and Leutze, life-long friends. 1856 in Rome. 1858 to New York. 1861 N.A. 1866 to France; 1869 settled in Rome; his studio became a cosmopolitan

meeting place. He often returned to the U.S., where he spent most of the 1890s. Marine and landscape painter, and a founder of the American Academy in Rome.

Capri PL. 62

Oil on canvas
13¾ x 24¼ in. (35 x 61.7 cm.)
Signed lower left: WSH

Acc. no. 52.59
Gift of Mrs. Helen Haseltine Plowden

COLLECTIONS: Helen Haseltine Plowden (daughter of the artist), England.

The island of Capri off the Italian coast near Naples has been celebrated for its beauty since ancient times. Haseltine often visited Capri when he lived in Rome.

According to his daughter and biographer he made hundreds of oil sketches and drawings of the island (H. H. Plowden, *William Stanley Haseltine*, London, 1947, p. 63). This canvas probably dates after Haseltine had settled in Rome.

Lake Garda PL. 61

Watercolor on board
15-1/16 x 22-1/16 in. (38.2 x 56 cm.)
Signed lower right: WSH

Acc. no. 52.60
Gift of Mrs. Helen Haseltine Plowden

COLLECTIONS: Helen Haseltine Plowden (daughter of the artist), England.

EXHIBITIONS: Boston, Doll and Richards, *Paintings and Water Colors by William S. Haseltine*, 1950, no. 33.

Lake Garda, the largest of the north Italian lakes, has been famous since antiquity for its splendid setting at the foot of the Alps. This watercolor, with the town of Riva at the lake's northern end, may have been done in 1882, when Haseltine visited Garda (H. H. Plowden, *William Stanley Haseltine*, London, 1947, p. 149).

CHILDE HASSAM

1859–1935. Born in Dorchester, Mass. Worked as wood engraver and illustrator; studied painting in his spare time. 1883 first trip to Europe. 1886–89 in Paris; briefly attended Académie Julian. 1889 settled in New York. Summers in Maine, Connecticut, and later at Easthampton, L.I. Seceded from the Society of American Artists to co-found with J. Alden Weir The Ten American Painters. About 1915 began serious work in etching and lithog-

raphy. Of all the American impressionists, Hassam modelled his style most consistently on that of the French impressionists, especially Monet, Pissarro and Sisley.

Rainy Day, Boston PL. 102

[1885] Oil on canvas
26⅛ x 48 in. (66.3 x 122 cm.)
Signed and dated lower right: Childe Hassam/1885

Acc. no. 56.53

COLLECTIONS: The artist, until ca. 1900; Mary Woodard Collection, Boston; (Hirschl and Adler, New York, 1955–56).

EXHIBITIONS: New York, Society of American Artists, *Eighth Exhibition*, 1886, no. 58; New York, Hirschl and Adler Galleries, *Childe Hassam, 1859–1935*, 1964, no. 11; Washington, Corcoran Gallery of Art, *Childe Hassam, A Retrospective Exhibition*, 1965, no. 1.

REFERENCES: M. Brown, *History of American Art to 1900*, New York, 1977, p. 559, pl. 695; D. Hoopes, *Childe Hassam*, New York, 1979, pp. 13, 22, 23, 26, 34, pl. 1.

Fashionable city life was a theme Hassam treated throughout his career. Although he did not work in an impressionist style until about 1887, Hassam's early Boston views, his first city scenes, show the plunging perspective and concern with weather and lighting which he developed in later paintings.

The subject of the Toledo picture is the junction in Boston's South End of Columbus Avenue, leading towards the Common, and Appleton Street, branching to the right. At this time, Hassam and his wife lived at 282 Columbus Avenue across from the Second Universal Church, whose spire is on the right side of the street; slightly further on the left is the clock tower of the Providence Depot. Barely visible in the distance is the spire of the Park Street Church across the Common.

In 1885 Hassam painted this subject from a closer viewpoint (*Columbus Avenue, Rainy Day*, Worcester Museum of Art).

Summer Sea, Isles of Shoals PL. 103

[1902] Oil on canvas
25-3/16 x 30-5/16 in. (64 x 77 cm.)
Signed lower right: Childe Hassam
Inscribed on reverse (covered by relining): C.H. 1902

Acc. no. 12.3

COLLECTIONS: Bought from the artist through the New York dealer Henry Reinhardt, 1910; Florence Scott Libbey, Toledo, 1910–12.

After his marriage in 1884, Hassam and his wife regularly spent summers at Appledore, one of the Isles of Shoals, a gathering place for artists and writers off the Maine-New Hampshire coast.

Hassam was attracted there by Celia Thaxter, a writer, amateur painter and art patron, whose summer salons at Appledore House included many famous authors, musicians and artists. During the thirty years he visited Appledore, Hassam painted the broad horizon and rocky shoreline in a brilliantly colored impressionist style.

CHARLES WEBSTER HAWTHORNE

1872–1930. Born in Lodi, Ill.; raised in Richmond, Me. Ca. 1893 studied at ASL. 1896 attended Chase's summer school at Shinnecock, and became his assistant. 1898 in Holland. 1897–1906 exhibited with Society of American Artists. 1899 opened Cape Cod School of Art at Provincetown, Mass., where he taught most summers until his death. 1906–07 in Italy. 1911 N.A. A figure painter and portraitist, Hawthorne was a notable teacher and the principal founder of the Provincetown art colony.

The Song PL. 141
[Ca. 1912] Oil on board
40 x 40 in. (101.6 x 101.6 cm.)
Signed upper left: C W Hawthorne

Acc. no. 17.599
Gift of Ralph King
COLLECTIONS: (Macbeth).

EXHIBITIONS: Philadelphia, PAFA, *107th Annual Exhibition*, 1912, no. 643, repr.; Macbeth, *Exhibition of Paintings by Chas. W. Hawthorne, N.A.,* 1913, no. 10; Provincetown (Mass.), Chrysler Art Museum, *Hawthorne Retrospective*, 1961, no. 32, repr.

REFERENCES: E. McCausland, *Charles W. Hawthorne,* New York, 1947, p. 30; University of Connecticut Museum of Art, *The Paintings of Charles Hawthorne,* Storrs, 1968, in Acknowledgments.

MARTIN JOHNSON HEADE

1819–1904. Born in Lumberville, Pa. 1837 studied with Edward Hicks. Ca. 1840–43 in Rome, with visits to England and France. 1848 in Rome. Heade led a restless life, living at various times in New York, Philadelphia, Boston, Trenton, St. Louis, Chicago and elsewhere. 1863, 1866 and 1870 in South and Central America, where he painted exotic birds and flowers. By 1860 gave up por-

traiture and genre for coastal landscapes and still life. 1883 settled in St. Augustine, Fla. Heade's concern with atmospheric effects make him one of the masters of American luminism.

Roman Newsboys PL. 31
[1848] Oil on canvas
28½ x 24-5/16 in. (72.5 x 61.7 cm.)
Fragmented handwritten label removed from reverse of canvas: Roman/M. J. Heade 1848./Western Art Union-1850./M. J....e/....49. Allotted..../e Gray S (?)..../member of Western Art.../Cincinnati Ohio./possession of Henry Swisshelm/present time, 1898.

Acc. no. 53.68

COLLECTIONS: Henry Swisshelm, Pittsburgh, 1850–after 1898; (Macbeth, 1953).
EXHIBITIONS: Cincinnati, Western Art Union, 1850, no. 98 (as *Roman News Boys)*; Boston, Museum of Fine Arts, *Martin Johnson Heade,* 1969, no. 1, repr. (cat. by T. Stebbins).
REFERENCES: Western Art Union, "Additional Catalogue," *Record,* Dec. 1849, no. 98; Western Art Union, "Distribution," *Transactions for Year 1850,* Cincinnati, 1850, p. 17, no. 2 (as *The News Boys,* 3366 to H. Swisshelm, Pittsburgh); Western Art Union, "Distribution," *Proceedings of the Annual Meetings,* Jan. 20, 1851, p. 17, no. 2 (as *The News Boys,* 3366 to H. Swisshelm, Pittsburgh); T. Stebbins, Jr., *The Life and Works of Martin Johnson Heade,* New Haven and London, 1975, pp. 9–11, 13, 212, no. 9, fig. 4.

This is the only genre subject by Heade now located, though his *Goat Herd* (unlocated) was also selected by the Western Art Union for distribution in its 1850 lottery.

It was painted in Rome in 1848 during the unrest caused by the Risorgimento movement which opposed the temporal government of Pope Pius IX (1846–78) in favor of a democratic republic. The partly legible graffiti and printed notices reflect the strident opposition to the Pope, caricatured in profile at lower right; a cardinal who supported the papacy is depicted as a stick figure. The poster slogan *"Gioberti ai Romani"* refers to Vincenzo Gioberti (1801–1852), an influential priest and philosopher who actively opposed the Pope's government. The newsboys, one of whom wears a cap lettered *"Pio IX,"* are distributing antipapal leaflets headed *"Pirlone,"* or hypocrite. The date (18)48 appears on a torn notice near the left edge.

Although many American artists were in Rome during the Risorgimento unrest, few concerned themselves

with politics. Thus, Heade, a liberal and individualist, who always maintained a distance from his fellow artists, gave this popular theme a characteristically independent treatment (Stebbins, p. 11).

ROBERT HENRI

1865–1929. Born Robert Henry Cozad in Cincinnati; raised in Cozad, Neb. Studied 1886–88 and 1892 at PAFA, and 1888–91 in Paris. 1892 returned to Philadelphia; gatherings at his studio attended by Sloan, Glackens, Luks, Shinn. 1895–96 and 1898–1900 in Europe; influenced by Manet, Velázquez and Hals. 1900 returned to New York. 1906 N.A. 1908 organized exhibition of The Eight at Macbeth Gallery. 1909 opened Henri Art School, New York. 1910 helped organize Independent Artists Exhibition. 1913 exhibited in Armory Show. 1916–28 taught at ASL. 1916 founding member Society of Independent Artists. 1923 published *The Art Spirit*. The leader of The Eight, Henri was the pivotal figure among progressive, non-academic artists until the Armory Show.

Cathedral Woods, Monhegan Island　　　PL. 144

[1911] Oil on canvas
31⅞ x 25⅞ in. (81 x 65.7 cm.)
Signed lower left: ROBERT HENRI
Inscribed on reverse by artist: 3G/Robert Henri/
　"Cathedral Woods, Monhegan, Id."

Acc. no. 19.47
Frederick B. Shoemaker Fund

COLLECTIONS: Bought from the artist.

EXHIBITIONS: New York, Montross, 1917; New York, Knoedler, 1918; Boston Art Club, 1918; Detroit Institute of Arts, 1919; Toledo Museum of Art, *Eighth Annual*, 1919, no. 35; Lincoln (Neb.), Sheldon Memorial Art Gallery, *Robert Henri, 1865–1929*, 1965, no. 42 (cat. by N. Geske).

REFERENCES: R. Henri, *Record Book G* (collection of Mrs. John LeClair, Glen Gardner, N.J.), p. 3, entry dated Sep. 1911.

Henri first discovered Monhegan Island off the Maine coast in the summer of 1903, while visiting at Boothbay Harbor. Henri was so taken with the landscape and the dramatically changing weather that he planned to build a studio there, but never did.

　In September 1911, on his second trip to Monhegan, he painted this canvas of Cathedral Woods, so-called because of the trees arching over the winding pathways.

EDWARD LAMSON HENRY

1841–1919. Born in Charleston, S.C. Raised in New York. 1855 studied with landscapist W. M. Oddie; 1858–60 at PAFA; 1860 with Charles Gleyre and Gustave Courbet in Paris. Several later European trips. From early 1860s–1885 studio in Tenth Street Studio Building, New York. 1869 N.A. Ca. 1882 began building home at Cragsmoor, N.Y., where he settled in 1887. He specialized in carefully detailed anecdotal scenes of eighteenth and nineteenth century American history and rural and town life.

The Coming Train　　　PL. 57

[1880] Oil on canvas
12-13/16 x 23⅞ in. (32.3 x 60.7 cm.)
Signed and dated lower right: E L Henry. N.Y./1880

Acc. no. 50.70

COLLECTIONS: (John Levy, New York).

EXHIBITIONS: Grand Rapids (Mich.) Art Museum, *Themes in American Painting*, 1977, no. 11, p. 31, repr. (cat. by J. G. Sweeney).

REFERENCES: C. Klackner, *Reproductions of the Works of E. L. Henry*, New York, 1906, no. 21, repr. (as *The Coming Train*); E. McCausland, *The Life and Work of Edward Lamson Henry, N.A.*, Albany, 1945, pp. 89, 175, no. 146.

Modes of transportation, especially the horse and carriage and the railroad, were favorite themes in Henry's meticulously detailed pictures. While several of his railroad subjects are identified, the Toledo picture is not known to show a specific place, although the composition resembles *Station at Orange, N.J. (Morris & Essex Railroad)* (1873; McCausland, no. A-105).

STEPHEN HOPKINS HENSEL

1921–1979. Born in New York. B.A. Yale University. Worked in Palm Beach, Maine and Majorca, Spain.

Ice-Cream Parlor　　　PL. 240

[1949] Oil on canvas
21 x 33⅞ in. (53.4 x 86 cm.)
Signed and dated lower left: Hopkins Hensel 49

Acc. no. 49.76
Gift of an Anonymous Donor

COLLECTIONS: (Grand Central Art Galleries, New York).

EXHIBITIONS: Toledo Museum of Art, *36th Annual*, 1949,

no. 31; Pittsburgh, Carnegie Institute, *Painting in the United States,* 1949, no. 144.

GEORGE HITCHCOCK

1850–1913. Born in Providence, R.I. 1872 B.A. Brown University; 1874 L.L.B. Harvard Law School. Practiced law, then studied watercolor painting in England. Studied in Paris; with Hendrik Mesdag in The Hague; and at the Düsseldorf Academy. In 1883 the first of several American painters to settle in Egmond, Holland. 1909, A.N.A. First specialized in religious subjects; in later impressionist landscapes often painted the tulip fields with which he became identified.

Flower Field near Leiden PL. 137

Oil on canvas
17⅛ x 21-13/16 in. (43.5 x 55.5 cm.)
Signed lower right: G. HITCHCOCK

Acc. no. 17.724
Gift of Mrs. George Hitchcock

EXHIBITIONS: Indianapolis, John Herron Art Institute, *Oil Paintings by George Hitchcock, A.N.A.,* 1911, no. 1; Buffalo, Albright Art Gallery, *Paintings of Flower Fields in Holland by the Late George Hitchcock,* 1914, no. 10; Toledo Museum of Art, *Paintings by George Hitchcock,* 1915, no. 203.

HANS HOFMANN

1880–1966. Born in Weissenberg, Bavaria, Germany. Studied science and engineering. 1903–14 in Paris; studied at Ecole de la Grande Chaumière; Matisse was a fellow-student; met Delaunay, Picasso, Braque. 1915–32 operated his own art school in Munich. Summers of 1930 and 1931 taught at University of California, Berkeley. 1932 settled permanently in U.S. 1934 opened school in New York, and in 1935 summer school at Provincetown, Mass., both of which ran through 1958, when he turned full-time to painting. 1948 published *Search for the Real and Other Essays.* As both a teacher and a painter, Hofmann was a major figure in the development of abstract expressionism.

Night Spell [COLOR PL. VIII] PL. 266

[1965] Oil on canvas
72 x 60 in. (182.9 x 152.4 cm.)
Signed and dated lower right: 65/hans hofmann
Inscribed on reverse: #1607/night spell/oil on canvas/
 72 x 60 1965/hans hofmann

Acc. no. 70.50
Gift of Edward Drummond Libbey

COLLECTIONS: Estate of the artist, to 1970; (André Emmerich Gallery, New York).

EXHIBITIONS: Syracuse (N.Y.), Everson Museum of Art, *Hans Hofmann,* 1969; Washington, Hirshhorn Museum and Sculpture Garden and Houston, Museum of Fine Arts, *Hans Hofmann, A Retrospective Exhibition,* 1976, no. 73, repr. (cat. by W. D. Bannard).

REFERENCES: R. Phillips, "Abstract Expressionists," *Toledo Museum of Art Museum News,* XIX, No. 4, 1977, pp. 89–91, repr. pl. 1 (color).

WINSLOW HOMER

1836–1910. Born in Boston. Chiefly self-taught. 1854 apprenticed to lithographer John Bufford. From 1857 freelance illustrator, chiefly for *Harper's Weekly;* artist-correspondent with the Union Army during the Civil War. 1859 to New York; briefly studied at NAD. 1865 N.A. 1866–67 ten months in France. 1873 began painting seriously in watercolor. 1881–82 at Tynemouth, England. 1883 settled at Prout's Neck, Me., with frequent winters in the Bahamas, Cuba, Florida or Bermuda, and summers in the Adirondacks and Canada. Despite his isolation from the art world, Homer achieved wide recognition in his lifetime, and is ranked as one of the great realists of American painting.

Boys Beaching a Dory PL. 58

[1880] Watercolor, pencil and gouache on paper
9½ x 13-7/16 in. (23.6 x 34.2 cm.)
Signed and dated lower left: Homer 1880

Acc. no. 50.274

COLLECTIONS: Osborn McArthur, Hyannis, Mass., ca. 1934; (Macbeth, 1936); Miss Bessie J. Howard, Melrose, Mass., ca. 1937; Horace D. Chapin, Boston; Mrs. Joseph L. Write, Upper Montclair, N.J., by 1940–50; (Macbeth, 1950).

EXHIBITIONS: Tucson, University of Arizona Art Gallery, *Yankee Painter, A Retrospective Exhibition of Oils, Watercolors and Graphics by Winslow Homer,* 1963, no. 128, repr. (cat. by W. Steadman).

REFERENCES: L. Goodrich, *Winslow Homer,* New York, 1959, pl. 38; J. Gould, *Winslow Homer: A Portrait,* 1962, p. 186, repr. p. 187.

Homer spent the summer of 1880 at Gloucester, Mass.,

where he made over a hundred watercolors of life in this famous fishing community.

Sunlight on the Coast [COLOR PL. V] PL. 60

[1890] Oil on canvas
30¼ x 48½ in. (76.9 x 123.3 cm.)
Signed and dated lower left: Winslow Homer 1890

Acc. no. 12.507
Gift of Mr. and Mrs. Edward Drummond Libbey

COLLECTIONS: (Reichard & Co., New York, 1891); John G. Johnson, Philadelphia, 1891–1911; (Henry Reinhardt, New York, 1911); Mr. and Mrs. Edward Drummond Libbey, Toledo, 1911–12.

EXHIBITIONS: New York, Reichard & Co., 1891; Chicago, *World's Columbian Exposition*, 1893; New York, Metropolitan Museum of Art, *Winslow Homer Memorial Exhibition*, 1911, no. 101; Toledo Museum of Art, *Inaugural Exhibition*, 1912, no. 44, repr.; Pittsburgh, Carnegie Institute, *Centenary Exhibition of Works of Winslow Homer, 1836–1936*, 1937, no. 34; Washington, National Gallery of Art, *Winslow Homer, A Retrospective Exhibition*, 1958, no. 57, repr. (cat. by A. Ten Eyck Gardner); Boston, Museum of Fine Arts, *Winslow Homer, A Retrospective Exhibition*, 1959, no. 53; New York, Whitney Museum of American Art, *Winslow Homer*, 1973, no. 51 (cat. by L. Goodrich).

REFERENCES: W. Downes, *The Life and Works of Winslow Homer*, Boston and New York, 1911, pp. 154, 155, 165, 258, repr. p. 158; L. Goodrich, *Winslow Homer*, New York, 1944, pp. 119–21, 127; A. Ten Eyck Gardner, *Winslow Homer, American Artist: His World and His Work*, New York, 1961, repr. p. 22; J. Gould, *Winslow Homer: A Portrait*, New York, 1962, pp. 241–42; P. Beam, *Winslow Homer at Prout's Neck*, Boston, 1966, pp. 92, 93, 95, repr. p. 92; P. Hannaway, *Winslow Homer in the Tropics*, Richmond, Va., 1973, p. 101.

Sunlight on the Coast inaugurated a theme which occupied Homer for many years—the sea, closely observed under many conditions of light and weather, breaking against the rocks below his studio at Prout's Neck on the Maine coast.

According to Lloyd Goodrich (1944), this canvas marked Homer's change from essentially narrative subjects to more simplified compositions, and greater feeling for the moods of nature. It is among his most broadly executed works up to that time, the pigment having been thickly applied with a palette knife in some passages. The Homer scholar Philip C. Beam considers *Sunlight on the Coast* Homer's first pure seascape without human figures to have been painted in oil (letter, Sep. 27, 1978).

Palm Trees, Bahamas PL. 59

[Ca. 1898–99] Watercolor on paper
17-5/16 x 14-9/16 in. (43.9 x 37 cm.)

Acc. no. 52.27

COLLECTIONS: Mr. and Mrs. Charles Homer; Mr. and Mrs. Arthur Homer; (Macbeth, 1943); Dr. C. J. Robertson, Pelham, N.Y., 1943–52; (Macbeth, 1952).

EXHIBITIONS: New York, American Federation of Arts, *From the Archives of American Art: The Role of the Macbeth Gallery*, 1962, no. 36.

REFERENCES: Coral Gables (Fla.), Lowe Art Museum, University of Miami, *Winslow Homer's Sub-Tropical America*, 1968, no. 17, repr.; P. Hannaway, *Winslow Homer in the Tropics*, Richmond, Va., 1973, p. 209, repr. pl. 34 (color).

In the winter of 1898–99 Homer returned to the Bahamas for the first time since 1885. He stayed for three months, working only in watercolor. In many of these later Bahamian watercolors Homer used strong colors and broad, calligraphic strokes in depicting tall palms against the changeable tropic sky. In *Palm Trees, Bahamas*, probably painted at Nassau, storm clouds are rapidly covering the sky.

EDWARD HOPPER

1882–1967. Born in Nyack, N.Y. 1899–1900 studied commercial art. 1900-ca. 1906 studied at New York School of Art with Robert Henri and Kenneth Hayes Miller. 1906–10 three trips to Europe; chiefly in Paris. In 1910s worked as illustrator and commercial artist. Exhibited in 1913 Armory Show. 1915–23 worked chiefly in etching. By late 1920s established as a painter. Influenced by The Eight and closely related to the Regionalists and urban realists, Hopper persistently treated the theme of man's loneliness and isolation.

Two on the Aisle [COLOR PL. VII] PL. 188

[1927] Oil on canvas
40⅛ x 48¼ in. (102 x 122.5 cm.)
Signed lower right: EDWARD HOPPER

Acc no. 35.49
Gift of Edward Drummond Libbey

COLLECTIONS: Carl W. Hamilton, New York, 1927; Henry C. Bentley, Boston, by 1933; (Macbeth).

EXHIBITIONS: Pittsburgh, Carnegie Institute, *27th International Exhibition of Paintings*, 1928, no. 2, repr.; New York, Museum of Modern Art, *Edward Hopper, Retro-*

spective Exhibition, 1933, no. 4, repr.; Pittsburgh, Carnegie Institute, *Edward Hopper, An Exhibition of Paintings, Water Colors and Etchings,* 1937, no. 8, repr.; New York, Whitney Museum of American Art, *Edward Hopper, Retrospective Exhibition,* 1950, no. 25 (cat. by L. Goodrich); New York, Whitney Museum of American Art, *Edward Hopper,* 1964, no. 14 (cat. by L. Goodrich); Sao Paulo, Brazil, Museu de Arte Moderna, *IX Bienal de Sao Paulo: Edward Hopper; Environment U.S.A. 1957–1967,* 1968, no. 6; Toledo Museum of Art, *Heritage and Horizon: American Painting 1776–1976,* 1976, no. 44, repr.; Edinburgh, Royal Scottish Academy, *The Modern Spirit: American Painting 1908–1935,* 1977, no. 115, repr. (cat. by M. Brown).

REFERENCES: Hopper Ledgers, MSS. in Lloyd Goodrich collection, Book I, p. 55 ("Lady in box, old fashioned theatre, man in aisle, lady putting down seat"); G. du Bois, *Edward Hopper,* New York, 1931, pp. 46, 47, repr.; M. Brown, "Early Realism of Hopper and Burchfield," *College Art Journal,* VII, Autumn 1947, p. 5, fig. 2; M. Brown, *American Painting From the Armory Show to the Depression,* Princeton, 1955, repr. p. 174; L. Goodrich, *Edward Hopper,* New York, 1971, repr. p. 197; G. Levin, *Edward Hopper as Illustrator,* New York, 1979, fig. 51.

WILLIAM MORRIS HUNT

1824–1879. Born in Brattleboro, Vt. Attended Harvard College. 1844 in Rome; studied sculpture with Henry Kirke Brown. 1845 briefly at Düsseldorf Academy. 1846–52 pupil of Thomas Couture in Paris. 1852–55 at Barbizon. 1855 returned to U.S.; settled in Newport. 1862 to Boston; opened a school there in 1868. 1875 published *Talks on Art.* As an artist, teacher and writer, Hunt was responsible for Boston's early recognition of the French Barbizon painters before they achieved general recognition in France.

The Little Gleaner PL. 46

[1854] Oil on canvas
54-13/16 x 38½ in. (139.3 x 97.8 cm.)
Signed and dated lower left: W. M. Hunt 1854

Acc. no. 23.18
Gift of Arthur J. Secor

COLLECTIONS: European collection; (United Art Gallery); (Vose, 1922–23).

EXHIBITIONS: Buffalo, Albright Art Gallery, *Centennial Exhibition of Paintings by William Morris Hunt,* 1924, no. 45.

REFERENCES: M. Shannon, *Boston Days of William Morris Hunt,* Boston, 1923, repr. opp. p. 88; P. Bermingham, *American Art in the Barbizon Mood* (exh. cat.), Washington, National Collection of Fine Arts, 1975, p. 83, fig. 65.

In 1852 in Paris Hunt met Jean-François Millet, whose work he had admired as a student. They became close friends, and Hunt painted at Barbizon until 1855.

Though Millet had already painted other subjects of peasants working for several years, Hunt's *Little Gleaner,* painted at Barbizon, preceded Millet's first gleaner subjects by about three years. As Bermingham noted, Hunt's choice of subject may have been inspired by Jules Breton's *Little Gleaner* (1853; unlocated). Shown at the Brussels Salon of 1853, this was one of Breton's first pictures to be acclaimed. Even though painted in Millet's warm earth colors, Hunt's wide-eyed, melancholic figure is closer in mood to Breton's sweet, contemplative peasants than to Millet's monumental, rugged laborers.

Francisca Paim da Terra Brum da Silveira PL. 45

[1858] Oil on canvas
40¾ x 30 in. (103.5 x 76.1 cm.)
Signed and dated lower right: W. M. Hunt Pinxit:/*1858*

Acc. no. 59.19
Museum Purchase Fund

COLLECTIONS: João José da Terra Brum (the subject's son), Horta, Fayal, Azores, to 1907; his wife, Horta, Fayal, to 1934; Christina da Conceição Vasconcelos, Lisbon, to 1956; Julio V. D'Oliveira, E. Providence, R.I.; (Vose, 1959).

EXHIBITIONS: Boston, Museum of Fine Arts, *William Morris Hunt: A Memorial Exhibition,* 1979, no. 3, repr.

REFERENCES: M. Hoppin, "William Morris Hunt: Aspects of His Work," unpublished Ph.D. dissertation, Harvard University, 1974, pp. 72–5, 230, repr, fig. 66.

The subject (1787–1857) belonged to a distinguished family of the Azores landed gentry. In 1803 she married her cousin, José Francisco da Terra Brum (1776–1842), an important figure in Fayal who was created Baron of Alagoa in 1841. The coat-of-arms was added by another hand, and includes quarterings of Terra, Pereira and Leite, Brum and Silveira; the cresting is Terra.

Hunt and his wife spent the winter of 1857–58 visiting the family of Harvard classmate Charles William Dabney at Horta on the island of Fayal in the Azores. Hunt presumably painted this portrait from a daguerreotype, as the sitter, whose family had close ties with the Dabneys, had died June 4, 1857. As the Hunt scholar Martha Hop-

pin noted, the formal frontal pose, contrast of dark and light, and emphasis on outline support the belief that Hunt worked from a photograph.

The concentration on the gaunt face and hands, and agitated drapery against an austere architectural background make this one of Hunt's most psychologically penetrating portraits. This, coupled with the subdued yet rich color scheme and bold contours, recalls the work of Velázquez, an influence reflected in many of Hunt's portraits.

DANIEL HUNTINGTON

1816–1906. Born in New York. Attended Yale College. 1832 entered Hamilton College, where Charles Loring Elliott encouraged him to become an artist. 1836 studied with Samuel F. B. Morse and Henry Inman in New York. 1839 and 1842–45 in Rome. 1840 N.A. 1851–58 worked in England. 1862–70 and 1877–90 President of NAD. Huntington succeeded Inman as the leading portraitist in New York.

John Sherman　　　　　　　　　　　　PL. 55

[1879] Oil on canvas
30-3/16 x 25¼ in. (76.7 x 63.8 cm.)
Signed and dated lower right: D. Huntington 1879

Acc. no. 23.22

John Sherman (1823–1900), younger brother of General William Tecumseh Sherman, served as a U.S. Representative from his native Ohio 1855–61, and as U.S. Senator 1861–77 and 1881–91. He was an authority on fiscal policy, and was largely concerned in the legislation of the Sherman Anti-Trust Act of 1890. Sherman was Secretary of Treasury (1877–81) in President Hayes' administration and Secretary of State (1897–98) in President McKinley's cabinet.

In 1880 this portrait was adapted for a full-length version commissioned by the New York Chamber of Commerce, where it has remained.

GEORGE INNESS

1825–1894. Born near Newburgh, N.Y. Chiefly self-taught. 1844 first exhibited NAD; 1868 N.A. In Rome 1847 and Florence 1850–51. 1854 in Paris; influenced by the Barbizon painters. 1859–64 lived in Medford, Mass., Eagleswood, N.J., and Brooklyn, N.Y. In early 1860s painted in Adirondacks, Catskills, Berkshires and

New Hampshire. 1870–74 in Italy and France. 1878 settled in Montclair, N.J. Traveled in Mexico, Cuba, Florida and Scotland. One of the most important landscapists of the late nineteenth century, Inness influenced a younger generation of painters including Wyant, Murphy and Martin.

The Tiber Below Perugia　　　　　　　PL. 64

[1871] Oil on canvas
19-7/16 x 30¼ in. (49.4 x 77 cm.)
Signed and dated lower left: G. Inness 1871

Acc. no. 22.36
Gift of Arthur J. Secor

COLLECTIONS: (Williams and Everett, Boston, 1871); R. H. White, Boston; (Vose); Arthur J. Secor, Toledo, 1912–22.

EXHIBITIONS: Boston Art Club, 1871; Buffalo, Albright Art Gallery, *George Inness, Centennial Exhibition, 1825–1925*, 1925, no. 25; Macbeth, *Italian Landscapes by George Inness*, 1952, no. 4; Detroit Institute of Arts and Toledo Museum of Art, *Travelers in Arcadia: American Artists in Italy 1830–1875*, 1951, no. 65, repr.

REFERENCES: E. Richardson, *American Romantic Painting*, New York, 1944, p. 38, pl. 186; O. Wittmann, "The Attraction of Italy for American Painters," *Antiques*, LXXV, May 1964, p. 552, repr.; L. Ireland, *The Works of George Inness, An Illustrated Catalogue Raisonné*, Austin and London, 1965, no. 526, repr.; N. Cikovsky, Jr., *The Life and Work of George Inness*, New York and London, 1977 (Garland reprint of Ph.D. dissertation, Harvard University, 1965), p. 217–18, fig. 64; N. Cikovsky, Jr., *George Inness*, New York, 1971, p. 43, repr. p. 43.

At the encouragement of his Boston dealers, Williams and Everett, who found that European subjects sold better than American views, Inness went to Italy in 1870, remaining until 1874. According to his son, Inness spent two summers at Perugia. The Toledo picture is among those Inness sent his dealers in exchange for regular payments, and as Cikovsky (1977) notes, it is one of his Italian views which shows greater realism and detail, prompted in part by the taste of the American public and the need to provide more readily salable pictures.

The Olives　　　　　　　　　　　　　PL. 65

[1873] Oil on canvas
20-1/16 x 30-1/16 in. (51 x 76.4 cm.)
Signed and dated lower right: Inness (illegible word) 1873
Acc. no. 30.3

Gift of J. D. Robinson in memory of his wife, Mary Elizabeth Robinson

COLLECTIONS: Given by the artist to Harrison E. and Edward D. Maynard, Boston; Mrs. Henry E. Dalley; (Knoedler, 1913); (Vose); J. D. Robinson, Toledo, 1914–30.

EXHIBITIONS: Springfield (Mass.), George Walter Vincent Smith Art Museum, *George Inness, An American Landscape Painter*, 1946, no. 23, repr. (cat. by E. McCausland); New York, Macbeth, *Italian Landscapes by George Inness*, 1952, no. 6; Oshkosh (Wis.), Paine Art Center and Arboretum, *A Retrospective Exhibition of Paintings by George Inness*, 1962, no. 15, repr.; Austin, University of Texas Museum, *The Paintings of George Inness (1844–1894)*, 1965, no. 60.

REFERENCES: L. Ireland, The *Works of George Inness, An Illustrated Catalogue Raisonné*, Austin and London, 1965, no. 630, repr.; N. Cikovsky, *The Life and Work of George Inness*, New York and London, 1977 (Garland reprint of Ph.D. dissertation, Harvard University, 1965, p. 219, fig. 67; N. Cikovsky, Jr., *George Inness*, New York, 1971, p. 43, repr. pl. 52; Davis and Long Company, *George Inness, Watercolors and Drawings* (exh. cat.), New York, 1978, in no. 17.

As the subjects of this picture and *Landscape Near Perugia* (ca. 1873; Ireland, no. 629) appear to be the same, the Toledo picture may also have been inspired by the countryside around Perugia.

Cikovsky notes a dichotomy in Inness' Italian landscapes of the early 1870s. One group shows meticulous realism and literal transcription of the landscape stemming from his need to produce salable paintings. Another group, which includes this picture, shows greater breadth in handling, less detail and more suggestive interpretation of subjects. Cikovsky does not believe that the latter tendency was due to any specific influence, but probably reflects Inness' continued development of an increasingly personal vision which culminated in his American landscapes of the late 80s and early 90s.

According to R. C. Vose, Jr., *The Olives* was a gift from the artist to two of his Boston patrons, the Maynard brothers, who did much to promote Inness' work (letter, Mar. 5, 1962).

The Goose Girl PL. 66

[1877] Oil on canvas
16-3/16 x 24-5/16 in. (41.1 x 61.8 cm.)
Signed and dated lower right: G. Inness 1877
Inscribed in ink on stretcher: Near Irvington, N.Y.

Acc. no. 26.81

Gift of Edward Drummond Libbey

COLLECTIONS: (Bought from the artist by Seth M. Vose, Boston); Edward Drummond Libbey, Toledo, about 1895 (?)–1926.

EXHIBITIONS: Vose, *Inness Exhibition,* 1899; Austin, University of Texas Museum, *The Paintings of George Inness (1844–1894)*, 1965, no. 68.

REFERENCES: "Inness," *Masters in Art*, IX, June 1908, p. 39, pl. VII; L. Ireland, *The Works of George Inness, An Illustrated Catalogue Raisonné*, Austin and London, 1965, no. 823, repr.

The inscription identifies this as a view near Irvington on the Hudson, where Inness had a studio in 1877. He probably added the European-looking peasant girl and flock of geese to make the picture more attractive to a market which favored paintings in the Barbizon style.

Sunset PL. 67

[1891] Oil on canvas
45⅛ x 35⅛ in. (114.7 x 89.2 cm.)
Signed and dated lower right: G. Inness 1891

Acc. no. 33.28
Gift of Arthur J. Secor

COLLECTIONS: Potter Palmer, Chicago; (Howard Young, New York, by 1922); Arthur J. Secor, Toledo, 1925–33.

EXHIBITIONS: New York, Howard Young Gallery, *Inness Exhibition,* 1922.

REFERENCES: L. Ireland, *The Works of George Inness, An Illustrated Catalogue Raisonné*, Austin and London, 1965, no. 1385, repr.

After a Spring Shower, Montclair PL. 68

[1893] Oil on canvas
40⅛ x 54-5/16 in. (102 x 138 cm.)
Signed and dated lower right: G. Inness 1893

Acc. no. 12.14

COLLECTIONS: Mrs. George Inness, Montclair, N.J.; Mrs. Jonathan Scott Hartley (daughter of the artist), New York; (Henry Reinhardt, New York).

REFERENCES: L. Ireland, *The Works of George Inness, An Illustrated Catalogue Raisonné*, Austin and London, 1965, no. 1465, repr.

JOHN WESLEY JARVIS

1780–1840. Born near South Shields, England. 1785 family emigrated to Philadelphia. 1796–1801 apprenticed to

Edward Savage. 1802–10 engraver and portraitist in New York, and 1810–13 in Baltimore. 1813 returned to New York but continued to work during winters in the South. 1814–22 Henry Inman was his apprentice and assistant. 1834 paralytic stroke ended his career as a leading portraitist.

Mordecai Myers PL. 14

[Ca. 1813] Oil on wood panel
33⅞ x 26⅝ in. (86.1 x 67.7 cm.)
Inscribed on reverse: Pinxit by/Jarvis

Acc. no. 50.275

COLLECTIONS: Algernon Sydney Myers (son of sitter); by descent to Mrs. Robert T. S. Lowell, Boston; Robert T. S. Lowell (son of above), Boston, to ca. 1938; (Tiena Baumstone, New York, ca. 1940 ?); (Macbeth, 1950).

REFERENCES: C. Julian-James, *Biographical Sketches of the Bailey-Myers-Mason Families, 1776–1905*, Washington, 1908, p. 16, repr. p. 8; H. London, *Portraits of Jews by Gilbert Stuart and Other Early American Artists*, New York, 1927, pp. 37–8, repr. p. 131; H. Dickson, *John Wesley Jarvis*, New York, 1949, p. 380, no. 385; R. Lowell, *Life Studies*, New York, 1949, pp. 11–3; J. Marcus, *Memoirs of American Jews, 1775–1865*, Philadelphia, 1955, pencil sketch as frontispiece.

Myers (1776–1870), a member of a distinguished Jewish family, was born in Newport, R.I. and raised in New York City. Early in his military career Myers served in the New York State militia, and when the War of 1812 broke out he was commissioned a captain in the 13th Infantry of the regular Army. In 1813 he was seriously wounded fighting against the British in the Battle of Crysler's Field on the Niagara frontier. During his subsequent political career Myers served six terms in the New York General Assembly beginning in 1828, and was president of Kinderhook village, near Albany, where he lived 1836–44. He then moved to Schenectady, where he was mayor during the 1850s. Myers' circle of friends included Aaron Burr, DeWitt Clinton, Alexander Hamilton and Martin van Buren.

Although his granddaughter stated the portrait was painted in January 1810 (Julian-James, p. 16), Myers is depicted as a captain in the Army, a rank he achieved in 1812 (Michael E. Moss, West Point Museum, letter, Nov. 21, 1978). Myers probably sat for his portrait in late 1813 or early 1814 after he had recovered from his war injuries, and after Jarvis had returned to New York from Baltimore.

A version on canvas is in the collection of the Columbia County Historical Society, Kinderhook, N.Y.

JOHN C. JOHANSEN

1876–1964. Born in Copenhagen, Denmark. Studied at Art Institute of Chicago, with Frank Duveneck in Cincinnati, in Paris at the Académie Julian, and with J. M. Whistler. 1901 in Chicago, where he taught at the Art Institute. 1906 to Europe. 1909 settled in New York; taught at ASL. 1914 N.A. Married to Jean MacLane (q.v.). Chiefly a portraitist.

The Little Trio PL. 180

[1926] Oil on canvas
31⅞ x 45⅞ in. (81 x 116.7 cm.)
Signed and dated lower left: JOHN C. JOHANSEN 1926

Acc. no. 26.144
Frederick B. Shoemaker Fund

COLLECTIONS: Bought from the artist.

EXHIBITIONS: Toledo Museum of Art, *14th Annual*, 1926, no. 24.

According to the artist, the musicians are (from left to right) Joseph Hawthorne, the artist's daughter Margaret, and Ruth Brooks. Joseph Hawthorne, son of the painter Charles W. Hawthorne (q.v.), was conductor of the Toledo Symphony Orchestra from 1955 to 1964.

EASTMAN JOHNSON

1824–1906. Born in Lovell, Me. 1839–46 worked in Boston lithography shop, and as a portrait draftsman in Washington, D.C. and Cambridge, Mass. 1849–55 in Europe; studied at Düsseldorf with Leutze; lived four years at The Hague; brief study in Paris with Thomas Couture. 1859 settled in New York. 1860 N.A. He was an influential painter of genre subjects and portraits.

Corn-Shelling PL. 40

[1864] Oil on academy board
15⅜ x 12½ in. (39.3 x 31.7 cm.)
Signed and dated lower left: E. JOHNSON 64.

Acc. no. 24.35

COLLECTIONS: James W. Ellsworth, Chicago, by 1888–1923; (Chester Johnson, Chicago).

EXHIBITIONS: Art Institute of Chicago, *First Annual Exhibition of American Paintings*, 1888, no. 101; Art Institute of Chicago, *Art Collections Loaned by James W. Ellsworth*, 1890, no. 50; Art Institute of Chicago, *Half a Century of American Art*, 1939, no. 85, pl. II; Brooklyn Museum, *An American Genre Painter, Eastman Johnson*, 1940, no. 90-A (cat. by J. I. H. Baur).

REFERENCES: E. Richardson, *American Romantic Painting*, New York, 1944, pl. 175; E. Richardson, *Painting in America, The Story of 450 Years,* New York, 1956, p. 232.

In the 1860s and 70s Johnson painted variations on the rural occupations of maple sugaring, cranberry harvesting and corn husking. The farm kitchen of *Corn-Shelling* more closely resembles the barn interior of Johnson's first and most famous version of this theme, *Corn Husking* (1860; Syracuse, Everson Museum of Art), than it does the open air setting of two larger corn husking pictures of 1876 (Metropolitan Museum of Art; Art Institute of Chicago), for by the later date Johnson had moved away from the Dutch intimacy and precision of the 60s to greater freedom in brushwork and in recording the effects of light. The Toledo picture is the smallest of the group. Johnson focused on the two figures of an old man shelling corn and a playing child; the sentimental motif of experienced age and innocent youth was widely popular in mid-nineteenth century American art.

JOE JONES

1902–1963. Born in St. Louis, Mo. Chiefly self-taught; influenced by T. H. Benton. Muralist for WPA Federal Art Project. During World War II, commissioned by War Department to cover the Alaskan and Aleutian fronts. 1942 settled in Morristown, N.J. Chiefly a landscape painter.

Island in the River PL. 242

[Ca. 1949] Pastel and watercolor on paper
13-9/16 x 26⅜ in. (34.5 x 67 cm.)
Signed lower right: Joe Jones

Acc. no. 50.60
Museum Purchase Fund

COLLECTIONS: (Associated American Artists, New York).

Regatta, Barnegat Bay, New Jersey PL. 243

[1951] Oil on canvas
22 x 40 in. (56 x 101.6 cm.)
Signed lower left: Joe Jones

Acc. no. 52.77
Gift of Mrs. C. Lockhart McKelvy

COLLECTIONS: (Associated American Artists, New York).

EXHIBITIONS: Toledo Museum of Art, *39th Annual,* 1952, no. 36; Toledo Museum of Art, *The Collection of Mrs. C. Lockhart McKelvy,* 1964, p. 24, repr.

The New Jersey coast was a favorite subject of Jones'. This shows Barnegat Bay bounded by Island Beach Peninsula and Long Beach Island. A lithograph by Jones of a similar view is in the Museum's collection.

JOHN FREDERICK KENSETT

1816–1872. Born in Cheshire, Conn. Studied engraving with his father; worked for New Haven and New York engravers. Began painting landscapes ca. 1838. 1840 with Durand, Rossiter and Casilear to Europe; worked there seven years, supplementing his income by engraving. 1847 returned to New York. 1849 N.A. Traveled to the Catskills, Adirondacks, White Mountains and the West. A founder and trustee of the Metropolitan Museum of Art. Kensett was a leader among the second generation Hudson River landscape painters and is associated with the painters of luminism.

Storm, Western Colorado PL. 42

[1870] Oil on canvas
18-5/16 x 28⅛ in. (46.5 x 71.5 cm.)
Signed on reverse (covered by relining canvas): J. F. Kensett
Colorman's stencil: PREPARED/BY/ED^wd DECHAUX/ NEW-YORK

Acc. no. 45.13

COLLECTIONS: Estate of the artist; Thomas Kensett (artist's brother), New York, 1872–77; Sarah Kensett Kellogg (?), New York, to 1912; James R. Kellogg (artist's grandnephew), New York, to 1945; (Old Print Shop, New York).

EXHIBITIONS: New York, NAD, *The Collection of Over Five Hundred Paintings and Studies by the Late John F. Kensett,* 1873; New York, Old Print Shop, *John F. Kensett, N.A., Exhibition of American Landscapes,* 1945; Oberlin (Ohio), Allen Memorial Art Museum, *American Artists Discover America,* 1946, no. 29; New York, American Federation of the Arts, *John Frederick Kensett, 1816–1872,* 1968, no. 43, repr. (cat. by J. Howat); Toledo Museum of Art, *Heritage and Horizon: American Painting 1776–1976,* 1976, no. 12, repr.

REFERENCES: M. Cowdrey, "The Return of John F. Kensett," *Portfolio,* IV, Feb. 1945, repr. frontispiece (dated 1866); N. Moure, "Five Eastern Artists Out West," *American Art Journal,* V, Nov. 1973, p. 17, fig. 2; J. Sweeney, "The Artist-Explorers of the American West," unpublished Ph.D. dissertation, Indiana University, 1975, pp. 293–96, illus. 17 (chap. 4).

This canvas was painted in the summer of 1870 on a trip to Colorado and the Rockies with Sanford Gifford and Worthington Whittredge. The title is descriptive. Based on Kensett's itinerary, John Howat (1968 exh. cat.) believes the view is near Loveland Pass, west of Denver. However, according to the Geological Survey of the U.S. Department of the Interior, the mountains are unlike those of the Front Range of the Rockies, and are more like those near Storm King and surrounding peaks in the northern San Juan mountains of southwestern Colorado. This location also fits better the traditional title of the painting.

It is one of many studies which Kensett painted on location during his western trip, and was in his studio at his death. Although it appears in the complete photographic record of paintings in the 1873 Kensett memorial exhibition (portfolio in the Metropolitan Museum of Art Library: *Paintings by J. F. Kensett*, repr. p. 1), it is not listed in the printed catalogue of his estate sale because it was apparently retained by his family and not offered for sale at that time.

WILLIAM AUSTIN KIENBUSCH

1914–. Born in New York. 1936 B.A. Princeton University. 1936–37 studied at ASL; 1938 at Académie Colarossi and with Abraham Rattner; 1938–40 in New York with Anton Refrégier; 1941–42 at the New School for Social Research with Stuart Davis. 1948–69 instructor, Brooklyn Museum Art School.

Barns and Fences, No. 2 PL. 241

[1949] Watercolor on paper
22-7/16 x 30-11/16 in. (57 x 78 cm.)
Signed and dated lower right: Kienbusch 49

Acc. no. 50.59
Museum Purchase Fund

COLLECTIONS: (Kraushaar Galleries, New York).

According to the artist, this is one of three compositions that were inspired by unfinished barns in Maine, where he has spent many summers (letter, Mar. 23, 1979).

DONG KINGMAN

1911–. Born in Oakland, Calif.; raised in Hong Kong, where he studied Oriental art. Ca. 1929 returned to California. In WPA Federal Art Project. Worked as illustrator, commercial artist and muralist. A watercolorist whose chief subjects are city scenes, Kingman has traveled widely in America, Europe and the Orient.

East River PL. 252

[1953] Watercolor on board
21⅞ x 29⅞ in. (55.5 x 76 cm.)
Signed and dated lower left: DONG KINGMAN 53
Inscribed on reverse: EAST RIVER 1953

Acc. no. 56.19
Museum Purchase Fund

COLLECTIONS: (Midtown Galleries, New York).

EXHIBITIONS: San Antonio, Witte Memorial Museum, *Dong Kingman*, 1968, no. 45.

R. B. KITAJ

1932–. Ronald B. Kitaj. Born in Cleveland, Ohio. 1951 studied at Cooper Union, New York; 1951 at Academy of Fine Art, Vienna; 1958 at Ruskin School of Drawing, Oxford; 1959–61 at Royal College of Art, London. Since 1958 has chiefly lived and taught in London. Kitaj uses elements from literature, history, current events and the media to form a personal imagery whose meanings are often obscure.

*Notes Towards a Definition of Nobody —
A Reverie* PL. 258

[1961] Oil on canvas
48 x 88 in. (122 x 223.5 cm.)
Signed in ink on reverse: R. B. KITAJ

Acc. no. 73.42
Gift of Dr. and Mrs. Joseph A. Gosman

COLLECTIONS: (Marlborough-New London Gallery, London, 1961–64); (Marlborough-Gerson Gallery, New York, 1964–65); Dr. and Mrs. Joseph A. Gosman, Toledo, 1965–73.

EXHIBITIONS: Valdagno, Italy, Premio Marzotto, *European Community Contemporary Painting Exhibition*, 1962, no. 51; New York, Marlborough-Gerson Gallery, *R. B. Kitaj*, 1964, no. 8; Los Angeles County Museum of Art, *R. B. Kitaj, Paintings and Prints*, 1965, no. 2, repr. (cat. by M. Tuchman); Cleveland Museum of Art, *Works by Ronald Kitaj*, 1967; Pittsburgh, University Art Gallery, *The Gosman Collection*, 1969, no. 24, repr.; Ann Arbor, University of Michigan Museum of Art, *Contemporary Art: The Collection of Dr. and Mrs. Joseph A. Gosman*, 1972, no. 19, repr.; Cincinnati Art Museum, *Dine-Kitaj*, 1973, no. 18, repr. (cat. by R. Boyle).

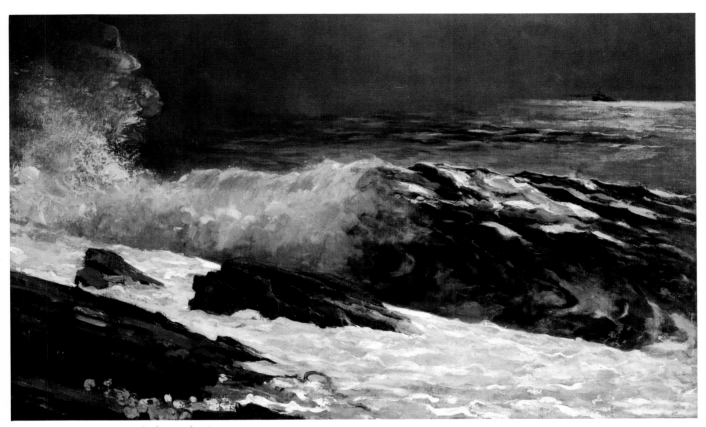

v. Winslow Homer, *Sunlight on the Coast,* 1890

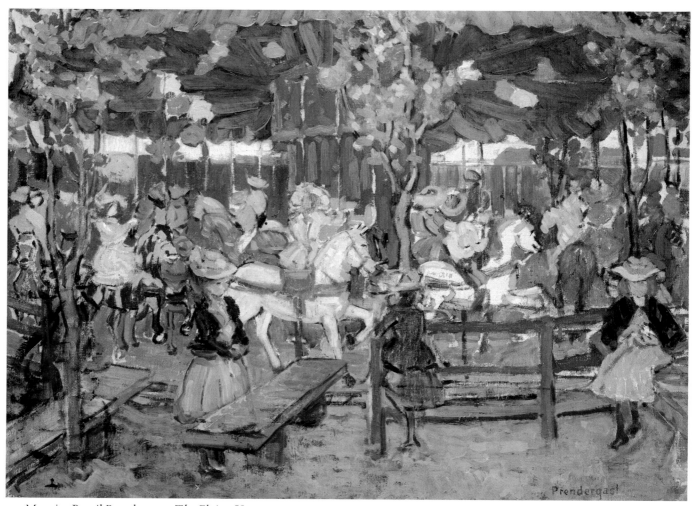

VI. Maurice Brazil Prendergast, *The Flying Horses*, ca. 1901

REFERENCES: G. Baro, "The British Scene: Hockney and Kitaj," *Arts Magazine*, XXXVIII, May-June 1975, repr. p. 98 (in first state); R. Phillips, "Ronald B. Kitaj's Definition of Nobody," *Toledo Museum of Art Museum News*, XVII, No. 1, 1974, pp. 19–22, repr. fig. 10.

Kitaj's interest in iconography has made him an enthusiastic reader of specialized periodicals. This canvas was inspired by an article tracing the treatment of "Nobody" in literature and art from the Renaissance to the early twentieth century (Gerta Calmann, "The Picture of Nobody," *The Journal of the Warburg and Courtauld Institutes*, XXIII, 1960, pp. 60–104). Nobody, a foolish figure unable to defend himself, came to symbolize virtuous patience, political rebellion, and, to Kitaj, human frustration and helplessness.

Kitaj used this theme in several paintings of 1961. The figure at the left in the Toledo canvas is an updated version of an engraving by Wolfgang Strauch illustrated in Calmann's article. Kitaj has recently said "the NOBODY figure represents a black man, which opens new doors in our time," and he has also pointed out sources for other images:

> The view in the center was taken from real life . . . it shows (outside the window), a side view of Annakirche in the Annagasse, seen from the rooms of my old friend Frederick L. Sprague, an American painter who was studying on the G.I. Bill at the Academy of Fine Arts in Vienna when I too was a student there (1951–52). . . . The gloomy interior returns NOBODY to his origins in Mittel Europe. . . . The deathbed vignette was taken from a photo of the dead Proust (I think) . . . it was so long ago . . . my pictures have always been full of secrets and elusions (letter, Mar. 1979).

Kitaj does not mention a source for the female figure at the lower right.

As Phillips notes, the composition evolved in two stages. Although all of the essential images are included in the first state (illustrated by Baro), in his revision Kitaj brought greater resolution and coherence to both the individual units of the composition and to the overall design.

KARL KNATHS

1891–1971. Born in Eau Claire, Wis. 1913–18 studied at Art Institute of Chicago, where he saw the 1913 Armory Show and was attracted by the Impressionists and Cézanne. 1919 settled in Provincetown, Mass. Mid-1920s met Duncan Phillips, who became his chief patron. 1934–35 muralist for WPA Federal Art Project. 1938–50 taught winters at Phillips Gallery, Washington, D.C.

The Clock PL. 246

[1951] Oil on canvas
27⅛ x 35⅞ in. (69 x 91.2 cm.)
Signed left center: Karl Knaths
Inscribed in red crayon on stretcher: Clock 1951 P-town Knaths/LINEN CANVAS—FREDRIX no. 107./WINDSOR NEWTON OIL COLORS

Acc. no. 53.151
Museum Purchase Fund

COLLECTIONS: (Paul Rosenberg, New York).

JOHN KOCH

1909–1978. Born in Toledo; raised in Ann Arbor, Mich. Chiefly self-taught. 1923–24 summers at Provincetown, Mass.; influenced by Charles Hawthorne. 1928–33 studied independently in Paris. 1933 settled in New York. 1944–45 instructor at ASL. Specialized in portraiture and interior figure subjects.

Hanging Clothes PL. 248

[1950] Oil on canvas
36 x 29-15/16 in. (91.5 x 76 cm.)
Signed lower left: Koch

Acc. no. 52.97
Museum Purchase Fund

COLLECTIONS: (C. W. Kraushaar Art Galleries, New York).

EXHIBITIONS: New York, NAD, 1951, no. 81; Toledo Museum of Art, *39th Annual*, 1952, no. 41; New York Cultural Center, *John Koch*, 1973, no. 6, repr.; Hamilton (N.Y.), Picker Art Gallery, Colgate University, *Models and Moments, Paintings and Drawings by John Koch*, 1977, no. 1, repr.

According to the artist's wife, Dora Koch, this canvas shows the artist painting in his garage at Setauket, Long Island, where he lived from 1941. Dora Koch posed for the seated figure reading the newspaper, and probably also for the woman hanging clothes (letter, Jan. 31, 1979).

This is an early treatment of the theme of the artist at work, a subject Koch often painted during the last thirty years of his life.

JOHN LEWIS KRIMMEL

1789–1821. Born in Ebingen, Württemberg, Germany. Ca. 1804–08 studied with Johann Baptist Seele, a painter

of military subjects. 1810 emigrated to Philadelphia. 1817–19 in Europe. 1821 President of Association of American Artists. Krimmel introduced genre subjects to American paintings. Engravings and lithographs after his paintings were important sources of motifs for younger genre painters.

Village Tavern PL. 15

[1813–14] Oil on canvas
16⅞ x 22½ in. (42.8 x 56.9 cm.)
Signed right center (on apron of table): JLK
Almanac dated upper right: 1814
Inscribed on reverse of relining canvas: J. L. KRIMMEL, PINX PHILA., 1813

Acc. no. 54.13

COLLECTIONS: S. Swett, Boston, ca. 1832(?); (Old Print Shop, New York, 1954).

EXHIBITIONS: Philadelphia, *Fourth Annual Exhibition of the Columbian Society of Artists and the Pennsylvania Academy of the Fine Arts*, 1814, no. 234 (as *Village Tavern*); New York, Whitney Museum of American Art, *The Painters' America; Rural and Urban Life, 1810–1910*, 1974, no. 70, repr. (color); Boston, Goethe Institute, *America Through the Eyes of German Immigrant Painters*, 1975, repr. p. 13; Kansas City, William Rockhill Nelson Gallery of Art, *Kaleidoscope of American Painting: Eighteenth and Nineteenth Centuries*, 1977, no. 66, repr.

REFERENCES: M. Naeve, "John Lewis Krimmel: His Life, His Art and His Circle," unpublished M.A. thesis, University of Delaware, 1955, pp. 40–1, 45, 126–29, pl. IV (as *A Village Tavern—Arrival of the Mail with News of Peace*, 1815); J. Flexner, *Nineteenth Century American Painting*, New York, 1970, repr. p. 45; H. Williams, *Mirror to the American Past*, Greenwich, Conn., 1973, p. 43, fig. 24; C. Montgomery, *A History of American Pewter*, New York and Washington, 1973, figs. 1–3.

The scene is laid in a country tavern, as are many of Krimmel's pictures. The center group relates the temperance theme of a tearful wife and anxious child pleading with the husband to come home. Most of the flanking figures are listening to an old man reading from the newspaper, while another enters with a basket of parcels and a bag holding mail delivered by the coach at the door.

Krimmel was influenced by William Hogarth, and particularly by the anecdotal tavern scenes of his Scottish contemporary David Wilkie, both known to him through engravings. Krimmel copied several compositions by Wilkie. As the Krimmel scholar Milo M. Naeve first noted, the child in the Toledo picture was probably in-

spired by the similar figure in the *Jews Harp* (1808; Liverpool, Walker Art Gallery; engraved in 1809), while the temperance theme appears in Wilkie's *Village Festival* (1809; London, National Gallery). Krimmel's temperance subject is one of the earliest in American genre painting and coincides with the beginnings of the temperance movement in this country.

This picture is probably the *Village Tavern* exhibited at Philadelphia in 1814. The date is borne out by the almanac dated 1814 hanging on the wall and by the date 1813 on the relining that presumably was copied from the original canvas.

In this as in other pictures, Krimmel's theme reflects events of the War of 1812. Topical naval broadsides and prints often appear in backgrounds. In this painting two ship prints and a map of the Great Lakes region where much of the war was fought are on the tavern wall. Below the map hang two issues of *Relf's Philadelphia Gazette*. It seems probable Krimmel's figures are excited by good news from the field of battle.

JOHN LA FARGE

1835–1910. Born in New York. First studied law. 1856 to Paris; studied painting with Thomas Couture. 1859 to Newport, R.I., where he studied with William Morris Hunt. In 1860s painted still lifes, landscapes and did illustrations. 1869 N.A.; first mural commission for H. H. Richardson's Trinity Church in Boston; other mural decorations in the 1870s and 80s. In late 1870s began work in stained glass and developed new techniques; organized a large workshop to carry out large-scale decorative commissions. 1886 to Japan. 1890–91 to South Seas. A man of great artistic versatility, La Farge was the foremost muralist and designer of stained glass of his time, and an accomplished writer and lecturer on art.

Garland of Fruit and Flowers PL. 84

[1882] Oil, gouache and wax on paper mounted on canvas
51 x 42⅞ in. (129.5 x 107.8 cm.)
Inscribed on paper glued to stretcher: Flower piece/ John LaFarge/51 W. 10th St./116

Acc. no. 12.1267
Gift of Edward Drummond Libbey

COLLECTIONS: The artist, to 1910; (New York, American Art Galleries, *The John La Farge Collection, Second Evening's Sale*, Mar. 30, 1911, no. 67 ("Garland. Fruit and Flower, 1882. Large Decorative panel known as Vanderbilt panel. Wax."); (Montross, New York, 1911); Edward Drummond Libbey, Toledo.

EXHIBITIONS: New York, Ortgies and Co., *Important Collection of Oil and Water Color Paintings by John La Farge*, 1884, no. 91 ("cartoon for embroidery for dining room of Cornelius Vanderbilt, Esq. Hanging garland of fruit and flowers. In oil, on paper, silver ground"); New York, Reichard and Co., *Catalogue of Drawings, Watercolors and Paintings by Mr. John La Farge, N.A.*, 1890, no. 25 ("Working design for embroidery. Hanging garland of fruit and flowers. Motif from Sansovino. Water, wax and oil"); Boston, Doll and Richards, *Catalogue of Drawings, Watercolors, and Paintings by Mr. John La Farge*, 1892; New York, Montross, *Catalogue of Works by John La Farge*, 1901, no. 116 ("Large Decorative Panel, Known as Vanderbilt panel"); Pittsburgh, Carnegie Institute, *Catalogue of Works by John La Farge*, 1901, no. 99.

REFERENCES: "Art Notes—Decorative Work," *Art Journal*, (New York), VIII, Nov. 1882, pp. 351–52; "La Farge Embroideries," *Art Amateur*, VIII, Jan. 1883, p. 49; R. Cortissoz, *John La Farge, A Memoir and a Study*, Boston, 1911, repr. opp. p. 194; H. B. Weinberg, *The Decorative Work of John La Farge*, New York, 1977, pp. 263–64 n.1, fig. 193 (Garland reprint of Ph.D. dissertation, Columbia University, 1972); H. A. La Farge, "Catalogue Raisonné of the Works of John La Farge," unpublished MS., no. 82.4.

This is the cartoon for part of one of four sets of needlework door hangings made after La Farge's designs for the dining room of the house by George B. Post built in 1880–82 for Cornelius Vanderbilt II on the northwest corner of Fifth Avenue and 57th Street in New York. La Farge was among the artists entrusted with the interiors, and the suite of rooms for which he, with his collaborators, was responsible was considered at the time among the chief examples of decorative art yet undertaken in this country. The curtain's design "of a heavy festoon of flowers, leaves, and fruits, the red seeds of pomegranate gleaming among apples, grapes and ears of corn," (*Art Amateur*, p. 49) was widely discussed in the contemporary art press. "The whole curtain is pitched in a low, rich tone, and has the effect of brush work . . . the silver cloth (of the background) is wrought with the tapestry stitch, and the peculiarity of the stitch is that it admits of the same modulations and melting of tint into tint that the brush effects. Through this is the gleam of metallic lustre, which results in an ensemble undescribably lovely" (*The Art Journal*, p. 351). La Farge in fact used silver metallic paint for the background of this cartoon. According to published descriptions, the curtain design also included two Japanese griffins and a Renaissance-style border. The house was

demolished in 1925. No photograph of the hanging is known, nor is it known if the hanging still exists.

The 1890 Reichard exhibition noted, "The motif (was derived) from Sansovino." While La Farge did not visit Italy until 1894, the garland motif was undoubtedly inspired by the cornice freize of Jacopo Sansovino's celebrated Library of St. Mark in Venice, known from engravings or photographs. La Farge lightened Sansovino's design by omitting the heads and putti and by emphasizing the fluttering ribbons. In this, La Farge was in accord with contemporary taste, which favored free adaptations of Renaissance designs, often using materials different from the originals.

In his unpublished catalogue raisonné of his grandfather's work, Henry A. La Farge notes *Garland* as painted on a photographic enlargement, based on a statement by his father Bancel, who managed John La Farge's studio during the 1890s (also see Weinberg, p. 264, n.1). Examination does not show evidence of a photograph beneath the painting. Henry La Farge has also noted that the artist developed a method of enlarging designs for mural and other decorations to the required size by using both photographs and projected lantern slides (letter, Feb. 10, 1979); it is possible this cartoon was based on a projected slide. The cartoon's wax medium was also used by La Farge for wall paintings to prevent darkening, and indeed the colors of the cartoon are still notably fresh.

The commissions for this and the many other large houses which La Farge received at this time were carried out by the La Farge Decorative Art Company, a large workshop, mostly for glass, near Union Square in New York employing 30–40 artists in different mediums. One of them, Roger Riordan, developed the design for this hanging, which like all of those in the dining room, were executed under the supervision of Mary Tillinghast.

Crows Flying, Japan PL. 81

[1886] Watercolor and gouache on paper
7¼ x 10-1/16 in. (18.5 x 25.5 cm.)
Inscribed on reverse: Japan/Rapid sketch from nature/ Crows flying/400 Pratt. Inst.

Acc. no. 12.531
Gift of Edward Drummond Libbey

COLLECTIONS: The artist, to 1910; (New York, American Art Galleries, *The John La Farge Collection, Second Evening's Sale*, Mar. 30, 1911, no. 549); (Montross, New York); Edward Drummond Libbey, Toledo.

EXHIBITIONS: Boston, Doll and Richards, *Drawings, Water Colors and Paintings by Mr. John La Farge*, 1892, no. 52; New York, Montross, *Catalogue of Works by*

John La Farge, 1901, no. 86; Pittsburgh, Carnegie Institute, *Catalogue of Works by John La Farge,* 1901, no. 76; Boston, Doll and Richards, *Oil and Water Color Paintings and Sketches by John La Farge, N.A.,* 1909, no. 8.

REFERENCES: J. La Farge, *An Artist's Letters from Japan,* London, 1897, repr. p. 158; H. La Farge, "Catalogue Raisonné of the Work of John La Farge," unpublished MS., no. 86.58.

In the summer of 1886 La Farge traveled to Japan with his close friend, the writer Henry Adams. This sketch from nature was illustrated by La Farge in his account of this trip published in 1897.

At Sunrise, Kilauea Crater, Sept. 17th PL. 83

[1890] Watercolor and gouache on paper
9¼ x 11-15/16 in. (23.5 x 30.4 cm.)
Inscribed on recto, lower margin: This—crater bed in full shadow/at Sunrise Kilauea crater Sept. 17ᵗʰ—the black floor of crater/still almost all in shadow/background is lighter/the wall of crater lit up/by sunlight except when/the steam cloud shadows it/(encircled) slope of Mauna Loa

Acc. no. 12.529
Gift of Edward Drummond Libbey

COLLECTIONS: The artist, to 1910; (New York, American Art Galleries, *The John La Farge Collection, Second Evening's Sale,* Mar. 30, 1911, no. 579); (Montross, New York); Edward Drummond Libbey, Toledo.

EXHIBITIONS: New York, Durand-Ruel Galleries, *Paintings, Studies, Sketches and Drawings, Mostly Records of Travel, 1886 and 1890–91,* 1895, no. 55; Boston, Doll and Richards, *Paintings in Water Color and Oil from the South Sea Islands and Japan by Mr. John La Farge,* 1895, no. 53; New York, Montross, *Catalogue of Works by John La Farge,* 1901, no. 72; Pittsburgh, Carnegie Institute, *Catalogue of Works by John La Farge,* 1901, no. 64; Boston, Doll and Richards, *Works by John La Farge,* 1907, no. 55; New York, Knoedler, *Catalogue of Glass, Oil and Water Color Paintings and Sketches by John La Farge, N.A.,* 1909, no. 22.

REFERENCES: J. La Farge, *Reminiscences of the South Seas,* New York, 1912, p. 48, repr. (color) opp. p. 48; J. Yarnall, "John La Farge and Henry Adams in the South Seas," unpublished M.A. thesis, University of Chicago, 1976, fig. 2; H. La Farge, "Catalogue Raisonné of the Work of John La Farge," unpublished MS., no. 90.20.

La Farge and Henry Adams went together to the South Seas in 1890–91, visiting Hawaii, Samoa, Tahiti, and

finally Fiji, returning to America via Australia, Java, Ceylon and Europe. Both men recorded their experiences in letters and journals. While many of La Farge's letters, illustrated with his watercolors, were published as *Reminiscences of the South Seas* (New York, 1912), Adams' full account of the trip was not published until recently (*Lettres des mers du sud, 1890–1891,* Evelyne de Chazeaux, ed. [Publications de la Société des Océanistes, no. 34], Musée de l'Homme, Paris, 1974).

In many cases La Farge's watercolor sketches made on the trip bear notations on the subject, colors, or the weather. Virtually all the Toledo watercolors, as well as forty drawings representing the remarkable range of La Farge's artistic enterprises, were acquired at his estate sale in 1911. Fifteen of these drawings, including three made on the South Seas trip, are illustrated in *Toledo Museum of Art Museum News,* Winter 1968.

Kilauea on the island of Hawaii, one of the world's largest active volcanic craters, has been a famous attraction since the nineteenth century. In *Reminiscences* La Farge described this view:

> In the morning Adams woke me out of sound sleep. . . . Before us was the volcano, still in shadow, but the walls of the crater lit up pink in the sun, and farther out the long line of Mauna Loa appearing to come right down to these cliffs, all clear and lit up except for the shadow of one enormous cloud that stretched half across the sky. The floor of the crater, of black lava, was almost all in shadow, so that as it stretched to its sunlit walls it seemed as if all below was shadow. In the centre of the space smoked the cones that rise from the bed of the crater. Through this vapour we saw the further walls, and on the other side of the flow, as it sloped away from us, more steam marked the lava openings at Dana Lake, invisible to us (p. 48).

Crater of Kilauea and the Lava Bed PL. 82

[1890] Gouache, watercolor and pencil on paper
11-15/16 x 17⅞ in. (30.3 x 45.4 cm.)
Signed and dated at lower right: Jno LaFarge Sept 1890
Inscribed on recto, lower margin: 12N—beginning to rain—shadows of clouds on volcano bed/shadows/Distance perhaps blue—but effect like color at A ("A" refers to color sample in lower right)/Later 2 PM sunlight—lava shining like sea

Acc. no. 12.530
Gift of Edward Drummond Libbey

COLLECTIONS: The artist, to 1910; (New York, American Art Galleries, *The John La Farge Collection, Second Evening's Sale,* Mar. 30, 1911, no. 591); (Montross, New York); Edward Drummond Libbey, Toledo.

EXHIBITIONS: New York, Durand-Ruel Galleries, *Paintings, Studies, Sketches and Drawings, Mostly Records of*

Travel, 1886 and 1890–91, 1895, no. 51; Boston, Doll and Richards, *Paintings in Water Color and Oil from the South Sea Islands and Japan by Mr. John La Farge,* 1895, no. 50; Cleveland, 1896, no. 23; New York, Montross, *Catalogue of Works by John La Farge,* 1901, no. 82; Pittsburgh, Carnegie Institute, *Catalogue of Works by John La Farge,* 1901, no. 72; Boston, Doll and Richards, *Exhibition and Private Sale of Pictures, Drawings and Sketches by Mr. John La Farge,* 1904, no. 77; Boston, Doll and Richards, *Works by John La Farge,* 1907, no. 51; New York, Knoedler, *Catalogue of Glass, Oil and Water Color Paintings and Sketches by John La Farge, N.A.,* 1909, no. 20.

REFERENCES: J. La Farge, *Reminiscences of the South Seas,* New York, 1912, pp. 48–9, repr. (color) opp. p. 52; H. La Farge, "Catalogue Raisonné of the Work of John La Farge," unpublished MS., no. 90.18

La Farge described the volcano crater in *Reminiscences:*

> We sketched that day and lounged in the afternoon, the rain coming down and shutting out things; but in the noon I was able to make a sketch in the faint sunlight; and that was of no value, but as I looked and tried to match tints, I realized more and more the unearthly look that the black masses take under the light. A slight radiance from these surfaces of molten black glass gives a curious sheen, that far off in tones of mirage does anything that light reflected can do, and fills the eye with imaginary suggestions. Hence the delightful silver; hence the rosy coldness, that had made fairylands for us of the desert aridity. But nearer, the glitter is like that of the moon on a hard cold night, and the volcano crater I shall always think of as a piece of dead world, and far away in the prismatic tones of the mountain sides, I shall see a revelation of landscapes of the morn (pp. 48–9).

Looking East in Tautira Village, Tahiti PL. 85

[1891] Watercolor and gouache on paper
17½ x 12 in. (44.5 x 30.5 cm.)
Inscribed on recto, lower margin: Looking East from our varandah (sic). Ori's-Tautira. Tahiti. March 1891./ The long building is the Fare-au or meeting house/or town hall. Clump of pandanus to left. Breadfruit trees very tall/in foreground. Abandoned house. 1891.

Acc. no. 12.525
Gift of Edward Drummond Libbey

COLLECTIONS: The artist, to 1910; (Montross, New York); Edward Drummond Libbey, Toledo.

EXHIBITIONS: New York, Durand-Ruel Galleries, *Paintings, Studies, Sketches and Drawings, Mostly Records of Travel, 1886 and 1990–91,* 1895, no. 182; Cleveland, Gallery of the Picture Exhibition Society, *Paintings, Studies, Sketches and Drawings by John La Farge,*

1896, no. 57; New York, Montross, *Catalogue of Works by John La Farge,* 1901, no. 53; Pittsburgh, Carnegie Institute, *Catalogue of Works by John La Farge,* 1901, no. 46; Boston, Doll and Richards, *Exhibition and Private Sale of Pictures, Drawings and Sketches by Mr. John La Farge,* 1904, no. 6; Boston, Doll and Richards, *Works by John La Farge,* 1907, no. 153; New York, Knoedler, *Catalogue of Glass, Oil and Water Color Paintings and Sketches by John La Farge, N.A.,* 1909, no. 67; New York, Anderson Galleries, 1910, no. 90; Salem (Mass.), Peabody Museum, *Paintings, Watercolors and Drawings by John La Farge (1835–1910) From His Travels in the South Seas, 1890–1891,* 1978, no. 39.

REFERENCES: K. C. Lee, "John La Farge, Drawings and Watercolors," *Toledo Museum of Art Museum News,* New Series, XI, Winter 1968, fig. 16; H. La Farge, "Catalogue Raisonné of the Work of John La Farge," unpublished MS., no. 91.28; H. Adams, *Lettres des mers du sud, 1890–1891,* Paris, 1974, fig. 27.

La Farge and Adams arrived in Tahiti in early February 1891, reaching Tautira village at the northeastern tip of Taiarapu, the smaller of two islands forming Tahiti, on March 1st. There they stayed with Ori, a chief of the Teva clan, from whose house this view was taken.

They left Tahiti June 5, only four days before Paul Gauguin arrived there. It must be regretted their paths did not cross, as the two Americans would have found him a remarkable subject for their journals. In any event, Gauguin went to work without delay, as he painted the Toledo *Street in Tahiti* before the end of June (*European Paintings,* Toledo Museum of Art, 1976, p. 62).

Hari, or Bundle of Cocoanuts, Tahiti PL. 86

[1891] Watercolor, gouache and ink on board
6-15/16 x 9-13/16 in. (17.6 x 24.9 cm.)
Inscribed on recto, lower margin: Hari. Bundle of cocoanuts—showing Tahitian manner/of preparing them & tying./Tautira. March 1891

Acc. no. 12.532
Gift of Edward Drummond Libbey

COLLECTIONS: The artist, to 1910; (New York, American Art Galleries, *The John La Farge Collection, Second Evening's Sale,* Mar. 30, 1911, no. 593); (Montross, New York); Edward Drummond Libbey, Toledo.

EXHIBITIONS: New York, Durand-Ruel Galleries, *Paintings, Studies, Sketches and Drawings, Mostly Records of Travel, 1886 and 1890–91,* 1895, no. 187; New York, Montross, *Catalogue of Works by John La Farge,* 1901, no. 56; Pittsburgh, Carnegie Institute, *Catalogue of*

Works by John La Farge, 1901, no. 48; Boston, Doll and Richards, *Works by John La Farge*, 1907, no. 56; New York, Knoedler, *Catalogue of Glass, Oil and Water Color Paintings and Sketches by John La Farge, N.A.*, 1909, no. 68; Salem (Mass.), Peabody Museum, *Paintings, Watercolors and Drawings by John La Farge (1835–1910) From His Travels in the South Seas, 1890–1891*, 1978, no. 42.

REFERENCES: K. C. Lee, "John La Farge, Drawings and Watercolors," *Toledo Museum of Art Museum News*, New Series, XI, Winter 1968, fig. 15; H. La Farge, "Catalogue Raisonné of the Work of John La Farge," unpublished MS., no. 91.32.

Mountain Hut of Devil Priest, PL. 87
Waikumbukumbu, Fiji

[1891] Watercolor on paper
6½ x 9-13/16 in. (16.5 x 25 cm.)
Inscribed on recto, lower right: Fiji/at Waikumbumku
 (sic)/July 9th

Acc. no. 12.533
Gift of Edward Drummond Libbey

COLLECTIONS: The artist, to 1910; (New York, *American Art Galleries, The John La Farge Collection, Second Evening's Sale*, Mar. 30, 1911, no. 399a); (Montross, New York); Edward Drummond Libbey, Toledo.

EXHIBITIONS: New York, Durand-Ruel Galleries, *Paintings, Studies, Sketches and Drawings, Mostly Records of Travel, 1886 and 1890–91*, 1895, no. 194; New York, Montross, *Catalogue of Works by John La Farge*, 1901, no. 58; Pittsburgh, Carnegie Institute, *Catalogue of Works by John La Farge*, 1901, no. 50; Boston, Doll and Richards, *Works by John La Farge*, 1907, no. 58; New York, Knoedler, *Catalogue of Glass, Oil and Water Color Paintings and Sketches by John La Farge, N.A.*, 1909, no. 79; New York, Anderson Galleries, 1910, no. 86; Salem (Mass.), Peabody Museum, *Paintings, Watercolors and Drawings by John La Farge (1835–1910) From His Travels in the South Seas, 1890–1891*, 1978, no. 55.

REFERENCES: J. La Farge, *Reminiscences of the South Seas*, Garden City, N.Y., 1912, repr. (color) opp. p. 460; H. La Farge, "Catalogue Raisonné of the Work of John La Farge," unpublished MS., no. 91.104.

The following passage from La Farge's journal was appended to the entry for this picture in the 1895 Durand-Ruel exhibition; it was later adapted for *Reminiscences:*

 This is the last of the mountain villages. The name means 'seething waters.' The houses of the village were on high mounds, covered with stones or grass. But the openings were the smallest I had seen—a big man in some cases might just fit in. One little one I have sketched for you, and which was placed by the side of a ditch, near a cocoanut and with the adornment of a few trees, was exceedingly small and queerly bulged out in roof, over its low red walls. The thatch had been very thick, its edges were cut perpendicularly down so as to make a line with the wall and you had a proportion of thickness of thatch greater than the wall or the roof. Time had given to the thatch of most houses a delightful picturesque tone, making them look as if covered with a grey fur. As the leaves are washed off, a fine grey stem alone remains. The little house, or Mbure, placed thus at the entrance of the village, just gave to two persons. Mr. Carew explained that such would have been a 'devil house' formerly, where the priest, or medium, or wise man could reside alone and be consulted. With their love for shutting things up, he could be happy in the sweating heat of the night (pp. 458–60).

The Hut Behind the Magistrate's House, PL. 89
Vunidawa, Fiji

[1891] Watercolor, gouache and pencil on paper
8⅜ x 12-9/16 in. (21.2 x 31.9 cm.)
Inscribed on recto, lower left: at Vunidawa/on hill
 behind magistrate's house.
In left margin: fence
At lower right: This house was a sort of/outpost. The
 old ditch/runs just behind it.

Acc. no. 12.534
Gift of Edward Drummond Libbey

COLLECTIONS: The artist, to 1910; (Montross, New York); Edward Drummond Libbey, Toledo.

EXHIBITIONS: New York, Durand-Ruel Galleries, *Paintings, Studies, Sketches and Drawings, Mostly Records of Travel, 1886 and 1890–91*, 1895, no. 197; New York, Montross, *Catalogue of Works by John La Farge*, 1901, no. 61; Pittsburgh, Carnegie Institute, *Catalogue of Works by John La Farge*, 1901, no. 53; Boston, Doll and Richards, *Exhibition and Private Sale of Pictures, Drawings and Sketches by Mr. John La Farge*, 1904, no. 13; Boston, Doll and Richards, *Works by John La Farge*, 1907, no. 61; New York, Knoedler, *Catalogue of Glass, Oil and Water Color Paintings and Sketches by John La Farge, N.A.*, 1909, no. 81.

REFERENCES: H. La Farge, "Catalogue Raisonné of the Work of John La Farge," unpublished MS., no. 91.92.

La Farge visited Vunidawa on the island of Viti Levu on June 27–28, 1891. This hut was probably behind the house of Mr. Joske, one of the two British magistrates who accompanied La Farge and Adams on their tour of Fiji.

Carew's Slide, Fiji PL. 88

[1891] Watercolor and gouache on paper
18 x 11-15/16 in. (45.7 x 30.3 cm.)
Inscribed on recto, lower margin: Carew's slide/Fiji.
 Aug. 1891

Acc. no. 12.528
Gift of Edward Drummond Libbey

COLLECTIONS: The artist, to 1910; (New York, American Art Galleries, *The John La Farge Collection, Second Evening's Sale,* Mar. 30, 1911, no. 557, dated August 1891); (Montross, New York); Edward Drummond Libbey, Toledo.

REFERENCES: H. La Farge, "Catalogue Raisonné of the Work of John La Farge," unpublished MS., no. 91.111.

Carew's Slide, named for one of Fiji's British magistrates who accompanied La Farge and Adams, cannot be precisely located, though it may be on the trail between Matakula and the mountain village of Waikumbukumbu over which La Farge and his party trekked on July 7–8 (*Reminiscences,* pp. 456–57).

 Although the watercolor is attached to a backing, the catalogue of the 1911 La Farge estate sale states it is signed and inscribed on the reverse, "Bed of dry river. Edge of village and huts." The catalogue also notes the inscribed date Aug. 1891, which is somewhat problematic, as La Farge left Fiji in late July. This may be one of many South Sea watercolors which La Farge painted after his trip, thus accounting for the confusion in dates.

The Tank at Kandy, Ceylon PL. 90

[1891] Watercolor and gouache on paper
11½ x 15¼ in. (29.2 x 38.7 cm.)
Inscribed on reverse (by another hand): The Tank at
 Kandy, Ceylon/by John La Farge

Acc. no. 12.526
Gift of Edward Drummond Libbey

COLLECTIONS: The artist, to 1910; (New York, American Art Galleries, *The John La Farge Collection, Second Evening's Sale,* Mar. 30, 1911, no. 554); (Montross, New York); Edward Drummond Libbey, Toledo.

EXHIBITIONS: New York, Durand-Ruel Galleries, *Paintings, Studies, Sketches and Drawings, Mostly Records of Travel, 1886 and 1890–91,* 1895, no. 208; Boston, Doll and Richards, *Paintings in Water Color and Oil From the South Sea Islands and Japan by Mr. John La Farge,* 1895, no. 63; Cleveland, Gallery of the Picture Exhibition Society, *Paintings, Studies, Sketches and Drawings . . . by John La Farge,* 1896, no. 61; New York, Montross, *Catalogue of Works by John La Farge,* 1901, no. 66;

Pittsburgh, Carnegie Institute, *Catalogue of Works by John La Farge,* 1901, no. 58; Boston, Doll and Richards, *Exhibition and Private Sale of Pictures, Drawings and Sketches by Mr. John La Farge,* 1904, no. 31; Boston, Doll and Richards, *Works by John La Farge,* 1907, no. 66; Boston, Doll and Richards, *Oil and Water Color Paintings and Sketches by John La Farge, N.A.,* 1909, no. 10; New York, Knoedler, *Catalogue of Glass, Oil and Water Color Paintings and Sketches by John La Farge, N.A.,* 1909, no. 17.

REFERENCES: H. La Farge, "Catalogue Raisonné of the Work of John La Farge," unpublished MS., no. 91.116.

Kandy is the site of the famous Buddhist shrine called the Temple of the Tooth. Much of Kandy overlooks the man-made reservoir shown here. Undoubtedly La Farge's and Adams' interest in Buddhism drew them to Ceylon enroute to Paris in the fall of 1891.

Spirit of the Storm, Japanese Folk Lore PL. 91

[1897] Watercolor on Japanese paper
15⅜ x 10¾ in. (39 x 27.3 cm.)
Signed and dated upper right: JLF/July/1897

Acc. no. 12.527
Gift of Edward Drummond Libbey

COLLECTIONS: The artist, to 1910; (New York, American Art Galleries, *The John La Farge Collection, Second Evening's Sale,* Mar. 30, 1911, no. 554); (Montross, New York); Edward Drummond Libbey, Toledo.

EXHIBITIONS: Boston, Doll and Richards, *Exhibition and Private Sale of Paintings in Water Color Chiefly from South Sea Islands and Japan by Mr. John La Farge,* 1898, no. 25; New York, Montross, *Catalogue of Works by John La Farge,* 1901, no. 77; Pittsburgh, Carnegie Institute, *Catalogue of Works by John La Farge,* 1901, no. 68; New York, Knoedler, *Catalogue of Glass, Oil and Water Color Paintings and Sketches by John La Farge, N.A.,* 1909, no. 15.

REFERENCES: H. La Farge, "Catalogue Raisonné of the Work of John La Farge," unpublished MS., no. 97.13.

It has not been possible to identify this subject with a specific episode from Japanese folklore. That this work painted eleven years after La Farge's visit to Japan was listed in the 1898 Doll and Richards exhibition under "Fantasies on Oriental Themes" suggests it may very well not depict an actual legend.

JACOB LAWRENCE

1917–. Born in Atlantic City, N.J. 1930 moved to Harlem. 1932–37 studied with Charles Alston and Henry Bannarn at Harlem Art Workshop; 1937–39 at American Artists School. 1938–39 Easel Division of WPA Federal Art Project. Since 1946 Lawrence has taught at Black Mountain College, Pratt Institute and ASL; now teaches at University of Washington, Seattle. Much of his work is composed in series on themes relating to black history and social struggle.

Barber Shop PL. 225

[1946] Gouache on paper
21⅛ x 29⅜ in. (53.6 x 74.6 cm.)
Signed and dated lower left: Jacob Lawrence 1946 ©

Acc. no. 75.15
Gift of Edward Drummond Libbey

COLLECTIONS: (Charles Alan, New York, 1946); Mr. and Mrs. Richard G. Davis, New York, by 1962–74; (Terry Dintenfass, Inc., New York).

EXHIBITIONS: New York, American Federation of Arts, *Masters of American Watercolor*, 1962, no. 22; New York, Whitney Museum of American Art, *Jacob Lawrence*, 1974, no. 95 (cat. by M. Brown); New York, Kennedy Galleries, *100 Artists Associated with the Art Students League of New York*, 1975, repr. p. 151; Boston, Museum of Fine Arts, *Jubilee: Afro-American Artists on Afro-America*, 1975, p. 42.

The artist has described this picture as:

> . . . one of the many works that was executed out of my experience of living in New York's Harlem community. The barber shop was one of my every day visual encounters. . . . It was inevitable that the barber shop with its daily gathering of Harlemites, its clippers, mirror, razors, the over-all pattern and the many conversations that took place there . . . was to become the subject of many of my paintings. Even now, in my imagination, when ever I relive my early years in the Harlem community, the barber shop, in both form and content . . . is one of the many scenes that I still see and remember (letter, Jan. 21, 1979).

ERNEST LAWSON

1873–1939. Born in Halifax, Nova Scotia. 1891–92 attended ASL and summer classes of J. Twachtman and J. Alden Weir at Cos Cob, Conn. 1893–95 mostly in Paris; met Alfred Sisley. 1898 moved to New York. 1908 exhibited with The Eight at Macbeth Gallery, in 1910 Exhibition of Independent Artists, and in 1913 Armory Show. 1917 N.A. Later traveled in Spain, France, Nova

Scotia and western U.S. 1936 settled in Coral Gables, Fla. While Lawson's style developed from impressionism, he was active in early twentieth century progressive art movements.

Early Spring, Harlem River PL. 158

[Ca. 1912–15] Oil on canvas
25-3/16 x 30¼ in. (64 x 76.9 cm.)
Signed lower right: E. Lawson

Acc. no. 52.23
Museum Purchase Fund

COLLECTIONS: (Charles Daniel Gallery, New York, ca. 1913–15); Sir William Van Horne, Montreal (sold, New York, Parke-Bernet, Jan. 24, 1946, lot 3, repr.); (Lily Emmerich, New York, 1946–52).

EXHIBITIONS: Art Association of Montreal, *A Selection from the Collection of Paintings of the late Sir William Van Horne, K.C.M.G.*, 1933, no. 161b (as *Spring, High Bridge*); Ottawa, National Gallery of Canada, *Ernest Lawson, 1873–1939*, 1967, no. 33 (cat. by B. O'Neal; dated before 1915).

REFERENCES: H. and S. Berry-Hill, *Ernest Lawson: American Impressionist, 1873–1939*, Leigh-on-Sea, England, 1968, no. 62, repr.

In 1898 Lawson moved to Washington Heights on the northern end of Manhattan. There he painted the bridges and boathouses on the Harlem River in canvases which emphasize the changing seasons. This is a view of Lawson's favorite subject, High Bridge, looking from the Bronx northeast towards the steep cliffs of Manhattan above 179th Street.

Lawson rarely dated his work, and the dating of this canvas is partly based on its ownership by the railroad magnate and art collector Sir William Van Horne (1843–1915). The stretcher bears the label of the Daniel Gallery, which opened in late 1913, and became Lawson's dealer in 1914. The style and palette also suggest a date ca. 1912–15.

LEONID

1896–1976. Leonid Berman. Born in St. Petersburg, Russia; brother of Eugene Berman (q.v.). 1918 to Paris; 1919–22 studied with several members of the Nabis group. 1924 first trip to Italy. 1925 exhibited with the Neo-Romantic group. 1948 settled in New York and became U.S. citizen. Leonid specialized in romantic coastal landscapes emphasizing exaggerated space and perspective.

Portuguese Sun PL. 232

[1948] Oil on canvas
33⅛ x 46-1/16 in. (84.1 x 117 cm.)
Signed and dated lower right: Leonid, 48
Inscribed on reverse of canvas: Soleil portugais/Leonid/
1948/N.50

Acc. no. 49.108
Museum Purchase Fund

COLLECTIONS: (Durlacher Bros., New York).

EXHIBITIONS: Toledo Museum of Art, *36th Annual*, 1949,
no. 42.

Leonid stayed several times in 1946–48 at Caparica,
near Lisbon, where he painted many beach subjects in
this thinly populated region (Sylvia Marlowe Berman,
letter, Mar. 3, 1979).

JULIAN EDWIN LEVI

1900–. Born in New York; raised in Philadelphia. 1917
enrolled in PAFA. Ca. 1919–24 studied in Europe. 1932
settled in New York. 1936–38 WPA Federal Art Project.
From 1945 taught at the New School for Social Research,
ASL, and PAFA. A romantic realist in the 1930s and 40s,
Levi later turned to abstraction.

Driftwood PL. 208

[Ca. 1939] Oil on canvas
19-15/16 x 29-15/16 in. (50.6 x 76 cm.)
Signed lower right: Julian Levi

Acc. no. 41.39
Museum Purchase Fund

COLLECTIONS: (Downtown Gallery, New York).

EXHIBITIONS: Toledo Museum of Art, *28th Annual*, 1941,
no. 33.

REFERENCES: L. Nordness, ed., *Art U.S.A. Now*, New
York, 1962, I, repr. p. 96.

ALVIN LOVING

1935–. Born in Detroit. 1963 B.F.A. University of Illinois
at Champaign; 1965 M.F.A. University of Michigan. Late
1960s moved to New York. Loving first worked in an
abstract expressionist style. His painting has since
progressed from hard-edged, geometric shaped canvases,
to stained, free-hanging canvas strips and cardboard
wall collages.

Dan PL. 274

[1973] Acrylic on paper and cardboard
90 x 106 in. (228.6 x 269.2 cm.)

Acc. no. 75.8
Purchased with funds provided by the National
Endowment for the Arts and an anonymous donor

COLLECTIONS: (Fischbach Gallery, New York).

EXHIBITIONS: Toledo Museum of Art, *Image, Color and
Form: Recent Paintings by Eleven Americans*, 1975, no.
21, repr. (with incorrect caption; cat. by R. Phillips).

LUIGI LUCIONI

1900–. Born in Malnate, Italy. 1911 emigrated to U.S.
1916–20 studied at Cooper Union; 1920–26 at NAD.
1925 in France and Italy. 1932–33 taught at ASL. 1941
N.A. An etcher and painter, Lucioni specializes in por-
traiture and intensely realistic still life and landscape sub-
jects.

Design for Color PL. 214

[1944] Oil on canvas
20⅛ x 27-3/16 in. (51.1 x 69.1 cm.)
Signed and dated lower left: Luigi Lucioni 1944

Acc. no. 45.33
Elizabeth C. Mau Bequest Fund

COLLECTIONS: (Associated American Artists, New York).

EXHIBITIONS: Toledo Museum of Art, *32nd Annual*, 1945.

GEORGE BENJAMIN LUKS

1867–1933. Born in Williamsport, Pa. Ca. 1884 studied
at PAFA with Thomas Anshutz. 1885 enrolled in Düs-
seldorf Academy; worked in Europe almost ten years.
1894 artist-reporter for Philadelphia *Evening Bulletin*
and *Press*. Attended Henri's weekly meetings, where he
met Shinn, Sloan and Glackens. 1908 exhibited with The
Eight and in the 1913 Armory Show. 1920–24 taught at
ASL. Strongly influenced by Hals, he is best remembered
for sensitive, boldly painted pictures of beggars, wrestlers
and city urchins.

The Little Milliner PL. 153

[Ca. 1905] Oil on canvas
36⅛ x 26-3/16 in. (91.8 x 66.5 cm.)
Signed lower left: George Luks
Signed lower right: George Luks

Acc. no. 46.17

COLLECTIONS: (Kraushaar, New York); Arthur F. Egner, South Orange, N.J., by 1917 (sold, Parke-Bernet, New York, May 4, 1945, lot 124, repr.; (C. W. Kraushaar Art Galleries, New York).

EXHIBITIONS: New York, C. W. Kraushaar Art Galleries, *Retrospective Exhibition of Paintings by George Luks*, 1923, no. 18; Newark Museum, *The Works of George Benjamin Luks*, 1934, no. 7, repr. (dated 1905); New York, Whitney Museum of American Art, *New York Realists 1900–1914*, 1937, no. 49; Philadelphia Museum of Art, *Artists of the Philadelphia "Press": William Glackens, George Luks, Everett Shinn, John Sloan*, 1945, no. 19; Philadelphia, PAFA, *150th Anniversary Exhibition*, 1955, no. 200; Utica (N.Y.), Munson-Williams-Proctor Institute, *George Luks*, 1973, no. 18, repr.

REFERENCES: G. Pène du Bois, "The Collection of Mr. Arthur F. Egner," *Art and Decoration*, Aug. 1917, p. 476, repr. p. 477; G. Pène du Bois, "George Luks, Artist and Flamboyance," *The Arts*, III, Feb. 1923, repr. p. 112; F. Watson, "George Luks, Artist and 'Character,'" *American Magazine of Art*, Jan. 1935, p. 26; M. Young, *American Realists, Homer to Hopper*, New York, 1977, repr. p. 138.

JEAN MacLANE

1878–1964. Born in Chicago. Studied at the Art Institute of Chicago with Frank Duveneck and W. M. Chase, and in France and Italy. 1926 N.A. Lived in New York. Wife of John C. Johansen (q.v.). Chiefly a portraitist.

On the Beach, Devonshire PL. 182

[1926] Oil on canvas
39-13/16 x 39-15/16 in. (101.1 x 101.5 cm.)
Signed on reverse: JEAN MacLANE

Acc. no. 26.145
Frederick B. Shoemaker Fund

COLLECTIONS: Bought from the artist.

EXHIBITIONS: Philadelphia, PAFA, *121st Annual Exhibition*, 1926, repr.; Toledo Museum of Art, *14th Annual*, 1926, no. 34.

Country Dog Show PL. 181

[1933–34] Oil on canvas
50 x 39⅞ in. (127 x 101.4 cm.)
Signed and dated lower right: JEAN MacLANE 1934
Signed and dated on reverse: JEAN MacLANE/1933

Acc. no. 35.42

Museum Purchase Fund
COLLECTIONS: Bought from the artist.

Florence Scott Libbey PL. 162

Oil on canvas
49¾ x 39-15/16 in. (126.5 x 101.5 cm.)
Signed lower left: M. JEAN MacLANE

Acc. no. 38.22

Florence Scott Libbey (1856–1938), born in Castleton, N.Y., was the wife of the Museum's founder, Edward Drummond Libbey. The Museum is located on the site of the house of her father, Maurice A. Scott. Mrs. Libbey left endowments to the Museum for acquisition of American art, decorative arts, and for programs in both music performance and education.

DONALD SHAW MacLAUGHLAN

1876–1938. Born in Charlottestown, P.E.I., Canada; raised in Boston, and studied there. 1898 to Paris; studied with Gérome. Worked in France, England and Italy, and after 1904 almost entirely as an etcher. Lived chiefly in Europe.

Venetian Canal PL. 133

[1912] Ink and watercolor on paper
12½ x 17 in. (31.7 x 43.2 cm.)
Signed and dated lower right: DS MacLaughlan/1912

Acc. no. 38.41
Gift of Alice Roullier

JOHN MARIN

1870–1953. Born in Rutherford, N.J. After working as an architect, studied at PAFA 1899–1901 and ASL 1903–04. 1905–11 in Europe. 1909 first exhibition at Stieglitz's galleries. 1911 returned to New York. Exhibited in 1913 Armory Show. 1914 began spending summers in Maine; turned increasingly to landscape. After 1930s worked more in oil. A leading modernist and member of the Stieglitz circle, Marin adapted influences from cubism and futurism to American subjects.

Pine Tree, Small Point, Maine PL. 185

[1926] Watercolor and charcoal on paper
13-9/16 x 19-3/16 in. (34.5 x 48.7 cm.)
Signed and dated lower left: Marin 26

Inscribed on reverse of backing: No. 2/Pine Tree/Small
Point Me./Series 1926/John Marin

Acc. no. 36.7
Museum Purchase Fund

COLLECTIONS: (Weyhe Gallery, New York, ca. 1932);
(C. W. Kraushaar Art Galleries, New York).

EXHIBITIONS: Art Institute of Chicago, *International Watercolor Exhibition*, 1939, no. 401.

REFERENCES: S. Reich, *John Marin: Part II, A Catalogue Raisonné*, Tucson, 1970, p. 575, no. 26.71, repr.

Marin first visited Small Point, fifteen miles south of
Bath, in 1914. The next year he bought a small island
near Small Point which he named Marin's Island.

CARL MARR

1858–1936. Born in Milwaukee, Wis. Briefly worked for
his father's engraving firm; 1875 to Germany to study.
1880 returned to Milwaukee. 1882 in Munich, where he
lived until his death. Achieved international success with
historical and genre subjects, and later with decorative
paintings and murals. 1893 instructor at Munich Academy, where he taught many Americans. Raised to the
nobility in 1909 as Carl von Marr.

Dusk PL. 117

[1908] Oil on canvas
Diam. 23½ in. (59.7 cm.)
Signed lower right: CARL/MARR

Acc. no. 12.2
Gift of Edward Drummond Libbey

COLLECTIONS: (Schulte, Berlin, 1912); (Henry Reinhardt,
New York); Edward Drummond Libbey, Toledo.

REFERENCES: G. J. Wolf, "Carl von Marr," *Die Kunst*,
XXIII, Dec. 1, 1910, repr. p. 111 (dated 1908).

REGINALD MARSH

1898–1954. Born in Paris of an American family; raised
in Nutley, N.J. 1920 B.A. Yale College; began working
as magazine illustrator. Studied at ASL with J. Sloan,
G. Luks, Kenneth Hayes Miller. 1925–26 study in Europe
led to increasing appreciation of the old masters, evident
in his technique and vigorous, baroque style. 1929 began
to experiment with egg tempera. 1935–54 taught at ASL.
1945 published *Anatomy for Artists*. As a painter,

muralist and printmaker, New York city life was his chief
subject.

Pursuit PL. 202

[1941–42] Oil emulsion on masonite
34⅛ x 42⅛ in. (86.7 x 107 cm.)
Signed and dated lower right: REGINALD/MARSH/1941–2

Acc. no. 43.62
Elizabeth C. Mau Bequest Fund

COLLECTIONS: (Frank K. M. Rehn, New York).

EXHIBITIONS: Toledo Museum of Art, *30th Annual*,
1943; Kalamazoo (Mich.) Institute of Arts, *Reginald Marsh*, 1973, pp. 10, 14, repr. p. 15.

REFERENCES: L. Goodrich, *Reginald Marsh*, New York,
1972, repr. p. 222.

HOMER DODGE MARTIN

1836–1897. Born in Albany, N.Y.; worked there until
1863. Studied with James Hart. 1863–81 in New York;
frequent sketching trips to Adirondacks, Catskills, Berkshires and White Mountains. 1876 in Europe. 1877 member, Society of American Artists. 1878 N.A. 1881–86 in
Europe; extended stay in Normandy. 1893 moved to St.
Paul, Minn. Martin's later poetic landscapes were influenced by Whistler, Corot and the Impressionists.

Normandy Landscape PL. 98

[1894] Oil on canvas
10⅜ x 15-1/16 in. (26.5 x 38.3 cm.)
Signed and dated lower right: H. D. Martin/1894

Acc. no. 24.34

COLLECTIONS: (Macbeth); (Chester Johnson, Chicago).

REFERENCES: D. Carroll, *Fifty-eight Paintings by Homer D. Martin*, New York, 1913, repr.

HENRY ELIS MATTSON

1887–1971. Born in Goteborg, Sweden. Ca. 1898 emigrated to Worcester, Mass. 1912 enrolled in Worcester
Art Museum School. 1916 studied with John Carlson at
ASL Summer School at Woodstock, N.Y., where he settled. Chiefly a landscape painter.

Big Rock Pool PL. 217

[Ca. 1942] Oil on canvas
25 x 32-1/16 in. (63.5 x 81.5 cm.)

Signed lower left: Mattson
Inscribed in pencil on stretcher: Mattson—Big Rock Pool

Acc. no. 43.63
Elizabeth C. Mau Bequest Fund

COLLECTIONS: (Frank K. M. Rehn, New York).

EXHIBITIONS: Toledo Museum of Art, *30th Annual*, 1943.

HENRY LEE McFEE

1886–1953. Born in St. Louis, Mo. Worked as surveyor until 1907, when he first studied art in Pittsburgh. 1909 studied with Birge Harrison at ASL Summer School at Woodstock, N.Y., where he lived for 25 years. Exhibited in 1916 Forum Exhibition. Late 1930s moved to Claremont, Calif. and taught at Scripps College. Chiefly a still life painter, McFee was influenced by Cézanne and cubism.

Petunias and Phlox PL. 186

[1926] Oil on canvas
30⅛ x 24 in. (76.6 x 61 cm.)
Signed lower right: McFee

Acc. no. 36.20
Gift of Temperance P. Reed in memory of Samuel R. Reed

COLLECTIONS: Carl W. Hamilton, New York, by 1931; Henry C. Bentley, Boston, 1936; (Macbeth).

EXHIBITIONS: Toledo Museum of Art, *23rd Annual*, 1936, no. 43.

REFERENCES: V. Barker, *Henry Lee McFee*, New York, 1931, repr. p. 40 (dated 1926).

HUGH F. McKEAN

1908–. Born in Beaver Falls, Pa. 1930 B. A. Rollins College. Studied painting at PAFA, ASL and in France. 1940 M.A. Williams College. Taught art at Rollins College 1932–50. President, Rollins College, 1952–69; Chancellor and board chairman, 1969–75. Director, Morse Gallery of Art, Winter Park, Fla. since 1942.

Early Morning Fishing Party PL. 205

[1934] Oil on canvas
25-13/16 x 30 in. (64 x 76.1 cm.)

Acc. no. 35.33
Gift of John Tiedtke

EXHIBITIONS: New York, Delphic Studios, *Paintings by Hugh McKean*, 1935, no. 8.

JULIUS GARI MELCHERS

1860–1932. Born in Detroit. 1877–81 studied at Düsseldorf Academy. 1881 with Lefebvre and Boulanger in Paris. 1884–1915 studio in Holland. Murals for Chicago World's Columbian Exposition, 1893; Library of Congress, 1895; Detroit Public Library. 1906 N.A. 1916 settled at Falmouth, Va. Portraitist, muralist and figure painter.

Easter Sunday PL. 121

[1910–11] Oil on canvas
52 x 56 in. (132.1 x 142.2 cm.)
Signed upper right: Gari Melchers

Acc. no. 23.21

COLLECTIONS: Bought from the artist.

EXHIBITIONS: Detroit Institute of Arts, *Paintings by Gari Melchers*, 1927, no. 7, repr.; Buffalo, Albright Art Gallery, *Retrospective Exhibition of Paintings Representative of the Life Works of Gari Melchers, N.A.*, 1930, no. 30, repr.; Richmond, Virginia Museum of Fine Arts, *Gari Melchers, A Memorial Exhibition of His Work*, 1938, no. 16, repr.

REFERENCES: *Gari Melchers, 1860–1932, American Painter* (exh. cat.), Graham Galleries, New York, 1978, in no. 3.

Melchers stated this work was begun in 1910 and finished in 1911 in his studio at Egmond-aan-Hoef in northern Holland. He also noted:

> The scene is laid in the old village church, which is said to be the first Protestant church ever built in north Holland. The stained glass windows in the church were presented by the various cities of the province of north Holland. The large window at the left (was) given by the city of Eukhuizen with the coat of arms of that city. The other window . . . shows . . . the coat of arms of the city of Monkendam. My models, who posed for the figures representing the congregation, are all natives of the village . . . , all of whom I had befriended. . . . A rather short time after I had finished this canvas, the old church of Egmond-aan-Hoef underwent some changes, for the interior was somewhat altered (letter, Jan. 25, 1925).

BARSE MILLER

1904–1973. Born in New York. Studied at NAD and at PAFA. 1923 in Europe. 1925–39 taught in Los Angeles. Guggenheim Fellowship 1946–47. N.A. Taught at Queens College, New York. Figure, mural and landscape painter.

Table in the Shade PL. 204

[1934] Watercolor on paper
20⅛ x 25⅜ in. (51.1 x 64.4 cm.)
Signed lower right: Barse Miller

Acc. no. 40.141
Museum Purchase Fund

Factory Town PL. 206

[1946] Oil on canvas
26 x 36 in. (66 x 91.5)
Signed lower center: Barse Miller—
Inscribed on reverse: Factory Town/Barse Miller

Acc. no. 48.70
Museum Purchase Fund

COLLECTIONS: (Ferargil, New York).

EXHIBITIONS: Toledo Museum of Art, *35th Annual*, 1948, no. 54.

According to the artist, this picture, based on studies of the sugar refining town of Crockett, California, was one of a series on Sacramento River themes which formed his Guggenheim Fellowship project.

FRANCIS LUIS MORA

1874–1940. Born in Montevideo, Uruguay. Studied with his father, a sculptor; in Boston with F. Benson and E. Tarbell; and at ASL. Worked as an illustrator. Painted murals for Missouri State Capital. 1906 N.A. Portrait, genre and history painter.

Jeanne Cartier PL. 166

[1915] Oil on canvas
71⅞ x 36⅛ in. (182.7 x 91.7 cm.)
Signed and dated lower left: F. Luis Mora/1915
Inscribed in paint on reverse of canvas: ARTIST F. LUIS
 MORA—NEW YORK/TITLE JEANNE CARTIER

Acc. no. 17.725
Frederick B. Shoemaker Fund

COLLECTIONS: Bought from the artist.

EXHIBITIONS: Cleveland Museum of Art, *Inaugural Exhibition*, 1916, no. 75.

Jeanne Cartier was a dancer with the Century Opera Company in New York.

RANDALL MORGAN

1920–. Born in Knightstown, Ind. Chiefly self-taught. Began landscape painting while with armed forces in Italy. Since 1962 has lived in Salerno, Italy, where in 1967 he opened Randall Morgan School of Art.

Ponte Vecchio, Florence PL. 230

[Ca. 1949] Oil on canvas
26 x 30 in. (66 x 76.2 cm.)
Signed lower right: Morgan

Acc. no 50.271
Museum Purchase Fund

COLLECTIONS: (New Art Circle, New York).

EXHIBITIONS: Toledo Museum of Art, *37th Annual*, 1950, no. 52; Detroit Institute of Arts and Toledo Museum of Art, *Travelers in Arcadia: American Artists in Italy 1830–1875*, 1951, no. 14.

KYLE RANDOLPH MORRIS

1918–1979. Born in Des Moines, Ia. 1935–40 studied at Art Institute of Chicago. 1939 B.A. and 1940 M.A. Northwestern University. M.F.A. Cranbrook Academy of Art. Although he first worked in a figurative style, by the mid-50s Morris turned to abstract expressionism.

Number 10, 1956 PL. 257

[1956] Lacquer on canvas
51-15/16 x 66-15/16 in. (132 x 169.8 cm.)
Signed lower right: Kyle Morris

Acc. no. 57.27
Museum Purchase Fund

COLLECTIONS: (Stable Gallery, New York).

EXHIBITIONS: Washington, Corcoran Gallery of Art, *25th Biennial Exhibition*, 1957, no. 24.

SAMUEL FINLEY BREESE MORSE

1791–1872. Born in Charlestown, Mass. 1810 B.A. Yale College. 1811–15 accompanied Washington Allston to London and studied with West. 1815 returned to Boston; active as itinerant artist in New England; winter trips to Charleston, S.C. 1818–21. 1824 settled in New York. 1825 founder of NAD; president 1826–45 and 1861–62. 1829–31 in Italy and France. 1835–37 professor of art, New York University. From 1837 concentrated on scientific interests, which led to his invention of the telegraph in 1839. Although now best known for his scientific in-

ventions, Morse was a leading painter of portraits, figures and landscape subjects of the Romantic period.

Scene from Spenser's "Faerie Queene": PL. 18
Una and the Dwarf

[1827] Oil on wood panel
26-5/16 x 47⅞ in. (66.9 x 109 cm.)
Inscribed on reverse (in an unknown hand): Subject of the picture/from/Spenser's Fairie Queene/Book I/Canto VII/Stanza 29.

Acc. no. 51.295

COLLECTIONS: James A. Stevens, Hoboken, N.J., 1828; Emma Willard, Troy, N.Y.; (Thomas, Coxsackie, N.Y.); (Vose, 1951).

REFERENCES: S. Morse, *Discourse delivered on Thursday, May 3, 1827, in the Chapel of Columbia College, before the National Academy of Design, on its first anniversary;* "To The Crayon," *The Crayon,* IV, June 1857, p. 181; T. Cummings, *Historic Annals of the National Academy of Design,* Philadelphia, 1865, p. 114; E. Morse, ed., *Samuel F. B. Morse Letters and Journals,* Boston, 1914, I, pp. 288–89; O. Larkin, *Samuel F. B. Morse and American Democratic Art,* Boston, 1954, p. 91; W. Gerdts, "Inman and Irving: Derivations from Sleepy Hollow," *Antiques,* LXXIV, Nov. 1958, p. 421; L. Konheim, "The Decoration of the Steamboat *Albany:* Thirteen Paintings by Contemporary Painters Commissioned by James Stevens of Hoboken, N.J. in 1827," unpublished M.A. thesis, New York University, 1968, pp. 6, 8, 9, 11–3, repr. opp. p. 12; P. Rider, "Samuel F. B. Morse and The Faerie Queene," *Research Studies,* XLVI, Dec. 1978, pp. 204–13, repr.

In 1826 James Stevens of Hoboken, N.J., head of a steamboat company, commissioned several leading artists including Cole, Doughty, William Birch, Sully, Vanderlyn and Morse to paint landscapes and historical scenes for the cabin of his Hudson River steamboat *Albany*. Morse's subject depicts the episode from Edmund Spenser's epic poem *Faerie Queene* (first published 1590), in which Prince Arthur encounters Una and the dwarf in the woods just after the capture of their master, the Redcross Knight, by the witch Duessa and the giant Orgoglio. Arthur promised to avenge the wrong, and the dwarf guided the party to the castle where the Knight was imprisoned:

> Then cryde the Dwarfe, lo yonder is the same,
> In which my Lord my liege doth luckless lie,
> Thrall to that Gyants hateful tyrannie:
> Therefore, deare Sir, your mightie powres assay.
> (Book I, canto VIII, stanza 2)

Arthur then slew Orgoglio and rescued the Knight.

There is a series of holes around the edges where the painting was fastened into the cabin panelling. The seven paintings of the original thirteen which have been located are all on panels of similar size (Konheim, p. 7).

In 1828 Morse exhibited another version of this subject at the NAD; it is now unlocated.

JOSEPH MORVILLER

?–1868. Native of southern France. Fresco painter in France, and copyist in England. 1852 arrived in Boston; worked mostly in Medford and Middlesex Falls. 1864 studio at Malden. Specialized in winter scenes.

Testing the Ice PL. 36

[1857] Oil on canvas
26-3/16 x 36⅛ in. (66.5 x 91.8 cm.)
Signed and dated lower right: J. Morviller 1857

Acc. no. 54.33

COLLECTIONS: Mrs. F. Keyes, Newtonville, Mass., to 1954; (Vose).

Skating at Medford PL. 37

[1865] Oil on canvas
32-11/16 x 52 in. (83.1 x 132.1 cm.)
Signed and dated lower left: J. Morviller 1865

Acc. no. 64.58
Gift of Mr. and Mrs. Roy Rike

COLLECTIONS: (Victor Spark, New York).

The title is traditional.

GUSTAVE HENRY MOSLER

1875–1906. Born in Munich. Son and pupil of the American painter Henry Mosler. Studied in Paris with Léon Bonnat. Later lived in New York. Figure, animal, landscape and portrait painter.

De Profundis PL. 118

[1900] Oil on canvas
90 x 132 in. (228.6 x 335.2 cm.)
Signed lower left: Gustave Henry Mosler

Acc. no. 06.255
Gift of Arthur J. Secor

COLLECTIONS: Bought from the artist.

EXHIBITIONS: Paris, Salon, 1901, no. 1504 (3rd class gold medal); St. Louis, *Universal Exposition,* 1904, United States no. 538 (bronze medal); Toledo Museum of Art, *American Paintings from the St. Louis Exposition,* 1905, no. 70.

REFERENCES: *Toledo Museum of Art Museum News,* 1, Mar. 1908, (p. 49).

The subject is the passing of a country funeral in Brittany. *De Profundis* ("Out of the depths") are the first words of Psalm 129, recited as part of the Roman Catholic prayers for the dead.

The Museum has five studies for the painting given in 1907 by Henry Mosler, the artist's father. These include three progressively developed oil studies for the full composition, an oil study for the plowman, and a pencil drawing for the team of horses.

WALTER TANDY MURCH

1907–1967. Born in Toronto, Ontario. 1925 studied at Ontario College of Art. 1927 stained glass designer in New York; attended ASL. 1927–29 studied with Arshile Gorky. 1931–60s illustrator, muralist and commercial artist. 1948 U.S. citizenship. Influenced by his friend Joseph Cornell and the European Surrealists, Murch specialized in precisely rendered still life compositions of mechanical devices.

Taking-Off PL. 250

[Ca. 1952] Oil on academy board
16⅛ x 16 in. (41 x 40.6 cm.)
Signed upper right: Walter Murch

Acc. no. 54.71
Museum Purchase Fund

COLLECTIONS: (Betty Parsons Gallery, New York).

EXHIBITIONS: Toledo Museum of Art, *41st Annual,* 1954, no. 46; New York, Betty Parsons Gallery, *Walter Murch: Recent Paintings,* 1954, no. 9; Providence, Museum of Art, Rhode Island School of Design, *Walter Murch, A Retrospective Exhibition,* 1966, no. 29, repr. (cat. by D. Robbins).

REFERENCES: J. van Wagner, "Walter Murch," unpublished Ph.D. dissertation, University of Iowa, 1972, p. 415, fig. 107.

JOHN FRANCIS MURPHY

1853–1921. Born in Oswego, N.Y. Chiefly self-taught. 1875 settled in New York. 1876 first exhibited NAD; 1887 N.A. 1887 built summer studio in the Catskills. Member, Society of American Artists. Landscape painter chiefly influenced by the Barbizon school.

Sunset PL. 99

[1895] Oil on canvas
8-1/16 x 12 in. (20.4 x 30.5 cm.)
Signed and dated lower left: J. FRANCIS MURPHY. '95

Acc. no. 66.125
Gift of Julia Paige Norton

COLLECTIONS: William M. Bullivant, to 1926; (Vose); Harold H. Norton, Toledo, 1927–49; Julia Paige Norton, Toledo, 1949–66.

JOHN NEAGLE

1796–1865. Born in Boston. Studied portraiture in Philadelphia with Bass Otis while apprenticed to a coach and sign painter until 1818. An itinerant artist in the South before settling in Philadelphia, where he married the step-daughter of Thomas Sully. 1825 in Boston, where he met Gilbert Stuart, whose instruction he sought. 1830–31 a director of the PAFA. Neagle was a leading portraitist of his generation.

Dr. Maurice Morrison PL. 29

[1841] Oil on canvas
30 x 24¾ in. (76.1 x 63.5 cm.)
Signed and dated at center left: J. Neagle Pinxt 1841.
 Philad^ia.

Acc. no. 44.31

COLLECTIONS: (John Levy, New York, 1943); (Macbeth, 1944).

The sitter is believed to be the surgeon Maurice Morrison (1807–1842) of Maryland, who received his M.D. from the University of Maryland and was elected to the Medical and Chirurgical Faculty of Maryland in 1831. He lived in Buenos Aires in the 1830s. Morrison studied the effects of malaria, from which he died in Havana, Cuba.

The book he holds titled *Sir A. Cooper's Lectures* is presumably from the edition of papers by the British surgeon, essayist and lecturer Sir Astley Cooper (1768–1841) published in Boston, 1825–28. Its lithographic il-

lustrations were printed by John Pendleton, whose portrait by Rembrandt Peale is in the Toledo collection.

BROR JULIUS OLSSON NORDFELDT

1878–1955. Born in Tullstorp, Scania, Sweden. 1891 emigrated with his family to Chicago. Studied at Art Institute of Chicago, and at Académie Julian, Paris. Studied wood-block printing in England. 1905 returned to Chicago and concentrated on etching. 1916-early 1920s summers at Provincetown, Mass. 1920–38 chiefly at Santa Fe., N.M.; then in New Jersey. As a painter, best known for landscape and marine subjects in a modified expressionist style.

Yellow Tablecloth PL. 219

[1945] Oil on canvas
35⅞ x 42⅛ in. (91.2 x 107 cm.)
Signed lower right: Nordfeldt

Acc. no. 47.49
Museum Purchase Fund

COLLECTIONS: (Passedoit Gallery, New York).

EXHIBITIONS: Toledo Museum of Art, *34th Annual*, 1947, no. 74.

KENZO OKADA

1902–. Born in Yokohama, Japan. Studied at Tokyo Fine Arts University. 1924–27 in Paris; studied with Foujita. 1927 returned to Tokyo. 1938 began exhibiting with Nikakai group of Japanese artists; work chiefly figurative. 1950 settled in New York, where he developed a lyrical abstract expressionist style influenced by Zen.

Tanabata PL. 268

[1955] Oil on canvas
43 x 37 in. (109.2 x 94 cm.)
Signed lower right: Kenzo Okada
Inscribed on stretcher: OKADA

Acc. no. 77.51
Gift of the Woodward Foundation

COLLECTIONS: Woodward Foundation, Washington, D.C.

GEORGIA O'KEEFFE

1887–. Born in Sun Prairie, Wis. Studied at Art Institute of Chicago; 1907–09 at ASL with W. M. Chase; 1914 with Arthur Wesley Dow. 1917 began exhibiting at Alfred Stieglitz's gallery. 1924 married Stieglitz. 1929 first summer in New Mexico, where she settled permanently at Abiquiu in 1949. O'Keeffe was a leading figure in the Stieglitz circle, and a pioneer of abstract painting in America who developed independently of outside influences. Her work ranges from pure abstraction to highly simplified and selective realism.

Brown Sail, Wing and Wing, Nassau PL. 189

[1940] Oil on canvas
38 x 30-1/16 in. (96.6 x 76.4 cm.)

Acc. no. 49.106
Museum Purchase Fund

COLLECTIONS: (Downtown Gallery, New York).

EXHIBITIONS: New York, An American Place, *Georgia O'Keeffe, New Paintings*, 1941, no. 13 (dated 1940); Toledo Museum of Art, *36th Annual*, 1949, no. 54; Toledo Museum of Art, *Heritage and Horizon: American Painting 1776–1976*, 1976, no. 45, repr.

The term "wing and wing" refers to the position of sails set to go directly before the wind. O'Keeffe's subject is the brown sails of a friend's boat on which she sailed during a trip to the Bahamas in 1940.

EDMUND HENRY OSTHAUS

1858–1928. Born in Hildesheim, Germany. 1874–82 studied at Düsseldorf Academy. 1882 to America; worked in St. Louis and Wisconsin. In 1886 *Toledo Blade* editor D. R. Locke brought him to Toledo as principal of Toledo Academy of Fine Arts, which Osthaus headed until 1892. Interest in dogs and hunting were a family tradition, and these subjects became his specialty. Annual trips in U.S. and Canada to attend field trials and make sketches and photographs. Trustee of The Toledo Museum of Art, 1901–11. Later lived at Summit, N.J.

Afield PL. 146

[Ca. 1900] Oil on canvas
40½ x 61 in. (103 x 155 cm.)
Signed lower right: Edm. H. Osthaus

Acc. no. 08.81
Gift of Edward Drummond Libbey

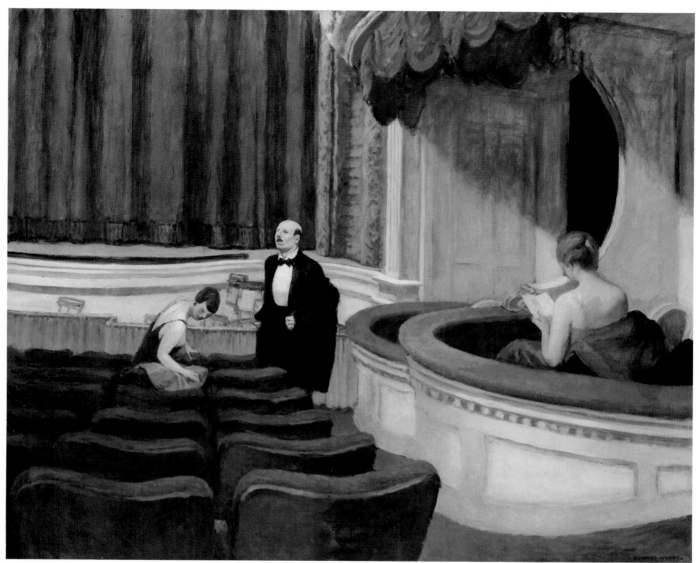

VII. Edward Hopper, *Two on the Aisle,* 1927

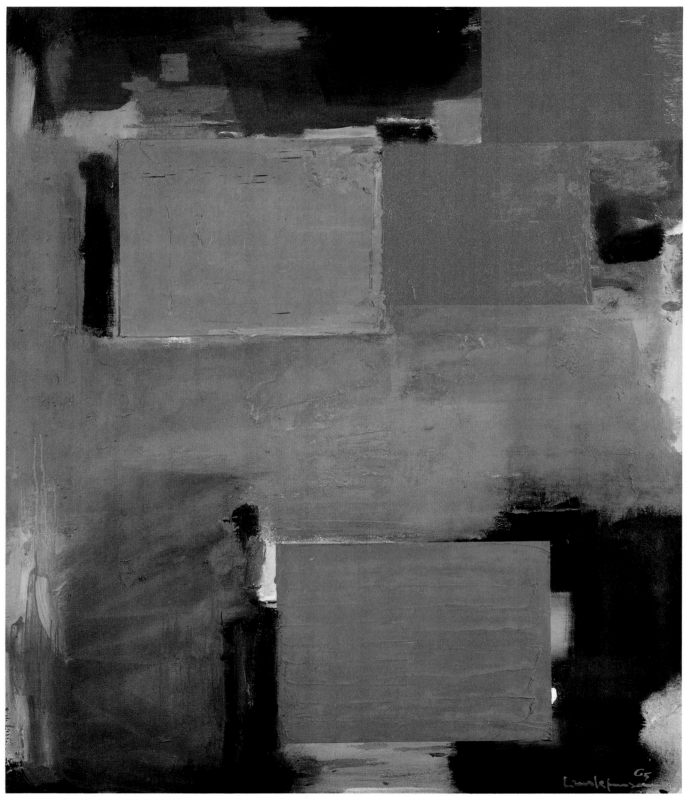

VIII. Hans Hofmann, *Night Spell*, 1965

Major PL. 145

Oil on canvas
28⅜ x 24⅛ in. (72 x 61.3 cm.)

Acc. no. 12.945
Gift of Nettie Poe Ketcham

ARTHUR OSVER

1912–. Born in Chicago. Studied at Northwestern University, and at Art Institute of Chicago. 1936–38 in Italy and France. 1938 WPA Federal Art Project in Chicago. Taught at Brooklyn Museum School, Columbia University, American Academy in Rome and Washington University. His work includes urban realism, cubist-inspired industrial subjects, and broadly painted abstract landscapes.

The Steam Jet PL. 221

[1946] Oil on canvas
36 x 43⅞ in. (91.5 x 111.5 cm.)
Signed and dated lower right: Osver/46
Inscribed on reverse: ARTHUR OSVER/THE STEAM JET/
 DEC. 1946

Acc. no. 47.50
Museum Purchase Fund

COLLECTIONS: (Grand Central Art Galleries, New York).

EXHIBITIONS: Toledo Museum of Art, *34th Annual*, 1947, no. 76.

THOMAS SHREWSBURY PARKHURST

1853–1923. Born in Manchester, England; raised in upper New York State. Ca. 1869 to Toledo. Chiefly self-taught. 1895 a founding member of Toledo Tile Club. An interior decorator until 1911, when he turned to painting. 1916 settled at Carmel, Calif. Specialized in marine and landscape subjects.

The Spirit of the Maumee PL. 148

Oil on canvas
30 x 30 in. (76.2 x 76.2 cm.)
Signed lower right: Thos. S. Parkhurst

Acc. no. 17.129
Museum Purchase Fund

COLLECTIONS: Bought from the artist.

Toledo is situated at the place where the Maumee River flows into Lake Erie.

STEPHEN PARRISH

1846–1938. Born in Philadelphia. After a business career, began painting in 1877. Chiefly self-taught. 1884–86 in Europe. Ca. 1893 settled in Cornish, N.H. Father of the illustrator Maxfield Parrish. Landscape painter and etcher.

The Breakup of Winter PL. 132

[1912] Oil on canvas
28½ x 38½ in. (72.4 x 97.7 cm.)
Signed and dated lower center: Stephen Parrish 1912
Inscribed on stretcher: "Subject-The Break up of
 Winter"/Cornish, N.H.

Acc. no. 12.922
Gift of Rose Milmine Parsons

This is a view at Cornish, N.H., which by the early 1890s became a summer colony of writers and artists, including Augustus Saint-Gaudens, Thomas Dewing, Kenyon Cox and George de Forest Brush.

RAPHAELLE PEALE

1774–1825. Born in Annapolis, Md. Eldest son and pupil of Charles Willson Peale. 1786 his father's assistant at Peale's Museum, Philadelphia. 1796–97 operated art and natural history museum with his brother Rembrandt (q.v.) in Baltimore. By 1799 working as a miniaturist; later as a silhouettist. By 1812 chiefly painting still lifes. An early specialist in this subject, his work set a standard for still life painting which was unmatched until the latter half of the nineteenth century.

Still Life with Oranges PL. 17

[Ca. 1818] Oil on wood panel
18⅝ x 22-15/16 in. (47.4 x 58.3 cm.)
Signed lower right: Raphaelle Peale, Pinxit.
Inscribed lower left: Painted for the Collection of John
 A. Alston, Esqr./The Patron of Living American
 Artists

Acc. no. 51.498

COLLECTIONS: John A. Alston, Bannockburn, Waccamaw, S.C., ca. 1820–31; Nickerson family, Plymouth, Mass.; (Robert Carlen, Philadelphia); (Knoedler, New York, 1951).

EXHIBITIONS: Cincinnati Art Museum, *Paintings by the Peale Family*, 1954, no. 64 (cat. by E. Dwight); Milwaukee Art Center, *Raphaelle Peale*, 1959, no. 21, repr. (cat. by C. C. Sellers).

REFERENCES: O. Larkin, *Art and Life in America,* New York, 1960, p. 112, pl. 3 (color); B. Novak, *American Painting of the Nineteenth Century,* New York, 1969, p. 22, fig. 1-9; J. Flexner, *Nineteenth Century American Painting,* New York, 1970, repr. p. 193 (detail).

According to the inscription, this still life was painted for John Ashe Alston (1780–1832), a brother-in-law of the painter Washington Allston (q.v.). Alston owned large rice and indigo plantations on the Waccamaw River near Georgetown, S.C., and was one of the most progressive art collectors in the South; his collection included paintings by West, Stuart, Sully, Vanderlyn, Gainsborough and Reynolds (Paul Staiti, "Samuel F. B. Morse in Charleston," *South Carolina Historical Magazine,* LXXIX, Apr. 1978, pp. 95–6).

The Toledo painting is the only record of Alston's relationship with Peale, who traveled widely in the South each winter from 1818 to 1821. While there is no record of his having been in Georgetown or Charleston at that time, the nature of the inscription suggests the picture may have been a gift to Alston, though Alston frequently commissioned paintings which were sent to him in South Carolina.

Peale usually dated those still lifes which he inscribed, often noting where they were painted. The Peale scholar Edward Dwight has dated the Toledo painting ca. 1818 because it is close in style to *Still Life with Wine Glass* dated 1818 (Detroit Institute of Arts).

The orange peel motif is found in other still lifes by Peale, and was a pun on the artist's name.

REMBRANDT PEALE

1778–1860. Born in Bucks County, Pa. Son and pupil of Charles Willson Peale. 1802–03 studied with Benjamin West in London. 1804 returned to Philadelphia. 1805 helped found PAFA. 1808 and 1809–10 in Paris, where he met J. L. David and F. P. Gérard. 1814 opened Peale's Museum and Gallery of Fine Arts in Baltimore. 1825 president of American Academy of Fine Arts; 1826 a founder of NAD. 1828–30 and 1832–34 in Europe. 1834 settled in Philadelphia. Peale painted history subjects, and was a gifted portraitist.

John B. Pendleton PL. 20

[Ca. 1828] Oil on canvas
30-1/16 x 25-1/16 in. (76.4 x 63.7 cm.)

Acc. no. 41.34

COLLECTIONS: John B. Pendleton, 1828; Pendleton family; (Macbeth, 1941).

EXHIBITIONS: Boston Athenaeum, *Second Exhibition of Paintings,* 1828, no. 137 (lent by J. Pendleton); Detroit Institute of Arts, *The Peale Family: Three Generations of American Artists,* 1967, no. 150, repr.

REFERENCES: M. Swan, *The Athenaeum Gallery, 1827–1873,* Boston, 1940, p. 38; D. Tatham, "The Pendleton-Moore Shop, Lithographic Artists in Boston, 1825–1840," *Old-Time New England,* LXII, Oct.-Dec. 1971, repr. frontispiece.

John B. Pendleton (1798–1866) and his older brother William, pioneers in commercial lithography in America, were closely associated with the Peales. In 1816 the Pendletons helped to install a gas lighting system in the Baltimore Peale Museum, and in 1820–21 John managed the successful tour of Rembrandt Peale's huge and sensational allegorical canvas, *The Court of Death* (Detroit Institute of Arts). In 1825 the Pendletons opened in Boston the first lithography firm in the country, and they published all but three of Rembrandt Peale's lithographs.

This portrait was painted in or shortly before 1828, as it was exhibited in Boston that year, when Peale and Pendleton were working together most closely.

IRENE RICE PEREIRA

1907–1971. Born in Chelsea, Mass. 1927–30 studied at ASL with Jan Matulka and Richard Lahey, and in 1931 briefly with Amedée Ozenfant in Paris. In Switzerland, Italy and North Africa. 1935–39 taught at Design Laboratory of WPA Federal Art Project. 1937 began working in a geometric abstract mode. 1938 member American Abstract Artists group. Late 1930s began to experiment with glass, parchment and metal. From 1955 published theories on aesthetics and metaphysics which strongly influenced her painting.

Projecting Planes PL. 227

[1947] Oil on canvas
30⅛ x 40⅛ in. (76.5 x 101.9 cm.)
Signed lower right: I. Rice Pereira

Acc. no. 48.71
Museum Purchase Fund

COLLECTIONS: (A.C.A. Gallery, New York).

EXHIBITIONS: Toledo Museum of Art, *35th Annual,* 1948, no. 61; New York, Whitney Museum of American Art, *Juliana Force and American Art,* 1949, no. 96, repr.; New York, Whitney Museum of American Art, *Loren*

MacIver and I. Rice Pereira, 1953, no. 27 (cat. by J. I. H. Baur).

HOBSON PITTMAN

1900–1972. Born in Epworth, N.C. 1921–22 at Pennsylvania State University. 1920–31 summers at Woodstock, N.Y. 1924 enrolled at Carnegie Institute of Technology; 1925 at Columbia University. Most important art studies were trips in 1928, 1930 and 1935 to Europe, where he was influenced by late cubism and the School of Paris. From 1949 taught at PAFA. Painter of nostalgic and visionary still lifes and interior subjects.

The Buffet PL. 222

[Ca. 1948] Oil on canvas
31⅞ x 45-1/16 in. (81 x 114.5 cm.)
Signed upper right: Hobson Pittman

Acc. no. 50.270
Museum Purchase Fund

COLLECTIONS: (Milch Gallery, New York).

EXHIBITIONS: Toledo Museum of Art, *37th Annual,* 1950, no. 59; Raleigh, North Carolina Museum of Art, *Hobson Pittman Retrospective Exhibit: His Work Since 1920,* 1963, no. 27, repr.

OGDEN MINTON PLEISSNER

1905–. Born in Brooklyn, N.Y. Studied at ASL with Frank V. DuMond and George Bridgman. From the late 1920s until ca. 1941 spent summers sketching in the West, chiefly Wyoming. As a watercolor and oil painter, Pleissner is best known for landscape and architectural subjects.

The Arno, Florence PL. 234

[1949] Oil on canvas
24-3/16 x 40 in. (61.5 x 101.5 cm.)
Signed lower right: Pleissner

Acc. no. 51.307
Museum Purchase Fund

COLLECTIONS: (Macbeth).

EXHIBITIONS: Pittsburgh, Carnegie Institute, *Painting in the United States,* 1949, no. 3, repr. pl. 43; Detroit Institute of Arts and Toledo Museum of Art, *Travelers in Arcadia: American Artists in Italy 1830–1875,* 1951, no. 16.

This view of the Arno is based on sketches made while Pleissner was on assignment for *Life* magazine shortly after World War II. Pleissner noted, ". . . the stark simplicity of the architecture, the beautiful tones of ochre, sienna, and the umbers all bathed in warm sunlight were all new to me. Also the church, San Frediano in Cestello, seemed something special to me and I guess I have done six or seven paintings where it is an important part of the composition" (letter, Apr. 11, 1965). According to the dealer, it was painted in the spring of 1949.

FAIRFIELD PORTER

1907–1975. Born in Winnetka, Ill. 1928 B.A. Harvard College. 1928–30 studied with T. H. Benton and Boardman Robinson at ASL. Porter was influenced by Bonnard and Vuillard, and later by his friend and mentor Willem de Kooning. In the 1950s he wrote criticism for *Art News, The Nation,* and other periodicals. While as a painter he was an intimist realist, Porter was also a sympathetic critic of the Abstract Expressionists, many of whom were his friends.

Frank O'Hara PL. 256

[1957] Oil on canvas
63⅞ x 45⅞ in. (162.3 x 116.5 cm.)
Signed and dated lower right: Fairfield Porter 57

Acc. no. 77.31
Gift of Edward Drummond Libbey

COLLECTIONS: Estate of the artist; (Susanne Hilberry Gallery, Birmingham, Mich.).

EXHIBITIONS: New York, Hirschl and Adler Galleries, *Fairfield Porter: Figurative Painting,* 1979.

REFERENCES: M. Feldman, "Frank O'Hara: Lost Times and Future Hopes," *Art in America,* LX, Mar. 1972, repr. p. 55.

Frank O'Hara (1926–1966), poet, playwright, and a curator at the Museum of Modern Art from 1955 until his death, was closely associated with the New York School artists. His many articles include one on Porter (*Art News,* LIII, Jan. 1955, pp. 38–41, 66–7). He organized many important exhibitions, and collaborated with several artists who incorporated poetry by him in their prints.

MAURICE BRAZIL PRENDERGAST

1859–1924. Born in St. John's, Newfoundland. Raised in Boston. Worked as a commercial artist. Chiefly self-

taught. 1891–94 in Paris, where he saw work by Cézanne, Gauguin and the Nabis. 1894 returned to join framing business with his brother Charles. 1897–1914 chiefly in Boston; several trips to New York and Europe. 1908 exhibited with The Eight and in the 1913 Armory Show. Prendergast was one of the first Americans to be influenced by the French Post-Impressionists.

The Flying Horses [COLOR PL. VI] PL. 151

[Ca. 1901] Oil on canvas
23⅞ x 32⅛ in. (60.7 x 81.5 cm.)
Signed lower right: Prendergast
Inscribed on reverse (covered by relining): The Flying
 Horses/The Flying Horses/Maurice B. Prendergast

Acc. no. 57.22

COLLECTIONS: Charles Prendergast; (C. W. Kraushaar Art Galleries, New York); (Hirschl and Adler, New York).

EXHIBITIONS: Brooklyn Museum, *The Eight*, 1944, no. 48, repr. (dated 1906–12; cat. by J. I. H. Baur); New York, C. W. Kraushaar Art Galleries, *Maurice Prendergast*, 1950, no. 5 (dated 1907); Boston, Museum of Fine Arts, *Maurice Prendergast*, 1960, no. 16, repr. (color) (dated 1908–09; cat. by H. Rhys); New York, Knoedler, *Maurice Prendergast*, 1966, no. 29, repr.; Toledo Museum of Art, *Heritage and Horizon: American Painting 1776–1976*, 1976, no. 35, repr. (color); Edinburgh, Royal Scottish Academy, *The Modern Spirit: American Painting 1908–1935*, 1977, no. 17 (cat. by M. Brown).

REFERENCES: M. Brown, *American Painting from the Armory Show to the Depression*, Princeton, 1955, repr. p. 53; W. Homer, *Robert Henri and His Circle*, Ithaca, N.Y., 1969, p. 102, fig. 14; M. Young, *The Eight*, New York, 1973, p. 136, repr. (color); College Park, University of Maryland Art Gallery, *Maurice Prendergast*, 1976, in no. 36 (cat. by E. Green and J. Hayes).

In the summer of 1900 Prendergast and his brother, the artist Charles Prendergast (1863–1948), with whom he was always on the closest terms, painted at several resorts on the New England coast. This composition may have been inspired by Nahant near Boston, as a closely related watercolor has traditionally been associated with Nahant (Springfield [Mass.] Museum of Fine Arts).

Prendergast dated very few paintings. The Toledo canvas, heretofore variously dated 1906–12, was probably painted several years earlier. It is similar in composition and subject to the Springfield watercolor, which can be dated ca. 1901 from its early exhibition history. According to Eleanor Green, who organized the 1976 Maryland Prendergast exhibition (see References), the long, broad brushstrokes, thinly applied paint and areas of

bare canvas in the Toledo picture are characteristic of Prendergast's early oils (letter, Nov. 28, 1978).

JOSEPH RAFFAEL

1933–. Born in Brooklyn, N.Y. 1951–54 studied at Cooper Union. 1956 B.F.A. Yale School of Fine Arts, where he studied with Josef Albers. 1958–59 studied in Florence and Rome. 1969 moved to San Geronimo, Calif., where he lives. Raffael is a Photo-Realist whose painterly style emphasizes light and color.

Water Painting No. 1 PL. 272

[1972] Oil on canvas
78¼ x 114¼ in. (198.7 x 290.2 cm.)
Signed and dated on reverse: Joseph Raffael/1 1972

Acc. no. 74.44
Gift of Edward Drummond Libbey

COLLECTIONS: (Nancy Hoffman Gallery, New York).

EXHIBITIONS: Berkeley (Calif.), University Art Museum, *Water Painting*, 1973, no. 1.

REFERENCES: R. Hughes, "A Slice of the River," *Time*, Oct. 15, 1973, p. 112, repr. p. 113 (incorrectly dated 1973).

This is Raffael's first "water painting" in a continuing series, now numbering about twenty canvases, that was inspired by a color slide taken by Raffael's friend William Allan, also a painter.

Raffael was attracted to this theme because, "I wanted to explore and describe the possibility of doing a painting with a realistic subject which was very abstract. In fact, I felt that water, always moving and therefore always changing, was in essence the most abstract of realistic subjects. It also gave me the opportunity to deal with a shimmering and special light energy. How light reflects on water" (letter, Feb. 20, 1979).

HENRY WARD RANGER

1858–1916. Born in Syracuse, N.Y. 1873–75 attended Syracuse University. 1884 settled in New York. Traveled extensively abroad. From 1899 summers at Old Lyme, Conn., where he started a short-lived "American Barbizon" artists' colony devoted to plein-airism. 1903 moved studio to Noank, Conn. 1906 N.A. Influenced by Barbizon and Hague School painters; specialized in woodland subjects.

The Woodland Pool PL. 127

[Ca. 1894] Oil on canvas
28-1/16 x 36 in. (71.3 x 91.5 cm.)
Signed and dated lower left: H. W. Ranger 189(4?)

Acc. no. 26.150
Gift of Elsie C. Mershon in memory of Edward C.
 Mershon

Forest and Stream PL. 126

[1910] Oil on canvas
36 x 28 in. (91.3 x 71 cm.)
Signed and dated lower left: H. W. Ranger. 1910
Inscribed on stretcher: Turkey's Point

Acc. no. 12.13

COLLECTIONS: (Henry Reinhardt, New York).

ROBERT RAUSCHENBERG

1925–. Born in Port Arthur, Tex. Studied at Kansas City
Art Institute, 1947–48; in Paris at Académie Julian, 1948;
at Black Mountain College with J. Albers and J. Cage,
1949; at ASL with M. Kantor and V. Vytlacil, 1948–52.
1950 window display designer. A major figure of the
second generation of the New York School, strongly in-
fluenced by Duchamp, Cage and the European dadaists
and surrealists. Rauschenberg has incorporated "found"
objects and popular images in his work in an effort to
obscure the boundaries between art and life.

Round Sum PL. 261

[1964] Oil and silkscreen ink on canvas
69¼ x 49 in. (175.9 x 124.5 cm.)
Signed and dated on reverse: Round Sum/Rauschen-
 berg/1964

Acc. no. 76.33
Gift of the Woodward Foundation

COLLECTIONS: Woodward Foundation, Washington,
D.C., 1964–76.

In 1962 Rauschenberg began to incorporate in his paint-
ings silkscreen images taken from newspaper and maga-
zine photographs. Many of the motifs, such as the Statue
of Liberty, army helicopter, construction site, and sail-
boat found in *Round Sum,* were used in different con-
texts in several of Rauschenberg's early silkscreened
paintings of 1962–65 and lithographs of 1964.

AD REINHARDT

1913–1967. Adolph Frederick Reinhardt. Born in Buffalo,
N.Y. 1935 B.A. Columbia University. 1936 studied at
NAD with Carl Holty and Francis Criss. 1936–39 easel
painter for WPA. 1937–47 member of American Abstract
Artists group. 1948 a founder of Subjects of the Artist
School. Painter, teacher, cartoonist, art historian and
critic. Influenced by suprematism, neoplasticism and
synthetic cubism; Reinhardt sought a rational art devoid
of imagery, emotion and evidence of the creative process.

Number 1, 1951 PL. 253

[1951] Oil on canvas
79⅞ x 34 in. (202.5 x 86.3 cm.)

Acc. no. 52.99
Museum Purchase Fund

COLLECTIONS: (Betty Parsons Gallery, New York).

EXHIBITIONS: Toledo Museum of Art, *39th Annual,* 1952,
no. 65.

REFERENCES: R. Phillips, "Abstract Expressionism," *To-
ledo Museum of Art Museum News,* XIX, No. 4, 1977,
p. 103, repr. pl. IV (color).

DEBORAH REMINGTON

1935–. Born in Haddonfield, N.J. The painter Frederic
Remington (q.v.) was a great-uncle. 1947 B.F.A. San
Francisco Art Institute, where she studied with Clyfford
Still, David Park and Elmer Bischoff. 1957–59 in the Far
East; studied calligraphy. 1968 settled in New York.
1973 began teaching at Cooper Union. Her early work
was derived from abstract expressionism. Since 1963 she
has developed a hard-edged, luminous style, and an
enigmatic imagery with both organic and mechanical
associations.

Chatham PL. 277

[1973] Oil on canvas
78 x 74 in. (198.1 x 188 cm.)
Signed and dated on reverse: Remington/1973

Acc. no. 75.14
Purchased with funds from the National Endowment for
 the Arts and an Anonymous Donor

COLLECTIONS: (Bykert Gallery, New York).

EXHIBITIONS: New York, Bykert Gallery, *Deborah Rem-
ington,* 1974; Art Institute of Chicago, *Seventy-First
American Exhibition,* 1974, no. 72; Toledo Museum of
Art, *Image, Color and Form: Recent Paintings by Eleven
Americans,* 1975, no. 24 (cat. by R. Phillips).

FREDERIC REMINGTON

1861–1909. Born in Canton, N.Y. 1878–80 at Yale School of Fine Arts. 1881 sketched in the West. By 1887 illustrations regularly appeared in *Harper's Weekly*, *Century* and *Outing* magazines; began exhibiting regularly at NAD. Studied briefly at ASL, and with J. Alden Weir. 1890–91 covered Indian Wars as artist-correspondent. 1895 settled in New Rochelle, N.Y., and executed first bronze sculpture. 1898 covered the Spanish American War in Cuba. By 1900 Remington was the most popular chronicler of life on the Western frontier.

Indians Simulating Buffalo PL. 150

[1908] Oil on canvas
26-15/16 x 40⅛ in. (68.9 x 102 cm.)
Signed and dated lower left: Frederic Remington/1908
Inscribed lower margin: COPYRIGHT 1908 BY P. F.
 COLLIER & SONS.

Acc. no. 12.1

COLLECTIONS: (Henry Reinhardt, New York, 1912).

EXHIBITIONS: New York, Wildenstein, *How the West was Won*, 1968, no. 14, repr.; Fort Worth, Amon Carter Museum of Western Art, *Frederic Remington*, 1973, no. 73, repr. (cat. by P. Hasserick); Fort Worth, Amon Carter Museum of Western Art, *The Bison in Art*, 1977, p. 82, repr. (color) p. 83 (cat. by L. Barsness).

REFERENCES: P. F. Collier (publisher), *Eight New Remington Paintings*, 1909, repr. (color); *Collier's Magazine*, XLIII, Sep. 18, 1909, repr. p. 10; H. McCracken, *The Frederic Remington Book*, Garden City, N.Y., 1966, p. 99, fig. 128 (reproduced from Collier's illustration).

Indians camouflaged themselves to look like grazing buffalo by slumping over the withers of their ponies and covering themselves with hides. This common hunting practice was later used to scout white men. A wagon train barely visible in the right distance suggests these Indians are scouts rather than hunters.

Remington's paintings of 1907–08 reflect increasing impressionist influence, partly through his teacher, J. Alden Weir, and also from Monet, whom Remington admired. In this canvas Remington adapted the broken brushwork and high-keyed palette of impressionism to record the intense sunlight and parched landscape of the western plains.

HENRY REUTERDAHL

1870–1925. Born in Malmö, Sweden. Little formal training. 1893 artist-reporter at World's Columbian Exposition in Chicago for a Swedish weekly; remained in Chicago as illustrator for *Leslie's Weekly*. 1897 settled in New York; began illustrations of U.S. Navy for *Harper's Weekly* and other periodicals. Navy artist in World War I. Reuterdahl was America's leading naval artist of the early twentieth century.

Blast Furnaces PL. 147

[1912] Oil on canvas
32-1/16 x 39⅞ in. (81.5 x 101.3 cm.)
Signed and dated lower right: Reuterdahl '12

Acc. no. 14.76
Museum Purchase Fund

COLLECTIONS: Bought from the artist.

EXHIBITIONS: New York, Association of American Painters and Sculptors, *International Exhibition of Modern Art*, 1913, no. 952; Utica, Munson-Williams-Proctor Institute, *1913 Armory Show: 50th Anniversary Exhibition*, 1963, no. 952, repr. p. 132; Annapolis, United States Naval Academy Museum, *The Art of Henry Reuterdahl*, 1977, no. 32.

REFERENCES: M. Brown, *The Story of the Armory Show*, New York, 1963, no. 952, p. 284.

Originally only invited work was to be exhibited in the 1913 Armory Show. However, demands were so great from excluded artists that the Domestic Committee, chaired by William Glackens, selected a group of works submitted by uninvited artists that included Reuterdahl's *Blast Furnaces*.

WILLIAM TROST RICHARDS

1833–1905. Born in Philadelphia. 1850–53 designer of ornamental metalwork; studied with Paul Weber, Philadelphia landscape painter. 1855 in Europe. 1863 member Association for the Advancement of Truth in Art. 1866–67 in Italy, Switzerland, Germany. 1870s increasing use of watercolors. 1878–80 in England; 1885 West Coast; 1890s several trips to British Isles. Specialist in marine subjects.

Near Durness, Scotland PL. 50

Oil on academy board
9 x 16 in. (22.8 x 40.6 cm.)

Acc. no. 54.81
Gift of National Academy of Design (Mrs. William T. Brewster Bequest)

COLLECTIONS: Anna Richards Brewster (daughter of the artist).

Sand Hills, Atlantic City, New Jersey PL. 51

Watercolor on paper
7⅞ x 13⅞ in. (20 x 35.3 cm.)
Inscribed on reverse: Sand Hills/Atlantic City
Acc. no. 54.82
Gift of National Academy of Design (Mrs. William T.
 Brewster Bequest)

New Jersey Coast PL. 52

Watercolor on paper
7½ x 14¾ in. (19 x 37.5 cm.)
Acc. no. 54.83
Gift of National Academy of Design (Mrs. William T.
 Brewster Bequest)

New England Coast PL. 53

Watercolor on paper
7¼ x 13½ in. (18.5 x 34.3 cm.)
Acc. no. 54.84
Gift of National Academy of Design (Mrs. William T.
 Brewster Bequest)

JULIAN WALBRIDGE RIX

1850–1903. Born in Peacham, Vt. Ca. 1867 settled in
San Francisco. Self-taught. 1872 worked as a commercial
artist; turned to landscape painting, mostly of California
subjects. Ca. 1888 moved to New York, with frequent
trips to California. Illustrator for *Harper's Magazine* and
Harper's Weekly. His landscapes were influenced by the
Barbizon artists.

Sunshine and Shadow PL. 101

Oil on canvas
47⅛ x 59⅝ in. (119.8 x 151.5 cm.)
Signed lower left: JULIAN RIX
Acc. no. 13.81
Gift of Arthur J. Secor

ALEXANDER ROBINSON

1867–1952. Born in Portsmouth, N.H. Studied at Lowell
School of Design and Boston Museum School, and in
Paris at Académie Julian. Lived several years in Holland.
Worked chiefly in watercolor.

Interior of a Dutch Church PL. 134

[1909] Gouache on board
27 x 23 in. (68.6 x 58.4 cm.)
Signed and dated lower left: Alexander Robinson/'09
Acc. no. 10.19
Gift of Toledo Federation of Women's Clubs

THEODORE ROBINSON

1852–1896. Born in Irasburg, Vt.; raised in Evansville,
Wis. 1874 studied at NAD. 1876–79 studied in Paris with
Carolus-Duran, Gérôme and Constant. 1878 met Whist-
ler in Venice. 1881 member Society of American Artists.
1881–83 mural assistant to La Farge. 1884–92 in France.
1887 met Monet, who became a close friend. 1892 re-
turned to New York. One of the first Americans to be
directly influenced by the French Impressionists.

Girl at Piano PL. 104

[Ca. 1887] Oil on canvas
20 x 16 in. (50.8 x 40.8 cm.)
Signed upper right: To my friend Louis Ritter -/Th.
 Robinson
Acc. no. 50.297
Museum Purchase Fund

COLLECTIONS: Louis Ritter, to 1892; Vincent I. Bowditch;
Mrs. Henry I. Bowditch; Harvey F. Additon; (Good-
man-Walker, Boston, 1943); Donald B. Wilson, West
Medford, Mass., 1943–48; (Charles D. Childs, Boston,
1948–50).

EXHIBITIONS: Brooklyn Museum, *Theodore Robinson,
1852–1896*, 1946, no. 120, pl. v (cat. by J. I. H. Baur);
Detroit Institute of Arts, *Painting in America, The Story
of 450 Years*, 1957, no. 128; Madison, Memorial Union
Art Gallery, University of Wisconsin, *Theodore Robin-
son*, 1964, no. 10.

REFERENCES: E. Richardson, *Painting in America, The
Story of 450 Years*, New York, 1956, p. 303, fig. 120;
S. Johnston, *Theodore Robinson, 1852–1896* (exh. cat.),
Baltimore Museum of Art, 1973, p. 17.

According to the inscription, Robinson painted the To-
ledo canvas as a gift to the Boston painter Louis Ritter
(1854–1892), a Cincinnati native and pupil of Duveneck;
in 1887 both Robinson and Ritter were reported to be
at Giverny, where Claude Monet had a studio (*The Art
Amateur*, Oct. 1887, p. 93).

Robinson painted this subject at least four times. Baur
based his dating of this unfinished sketch on its similarity

of subject and style to *At the Piano*, dated 1887 (Washington, National Collection of Fine Arts).

Robinson relied extensively on photographs for most of his figure subjects. Although no photograph related to this composition is known, the faintly visible grid pattern which Robinson frequently used to transfer the composition from the photograph to the canvas, strongly suggests a photograph was also used here.

MARK ROTHKO

1903–1970. Born in Dvinsk, Russia. 1913 emigrated to U.S. 1921–23 at Yale University. 1923 moved to New York. 1924–29 studied at ASL with Max Weber and Vaclav Vytlacil. 1935–40 member of The Ten. 1936–37 easel painter for WPA Federal Art Project. During late 1930s interested in mythology and primitive art. 1948 founding member of Subjects of the Artist School. A major figure of the New York School who influenced the development of color field painting, Rothko sought to express timeless and tragic themes of human experience.

Untitled PL. 265

[1960] Oil on canvas
92⅞ x 81 in. (235.9 x 205.7 cm.)
Signed and dated on reverse: MARK ROTHKO/1960

Acc. no. 70.55
Gift of Edward Drummond Libbey

COLLECTIONS: Estate of the artist; (Marlborough-Gerson, New York).

EXHIBITIONS: Toledo Museum of Art, *Heritage and Horizon: American Painting 1776–1976*, 1976, no. 54, repr. (color); New York, Solomon R. Guggenheim Museum, *Mark Rothko, 1903–1970, A Retrospective*, 1978, no. 156, repr. (cat. by D. Waldman).

REFERENCES: R. Phillips, "Abstract Expressionists," *Toledo Museum of Art Museum News*, XIX, No. 4, 1977, pp. 99, 101, repr. pl. III (color).

ALBERT PINKHAM RYDER

1847–1917. Born in New Bedford, Mass. Ca. 1867 moved to New York. Chiefly self-taught except for brief study at NAD and informal instruction from William E. Marshall, whose religious pictures influenced him. 1877 and 1882 visits to Europe. 1887 and 1896 made Atlantic crossings to study the ocean. 1877 a founder of Society of American Artists. 1906 N.A. Ryder is one of the great visionaries of late nineteenth century American romantic painting.

Spring PL. 73

[Ca. 1879] Oil on canvas
14-3/16 x 18-11/16 in. (36 x 47.5 cm.)

Acc. no. 23.3134

COLLECTIONS: Bought from the artist by James W. Ellsworth, New York; (Knoedler, New York, 1923); (Chester H. Johnson, Chicago).

EXHIBITIONS: New York, Society of American Artists, *Catalogue of the Second Exhibition*, 1879, no. 146; Art Institute of Chicago, *Art Collections Owned by James W. Ellsworth*, 1890, no. 84; Venice, *XXI Biennale internationale d'arte*, 1938, United States no. 46; Pittsburgh, Carnegie Institute, *A Century of Landscape Painting*, 1939, no. 15; New York, Whitney Museum of American Art, *Albert P. Ryder, Centenary Exhibition*, 1947, no. 40.

REFERENCES: W. Brownell, "The Younger Painters of America: First Paper," *Scribner's Monthly*, XX, May 1880, repr. p. 6 (engraving); C. Ekford (Charles de Kay), "A Modern Colorist, Albert Pinkham Ryder," *Century Illustrated Monthly Magazine*, XL, June 1890, p. 259; F. Sherman, *Albert Pinkham Ryder*, New York, 1920, p. 70, repr. opp. p. 54; L. Goodrich, *Albert P. Ryder*, New York, 1950, pp. 14, 113, pl. 5.

While Ryder never dated his work, *Spring* was painted about 1879, as it was included in the Society of American Artists exhibition that year. It clearly fits into Ryder's work of the 70s, when he painted small, idyllic yet relatively naturalistic landscapes before developing the more dramatic style of his maturity.

GORDON SAMSTAG

1906–. Born in New York. 1924–28 studied at NAD with Charles W. Hawthorne, and in Paris at Académie Colarossi. 1930–61 taught at NAD. 1951–61, director of American School of Art, New York. Has taught in Australia since 1961.

Proletarian PL. 195

[1934] Oil on canvas
48-5/16 x 42 in. (122.7 x 106.7 cm.)

Acc. no. 35.34
Museum Purchase Fund

COLLECTIONS: Bought from the artist.

EXHIBITIONS: Toledo Museum of Art, *22nd Annual*, 1935, no. 54; New York, Montross, *Gordon Samstag*, 1936.

JOHN SINGER SARGENT

1856–1925. Born in Florence, Italy of an American family, who encouraged his early interest in art. 1874 his family moved to Paris, where he studied with Carolus-Duran. 1876 first trip to U.S. Traveled to Italy, Spain, Holland and studied the old masters, particularly Hals and Velazquez. 1885 settled in London. 1890–1925 carried out large mural commissions in Boston. Sargent was among the most cosmopolitan artists of his time, and by the mid-1880s had become the most sought-after portraitist of Anglo-American society. He was also a brilliant watercolorist.

Florence Addicks PL. 96

[1890] Oil on canvas
30 x 25⅛ in. (76.2 x 63.8 cm.)
Signed upper left: John S. Sargent
Dated upper right: 1890

Acc. no. 33.36
Gift of Arthur J. Secor

COLLECTIONS: Tolley A. Biays, Baltimore; Bryn Mawr Trust Company, Bryn Mawr, Pa., 1926; (Knoedler, New York); Arthur J. Secor, Toledo, 1929–33.

EXHIBITIONS: Philadelphia, PAFA, *121st Annual Exhibition*, 1926, no. 217 (lent by Bryn Mawr Trust Company, as *Portrait of a Young Lady*).

REFERENCES: D. McKibben, *Sargent's Boston,* Boston, 1956, p. 81.

Florence Addicks (1866–1942) was the daughter of a Philadelphia industrialist, John Edward O'Sullivan Addicks.

According to the Sargent scholar David McKibben, Addicks, his second wife and his daughter were at the seaside resort of Nahant, Mass. in the summer of 1890 when Sargent painted this portrait (letter, Sep. 15, 1970).

Princess Demidoff PL. 95

[Ca. 1895–96] Oil on canvas
65¾ x 38-3/16 in. (167 x 97 cm.)
Signed upper left: John S. Sargent

Acc. no. 25.109

COLLECTIONS: Prince Demidoff de San Donato, 1895–1925; (Spink & Son, London); (John Levy Galleries, New York); (Henry Reinhardt, New York).

EXHIBITIONS: London, Royal Academy, 1896, no. 402 (as *Portrait of a Lady*).

REFERENCES: D. McKibben, *Sargent's Boston,* Boston, 1956, p. 92.

Princess Demidoff, née Sophie Illarionovna, Countess Woronzoff-Daschkoff (1871–1953), belonged to one of the richest and most distinguished Russian families. Her father was a high ranking member of the courts of Alexander III and Nicholas II. In 1893 she married Elim Demidoff, whose family had built a fortune chiefly in mining gold, silver, copper and platinum.

According to Prince Demidoff, Sargent painted this portrait in 1895 or 1896 in London, where the Prince was first secretary of the Russian embassy (letter, Feb. 26, 1925). In 1913 Demidoff was appointed Ambassador to Greece, and Athens remained the couple's home after the Russian Revolution.

According to her nephew, Count Hilarion Woronzoff-Daschkoff, Sargent painted two other portraits of the Princess, an oval bust still in Athens, the other in an unknown Russian collection (letter, Oct. 26, 1978).

JOHN SEERY

1941–. Born in Cincinnati, Ohio. At Miami (Ohio) University 1959–63; Ohio State University 1963–64. Settled in New York, 1964. Drawing from both abstract expressionism and color field painting, Seery belongs to the group of young New York artists whose work stresses the expressive qualities of surface and of mixed color.

Letter to a Poet PL. 273

[1973] Acrylic on canvas
91 x 78-1/16 in. (198 x 131.1 cm.)
Signed, dated and inscribed on reverse: John Seery/ 3/73/"Yellow Noon"

Acc. no. 75.16
Gift of Toledo Modern Art Group and matching funds provided by the National Endowment for the Arts

COLLECTIONS: (André Emmerich Gallery, New York).

EXHIBITIONS: Madison (Wis.) Art Center, *John Seery Paintings,* 1974, repr. (color) (cat. by C. Ratcliff); Toledo Museum of Art, *Image, Color and Form: Recent Paintings by Eleven Americans,* 1975, no. 29, repr. (cat. by R. Phillips).

At the time he painted this work Seery was deeply involved with poetry, largely through two close friends, the poets and critics Carter Ratcliff and Peter Schjeldahl, both of whom have written about Seery's work. Originally, Seery titled this canvas *Yellow Noon,* but he later changed the title in response to a letter from Ratcliff.

ZOLTAN SEPESHY

1898–1974. Born in Kassa, Hungary. Studied at Royal Academy of Art at Budapest, and in Vienna and Paris. 1921 settled in Detroit. 1926–28 instructor at Detroit Society of Arts and Crafts. 1930–47 taught at Cranbrook Academy of Art; 1947–59 director; 1959–66 president. 1946 published *Tempera Painting*. Still life, portrait, landscape and mural painter.

Sandscape PL. 211

[Ca. 1938] Tempera on masonite
24⅞ x 29-15/16 in. (63.2 x 76 cm.)
Signed lower right: Z. Sepeshy
Inscribed on reverse: "SANDSCAPE"

Acc. no. 39.8
Museum Purchase Fund

COLLECTIONS: Bought from the artist.

EXHIBITIONS: New York, Midtown Galleries, *Zoltan Sepeshy*, 1938; Syracuse (N.Y.), Lowe Art Center, *Zoltan Sepeshy: Forty Years of His Work*, 1966, p. 75, repr. (dated 1939; cat. by L. Schmeckebier); New York, American Academy of Arts and Letters, *Memorial Exhibition, Adolph Gottlieb, Leon Kroll, Zoltan Sepeshy, Moses Soyer*, 1975, no. 30.

REFERENCES: Z. Sepeshy, *Tempera Painting*, New York and London, 1946, repr. p. 67.

Faint Sunshine PL. 212

[1940] Watercolor on paper
19-11/16 x 28-5/16 in. (50 x 72 cm.)
Signed lower right: Z. Sepeshy

Acc. no. 47.14
Gift of the artist in memory of William A. Gosline, Jr.

EXHIBITIONS: Syracuse (N.Y.), Lowe Art Center, *Zoltan Sepeshy: Forty Years of His Work*, 1966, repr. p. 40 (dated 1940; cat. by L. Schmeckebier).

CHARLES SHEELER

1883–1965. Born in Philadelphia. Studied 1900–03 at Philadelphia Industrial School of Art; 1903–06 with W. M. Chase at PAFA and in Europe. 1908–09 in Italy and Paris, where he met the Steins. 1910–20 influenced by Cézanne, cubism and futurism. Exhibited at 1913 Armory Show. 1919 settled in New York. 1912-ca. 1932 a commercial photographer, specializing in architecture, a recurrent theme in his painting. While his earlier subjects were rural, after the mid-1940s he increasingly painted and photographed industrial themes.

Variations in Red PL. 228

[1949] Oil on canvas
15-1/16 x 23 in. (38.3 x 58.5 cm.)
Signed and dated lower right: Sheeler—49
Inscribed on cardboard backing: Charles Sheeler/1949

Acc. no. 49.107
Museum Purchase Fund

COLLECTIONS: (Downtown Gallery, New York).

EXHIBITIONS: New York, Downtown Gallery, *The Artist Speaks*, 1949, no. 18; Toledo Museum of Art, *36th Annual*, 1949, no. 68; New York, Downtown Gallery, *Paintings, 1949 to 1951, by Charles Sheeler*, 1951; Los Angeles, University of California Art Galleries, *Charles Sheeler, A Retrospective Exhibition*, 1954, no. 33; Allentown (Pa.) Art Museum, *Charles Sheeler, Retrospective Exhibition*, 1961, no. 39; Washington, National Collection of Fine Arts, *Charles Sheeler*, 1968, no. 119, repr. p. 133.

REFERENCES: M. Friedman, *Charles Sheeler*, New York, 1975, p. 141, repr. (color) p. 196.

For three years, beginning with the month he spent as artist-in-residence at Phillips Academy, Andover, Mass. in 1946, Sheeler repeatedly painted and photographed an abandoned textile mill at Ballardvale, a small manufacturing town near Andover.

As Bartlett Hayes pointed out, Sheeler's Ballardvale paintings show a change in style and concept, color becoming more brilliant and forms more simplified (Washington exh. cat., 1968, pp. 66–8). The later Ballardvale paintings of 1949, including the Toledo canvas, show a greater degree of abstraction than earlier pictures, achieved by organizing architectural planes into flatter patterns.

EVERETT SHINN

1876–1953. Born in Woodstown, N.J. Early training in mechanical drawing. 1893–97 artist-reporter in Philadelphia; studied at PAFA; attended weekly meetings at Henri's studio, where he met Luks, Glackens and Sloan. 1897 moved to New York and continued illustration. 1900 in Paris. Exhibited with The Eight in 1908, and in the 1910 Exhibition of Independent Artists. Shinn's interests in theater design and house decoration, as well as his work as a playwright and cinema art director, gradually drew him away from the circle of The Eight.

Winter Night PL. 154

[1903] Pastel and watercolor on board
20⅝ x 21⅞ in. (52.4 x 55.5 cm.)
Signed and dated lower right: E. Shinn/1903

Acc. no. 50.296
Museum Purchase Fund

COLLECTIONS: (Charles J. Childs, Boston).

This shows a corner of Trinity Church in lower Manhattan as seen from Rector Street.

Street in Winter—Sailors on Leave PL. 155

[1903] Pastel on board
14⅜ x 14-15/16 in. (36.5 x 38 cm.)
Signed and dated lower right: E. Shinn/1903

Acc. no. 52.26

COLLECTIONS: (Victor D. Spark, New York); (Macbeth).

WALTER SHIRLAW

1838–1909. Born in Paisley, Scotland. Ca. 1840 emigrated to New York with his family. Ca. 1850–55 apprenticed to an engraver. 1860s engraver in Chicago, where he helped found the Art Institute. 1870–76 studied in Munich and traveled in Europe. A founder and the first president of the Society of American Artists; a founder of and instructor at ASL. Muralist, portrait, genre and landscape painter.

Market Scene PL. 77

Watercolor on paper
6⅞ x 10 in. (17.5 x 25.4 cm.)
Signed lower right: W. Shirlaw

Acc. no. 13.25
Gift of Mrs. Walter Shirlaw

Hillside PL. 78

Watercolor on paper
6½ x 10⅛ in. (16.5 x 25.7 cm.)
Signed lower left: W. Shirlaw

Acc. no. 13.30
Gift of Mrs. Walter Shirlaw

Barnyard Scene PL. 79

Watercolor on paper
6 x 11¼ in. (15.2 x 28.5 cm.)
Signed lower right: W. Shirlaw

Acc. no. 13.32
Gift of Mrs. Walter Shirlaw

JOHN SLOAN

1871–1951. Born in Lock Haven, Pa. 1890–92 as a commercial artist, and learned to etch. 1892–93 at PAFA; met Robert Henri; became a newspaper artist. 1896–97 began to paint seriously at Henri's urging. 1904 settled in New York. 1902–05 illustrator. Exhibited with The Eight in 1908, and in the 1910 Exhibition of Independent Art-tists. Organizer and exhibitor, 1913 Armory Show. 1916–38 taught at ASL. 1918–51 president, Society of Independent Artists. 1919–50, summered in Santa Fe, N.M. 1939 published *Gist of Art*. Best known for etchings and paintings of New York life. Sloan was also an important teacher and supporter of the progressive independent art movement.

Movies PL. 157

[1913] Oil on canvas
19⅞ x 24 in. (50.5 x 61 cm.)
Signed lower right: John Sloan
Inscribed on reverse: MOVIES/John Sloan

Acc. no. 40.16
Museum Purchase Fund

COLLECTIONS: Bought from the artist through C. W. Kraushaar Art Galleries, New York.

EXHIBITIONS: New York, MacDowell Club, 1914; Buffalo, Albright Art Gallery, *9th Annual Exhibition of Selected Paintings by American Artists*, 1914, no. 103 (as *Movies*); San Diego, *Panama-California Exposition*, 1915, no. 27, repr.; New York, Whitney Museum of American Art, *John Sloan, 1871–1951*, 1952, no. 35, repr.

REFERENCES: Sloan Archives, Delaware Art Museum, in card file by the artist: "Night outside show. Carmine St., N.Y."; American Artist Group, *John Sloan*, New York, 1945, repr.; G. Holcomb, III, "A Catalogue Raisonné of the Paintings of John Sloan, 1900–1913," unpublished Ph.D. dissertation, University of Delaware, 1972, no. 187, repr.; J. Stern, "Robert Henri and the 1915 San Diego Exposition," *American Art Review*, II, Sep.-Oct. 1975, p. 117, repr. (color) p. 115.

JOHN SMIBERT

1688–1751. Born in Edinburgh, Scotland. Apprenticed to house painter. 1709 in London, where he worked as coach painter and copyist. Attended art academy on Great Queen Street. 1719–22 in Italy. 1722–28 active as portraitist in London. 1728 sailed to America. 1729 settled in Boston. Smibert brought the baroque portrait

style of Peter Lely and Godfrey Kneller to the colonies, where he set a new standard in portraiture.

Mrs. Nathaniel Cunningham PL. I

[1730] Oil on canvas
49⅞ x 40¼ in. (126.8 x 120 cm.)

Acc. no. 48.19

COLLECTIONS: By descent to Mrs. Henry D. Roger, 1882; Mrs. Charles F. Russell, by 1916; Mrs. Mary Otis Porter, ca. 1936; Miss Frances R. Porter and Mrs. William Stanley Parker, Boston, 1942–47; (Vose).

EXHIBITIONS: Boston Art Club, *American Painters Before the Revolution*, 1922, p. 12, no. 24; Boston, Museum of Fine Arts, *53 Early American Portraits*, 1935.

REFERENCES: F. Bayley, *Five Colonial Artists of New England*, Boston, 1929, p. 375, repr. (incorrectly as Sarah Kilby Cunningham); C. Bolton, ed., *American Portraits 1620–1825 Found in Massachusetts*, Boston, 1939, I, p. 100, no. 528; H. Foote, *John Smibert, Painter*, Cambridge, 1950, p. 149; C. Sellers, "Mezzotint Prototypes of Colonial Portraiture," *Art Quarterly*, XX, No. 4, Winter 1957, p. 434, no. 22c, repr. p. 438; W. Belknap, *American Colonial Painting: Materials for a History*, Cambridge, 1959, pp. 298, 348, repr. pl. XXV, no. 22c; J. Prown, *John Singleton, Copley*, Cambridge, 1966, I, p. 19, fig. 24; Massachusetts Historical Society, *The Notebook of John Smibert*, Boston, 1969, pp. 23, 89, 107.

Ann Boucher (1703– ?) married Captain Nathaniel Cunningham, a Boston merchant, in 1722. According to the entry in Smibert's *Notebook* (Public Record Office, London), this portrait was painted in November 1730, its size the standard half-canvas customarily used by Smibert, the price £40. The sitter's pose and the background are derived from the mezzotint by John Smith (1699) after Godfred Kneller's *The Countess of Ranelagh*.

Mrs. Cunningham's mother, Sarah Middlecott Boucher, had been painted by Smibert in February 1730. A portrait by John Greenwood of Sarah Kilby, a daughter-in-law of the Cunninghams, is also owned by the Museum.

ALBERT DELMONT SMITH

1886–1962. Born in New York. Studied at ASL with Frank DuMond and W. M. Chase. Worked in New York with summers at Southampton, Long Island. In the 1950s first director of the Heckscher Museum, Huntington, Long Island. Chiefly a portraitist.

Childe Hassam PL. 177

[1922] Oil on canvas
53⅞ x 36 in. (137 x 91.5 cm.)
Signed and dated lower left: Albert Smith 1922
Inscribed on reverse: Albert Delmont Smith/1922

Acc. no. 25.10
Gift of an Anonymous Donor

EXHIBITIONS: Toledo Museum of Art, *13th Annual*, 1924, no. 127.

The painter and printmaker Childe Hassam (1859–1935) was one of the principal American Impressionists. The Toledo collection includes two paintings and fifty-three prints by him.

JOSEPH LINDON SMITH

1863–1950. Born in Pawtucket, R.I. Studied at the Boston Museum School and in Paris. Worked as a mural painter; then specialized in architectural and sculptural subjects. Developed a method of painting exact replicas of ancient relief sculpture. Worked with Harvard University-Boston Museum of Fine Arts Egyptian Expedition in Egypt, 1916–39, and also in the Far East and Central America.

Offering Bearers in the Tomb of Kagemni, PL. 233
Sakkara

[1948–49] Oil on canvas
19½ x 45 in. (49.5 x 114.3 cm.)

Acc. no. 51.310
Gift of Lyman Spitzer

EXHIBITIONS: Cairo, Egyptian Museum, 1949; Washington, National Collection of Fine Arts, *Paintings of Ancient Egyptian Monuments by Joseph Lindon Smith*, 1950.

This is a full-size copy of a polychromed limestone relief in the tomb of the Vizier Kagemni (Dynasty VI, 2420–2258 B.C.) at the principal Old Kingdom burial site of Sakkara.

MOSES SOYER

1899–1974. Born in Borisoglebsk, Russia; twin of Raphael and brother of Isaac Soyer, also painters. Emigrated with his family to New York. 1914–17 studied at

Cooper Union; 1918–19 at NAD with Charles Curran; at Ferrer Center with Henri and Bellows. 1925 became U.S. citizen. 1924–26 in Europe. 1933 muralist for WPA Federal Art Project. Influenced by Degas and The Eight, Soyer and his brothers chiefly painted the somber life of humble city dwellers.

Dancer Resting PL. 197

[1939] Oil on canvas
24 x 30 in. (61 x 76.2 cm.)
Signed lower left: M. Soyer

Acc. no. 40.169
Gift of the artist in memory of his father, Abraham Soyer

EXHIBITIONS: Toledo Museum of Art, *27th Annual*, 1940, no. 51.

EUGENE EDWARD SPEICHER

1883–1962. Born in Buffalo, N.Y. Studied at Buffalo Fine Arts Academy; 1907 at ASL with Frank Dumond and W. M. Chase; 1908 at Henri School of Art. 1910, 1926, 1929 in Europe. Ca. 1910 first summer at Woodstock, N.Y., where he settled. 1927 N.A. 1920s chiefly a portraitist; after 1930 mostly painted landscape and flower subjects. Speicher's figures reflect the influence of Henri, Bellows and Cézanne.

The Blue Necklace PL. 196

[Ca. 1937] Oil on canvas
39½ x 33¼ in. (100.5 x 84.3 cm.)
Signed lower left: Eugene Speicher

Acc. no. 37.11
Gift of Edward Drummond Libbey

COLLECTIONS: (Frank K. M. Rehn, New York).

EXHIBITIONS: Pittsburgh, Carnegie Institute, *1937 International Exhibition of Paintings*, 1937, no. 16, repr. pl. 22; Buffalo, Albright Art Gallery, *Eugene Speicher, A Retrospective Exhibition of Oils and Drawings . . . 1908-1949*, 1950, no. 17; New York, American Academy of Arts and Letters, *Eugene Speicher, Memorial Exhibition*, 1963, no. 58.

REFERENCES: P. Boswell, *Modern American Painting*, New York, 1939, p. 193, repr. opp. p. 190 (color); American Artists Group, *Eugene Speicher*, New York, 1945, repr.

FREDERICK R. SPENCER

1806–1875. Born in Lennox, N.Y. 1825–27 studied with John Trumbull. By 1827 active as portraitist in Albany-Utica area. 1831 settled in New York. 1833–35 board member, American Academy of Fine Arts. 1837 A.N.A.; 1846 N.A. 1858 returned to upper New York State. Chiefly a portraitist.

Fannie Peckham PL. 30

[1849] Oil on canvas
30⅝ x 23-3/16 in. (77.8 x 64.1 cm.)
Signed and dated on reverse of original canvas (covered by relining): Painted by F. R. Spencer Dec 1849

Acc. no. 54.86
Gift of Anna Louise Thorne

COLLECTIONS: Dr. and Mrs. Samuel Sprinkett Thorne, Toledo, to 1896; Anna Louise Thorne, Toledo, to 1954.

EXHIBITIONS: Utica (N.Y.), Munson-Williams-Proctor Institute, *A Retrospective Exhibition of the Work of Frederick R. Spencer, 1806–1875*, 1969, no. 24.

Fannie Peckham (1835–1896) was 14 when Spencer painted this portrait at Utica, New York. She married Samuel Sprinkett Thorne, a physician, and in 1865 they moved to Toledo, where they lived at 506 Lagrange Street. The donor, Anna Louise Thorne, was a Toledo artist, and the daughter of the subject.

JUNIUS BRUTUS STEARNS

1810–1885. Born in Arlington, Vt. Ca. 1838 student NAD; 1850 N.A. 1850 in London and Paris. Known as a genre and portrait painter, and for an historical series on George Washington.

Still Life with Trout and Fishing Tackle PL. 33

[1853] Oil on canvas
22 x 26-15/16 in. (56 x 68.4 cm.)
Signed and dated lower right: STEARNS/1853
Stencilled on reverse: Williams, Stevens, and Williams/ Looking Glass/and Art Repository/Engravings, Art Materials/353 Broadway, N.Y.

Acc. no. 51.410
Museum Purchase Fund

COLLECTIONS: (Appleby Bros., London); (Robert Frank, London).

EXHIBITIONS: New York, NAD, 1853, no. 205 (as *Trout*).

REFERENCES: Cowdrey, *NAD,* I, p. 139; M. Rogers, Jr., "Fishing Subjects by Junius Brutus Stearns," *Antiques,* XCVIII, Aug. 1970, p. 249, fig. 3; W. Gerdts, *American Still-Life Painting,* New York, 1971, p. 122, fig. 9-1; K. Cameron, "Nineteenth-century American Fly Rods," *Antiques,* CV, June 1974, repr. (color) p. 1296.

Between 1849 and 1882 Stearns painted eleven fishing subjects, including two still lifes. According to Cameron, Stearns accurately depicted a fly rod and hook, and a multiplier reel typical of the period 1830–65.

The background landscape may have been inspired by the scenery around Trenton Falls, a popular nineteenth century resort area near Utica, New York.

EDWARD J. STEICHEN

1879–1973. Born in Luxembourg; raised in Milwaukee. 1894–98 apprenticed to a lithography firm; began to paint and photograph in spare time. 1900 met Alfred Stieglitz in New York, and went to Paris. 1902 founding member of Photo-Secession group. After 1905 helped to organize exhibitions of modern European art at Stieglitz's '291' gallery. 1922 stopped painting and burned many canvases; thereafter turned to photography. 1947–62 director of Department of Photography at Museum of Modern Art. Despite the conservative tendencies of his painting, Steichen early recognized the merits of European and American modernism.

Across the Salt Marshes, Huntington PL. 115

[Ca. 1905] Oil on canvas
15-1/16 x 17⅞ in. (38.2 x 45.5 cm.)
Signed lower right: STEICHEN/STEICHEN/MDCCC (?)
Inscribed on the stretcher: across the salt marshes/ Huntington/E. J. Steichen/291 5th Ave.

Acc. no. 12.4

COLLECTIONS: (Henry Reinhardt, New York).

EXHIBITIONS: Worcester Art Museum, *Exhibition of Paintings by Edward J. Steichen,* 1910, no. 19; San Francisco, M. H. DeYoung Memorial Museum and the California Palace of the Legion of Honor, *The Color of Mood, American Tonalism 1880–1910,* 1972, no. 39 (cat. by W. Corn).

As the last numerals of the date on this Long Island landscape are now illegible, the date is based on several photographs of Long Island subjects which Steichen made ca. 1904–06.

FRANK STELLA

1936–. Born in Malden, Mass. 1950–54 studied painting at Phillips Academy, Andover with Patrick Morgan. 1954–58 at Princeton University and studied with William Seitz and Stephan Greene. 1958 settled in New York. 1960 first shaped canvases. 1970 began wall reliefs. A principal exponent of modernist painting, Stella has systematically explored pictorial structure deduced from the shape of the canvas and spatial illusionism through color and value.

Lac Laronge IV PL. 267

[1969] Acrylic polymer on raw canvas
108⅛ x 162 in. (274.7 x 311.5 cm.)

Acc. no. 72.4
Gift of Edward Drummond Libbey

COLLECTIONS: (Lawrence Rubin, New York).

This is one of four canvases named for a lake in central Saskatchewan that forms part of Stella's Saskatchewan series begun in Canada in 1967. The motif used developed out of the "Gur" variation, one of twenty-seven design types Stella planned for his Protractor series.

In his Saskatchewan pictures, Stella departed from his normal practice of using shaped canvases, in part because he could not obtain appropriate stretchers. By adapting the curvilinear interior motif within a rectangular format, Stella introduced a definite figure-ground relationship, atypical of his work at this time.

JOSEPH STELLA

1877–1946. Born in Muro Lucano, Italy. 1896 emigrated to New York. 1897 studied at ASL, and 1898–1900 with W. M. Chase at New York School of Art. 1909–12 in Europe; in Paris met Picasso, Matisse and saw work by the Italian Futurists. Exhibited in 1913 Armory Show; began futurist compositions. By mid-1920s worked in representational mode related to nineteenth century symbolism. Stella was a principle member of the early twentieth century American avant-garde.

Nocturne PL. 160

[Ca. 1918] Pastel on paper
23¼ x 17-15/16 in. (59 x 45.5 cm.)
Signed lower center: Joseph Stella

Acc. no. 53.51
Museum Purchase Fund

COLLECTIONS: (Stephen Bourgeois, New York, ca. 1920); (Alice Roullier, Chicago).

From about 1916 Stella did numerous pastels titled *Nocturne;* this one has been dated ca. 1918 by the Stella scholar Irma B. Jaffe.

HEDDA STERNE

1916–. Born in Bucharest, Romania. Studied there and in Vienna and Paris. 1941 to U.S.; 1944 U.S. citizenship. Married to Saul Steinberg. 1963 studied in Venice. Influenced by surrealism, Sterne works in both abstract and figurative styles.

New York, No. 1 PL. 254

[1954] Oil on canvas
86-3/16 x 50¼ in. (219 x 127.3 cm.)
Signed lower left: Hedda Sterne
Inscribed on reverse: Hedda/Sterne/173 E. 71ˢᵗ/NY NY

Acc. no. 57.29
Museum Purchase Fund

COLLECTIONS: (Betty Parsons, New York).

EXHIBITIONS: New York, Betty Parsons Gallery, *Hedda Sterne,* 1954.

GEORGE WASHINGTON STEVENS

1866–1926. Born in Utica, N.Y. Studied with J. Francis Murphy. 1900–03 on editorial staff of the *Toledo Times.* Founding member of Toledo Tile Club. 1903–26 first director of The Toledo Museum of Art. 1919–26 president, Association of Museum Directors. Accounts of his life were published by his wife Nina S. Stevens (*A Man and His Dream,* Hollywood, 1940), and by Blake-More Godwin (*Toledo Museum of Art Museum News,* IX, Spring 1966).

Venice PL. 107

[1898] Watercolor on paper
18¼ x 12-3/16 in. (46.5 x 31 cm.)
Signed lower left: G. W. STEVENS '98

Acc. no. 60.33
Gift of Mrs. Richard Baker

COLLECTIONS: Phelps Berdan, Toledo; Mrs. Richard Baker, Toledo.

A Canal in Venice PL. 108

[Ca. 1902] Watercolor on paper
18⅞ x 12⅛ in. (48 x 30.8 cm.)
Signed lower right: GEO. W. STEVENS

Acc. no. 63.36
Bequest of Carl B. Spitzer

Dutch Landscape PL. 110

[Ca. 1904] Watercolor on cardboard
10½ x 13⅞ in. (26.6 x 35.3 cm.)
Signed lower right: GEO. W. STEVENS

Acc. no. 59.125
Gift of Emmett F. Martin

COLLECTIONS: Gift of the artist to Edward Drummond Libbey; Emmett F. Martin, Toledo.

Dutch Boats PL. 111

[Ca. 1904] Watercolor on paper
9½ x 11⅞ in. (24.2 x 30.2 cm.)
Signed lower right: GEO. W. STEVENS

Acc. no. 59.128
Gift of William A. Geroe

COLLECTIONS: William A. Geroe, Toledo.

London Fog PL. 109

Watercolor on paper
9¼ x 6⅞ in. (23.5 x 17.5 cm.)
Signed lower right: GEO. W. STEVENS

Acc. no. 27.322
Gift of an Anonymous Donor

GORDON STEVENSON

1892–. Born in Chicago. Studied at the Art Institute of Chicago and in Spain with Joaquin Sorolla. Lives in New York. Portrait painter.

Edward Drummond Libbey PL. 139

Oil on canvas
36 x 30 in. (91.4 x 76.2 cm.)

Acc. no. 17.762
Gift of Edward Drummond Libbey

Biographical data on the sitter appears in the entry for his portrait by August Franzen.

GILBERT STUART

1755–1828. Born in North Kensington Township, R.I. Ca. 1769 a pupil of the portraitist Cosmo Alexander with whom he went to Edinburgh in 1772. 1774–75 por-

traitist in Newport, but due to lack of commissions went to London, where he lived and studied with Benjamin West 1777–82. A successful portraitist in London until financial problems forced him to flee to Dublin, where he worked 1787–92. 1794–1803 in Philadelphia and Germantown; 1803–05 in Washington; 1805 settled in Boston. Stuart was the foremost portraitist of the Federal era.

John Ashley PL. 10

[1799] Oil on canvas
29¼ x 24⅜ in. (73.9 x 61.4 cm.)
Inscribed lower left (on book spine): (?) B.U.S./1799

Acc. no. 12.12

COLLECTIONS: (Charles Brunner, Paris, 1910); (Henry Reinhardt, New York, 1912).

EXHIBITIONS: Indianapolis, John Herron Art Institute, *Retrospective Exhibition of Portraits by Gilbert Stuart,* 1942, no. 17, repr.

REFERENCES: M. Fielding, "Paintings by Gilbert Stuart not mentioned in Mason's Life of Stuart," *Pennsylvania Magazine of History and Biography,* XXXVIII, No. 1, 1914, p. 320, no. 34; L. Park, *Gilbert Stuart,* New York, 1926, I, pp. 114–15; II, p. 926; III, pl. 35; C. Lee, *Early American Portrait Painters,* New Haven, 1929, p. 32; C. Mount, *Gilbert Stuart, A Biography,* New York, 1964, p. 364.

John Ashley (1754–1831) is listed in Philadelphia directories as an agent and merchant. Identification of the sitter is based on another version of this portrait (Dallas Museum of Fine Arts), undated on the face but which bears on the reverse a label inscribed: "Portrait by Gilbert Stuart/Painted 1798/of/John Ashley/who was born in London Sep. 27, 1754/married to Sarah MacDonald Feb. 5, 1776/Died in Philadelphia Dec. 19, 1831." This information was provided by the last owner of the Dallas painting, a descendant of the sitter. In 1799 Stuart also painted portraits of Ashley's daughter Marianne (Indianapolis Museum of Art) and her husband Simon Walker.

For some forty-five years after the Toledo portrait came on the art market in 1910, the sitter was erroneously identified as Ashley Cooper, sixth Earl of Shaftesbury. However, the portrait bears no resemblance to engraved likenesses of Cooper, nor is there evidence he was in Philadelphia in 1798–99, when Stuart was active there.

GILBERT STUART and JANE STUART

Gilbert Stuart: see above entry.
Jane Stuart (1812–1888). Born in Boston. Studio assistant to her father until his death in 1828. Later made copies of her father's work and painted portraits from daguerreotypes. In 1850s her studio burned. Moved to Newport, and painted there until her death.

Commodore Oliver Hazard Perry PL. 11

[1818–28] Oil on wood panel
26⅝ x 21¾ in. (67.7 x 55.3 cm.)

Acc. no. 67.140

COLLECTIONS: Mrs. Oliver Hazard Perry, 1858 (?); Oliver Hazard Perry, Jr., Andover, Mass., 1858–78; Oliver Hazard Perry, III, Lowell, Mass., 1878–1915; Helen Perry Cabot, Chester, Pa., 1915–22; Oliver Hazard Perry Cabot, Chester, 1922–65; Mrs. Oliver Hazard Perry Cabot, Orleans, Mass., 1965–67; (Kennedy Galleries, New York).

EXHIBITIONS: Boston Athenaeum, *An Exhibition of Portraits Painted by the Late Gilbert Stuart, Esq.,* 1828, no. 180; Boston, Museum of Fine Arts, *Exhibition of Portraits Painted by Gilbert Stuart,* 2nd ed., 1880, no. 474 (lists an engraving after this portrait); Toledo Museum of Art, *Perry Victory Centennial Exposition,* 1913, no. 1, repr.; Boston, Museum of Fine Arts, *Gilbert Stuart Memorial Exhibition,* 1928, no. 55; Toledo Museum of Art, *Heritage and Horizon: American Painting 1776–1976,* 1976, no. 3, repr.

REFERENCES: G. Mason, *The Life and Works of Gilbert Stuart,* New York, 1879, p. 239; J. Smith, *Civil and Military List of Rhode Island, 1800–1850,* Providence, 1901, p. 262; A. Mahan, *Sea Power in Relation to the War of 1812,* Boston, 1905, II, repr. opp. p. 66; L. Park, *Gilbert Stuart,* New York, 1926, II, pp. 589–90, no. 630, p. 908; IV, repr. p. 387; W. Whitley, *Gilbert Stuart,* Cambridge, 1932, p. 165; C. Bolton, *American Portraits 1670–1825 Found in Massachusetts,* Boston, 1939, II, p. 313, no. 1670; M. Swan, *The Athenaeum Gallery, 1827–1873,* Boston, 1940, p. 72; C. Mount, *Gilbert Stuart, A Biography,* New York, 1964, pp. 307, 373.

The American naval officer Oliver Hazard Perry (1785–1819) became a national hero after his defeat of a British squadron on Lake Erie near Put-in-Bay on Sep. 10, 1813. The defeat of an entire British force by an American squadron was unprecedented, and strategically it gave the United States control of much of the Great Lakes. At the time of his victory Captain Perry held the title of commodore, denoting an officer in charge of a fleet of ships. Perry died of yellow fever in 1819, while com-

manding a small fleet in the West Indies, where foreign vessels were attacking American merchant ships.

A full-length portrait of Perry, a Rhode Island native, was commissioned from Stuart by the General Assembly of Rhode Island in June 1818. It was never carried out. Perry sat for Stuart in his captain's uniform for the present bust-length portrait before leaving for the West Indies. According to Whitley, Washington Allston, a great admirer of Stuart, praised this portrait in a now-untraced letter of 1819 to Samuel F. B. Morse.

The portrait was apparently still unfinished at Stuart's death in 1828. A letter of July 27, 1828 from Isaac P. Davis to Benjamin Hazard, states that Stuart had completed only the face, and that his daughter Jane painted the shoulders and uniform (Oliver Hazard Perry Papers, William Clements Library, University of Michigan, Ann Arbor). Davis, a Boston collector and close friend of Stuart, was instrumental in organizing the Boston Athenaeum's 1828 memorial exhibition of Stuart's work, and he may have prompted Jane Stuart to complete the Perry portrait in time for the exhibition. While the portrait descended in the Perry family for several generations, exactly when the family acquired it is not known.

A three-quarter length portrait of Perry based on the Toledo bust was also painted by Jane Stuart (Brown University, Providence, R.I.). Although Toledo's portrait is listed as having been engraved (Mason, p. 239), no impression is known.

GILBERT STUART, Copies after

George Washington PL. 13

Oil on canvas
29-1/16 x 24 in. (73.9 x 61 cm.)

Acc. no. 33.34
Gift of Arthur J. Secor

COLLECTIONS: John Inskeep (1757–1834), Philadelphia (?); Eliza Inskeep Brooks (d. 1868), Philadelphia; Henry Brooks (d. 1893), Philadelphia; Eliza Inskeep Waterworth, St. Louis, 1887–1927; (Howard Young, New York); Arthur J. Secor, Toledo, 1928–33.

REFERENCES: J. F. Morgan and M. Fielding, *The Life Portraits of Washington and the Replicas*, Philadelphia, 1931, p. 333, no. LII (among portraits attributed to Stuart but unattributed by the authors); C. M. Mount, *Gilbert Stuart, A Biography*, New York, 1964, p. 378.

This is an "Athenaeum" type portrait of Washington, so-called because it is based on Stuart's prime original,

painted from life in 1796, which belongs to the Boston Athenaeum. Since 1876 both it and the companion portrait of Martha Washington have been on loan to the Museum of Fine Arts, Boston.

While Stuart made over seventy replicas of the Athenaeum *Washington*, the heavily applied paint and harsh modelling indicate this canvas is not by Stuart. The painter is unknown, though it appears to have been done later than Stuart's lifetime.

According to a statement made in 1927 by his descendants, this portrait was painted by Stuart for John Inskeep, Mayor of Philadelphia 1800–01 and 1804–05. However, Inskeep's will (City Hall, Philadelphia) mentions no portraits of any kind.

Mrs. Luke White and Her Son PL. 12

Oil on canvas
30-1/16 x 21-13/16 in. (76.3 x 55.3 cm.)

Acc. no. 26.77
Gift of Edward Drummond Libbey

COLLECTIONS: Luke White, Killakee, Ireland; Matilda White Massy (d. 1883), Killakee; 6th Baron Massy, to 1916; (T. K. Laidlaw, 1916–19); (Knoedler, London, 1919–21); (Henry Reinhardt, New York, 1921–26).

REFERENCES: L. Park, *Gilbert Stuart, An Illustrated Descriptive List of His Work*, New York, 1926, II, no. 903, pp. 807–08, 923, 951, 954; IV, repr. p. 568; W. Sawitzky, "Some Unrecorded Portraits by Gilbert Stuart, Part Two: Portraits Painted in Ireland," *Art in America*, XXI, Mar. 1933, p. 42 (as a copy after Stuart).

Elizabeth de la Maziere (d. 1799) of Dublin married Luke White of Killakee in 1781; she is shown here with either her third or fourth son.

Although Park catalogued the Toledo canvas as painted by Stuart in Dublin ca. 1790, the fairly thick paint and smooth brushwork indicates it is a copy after Stuart, whose original may be the unfinished oval canvas illustrated by Park (no. 904), most recently in the collection of David R. Russell, Dallas, Texas.

The copyist is unknown, and in connection with the Toledo picture Park mentions two other copies of unknown authorship in Irish collections.

WALTER STUEMPFIG, JR.

1914–1970. Born in Germantown, Pa. 1928–29 traveled in Europe and Egypt. 1931–34 studied at PAFA. 1934 in Europe. 1948–70 taught at PAFA. Lived near Philadelphia. Still life, portrait and landscape painter.

Tempest　　　　　　　　　　　　　PL. 215

[1944] Oil on canvas
25⅛ x 29-15/16 in. (63.7 x 76 cm.)
Signed: Stuempfig
Inscribed in pencil on stretcher: Walter Stuempfig/title
　Tempest

Acc. no. 46.26
Elizabeth C. Mau Bequest Fund

COLLECTIONS: (Durlacher Brothers, New York).

EXHIBITIONS: Toledo Museum of Art, *33rd Annual*, 1946.

THOMAS SULLY

1783–1872. Born in Horncastle, England. Family emigrated to Charleston, S.C. in 1792. First art instruction from Charles Fraser. Studied with his older brother Lawrence. Painted first miniatures and oils in Norfolk, Va. 1801. 1806 in New York. 1807 met Stuart in Boston. 1808 settled in Philadelphia. 1809–10 in London; met Benjamin West and Thomas Lawrence, who influenced him. Sully was the leading portraitist in mid-nineteenth century Philadelphia.

Mrs. Burnett of Philadelphia　　　　PL. 28

[1844] Oil on canvas
23⅞ x 19-15/16 in. (60.7 x 50.7 cm.)
Signed and dated on reverse: TS 1844./June
Colorman's stencil on reverse: T. Brown/163 High
　Holborn/London

Acc. no. 20.12

COLLECTIONS: Albert Rosenthal, Philadelphia; (Knoedler, New York); (Henry Reinhardt, New York).

REFERENCES: C. Hart, *Register of Portraits Painted by Thomas Sully, 1801–1871*, Philadelphia, 1909, no. 248; E. Biddle and M. Fielding, *The Life and Works of Thomas Sully*, Philadelphia, 1921, p. 113, no. 257.

Sully's *Register* shows he painted Mrs. Burnett between June 9 and 18, 1844 for $80. The sitter may be Hannah K. Burnett (1820–1886), wife of Eli S. Burnett, listed in Philadelphia directories as a drygoods merchant.

GEORGE GARDNER SYMONS

1861–1930. Born in Chicago, where he studied at the Art Institute. Studied in Paris, London and Munich. 1909 returned to U.S. Settled near New York; visits to California, New England and Europe. 1911 N.A. Chiefly a landscape painter.

Snow Clad Fields in Morning Light　　PL. 176

[Ca. 1910] Oil on canvas
50-3/16 x 60-3/16 in. (127.5 x 152.8 cm.)
Signed lower left: Gardner Symons

Acc. no. 12.5

COLLECTIONS: Bought from the artist.

HENRY OSSAWA TANNER

1859–1937. Born in Pittsburgh, Pa. 1866 family moved to Philadelphia. 1872 began to paint. 1880–82 studied with Eakins at PAFA. 1888 in Atlanta, Ga., teaching at Clark University and working as a photographer. 1891 settled in Paris; studied with Benjamin Constant and J. P. Laurens. 1897 and 1898 trips to Palestine and Holy Land. 1902–04 in U.S. 1927 N.A. His genre paintings reflect Eakins' influence; from 1890 he painted chiefly religious subjects and landscapes in an eclectic romantic style. He was the leading black artist to emerge in nineteenth century America.

The Disciples on the Sea　　　　　PL. 143

[Ca. 1910] Oil on canvas
21⅝ x 26½ in. (55 x 67.3 cm.)
Signed lower left: H. O. Tanner

Acc. no. 13.127
Gift of Frank W. Gunsaulus

COLLECTIONS: Frank W. Gunsaulus, Chicago.

EXHIBITIONS: Chicago, Thurber Art Galleries, *Exhibition of Paintings by Henry O. Tanner*, 1913, no. 3.

The subject is from the New Testament (Mark VI: 45–52):

> Immediately he made his disciples get into the boat and go before him to the other side, to Bethsaida, while he dismissed the crowd. And after he had taken leave of them, he went into the hills to pray. And when evening came, the boat was out on the sea, and he was alone on the land. And he saw that they were distressed in rowing, for the wind was against them. And about the fourth watch of night he came to them, walking on the sea. He meant to pass by them, but when they saw him walking on the sea they thought it was a ghost, and cried out; for they all saw him, and were terrified. But immediately he spoke to them and said, "Take heart, it is I; have no fear." And he got into the boat with them and the wind ceased.

The date is based on the style of drawing, on the char-

acteristically blue palette Tanner used about 1910, and on the picture's earliest exhibition record. The subject and composition are also related to a 1913 etching, *Christ Walking on the Water* (an impression is in the Museum of African Art, Washington, D.C.).

ABBOTT HANDERSON THAYER

1849–1921. Born in Boston; raised in Keene, N.H. 1867 attended Brooklyn Art School and NAD. 1875–79 studied in Paris at Ecole des Beaux-Arts, and with J. L. Gérome. 1879 settled in New York; summers in New Hampshire. Late 1890s began studies of natural history. 1901 moved to Dublin, N.H. Thayer painted landscapes and portraits, but his reputation rests chiefly upon idealized, often allegorical, figures of women.

Helen Sears PL. 94

[1891–92] Oil on canvas
54½ x 38½ in. (137.5 x 97.8 cm.)
Signed lower right: Abbott H. Thayer
Partial signature extends to right of plant in right corner: ayer.

Acc. no. 58.26

COLLECTIONS: Mrs. J. Montgomery Sears, Boston, 1892; Mrs. J. D. Cameron Bradley (née Helen Sears), Southboro, Mass., to 1958; (Childs Gallery, Boston).

EXHIBITIONS: New York, Society of American Artists, *Fourteenth Exhibition*, 1892, no. 212 (as *Portrait of a Child);* New York, Metropolitan Museum of Art, *Memorial Exhibition of the Work of Abbott Handerson Thayer,* 1922, no. 37.

REFERENCES: Carnegie Institute, *Exhibition of Paintings by Abbott H. Thayer,* Pittsburgh, 1913, p. 37 (in "Record of Paintings," as *Portrait of Her Child,* owned by Mrs. J. Montgomery Sears); N. Pousette-Dart, *Abbott H. Thayer,* New York, 1923, repr., p. (33); N. White, *Abbott H. Thayer, Painter and Naturalist,* Hartford, 1951, pp. xx, 60, 61, 62, repr.

Helen Sears (1889–1966) was the daughter of J. Montgomery Sears and Sarah Choate of Boston, friends and patrons of Mary Cassatt, Edgar Degas, John La Farge and John Singer Sargent, who also painted a portrait of Helen Sears as a child (1895; Boston, Museum of Fine Arts). She married J. D. Cameron Bradley in 1913.

This portrait was recorded on November 23, 1891 in the diary of his father, Dr. William Henry Thayer: "He (Abbott) went to Boston to paint a portrait of a daughter of J. M. Sears, a child," noting also that Sears

had paid $8,000 for *Virgin Enthroned,* the highest price Thayer had yet obtained. In an entry of early February 1892 Dr. Thayer added, "Abbott brought the Sears portrait back to N.Y. to finish the drapery in his studio—and sent it home at last on the 7th of February."

According to Nelson White, Thayer's biographer, the artist frequently reworked his compositions (letter, May 23, 1964). It is evident that Thayer revised this canvas, adding the lilies at the left and right, partly covering his first signature, extending the platform beneath the figure, and signing the picture a second time. White also believes the frame was probably designed by Thayer's friend, the architect Stanford White, who designed the frames for most of his paintings at this time (letter, Dec. 30, 1963).

WILLIAM THON

1906–. Born in New York. Chiefly self-taught; studied at NAD ca. 1924. After 1945 settled in Port Clinton, Me., where he lives. 1947 fellowship to the American Academy in Rome. In the 1950s traveled in Italy, Spain, Portugal and Greece.

The Baptistry, Florence PL. 231

[Ca. 1949] Watercolor on paper
21½ x 29½ in. (54.5 x 75 cm.)
Signed lower right: Thon

Acc. no. 50.68
Museum Purchase Fund

COLLECTIONS: (Midtown Galleries, New York).

EXHIBITIONS: New York, NAD, *123rd Annual Exhibition,* 1949, no. 99.

MARK TOBEY

1890–1976. Born in Centerville, Wis. Studied at Art Institute of Chicago. 1911 to New York. 1922–25 in Seattle; first introduced to Chinese brushwork. 1925–27 in Europe and Near East. 1931–38 resident artist at Dartington Hall school in England. 1935 lived in Zen monastery in Japan; developed "white writing" of his mature style. 1960 settled in Basel, Switzerland.

Quiet One PL. 251

[1950] Oil on paper board
44 x 28 in. (111.9 x 71.1 cm.)
Signed and dated lower left: Tobey/'50

Acc. no. 52.128

Museum Purchase Fund

COLLECTIONS: (Willard Gallery, New York).

EXHIBITIONS: Toledo Museum of Art, *39th Annual*, 1952, no. 79.

JOHN TRUMBULL

1756–1843. Born in Lebanon, Conn. 1773 B.A. Harvard College. Served in Revolutionary forces; briefly aide-de-camp to General Washington. 1780 pupil of Benjamin West in London. Expelled from England, but in 1783 returned to West's studio. 1785 began the series of American Revoltuionary subjects which occupied much of his career, and for which he is chiefly known. 1789 in New York; chiefly a portraitist. In Europe 1794–1804, 1808–15. 1817 president of American Academy of Fine Arts. 1817–37 worked on Revolutionary subjects for the Capitol Rotunda.

Scene from Ossian's "Fingal": Lamderg PL. 9
and Gelchossa

[1792] Oil on canvas (mounted on panel)
11-15/16 x 14 in. (30.3 x 35.6 cm.)

Inscribed by the artist on paper attached to the reverse
 of panel: You will find the Subject of the picture in/
 the 5th book of Fingal, the episode of Lamderg and/
 Gelchossa. "What blood, my Love" She trembling/
 said "what blood runs down my warrior's side"/
 "It's Ullin's blood" the chief replies. "Thou fairer/
 than the Snow." Gelchossa let me rest here a while"/
 the mighty Lamderg died./
 I hope you will like the picture & am/D^e Sir/
 faithfully yours/J^no Trumbull

Inscribed by Warren Dutton at the bottom of the same
 paper: Boston Nov 14^th 1817/ This picture was
 painted by John Trumbull Esquire at/Lebanon,
 Connecticut, in the summer of the year 1792–/Warren
 Dutton

Inscribed on an old label originally attached to frame:
 Mr. Hubbard Dutton/posed for the warrior figure/
 Lamderg.

Acc. no. 58.27

COLLECTIONS: Warren Dutton, Boston, by 1817-after 1872; Miss Sarah L. Barnard, Boston, by 1915; H. Daland Chandler, Boston; (Charles Childs, Boston, 1958).

EXHIBITIONS: Boston Athenaeum, *First Exhibition of Paintings*, 1827, no. 77 (lent by Warren Dutton); Allentown (Pa.) Art Museum, *The World of Benjamin West*, 1962, no. 17, repr.

REFERENCES: T. Sizer, "A Tentative 'Short-Title' Checklist of the Works of Col. John Trumbull," *Art Bulletin*, XXX, 1948, p. 219 (as *Subject from Ossian*, before 1815, lost); T. Sizer, *The Works of Colonel John Trumbull*, New Haven, 1950, p. 79 (as *Subject from Ossian*, 1809); M. Rogers, "John Trumbull's Scene from Ossian's 'Fingal,' " *The Art Quarterly*, XXII, Summer 1959, pp. 171–76, repr. p. 172; T. Sizer, *The Works of Colonel John Trumbull*, rev. ed., New Haven, 1967, p. 104, fig. 212; I. Jaffe, *John Trumbull, Patriot-Artist of the American Revolution*, Boston, 1975, pp. 233, 324–25, fig. 164.

The subject is from Book V of the once-famous epic poem *Fingal* (first published in 1761) by Ossian, a fictitious third century bard who was the invention of the Scotsman James MacPherson. It depicts the moment after Lamderg slew a rival chieftain, Ullin, who had abducted his wife, Gelchossa. Lamberg himself was mortally wounded and shortly died. Gelchossa died after three days of mourning her husband, and a tomb was erected over their bodies.

According to the inscriptions, the Boston art collector Warren Dutton evidently acquired the Toledo picture in or about 1817; it may be the same small *Ossian* that was in Trumbull's possession in 1816 (Jaffe, p. 352, who also notes a reference to small sketches of Lamderg and Gelchossa now unlocated).

Before the Toledo picture reappeared in 1958, Sizer (1950) had believed it was painted in 1809 because a larger painting of this subject by Trumbull bears this date (Yale University Art Gallery).

DWIGHT WILLIAM TRYON

1849–1925. Born in Hartford, Conn. 1864–71 studied calligraphy and art history. 1873 opened studio in Hartford. 1876–81 studied in Paris; worked briefly with Daubigny, Harpignies and Guillemet. 1881 returned to New York. 1885–1923 professor of art at Smith College. 1889 met the collector Charles Lang Freer, who became Tryon's friend and great patron. Tryon was a leading tonalist landscape painter of the aesthetic movement, his work owing much to Corot.

Spring Morning PL. 114

[1910] Oil on panel
16-1/16 x 24 in. (40.9 x 61 cm.)
Signed and dated lower right: D. W. Tryon 1910

Acc. no. 12.11

EXHIBITIONS: Storrs, University of Connecticut Museum

of Art, *Dwight A. Tryon: A Retrospective Exhibition*, 1971, no. 41, repr. (intro. by N. White).

JOHN HENRY TWACHTMAN

1853–1902. Born in Cincinnati. 1874 studied with Duveneck, with whom he went to Munich in 1875. 1875–77 studied in Munich. 1877 to Venice with Duveneck and Chase. 1878 returned to U.S., met J. Alden Weir. 1879 member of Society of American Artists. 1880 taught in Duveneck's school in Florence and Venice, where he met Whistler. 1889 settled near Greenwich, Conn. 1898 founding member of The Ten American Painters. Of all the American Impressionists, Twachtman was more interested in mood and compositional effects than in light and atmosphere.

Lilacs in Winter PL. 80

(Ca. 1890–1900) Oil on canvas
30-1/16 x 30-3/16 in. (76.3 x 76.7 cm.)
Stamped in red, lower left: Twachtman/Sale

Acc. no. 54.59

COLLECTIONS: Estate of the artist (sold, New York, American Art Association, Mar. 24, 1903, no. 79); Mrs. Williams, 1903; Mrs. John A. Howell (Mrs. Williams' granddaughter), Morristown, N.J., to 1948; (Macbeth); Mrs. Jacob Rand, New York, 1950–54; (Macbeth).

EXHIBITIONS: Cincinnati Art Museum, *John Henry Twachtman, A Retrospective Exhibition*, 1966, no. 38 (cat. by R. Boyle).

REFERENCES: J. D. Hale, "The Life and Creative Development of John H. Twachtman," unpublished Ph.D. dissertation, Ohio State University, 1958, II, no. 383, fig. 108.

The countryside around his farm on Round Hill Road at Greenwich was the subject of many of Twachtman's paintings in the 1890s.

SAMUEL LOVETT WALDO

1783–1861. Born in Windham, Conn. Ca. 1799 studied with Joseph Steward in Hartford, where Waldo opened a studio in 1803. Worked in Litchfield, Conn. and Charleston, S.C. 1806–08 studied in London at the Royal Academy with West and Copley. 1809 settled in New York. 1812 William Jewett became his pupil. 1818–54 in partnership with Jewett. 1826 a founder of NAD; 1848 A.N.A. Waldo and Jewett were among New York's leading mid-nineteenth century portraitists.

Portrait of a Man PL. 25

[Ca. 1829–30] Oil on panel
30 x 24¾ in. (76.3 x 62.9 cm.)

Acc. no. 54.31

COLLECTIONS: Robert Fridenberg, New York, to 1934; Erskine Hewitt (Parke-Bernet, Oct. 18, 1938, lot 780, repr., as a portrait of Durand); (Hirschl and Adler, New York).

The subject was formerly identified as the painter Asher B. Durand. However, comparisons with portraits of Durand as a young man by William Jewett, John Trumbull, and Elias Metcalf, as well as a self-portrait by Durand (all New-York Historical Society, *Catalogue of American Portraits*, 1974, nos. 584, 587, 585, 582) appear to exclude this identification. However, it is reasonably certain the subject of the Toledo portrait is either an artist or collector, as the pamphlet he holds is titled "CATALOGUE."

Dating is based on the costume, and on the artist's style of painting at this time.

HORATIO WALKER

1853–1938. Canadian. Born in Listowel, Ontario. Chiefly self-taught. 1878 opened studio in New York. 1882 first trip to Europe. From 1883 summers at Ile d'Orléans, Quebec and winters in New York. 1887 member Society of American Artists. 1893 N.A. Often called "The American Millet," Walker was influenced by the Barbizon painters and by the Hague School.

The Woodcutter PL. 128

[1900] Oil on canvas
22-1/16 x 17-15/16 in. (56 x 45.6 cm.)
Signed and dated lower right: Horatio Walker/1900

Acc. no. 12.15

MARTHA WALTER

1875–1976. Born in Philadelphia. Studied at PAFA with W. M. Chase, and 1908–14 in Paris. Traveled in Holland, Spain, Italy; studio in Paris. Ca. 1914 to New York. Taught at New York School of Art; studio in Gloucester, Mass.

Anne PL. 167

Oil on canvas

26⅛ x 21-1/16 in. (66.4 x 53.5 cm.)
Signed lower right: Martha Walter

Acc. no. 14.139

Alice Roullier PL. 168

[Ca. 1915] Oil on canvas
26 x 21 in. (66 x 53.2 cm.)
Signed lower left: To my friend/Alice Roullier/Martha
 Walter

Acc. no. 51.264
Gift of Alice Roullier

COLLECTIONS: Alice Roullier, Chicago.

The daughter of Albert Roullier, a Chicago print dealer,
Alice Roullier was a friend of George W. Stevens, first
director of The Toledo Museum of Art and of his wife.

EVERETT LONGLEY WARNER

1877–1963. Born in Vinton, Iowa. Studied at ASL in
Washington, D.C. and in New York, and later in Paris
at the Académie Julian. 1913 A.N.A.; 1937 N.A. Orig-
inator of ship camouflage methods in both World Wars.
Taught at Carnegie Institute, Pittsburgh, 1924–42.
Painter of landscape and city subjects; etcher and lithog-
rapher.

Along the River Front, New York PL. 149

[1912] Oil on canvas
32 x 40 in. (81.2 x 101.6 cm.)
Signed lower left: EVERETT WARNER

Acc. no. 14.109
Museum Purchase Fund

COLLECTIONS: Bought from the artist.

EXHIBITIONS: New York, NAD, 1912; Toledo Museum
of Art, *Paintings by Everett L. Warner*, 1914; Pittsburgh,
Carnegie Institute, *Everett Warner*, 1941, no. 18, repr.

FREDERICK JUDD WAUGH

1861–1940. Born in Bordentown, N.J. 1880–83 studied
at PAFA with Eakins and Anshutz; 1883 in Paris at
Académie Julian. 1893–95 first painted seascapes on the
island of Sark in the English Channel. 1911 N.A. 1927
settled in Provincetown, Mass. An illustrator and figure
painter early in his career, Waugh is best known as a
marine painter.

Monhegan Surf PL. 124

[1913] Oil on board
24 x 36 in. (61 x 91.5 cm.)
Signed lower right: Waugh
Inscribed on reverse: Frederick J. Waugh/Monhegan
 Surf/1913

Acc. no. 13.125
Gift of the artist

REFERENCES: H. Poore, "The Many-Sided Waugh," *In-
ternational Studio,* Dec. 1921, p. CXXXV; E. S. Barrie, ed.,
Paintings of the Sea by Frederick Judd Waugh, New
York, 1936, p. 38, repr. p. 39; C. Waugh, "The Master
Path, A Study of Composition," *American Artist,* XXVII,
June-Aug. 1963, repr. p. 51; G. Havens, *Frederick J.
Waugh, American Marine Painter,* Orono, Me., 1969,
pp. 135, 271, 280.

Monhegan Island is off the Maine coast. Waugh sketched
there the summers of 1911–13.

BENJAMIN WEST

1738–1820. Born in Swarthmore, Pa. By 1756 portraitist
and sign painter in Philadelphia. 1759 to Italy; West was
the first American-born artist to study abroad. 1763 set-
tled in London. 1768 charter member, Royal Academy.
1772 appointed history painter to George III. 1792–1820
president of Royal Academy. West was an influential
teacher of many American painters in his London studio.
As a leading international history painter, he con-
tributed to the development of both neoclassicism and
romanticism in England and Europe.

Scene from Ariosto's "Orlando Furioso": PL. 6
The Damsel and Orlando

[1793] Oil on canvas
35⅞ x 28 in. (91.1 x 71 cm.)
Signed and dated lower left: B. West/1793

Acc. no. 12.10

COLLECTIONS: Henry Hope (d. 1812), London (sold, Lon-
don, Christie, June 28, 1816, lot 84, as "Historical, the
companion" [to lot 83, *Angelica and Medoro*]); (Cooper
and Griffith, New York, 1912).

REFERENCES: *Public Characters of 1805,* London, 1805,
VII, p. 562 (as *The Damsel and Orlando* in the Hope
Collection, "first painted for the late Bishop of Bristol");
J. Barlow, *The Columbiad, a poem,* Philadelphia, 1808,
p. 398 (as *The Damsel and Orlando*); J. Galt, *The Life*

Studies and Works of Benjamin West, Esq., London, 1820, II, p. 221; A. Gardner and S. Feld, *American Painting, A Catalogue of the Collection of The Metropolitan Museum of Art,* Greenwich, Conn., 1965, p. 32.

The subject is inspired by Canto XXIII of Lodovico Ariosto's epic poem *Orlando Furioso* (first published in 1516), in which Orlando is told by a shepherd and his wife of the marriage of his once-beloved Angelica to Medoro. As proof of her knowledge of the marriage, the shepherd's wife shows Orlando a bracelet which he had given Angelica as a token of his love. Orlando is eventually driven mad by the loss of Angelica.

Allen Staley, who is preparing a catalogue raisonné of West's paintings in collaboration with the West scholar Helmut von Erffa, believes the Toledo canvas belonged to West's patron, the collector Henry Hope, and that it is the *Damsel and Orlando* listed in three early inventories of West's work (letter, Oct. 15, 1978).

A nearly identical version was left unfinished in West's studio at his death (not signed or dated; Metropolitan Museum of Art).

St. Thomas à Becket PL. 8

[1797] Oil on canvas
50½ x 23⅜ in. (128.3 x 59.5 cm.)
Signed and dated lower left: B. West 1797
Inscribed lower center: St. Thos. Becket

Acc. no. 59.32
Museum Purchase Fund

COLLECTIONS: William Beckford, Fonthill Abbey, Wiltshire, England, 1797–1822; John Farquhar, Fonthill Abbey, 1822–23 (sold at auction, H. Phillips, *The Pictures and Miniatures at Fonthill Abbey, Catalogue . . . ,* Oct. 10–11, 14–15, 1823, no. 250); (sold, Foster's Auction House, London, 1941); Charles Mitchell, London and Bryn Mawr, Pa., 1941–59.

EXHIBITIONS: London, Royal Academy, 1798, no. 267; Allentown (Pa.) Art Museum, *The World of Benjamin West,* 1962, no. 24, repr.

REFERENCES: *Public Characters of 1805,* London, VII, 1805, p. 561; J. Barlow, *Columbiad, a poem,* Philadelphia, 1808, p. 398; "A Catalogue of the Works of Benjamin West, Esq.," *Supplement to La Belle Assemblée,* IV, July 1, 1808, p. 14; J. Galt, *The Life, Studies and Works of Benjamin West, Esq.,* London, 1820, II, p. 220; *Magnificent Effects at Fonthill Abbey, Wilts. To be Sold by Auction, by Mr. Christie . . . Sept. 17–26, 1822,* London, 1822, no. 90; J. Rutter, *An Illustrated History and Description of Fonthill Abbey, Delineations . . . ,* London, 1823, p. 31; M. Rogers, Jr., "Benjamin West and the

Caliph; Two Paintings for Fonthill Abbey," *Apollo,* LXXXIII, June 1966, pp. 420–25, fig. 3; J. Dillenberger, *Benjamin West: The Context of His Life's Work,* San Antonio, 1977, pp. 109, 151, 194, 209, fig. 76.

St. Michael and the Dragon PL. 7

[1797] Oil on canvas
50½ x 23-9/16 in. (128.3 x 59.9 cm.)

Acc. no. 59.33
Museum Purchase Fund

COLLECTIONS: See *St. Thomas à Becket.*

EXHIBITIONS: London, Royal Academy, 1797, no. 242; Allentown (Pa.) Art Museum, *The World of Benjamin West,* 1962, no. 25, repr.

REFERENCES: *Public Characters of 1805,* London, VII, 1805, p. 561; J. Barlow, *Columbiad, a poem,* Philadelphia, 1808, p. 398; "A Catalogue of the Works of Benjamin West, Esq.," *Supplement to La Belle Assemblée,* IV, July 1, 1808, p. 14; J. Galt, *The Life, Studies and Works of Benjamin West, Esq.,* London, 1820, II, p. 219; *Magnificent Effects at Fonthill Abbey, Wilts. To be Sold by Auction, by Mr. Christie . . . Sept. 17–26, 1822,* London, 1822, no. 89; M. Rogers, Jr., "Benjamin West and the Caliph; Two Paintings for Fonthill Abbey," *Apollo,* LXXXIII, June 1966, pp. 420–25, fig. 2; Montgomery Art Gallery, Pomona College, *18th Century Drawings from California Collections,* Claremont, Calif., 1976, p. 46, fig. 24 (cat. by D. Steadman); J. Dillenberger, *Benjamin West: The Context of His Life's Work,* San Antonio, 1977, pp. 109, 150, 194, 209, fig. 75.

These canvases were commissioned in 1797 by William Beckford (1760–1844) for Fonthill Abbey, his immense neo-Gothic house in Wiltshire. Millard Rogers (1966) gives a comprehensive discussion of the commission, and of the placement and different versions of both subjects, as well as of the sale of Fonthill Abbey and its collections.

St. Thomas à Becket: This composition was also executed as a grisaille window which was installed after the 1823 Fonthill auction, together with other stained glass from the Abbey, in St. Mark's Church (also known as the Lord Mayor's Chapel), Bristol, England, where it remains.

West depicted Becket (1118–1170) as Archbishop of Canterbury, though with reference to his earlier position as Lord Chancellor under Henry II. Becket wears the mitre and robes and carries the crozier of an archbishop, while in his right hand he holds his attribute as Lord Chancellor, the purse emblazoned with the King's image and name containing the royal seal.

Shortly after his martyrdom, the cult of St. Thomas à

Becket spread quickly in Europe, and his image often appears in medieval art. Beckford was probably drawn to this subject by his passion for the Middle Ages, and also because he may have empathized with Becket's fall from the king's graces.

St. Michael and the Dragon: Although probably intended for a window, this subject from the Book of Revelation (12:7) was never carried out in glass. In a diary entry of Sep. 29, 1787, his birthday and also the Feast of St. Michael, Beckford, who had been socially ostracized after two scandalous love affairs, hinted why he may have been drawn to this subject:

> Mass was performed in my chapel this morning in honour of the valiant St. Michael. I assisted with apparent devotion, but could not help feeling all the while more sympathy for the old Dragon than becomes a pious Catholic. Alas, we are both fallen angels! Six years ago how triumphantly did I pass this festival at Fonthill, seated at the foot of my father's statue, receiving the congratulations of the first personnages in my nation, universally esteemed.... (B. Alexander, ed., *The Journal of William Beckford in Portugal and Spain 1787–88,* New York, 1955, p. 213.)

In this reference to his twenty-first birthday, Beckford equated his own social ostracism to the dragon's fall.

Among several drawings by West of the figure of St. Michael related to his paintings of this subject, the closest to the Toledo picture is an ink drawing which shows variant positions for the right leg and a slightly different placement of the arms (Grunwald Center for the Graphic Arts, University of California, Los Angeles; Steadman, fig. 65). In the Toledo painting, the legs are foreshortened to compensate visually for the intended high placement of the window.

JAMES ABBOTT McNEILL WHISTLER

1834–1903. Born in Lowell, Mass. 1843–49 in Russia. 1851–54 at U.S. Military Academy. 1854 learned etching and worked as a cartographer. In 1855 he determined to become an artist and went to Paris; never returned to U.S. Became closely associated with the leading figures of French modern art and adopted many ideas from Oriental, especially Japanese, art. 1859 settled in London, but often traveled to the Continent. 1890 published *The Gentle Art of Making Enemies.* Portrait, figure and landscape painter and printmaker; among the principal artists of his time. He was the dominant personality and tastemaker of the aesthetic movement.

Crepuscule in Opal, Trouville PL. 47

[1865] Oil on canvas

13¾ x 18⅛ in. (35 x 46 cm.)

Acc. no. 23.20

COLLECTIONS: Frederick Jameson, London, ca. 1868–after 1905; A. Arnold Hannay, London, after 1905.

EXHIBITIONS: London, Goupil Gallery, *Loan Exhibition of Nocturnes, Marines, and Chevalet Pieces by Whistler,* 1892, no. 39; London, New Gallery, International Society of Sculptors, Painters and Gravers, *Memorial Exhibition of the Works of James A. Whistler,* 1905, no. 140; New York, Macbeth, *Whistler,* 1947, no. 22; London, Arts Council Gallery, and New York, Knoedler, *James McNeill Whistler,* 1960, no. 14, repr. pl. 5 (cat. by A. Young); Berlin, Nationalgalerie, *James McNeill Whistler,* 1969, no. 6 (cat. by A. Young and R. Spencer); Ann Arbor, University of Michigan Museum of Art, *Whistler: The Later Years,* 1978, no. 40.

REFERENCES: B. Sickert, *Whistler,* London and New York, 1908, p. 165, no. 107; E. Carey, *The Works of James McNeill Whistler, A Study,* New York, 1913, p. 226, no. 474; A. Graves, *A Century of Loan Exhibitions,* London, 1914, IV, pp. 1660, no. 107; D. Sutton, *Nocturne: The Art of James McNeill Whistler,* Philadelphia and New York, 1964, p. 51, 140; B. Novak, *American Painting of the Nineteenth Century,* New York, 1969, p. 251, fig. 14–7; R. McMullen, *Victorian Outsider: A Biography of J. A. M. Whistler,* 1973, pp. 132, 274; S. Weintraub, *Whistler, A Biography,* New York, 1974, p. 130.

Whistler spent the fall of 1865 at the Channel coast resort of Trouville in the company of Courbet, his friend and mentor of the early 1860s. While there he painted seascapes which show his change from literal realism towards increasingly abstract compositions. The Toledo canvas is among the most abstract of the Trouville pictures, presaging the 1866 Valpariso seascapes and later *Nocturnes.*

This canvas was in the famous 1892 retrospective exhibition at the Goupil Gallery, largely organized by Whistler himself, which marked his achievement of serious public recognition on both sides of the Atlantic. To expose and to ridicule his critics, Whistler quoted in the catalogue many misinformed comments on his art. He appended this comment, previously published in *The Artist* at an unknown date, to the entry for the Toledo painting:

> Mr. Whistler is eminently an "Impressionist." The final business of art is not with "impressions." We want not "impressionists but expressionists," men who can say what they mean because they know what they have heard. We want not always the blotches and misty suggestions of the impressionist, etc.

Whistler was clearly bemused by the unnamed critic's association of him with the Impressionists, with whom he shared little affinity.

ALMON CLARK WHITING

1873–1962. Born in Worcester, Mass. Studied at Massachusetts Art School, Boston; with Whistler, and in Paris with Constant, Laurens, Gérome, Lhermitte and Cazin. 1901–04 Secretary, 1912–15 curator, Toledo Museum of Art. Later lived in Paris and New York. Painter, printmaker and sculptor.

Notre Dame PL. 113

[1897] Oil on canvas
24⅛ x 18-5/16 in. (61.3 x 46.5 cm.)
Signed lower right: -A-C-WHITING/Paris 1898

Acc. no. 09.1
Gift of Ten Members of the Museum

REFERENCES: *Toledo Museum of Art Museum News,* III, Mar. 1910, (p. 4), repr.

As illustrated with an early photograph in 1910, the signature and date at lower left read: Whiting/Paris '97. This was later painted out when the artist redated the picture at lower right.

JOHN WHORF

1903–1959. Born in Boston. Studied with his father, at the Boston Museum School, with Charles Hawthorne at Provincetown, Mass., and in Paris. Chiefly a watercolorist.

New England Winter PL. 200

[1925] Watercolor on paper
18½ x 24⅝ in. (47 x 62.5 cm.)
Signed and dated lower left: John Whorf '25

Acc. no. 37.29
Gift of Charles Lockhart McKelvy

COLLECTIONS: Charles Lockhart McKelvy, Toledo.

Wet Snow PL. 201

[Ca. 1938] Watercolor on paper
15⅝ x 22¼ in. (39.7 x 56.5 cm.)
Signed lower right: John Whorf 5

Acc. no. 39.83
Museum Purchase Fund

COLLECTIONS: (E. & A. Milch, New York).

West Indies Scene PL. 203

[Ca. 1938] Watercolor on paper
17 x 22⅛ in. (43.2 x 56.2 cm.)
Signed upper left: John Whorf

Acc. no. 40.140
Museum Purchase Fund

COLLECTIONS: Bought from the artist.

EXHIBITIONS: Art Institute of Chicago, *18th Annual Watercolor Exhibition,* 1939.

FREDERICK BALLARD WILLIAMS

1871–1956. Born in Brooklyn, N.Y. Studied at Cooper Union and NAD. Encouraged to paint by A. B. Davies. Ca. 1910–16 trips to Europe, especially England and France. Williams' idyllic landscapes and figure subjects show influences from Diaz and Monticelli, among others.

Fête Champêtre PL. 120

[1915] Oil on panel
11-15/16 x 16 in. (30.3 x 40.7 cm.)
Signed and dated lower right: Fredk Ballard Williams '15

Acc. no. 33.32
Gift of Arthur J. Secor

COLLECTIONS: (Vose); Arthur J. Secor, Toledo, 1915–33.

REFERENCES: A. Sheon, *Monticelli, His Contemporaries, His Influence* (exh. cat.), Pittsburgh, Carnegie Institute, 1978, p. 88, fig. 76.

ALEXANDER HELWIG WYANT

1836–1892. Born in Evans Creek, Ohio. 1850s itinerant sign painter. 1859 met Inness, who encouraged him to paint; studied at NAD. 1865–66 in Germany, England and Ireland. 1866 settled in New York. 1869 N.A. 1873 paralytic stroke forced Wyant to paint with his left hand. 1878 member Society of American Artists. 1889 moved to Arkville in the Catskills. Landscapist strongly influenced by the Barbizon painters and Inness.

The Cloudy Day PL. 74

[Late 1880s] Oil on canvas
26¼ x 39⅝ in. (66.5 x 101.7 cm.)
Signed lower right: A. H. Wyant

Acc. no. 22.28
Gift of Arthur J. Secor

COLLECTIONS: Arthur J. Secor, Toledo, 1913–22.

EXHIBITIONS: Pittsburgh, Carnegie Institute, *A Century of American Landscape Painting, 1800–1900*, 1939, no. 12, repr.; Pittsburgh, Carnegie Institute, *Survey of American Painting*, 1940, no. 167, pl. 64.

REFERENCES: E. Clark, *Alexander Wyant*, New York, 1916, pp. 59–60, repr. opp. p. 54; R. Olpin, "Register of Alexander H. Wyant Paintings in American Public Collections," in *Alexander Helwig Wyant, 1836–1892* (exh. cat.), Salt Lake City, University of Utah, 1968, p. 20; R. Olpin, "Alexander Helwig Wyant (1836–1892)," unpublished Ph.D. dissertation, Boston University, 1971, no. 160.

The Pool PL. 75

[Late 1880s] Oil on canvas
17⅜ x 14½ in. (44.1 x 36.8 cm.)
Signed lower right: A. H. Wyant

Acc. no. 22.47
Gift of Arthur J. Secor

COLLECTIONS: Mrs. A. H. Wyant, New York; William S. Hurley; (Gabriel and Leroy Gallery); (Moulton and Ricketts, Chicago, 1910); (John Levy Galleries, New York, 1911); (Vose); Arthur J. Secor, Toledo, 1912–22.

EXHIBITIONS: San Francisco, M. H. De Young Memorial Museum and the California Palace of the Legion of Honor, *The Color of Mood: American Tonalism, 1880–1910*, 1972, no. 49 (cat. by W. Corn).

REFERENCES: J. Flexner, *That Wilder Image*, Boston, 1962, p. 326, fig. 100; R. Olpin, "Register of Alexander H. Wyant Paintings in American Public Collections," *Alexander Helwig Wyant 1836–1892* (exh. cat.), Salt Lake City, University of Utah, 1968; R. Olpin, "Alexander Helwig Wyant (1836–1892)," unpublished Ph.D. dissertation, Boston University, 1971, no. 212.

ANDREW NEWELL WYETH

1917–. Born in Chadds Ford, Pa. Ca. 1931 began study of art with his father, the painter and illustrator N. C. Wyeth; largely self-taught. Ca. 1939 began to use egg tempera. Lives in Chadds Ford and in Maine. Wyeth's seemingly detached and intensely realistic depictions of rural subjects often evoke nostalgia for America's past.

The Hunter PL. 224

[1943] Tempera on masonite

33 x 33⅞ in. (83.8 x 86 cm.)
Signed lower right: Andrew Wyeth

Acc. no. 46.25
Elizabeth C. Mau Bequest Fund

COLLECTIONS: (Macbeth).

EXHIBITIONS: Toledo Museum of Art, *33rd Annual*, 1946, no. 53.

REFERENCES: *Saturday Evening Post*, Oct. 16, 1943, repr. on cover (color); L. Goodrich, "Andrew Wyeth," *Art in America*, XLIII, Oct. 1955, p. 8, repr.; W. Corn, *The Art of Andrew Wyeth*, Greenwich, Conn., 1973, pp. 135, 138, repr. p. 137 (color).

"This first appeared as my one and only cover for *The Saturday Evening Post*. Fall in Pennsylvania. The buttonwood is a giant specimen towering over Lafayette's Headquarters, Chadds Ford" (quoted by Goodrich). According to Betsy Wyeth, the artist's wife, this work was commissioned especially for the magazine cover (letter, Feb. 2, 1979).

There is a drybrush watercolor study of the tree in the artist's possession.

ZSISSLY

1897–. Born Malvin Marr Albright in Chicago; twin brother of painter Ivan Le Lorraine Albright. Studied with his father, the painter Adam Emery Albright; at Art Institute of Chicago; PAFA and in France. First active as a sculptor, but began to paint in late 1920s. Lives in Chicago; summer studio in Maine. As a sculptor uses his own name; as a painter is known as Zsissly.

Incoming Tide, Maine PL. 223

[1939] Oil on canvas
35¾ x 45 in. (91 x 114.3 cm.)
Signed lower right: ZSISSLY

Acc. no. 46.22
Elizabeth C. Mau Bequest Fund

COLLECTIONS: Bought from the artist.

EXHIBITIONS: Pittsburgh, Carnegie Institute, *Painting in the United States*, 1945, no. 299; Toledo Museum of Art, *33rd Annual*, 1946, no. 54.

According to the artist, this view of Pemaquid Beach, Maine, was painted in the summer of 1939, when he was staying at New Harbor (letter, Feb. 2, 1979).

Plates

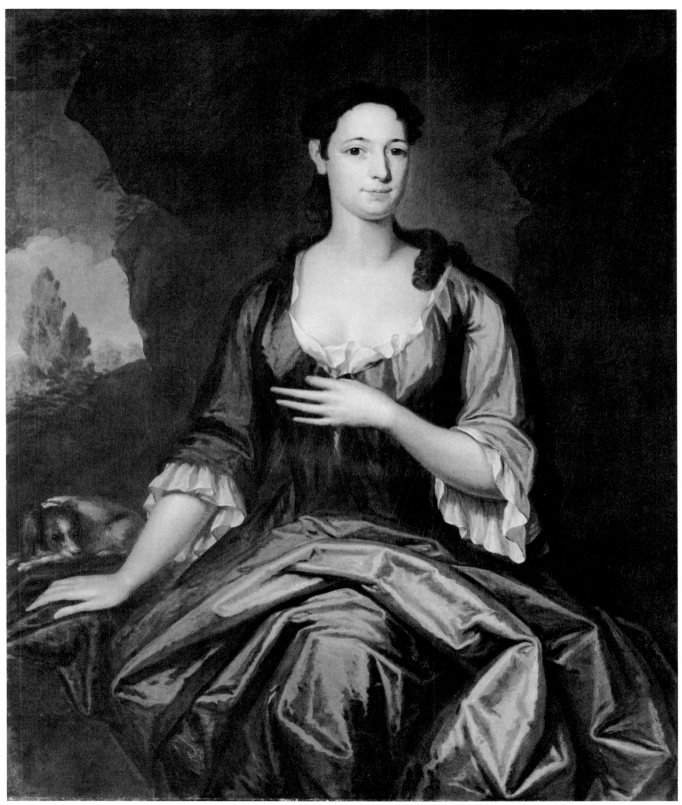

1. John Smibert, *Mrs. Nathaniel Cunningham*, 1730

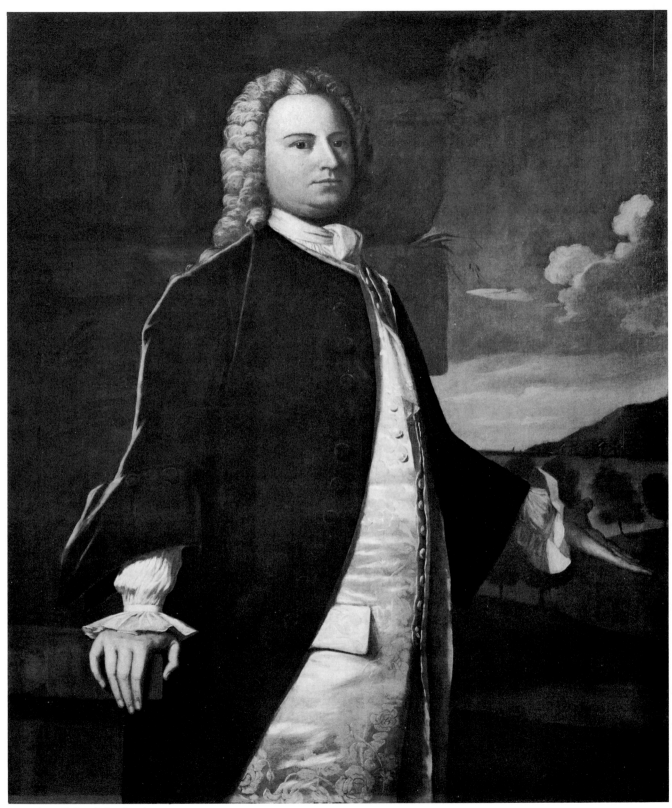

2. Robert Feke, *John Banister*, 1748

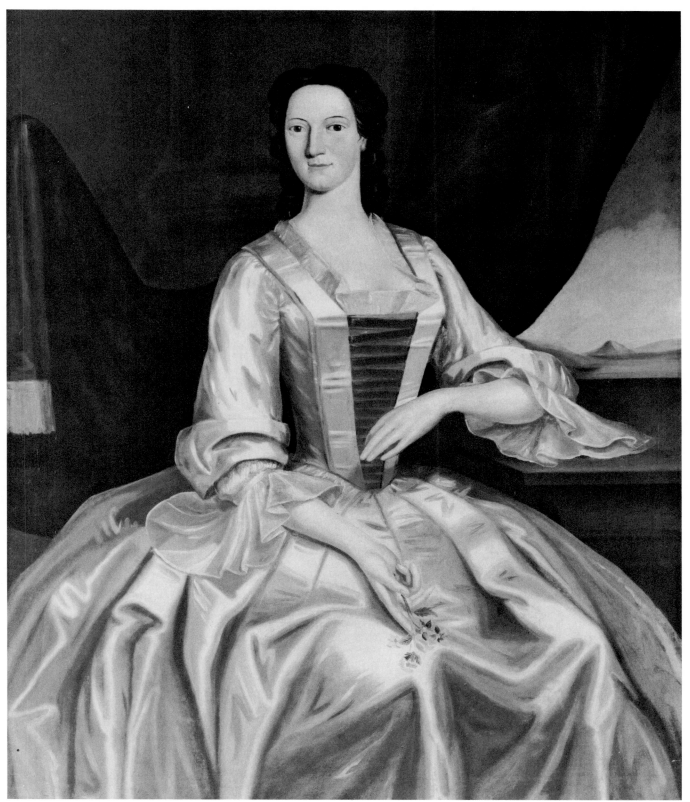

3. John Greenwood, *Sarah Kilby,* ca. 1752

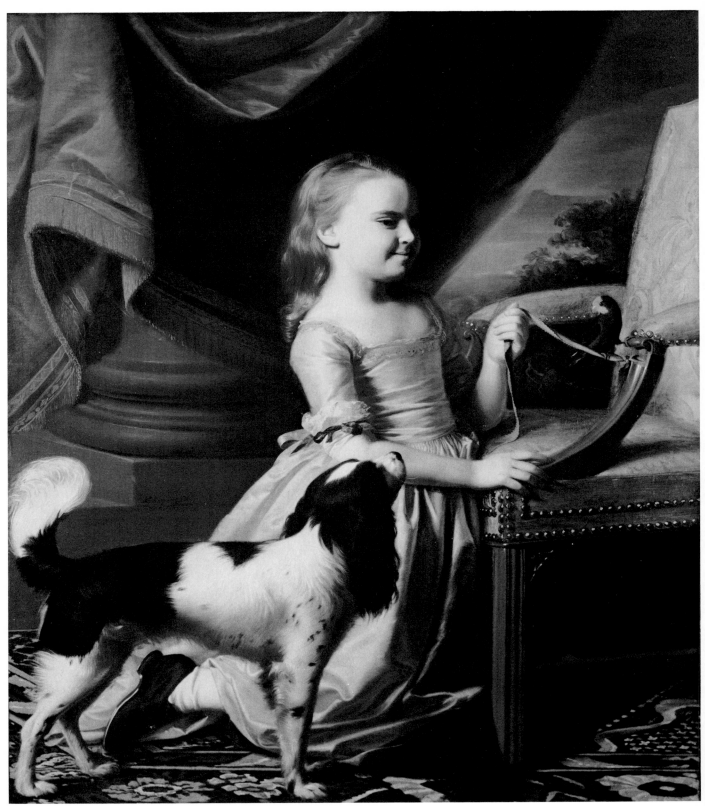

4. John Singleton Copley, *Young Lady with a Bird and Dog*, 1767

5. Ralph Earl, *The Taylor Children*, 1796

6. Benjamin West, *Scene from Ariosto's "Orlando Furioso": The Damsel and Orlando*, 1793

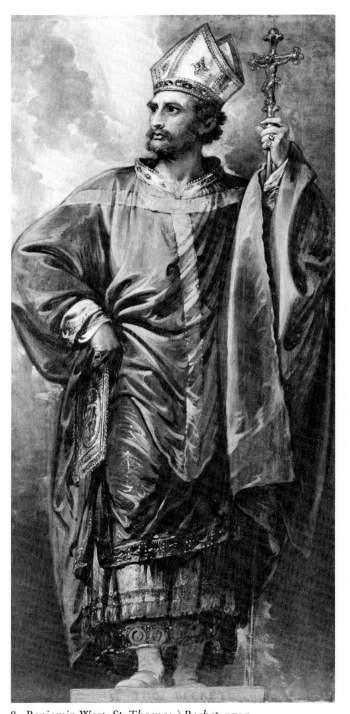

7. Benjamin West, *St. Michael and the Dragon*, 1797

8. Benjamin West, *St. Thomas à Becket*, 1797

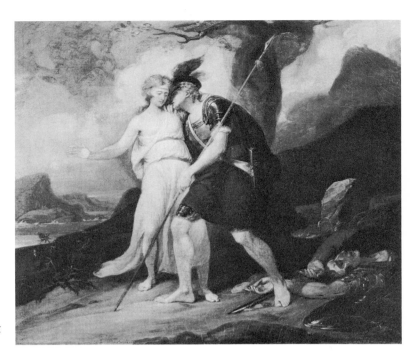

9. John Trumbull, *Scene from Ossian's "Fingal": Lamderg and Gelchossa*, 1792

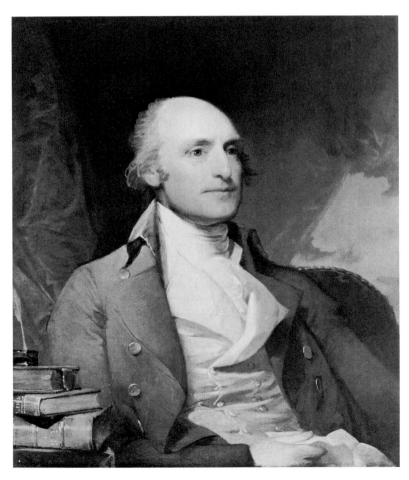

10. Gilbert Stuart, *John Ashley*, 1799

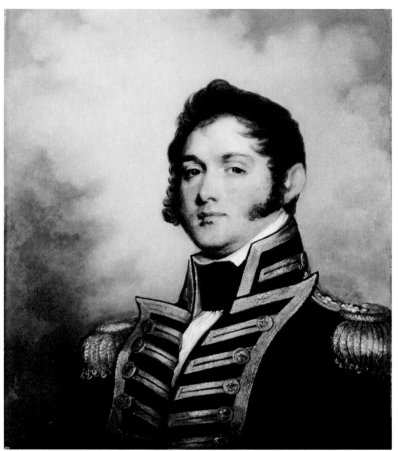

11. Gilbert Stuart and Jane Stuart,
 Commodore Oliver Hazard Perry, 1818–28

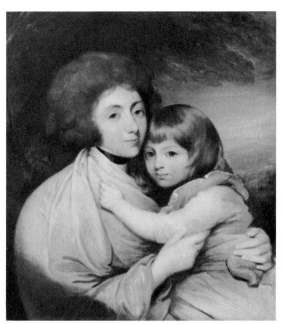

12. Copy after Gilbert Stuart, *Mrs. Luke White and Her Son*

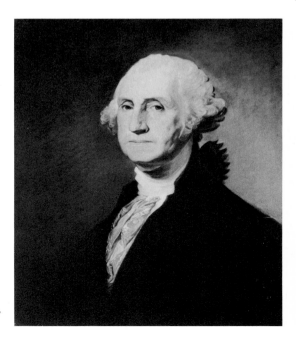

13. Copy after Gilbert Stuart,
 George Washington

124

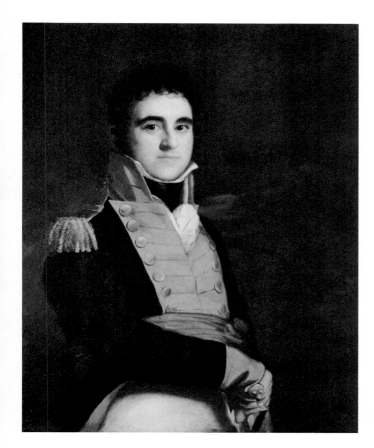

14. John Wesley Jarvis, *Mordecai Myers,*
ca. 1813

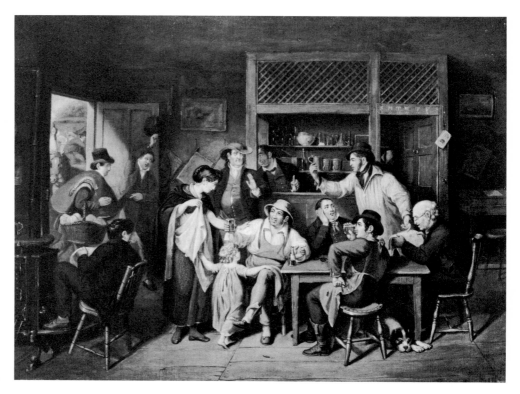

15. John Lewis Krimmel,
Village Tavern, 1813–14

16. Washington Allston, *Italian Landscape*, 1814

17. Raphaelle Peale, *Still Life with Oranges*, ca. 1818

18. Samuel Finley Breese Morse, *Scene from Spenser's "Faerie Queene": Una and the Dwarf*, 1827

19. Thomas Doughty, *View near Cornwall-on-Hudson*, ca. 1839

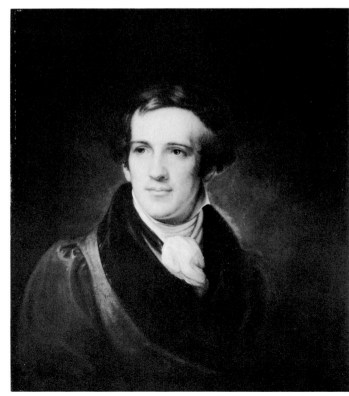

20. Rembrandt Peale, *John B. Pendleton*, ca. 1828

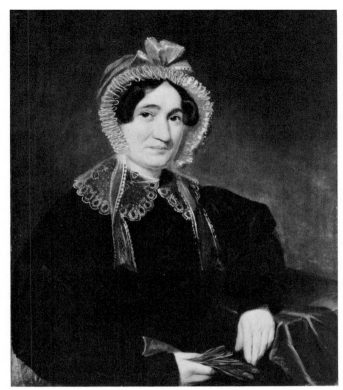

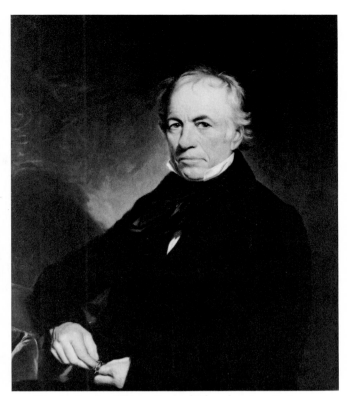

21. Charles Loring Elliott, *Electa Cleaveland Rhoades*, 1836

22. Charles Loring Elliott, *Samuel Rhoades, Jr.*, 1836

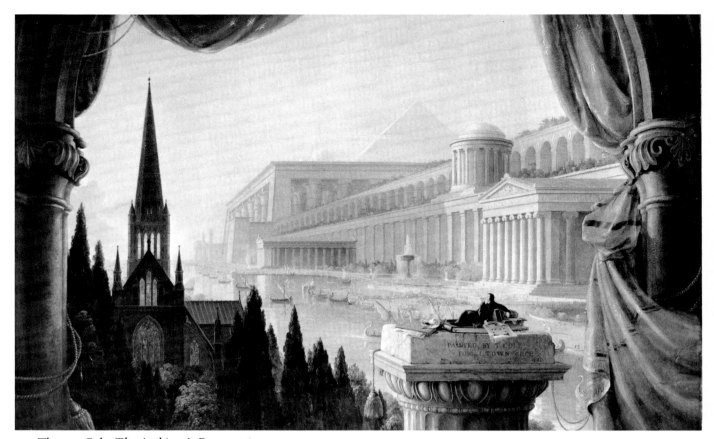

23. Thomas Cole, *The Architect's Dream,* 1840

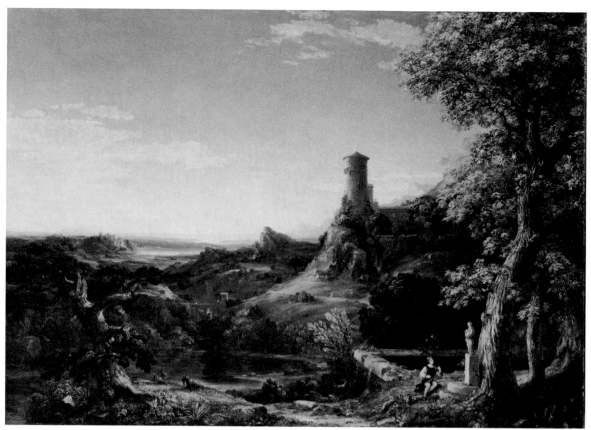

24. Thomas Cole, *Landscape, The Vesper Hymn: An Italian Twilight*, 1841

25. Samuel Lovett Waldo, *Portrait of a Man,*
 ca. 1829–30

26. Oliver Tarbell Eddy, *Henrietta Ten
 Broeck Day,* ca. 1835

27. Anonymous, *Emma Gordon Shields,*
 ca. 1840–43

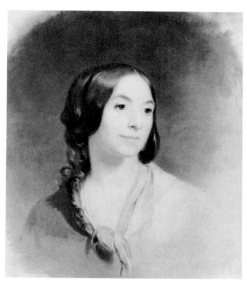

28. Thomas Sully, *Mrs. Burnett of Philadelphia*, 1844

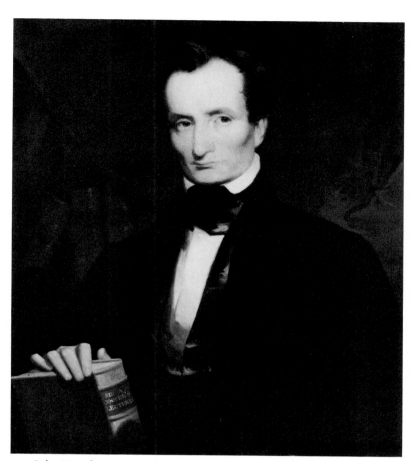

29. John Neagle, *Dr. Maurice Morrison*, 1841

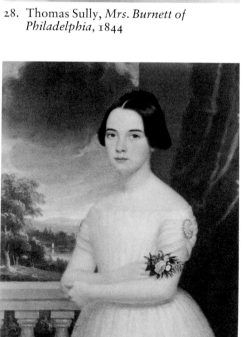

30. Frederick R. Spencer, *Fannie Peckham*, 1849

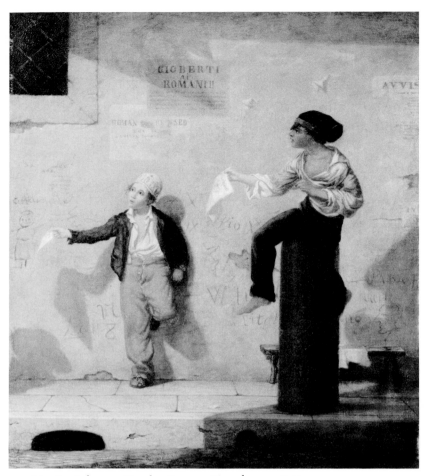

31. Martin Johnson Heade, *Roman Newsboys*, 1848

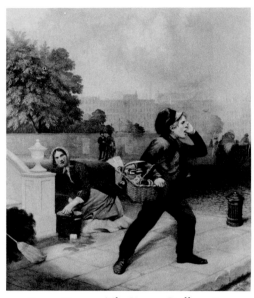

32. James Brown, *The Young Pedlar*, 1850

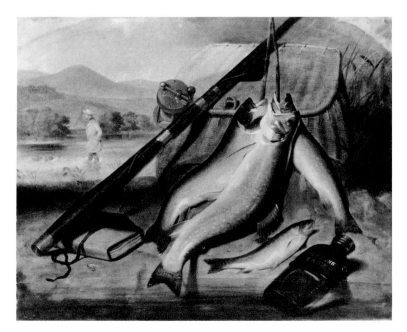

33. Junius Brutus Stearns, *Still Life with Trout and Fishing Tackle*, 1853

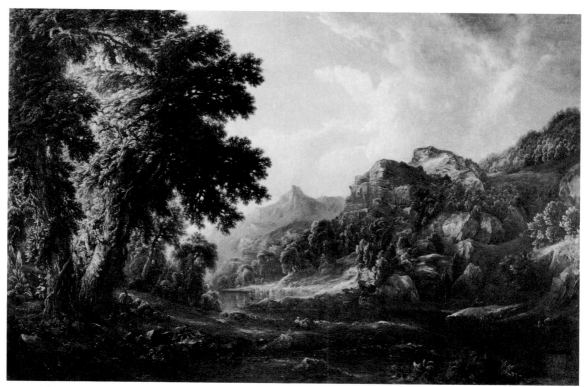

34. William Mason Brown, *Landscape with Two Indians*, ca. 1855

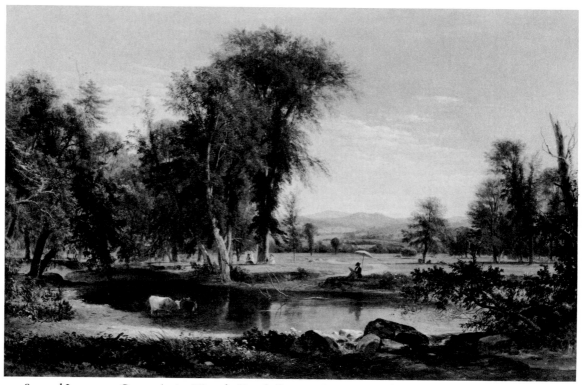

35. Samuel Lancaster Gerry, *Artists' Brook, North Conway, New Hampshire*, ca. 1857

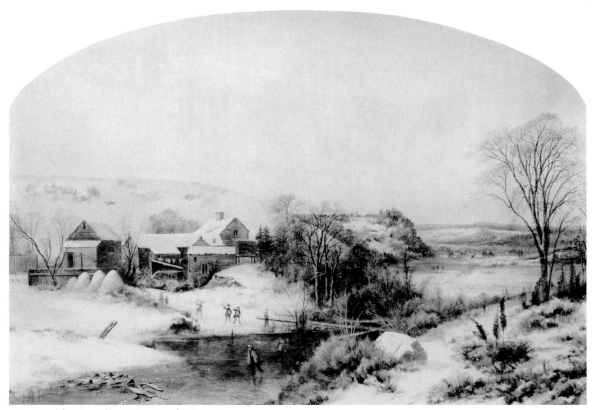

36. Joseph Morviller, *Testing the Ice*, 1857

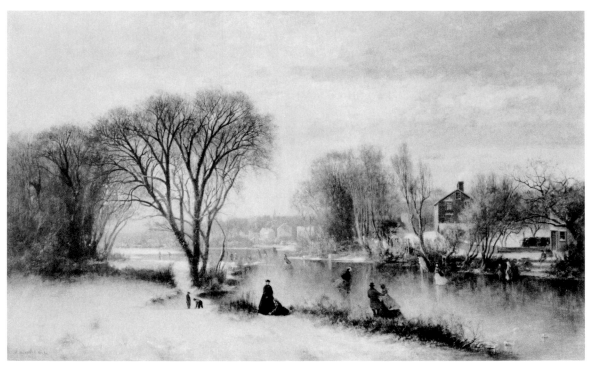

37. Joseph Morviller, *Skating at Medford*, 1865

136

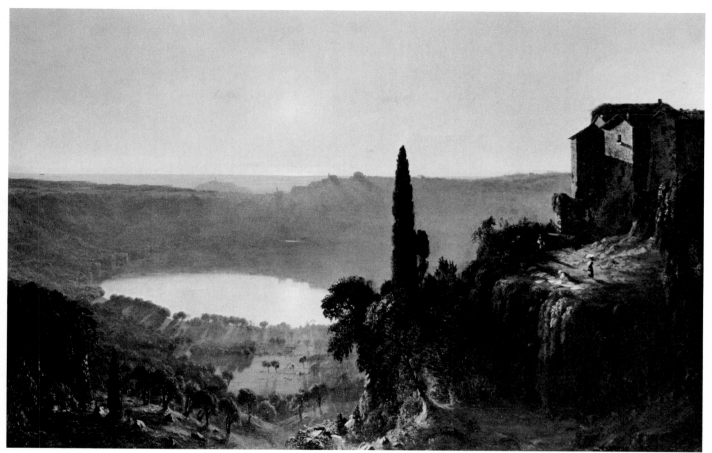

38. Sanford Robinson Gifford, *Lake Nemi*, 1856–57

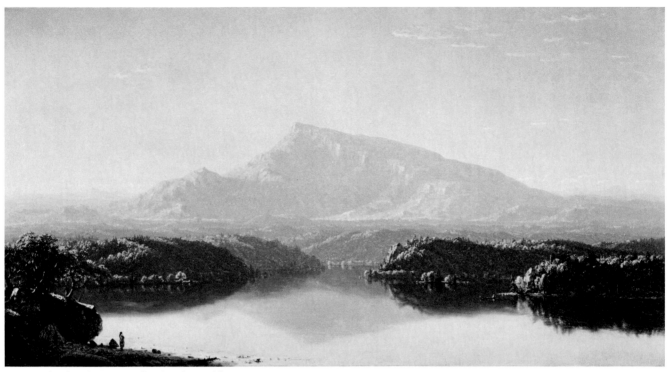

39. Sanford Robinson Gifford, *The Wilderness*, 1860

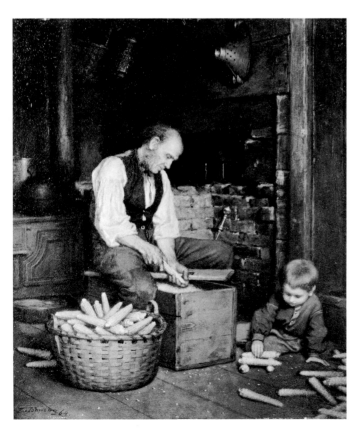

40. Eastman Johnson, *Corn-Shelling*, 1864

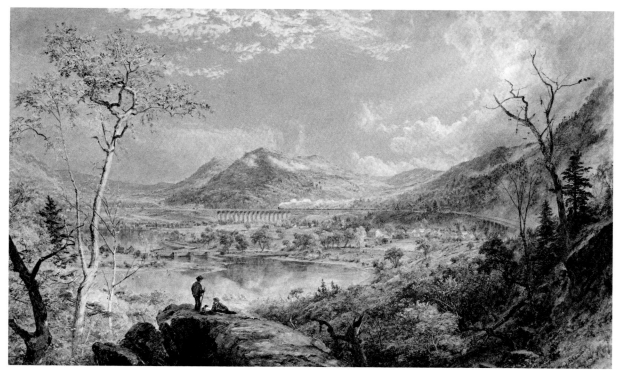

41. Jasper Francis Cropsey, *Starrucca Viaduct, Pennsylvania*, 1865

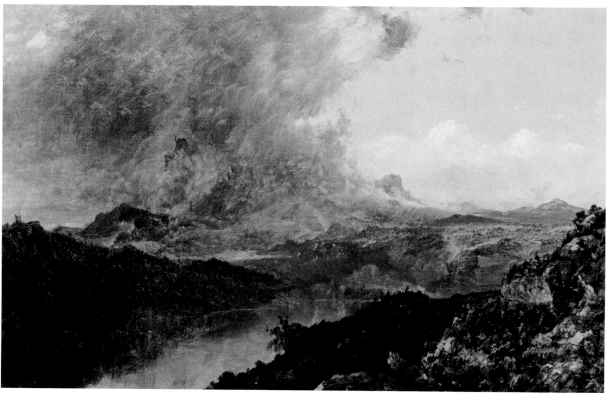

42. John Frederick Kensett, *Storm, Western Colorado*, 1870

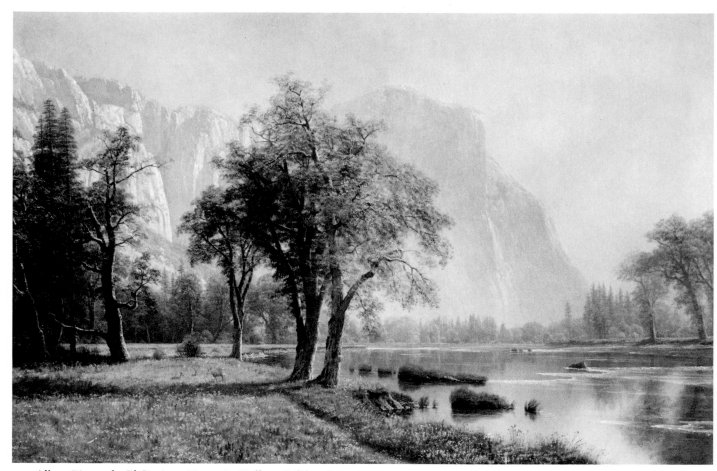

43. Albert Bierstadt, *El Capitan, Yosemite Valley, California*, 1875

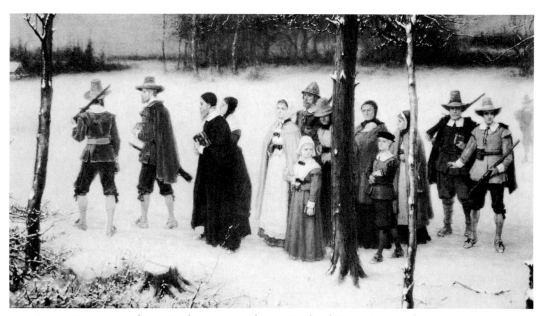

44. George Henry Boughton, *Early Puritans of New England Going to Worship*, 1872

45. William Morris Hunt, *Francisca Paim da Terra Brum da Silveira*, 1858

46. William Morris Hunt, *The Little Gleaner*,
1854

47. James Abbott McNeill Whistler, *Crepuscule in Opal, Trouville*, 1865

48. Felix Octavius Carr Darley,
A Street Scene in Rome, 1867

49. Felix Octavius Carr Darley, *The Camp*, 1876

50. William Trost Richards, *Near Durness, Scotland*

51. William Trost Richards, *Sand Hills, Atlantic City, New Jersey*

52. William Trost Richards, *New Jersey Coast*

53. William Trost Richards, *New England Coast*

54. John George Brown, *The Country Gallants*, 1876

55. Daniel Huntington, *John Sherman*, 1879

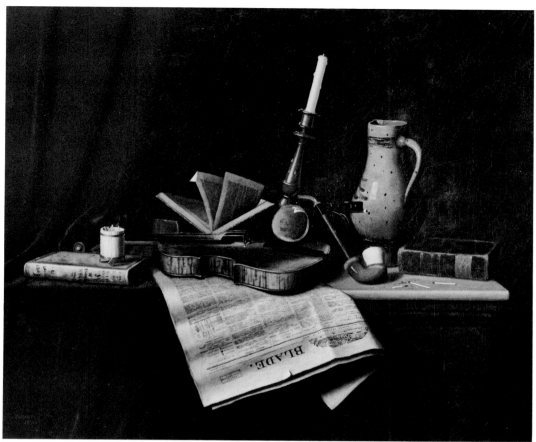

56. William Harnett, *Still Life with the* Toledo Blade, 1886

57. Edward Lamson Henry, *The Coming Train*, 1880

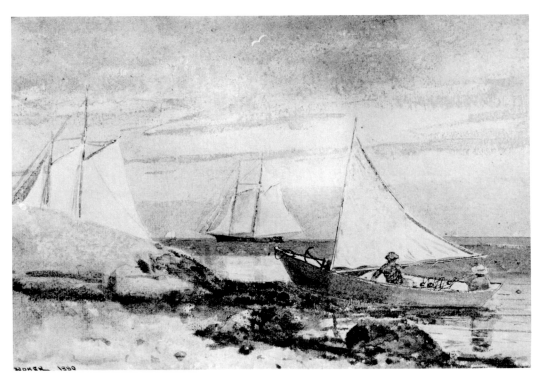

58. Winslow Homer,
Boys Beaching a Dory,
1880

59. Winslow Homer, *Palm Trees, Bahamas*,
ca. 1898–99

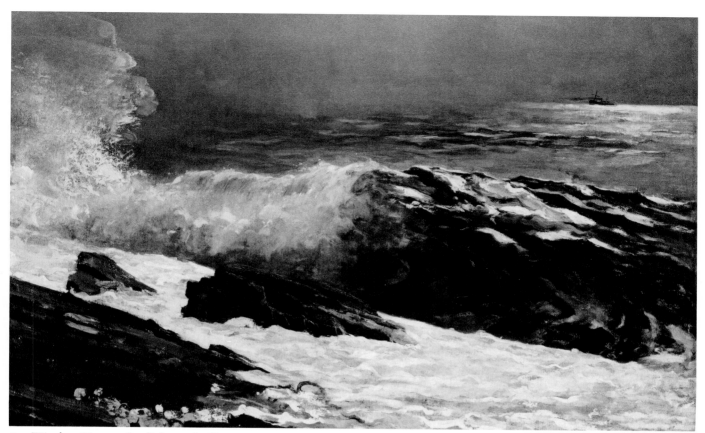

60. Winslow Homer, *Sunlight on the Coast*, 1890

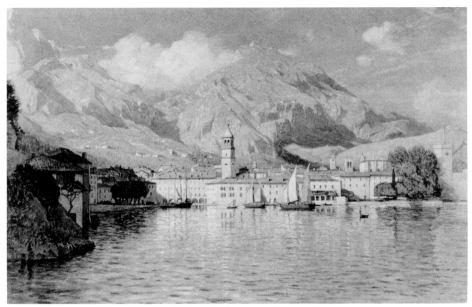

61. William Stanley Haseltine, *Lake Garda*

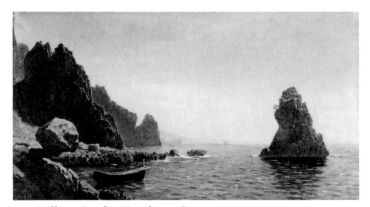

62. William Stanley Haseltine, *Capri*

63. Frank Duveneck, *Head of an Old Man*, ca. 1883

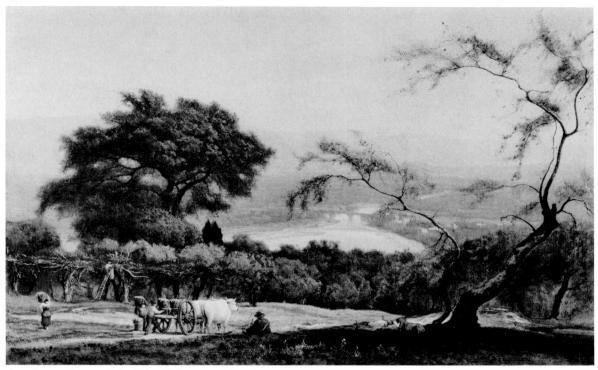

64. George Inness, *The Tiber Below Perugia*, 1871

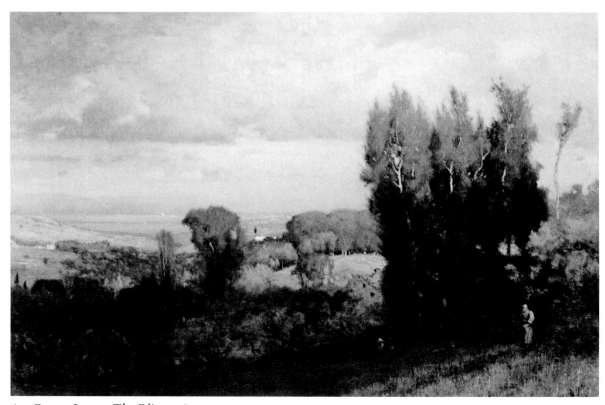

65. George Inness, *The Olives*, 1873

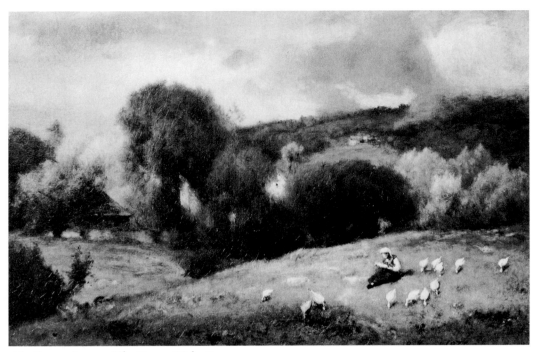

66. George Inness, *The Goose Girl*, 1877

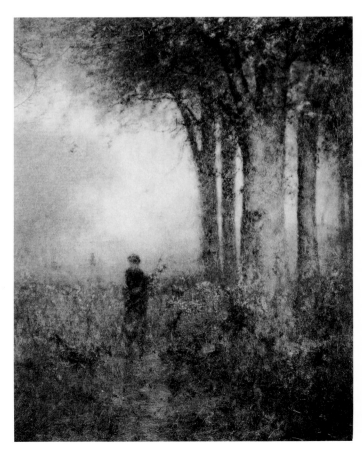

67. George Inness, *Sunset*, 1891

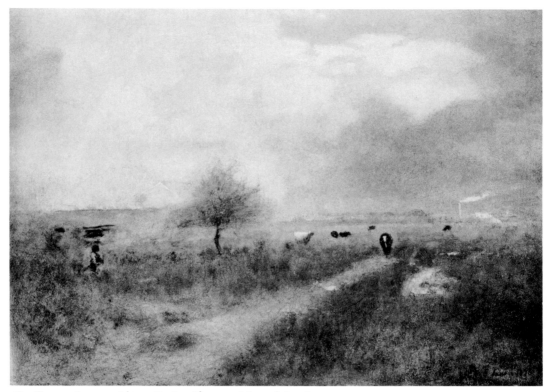

68. George Inness, *After a Spring Shower, Montclair*, 1893

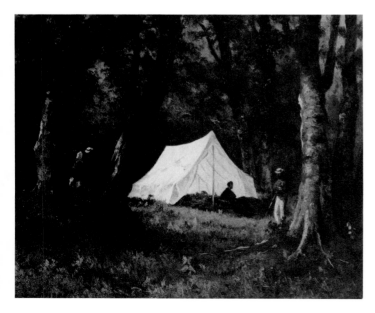

69. Anonymous, *Camp in the Adirondacks*

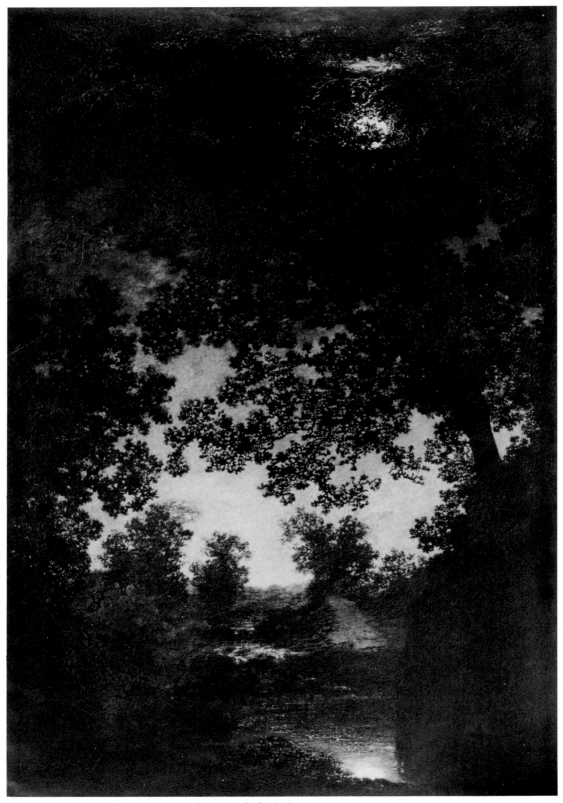

70. Ralph Albert Blakelock, *Brook by Moonlight*, before 1891

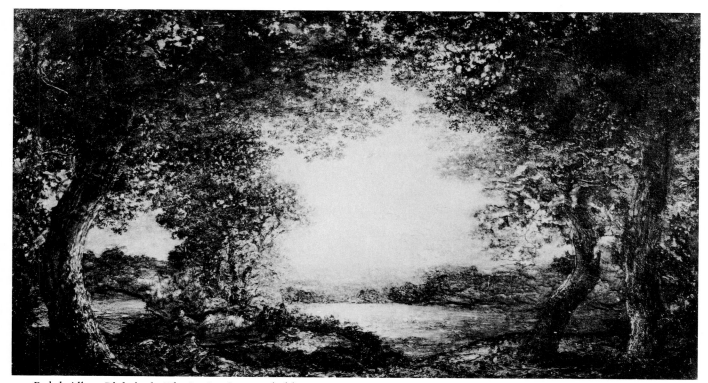

71. Ralph Albert Blakelock, *The Setting Sun,* probably 1890s

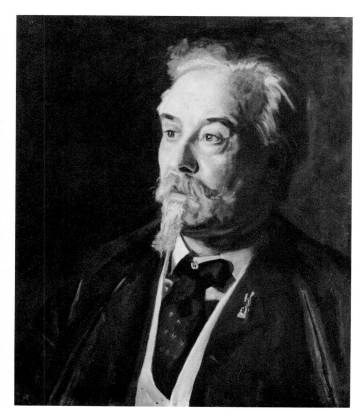

72. Thomas Cowperthwait Eakins,
B. J. Blommers, 1904

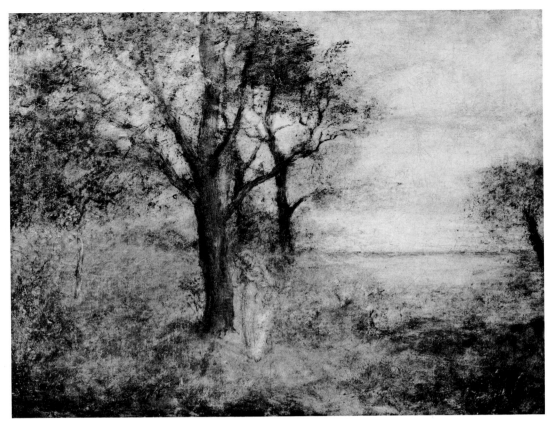

73. Albert Pinkham Ryder, *Spring*, ca. 1879

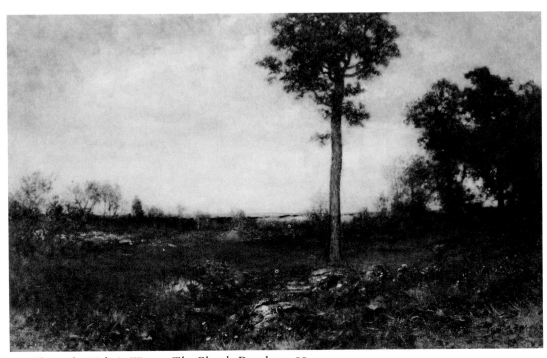

74. Alexander Helwig Wyant, *The Cloudy Day*, late 1880s

154

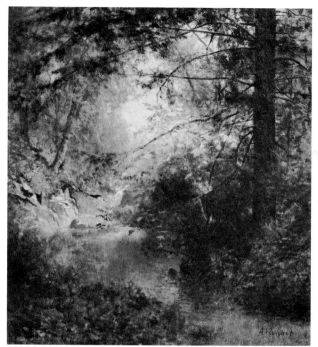

75. Alexander Helwig Wyant, *The Pool,* late 1880s

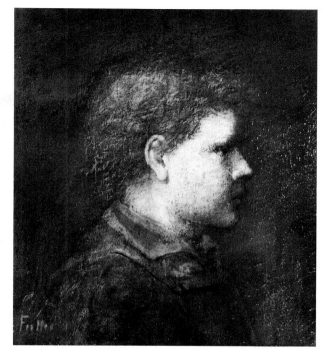

76. George Fuller, *Head of a Boy*

77. Walter Shirlaw, *Market Scene*

78. Walter Shirlaw, *Hillside*

79. Walter Shirlaw, *Barnyard Scene*

80. John Henry Twachtman, *Lilacs in Winter*, ca. 1890–1900

81. John La Farge, *Crows Flying, Japan*, 1886

82. John La Farge, *Crater of Kilauea and the Lava Bed*, 1890

83. John La Farge, *At Sunrise, Kilauea Crater, Sept. 17th*, 1890

84. John La Farge, *Garland of Fruit and Flowers*, 1882

85. John La Farge, *Looking East in Tautira Village, Tahiti*, 1891

86. John La Farge, *Hari, or Bundle of Cocoanuts, Tahiti*, 1891

87. John La Farge, *Mountain Hut of Devil Priest, Waikumbukumbu, Fiji,* 1891

89. John La Farge, *The Hut Behind the Magistrate's House, Vunidawa, Fiji,* 1891

90. John La Farge, *The Tank at Kandy, Ceylon,* 1891

88. John La Farge, *Carew's Slide, Fiji,* 1891

91. John La Farge, *Spirit of the Storm, Japanese Folk Lore,* 1897

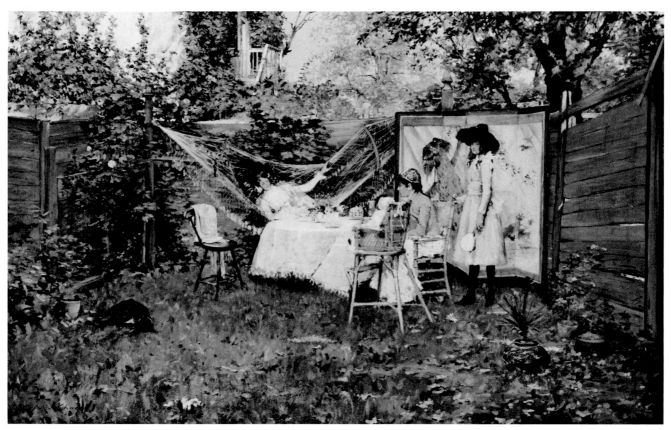

92. William Merritt Chase, *The Open Air Breakfast,* ca. 1888

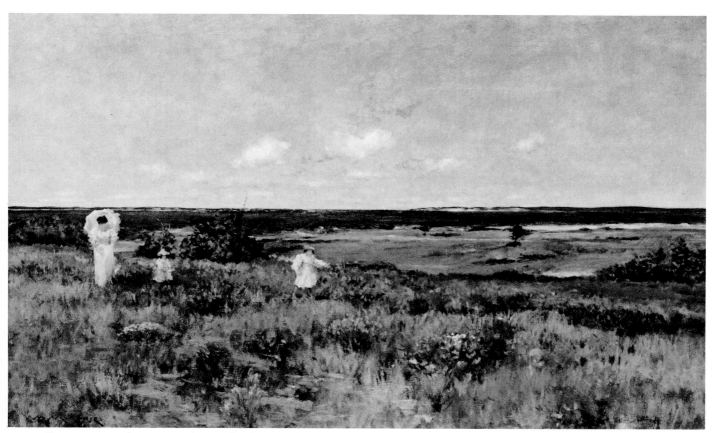

93. William Merritt Chase, *Near the Beach, Shinnecock*, ca. 1895

94. Abbott Handerson Thayer, *Helen Sears*, 1891–92

95. John Singer Sargent, *Princess Demidoff*, ca. 1895–96

96. John Singer Sargent, *Florence Addicks*, 1890

97. Wilder M. Darling, *Head of a Dutch Peasant*

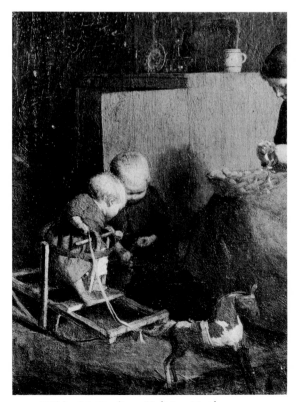

100. Wilder M. Darling, *Helping Mother*, 1900

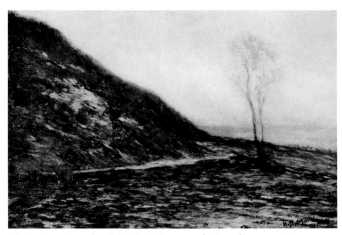

98. Homer Dodge Martin, *Normandy Landscape*, 1894

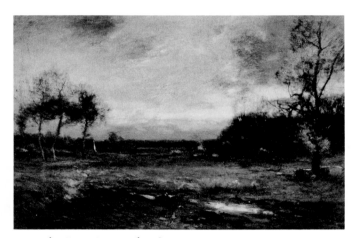

99. John Francis Murphy, *Sunset*, 1895

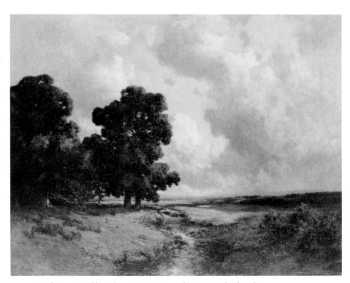

101. Julian Walbridge Rix, *Sunshine and Shadow*

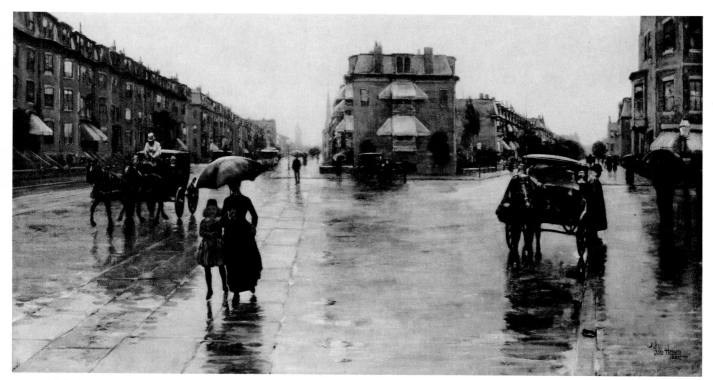

102. Childe Hassam, *Rainy Day, Boston*, 1885

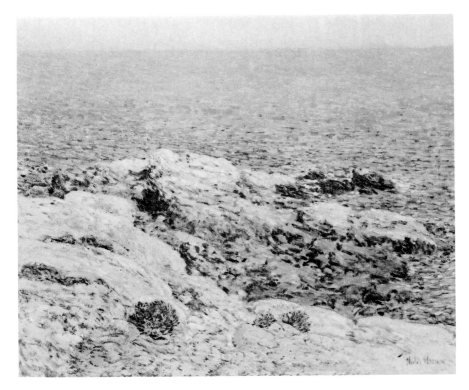

103. Childe Hassam,
Summer Sea, Isles of Shoals,
1902

104. Theodore Robinson,
Girl at Piano, ca. 1887

105. Luther Emerson van Gorder, *Quai aux Fleurs, Paris*

106. Luther Emerson van Gorder, *Flower Market, Paris*

107. George Washington Stevens, *Venice*, 1898

108. George Washington Stevens, *A Canal in Venice*, ca. 1902

109. George Washington Stevens, *London Fog*

110. George Washington Stevens, *Dutch Landscape*, ca. 1904

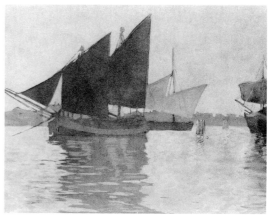

111. George Washington Stevens, *Dutch Boats*, ca. 1904

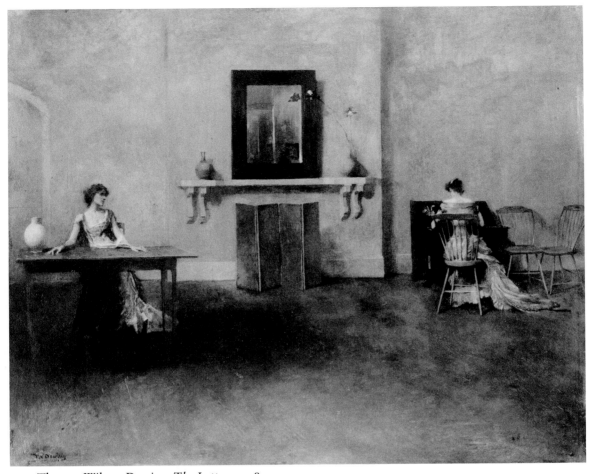

112. Thomas Wilmer Dewing, *The Letter,* 1908

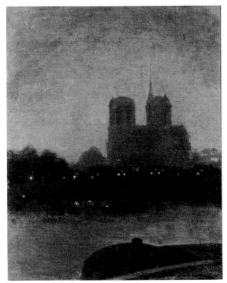

113. Almon Clark Whiting, *Notre Dame,* 1897

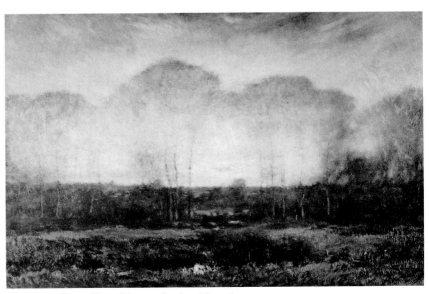

114. Dwight William Tryon, *Spring Morning,* 1910

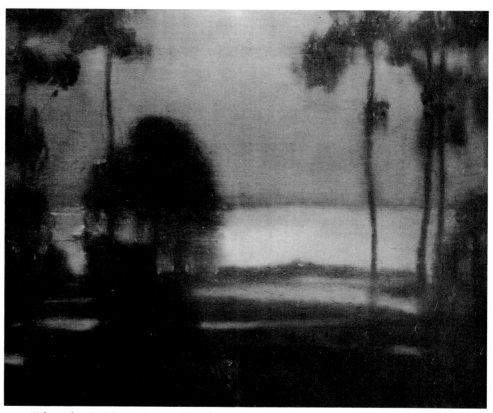

115. Edward J. Steichen, *Across the Salt Marshes, Huntington*, ca. 1905

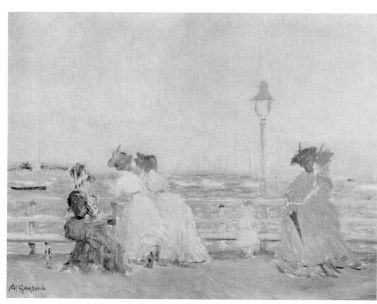

116. Arthur Clifton Goodwin, *On South Boston Pier*, ca. 1904

117. Carl Marr, *Dusk*, 1908

118. Gustave Henry Mosler, *De Profundis*, 1900

119. Charles Courtney Curran, *The Jungfrau, Afternoon Sunlight*, 1900

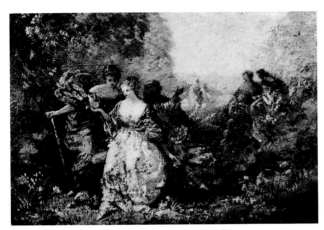

120. Frederick Ballard Williams, *Fête Champêtre*, 1915

121. Julius Gari Melchers, *Easter Sunday*, 1910-11

122. Charles Courtney Curran, *The Swimming Hole*, ca. 1894

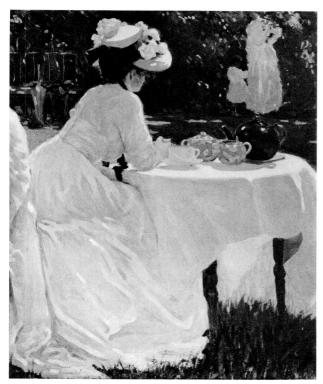

123. Frederick Frary Fursman, *In the Garden*, 1909

124. Frederick Judd Waugh, *Monhegan Surf*, 1913

125. Carlton Theodore Chapman, *A Rocky Coast*

126. Henry Ward Ranger, *Forest and Stream*, 1910

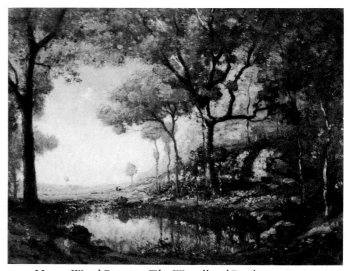

127. Henry Ward Ranger, *The Woodland Pool*, ca. 1894

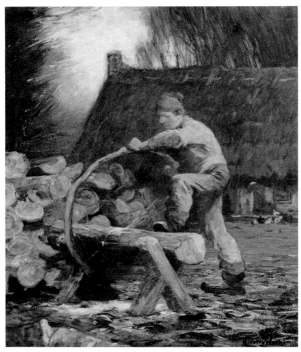

128. Horatio Walker, *The Woodcutter*, 1900

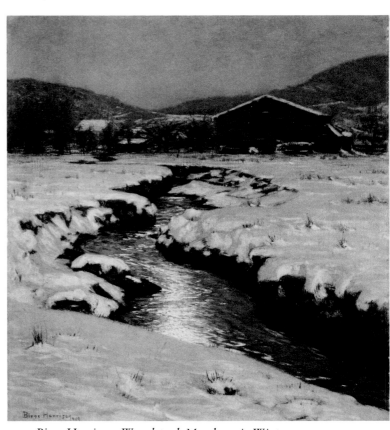

129. Birge Harrison, *Woodstock Meadows in Winter*, 1909

130. Ben Foster, *Early Moonlight*, ca. 1912

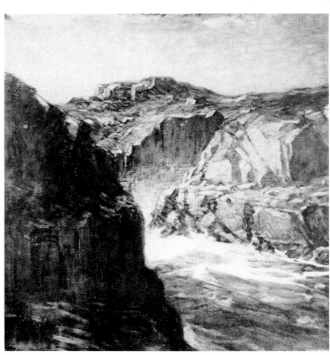

131. Paul Dougherty, *Moonlit Cove*, 1908

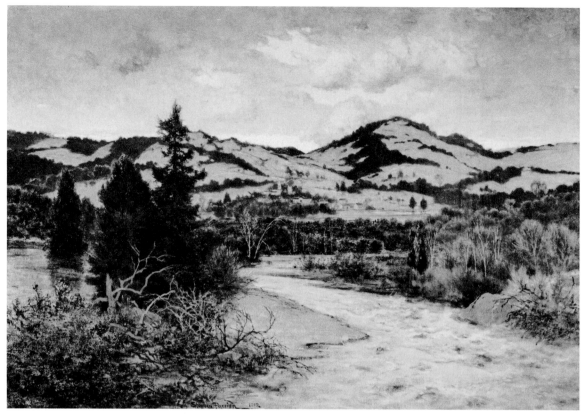

132. Stephen Parrish, *The Breakup of Winter*, 1912

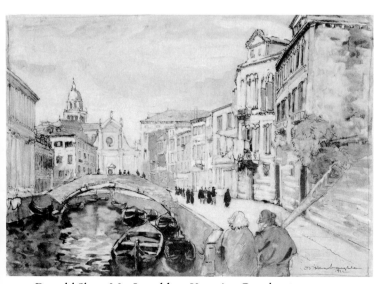

133. Donald Shaw MacLaughlan, *Venetian Canal*, 1912

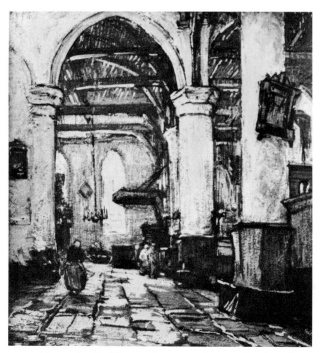

134. Alexander Robinson, *Interior of a Dutch Church*, 1909

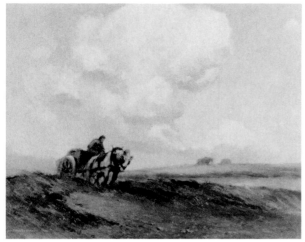

135. George Elmer Browne, *The White Cloud*, 1910

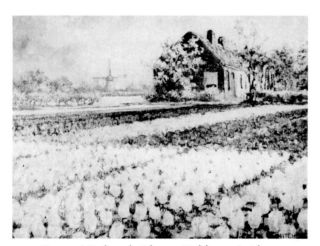

137. George Hitchcock, *Flower Field near Leiden*

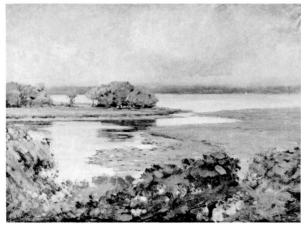

138. Carlton Theodore Chapman, *The Maumee River*, 1921

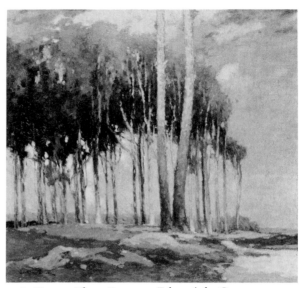

136. George Elmer Browne, *Edge of the Grove*, ca. 1916

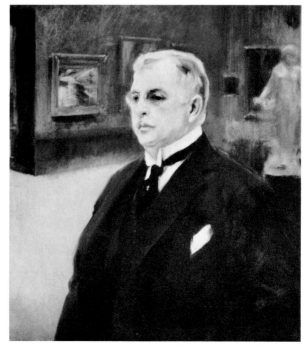

139. Gordon Stevenson, *Edward Drummond Libbey*

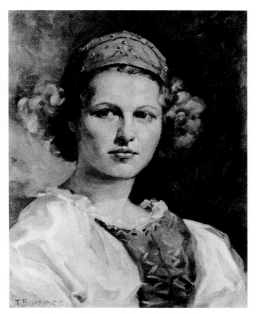

140. Fritz Boehmer, *Head of a Girl*

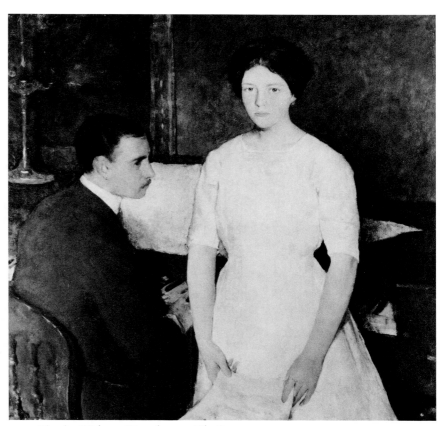

141. Charles Webster Hawthorne, *The Song,* ca. 1912

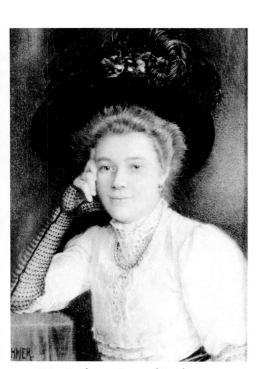

142. Fritz Boehmer *Gertrud Boehmer,*
ca. 1895

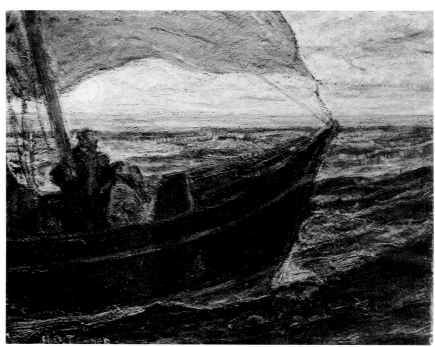

143. Henry Ossawa Tanner, *The Disciples on the Sea,* ca. 1910

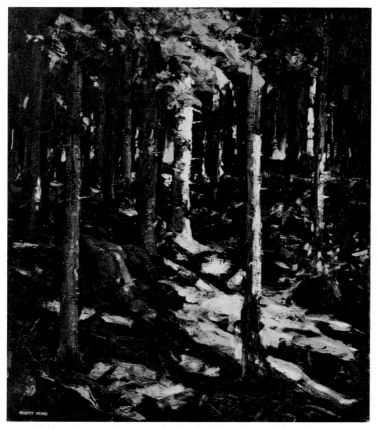

144. Robert Henri, *Cathedral Woods, Monhegan Island*, 1911

145. Edmund Henry Osthaus, *Major*

146. Edmund Henry Osthaus, *Afield*, ca. 1900

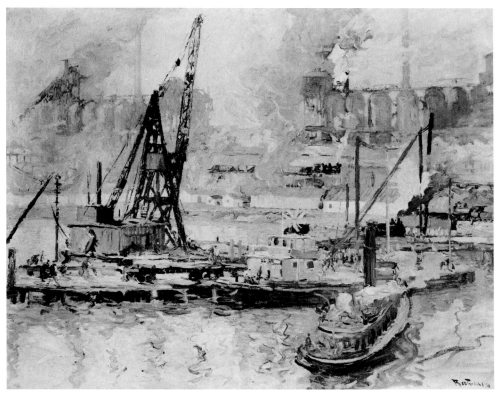

147. Henry Reuterdahl, *Blast Furnaces*, 1912

148. Thomas Shrewsbury Parkhurst, *The Spirit of the Maumee*

149. Everett L. Warner, *Along the River Front, New York*, 1912

150. Frederic Remington, *Indians Simulating Buffalo*, 1908

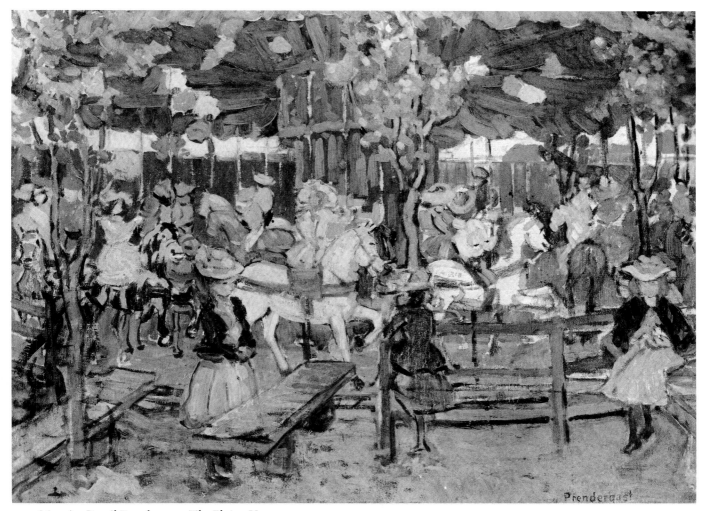

151. Maurice Brazil Prendergast, *The Flying Horses*, ca. 1901

152. Arthur Bowen Davies,
 The Redwoods, 1905

153. George Benjamin Luks,
 The Little Milliner, ca. 1905

154. Everett Shinn, *Winter Night*, 1903

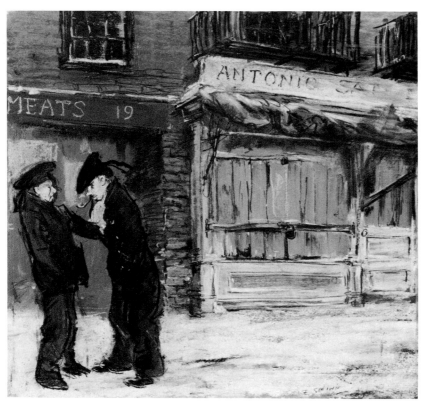

155. Everett Shinn, *Street in Winter— Sailors on Leave*, 1903

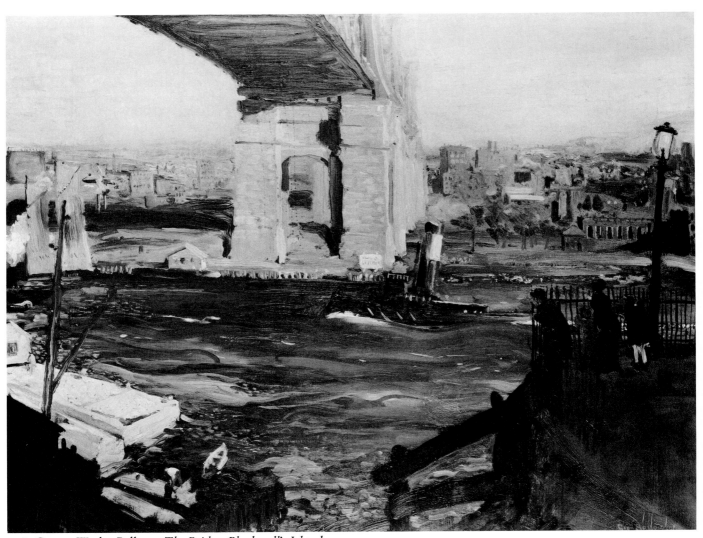

156. George Wesley Bellows, *The Bridge, Blackwell's Island*, 1909

157. John Sloan, *Movies*, 1913

158. Ernest Lawson, *Early Spring,
Harlem River*, ca. 1912-15

159. Charles Henry Demuth,
The Bay, Provincetown,
ca. 1914

160. Joseph Stella, *Nocturne*, ca. 1918

161. Cecilia Beaux, *After
the Meeting*, 1914

162. Jean MacLane, *Florence Scott Libbey*

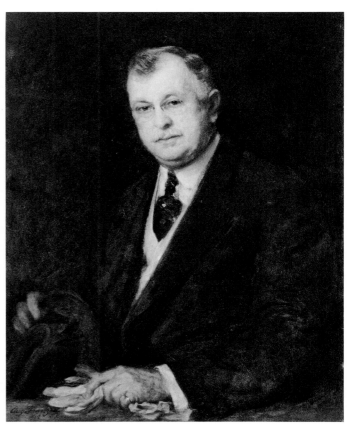

163. August Franzen, *Edward Drummond Libbey*, 1914

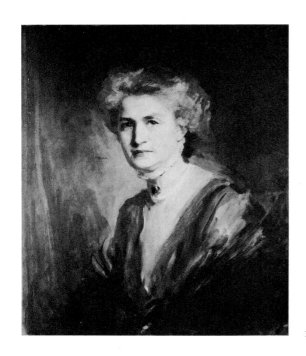

164. Anonymous, *Florence Scott Libbey*

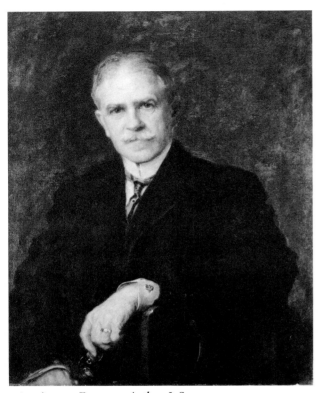

165. August Franzen, *Arthur J. Secor*, ca. 1913

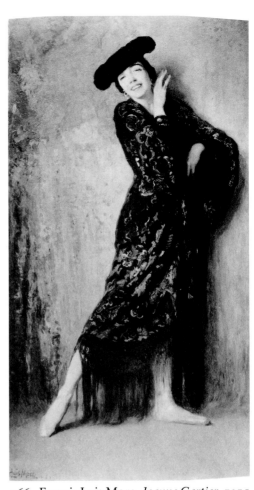

166. Francis Luis Mora, *Jeanne Cartier*, 1915

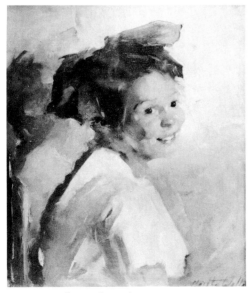

167. Martha Walter, *Anne*

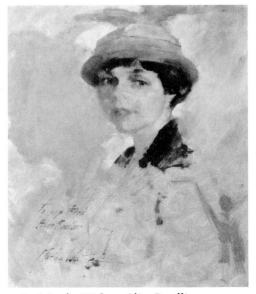

168. Martha Walter, *Alice Roullier*, ca. 1915

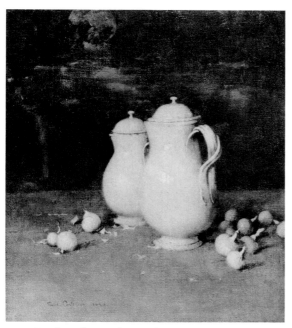

169. Emil Carlsen, *The Leeds Jug*, 1920

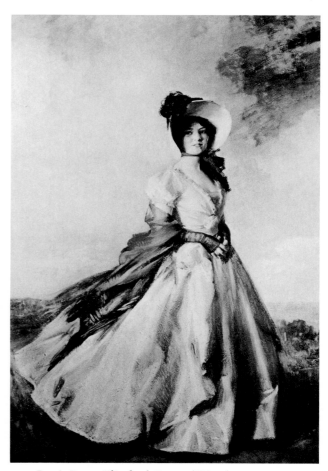

170. Louis Betts, *Elizabeth Betts of Wortham*, 1923

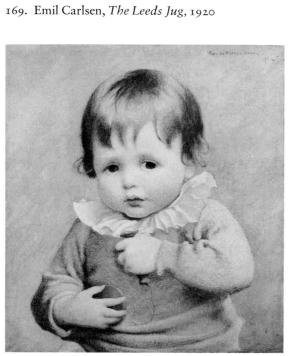

171. George de Forest Brush,
Portrait of a Child, 1922

172. Elliott Daingerfield, *Storm Breaking Up*, ca. 1912

173. Elliott Daingerfield, *Westglow*, ca. 1920

174. John Fabian Carlson, *Woodland Repose*, 1915

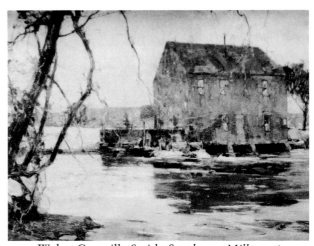

175. Walter Granville-Smith, *Southaven Mill*, 1926

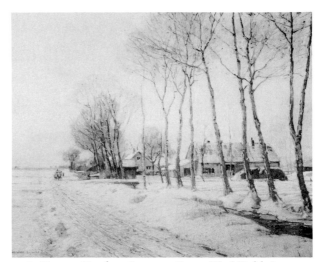

176. George Gardner Symons, *Snow Clad Fields in Morning Light*, ca. 1910

Albert Delmont Smith, *Childe Hassam*, 1922

178. Frederick Carl Frieseke, *Silhouette*, 1933

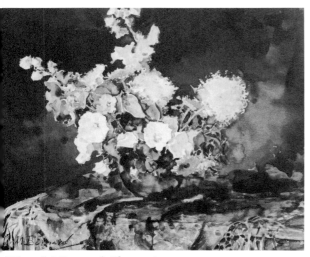

Elinor M. Barnard, *Flower Arrangement*

180. John C. Johansen, *The Little Trio*, 1926

181. Jean MacLane, *Country Dog Show*, 1933–34

182. Jean MacLane, *On the Beach, Devonshire*, 1926

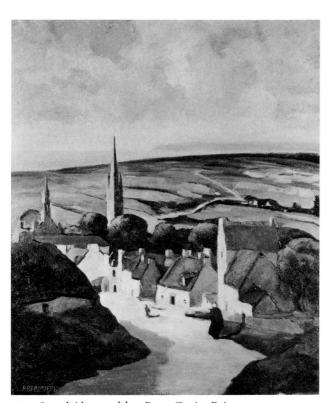

183. Israel Abramofsky, *Pont-Croix, Brittany*, 1931

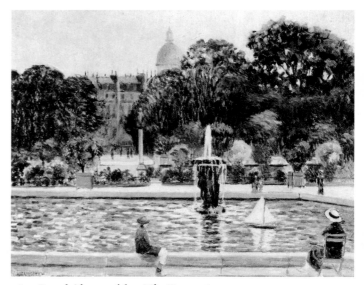

184. Israel Abramofsky, *The Fountain*, 1921

185. John Marin,
*Pine Tree, Small Point,
Maine*, 1926

187. Preston Dickinson, *Spanish Landscape*, 1930

186. Henry Lee McFee, *Petunias and Phlox*, 1926

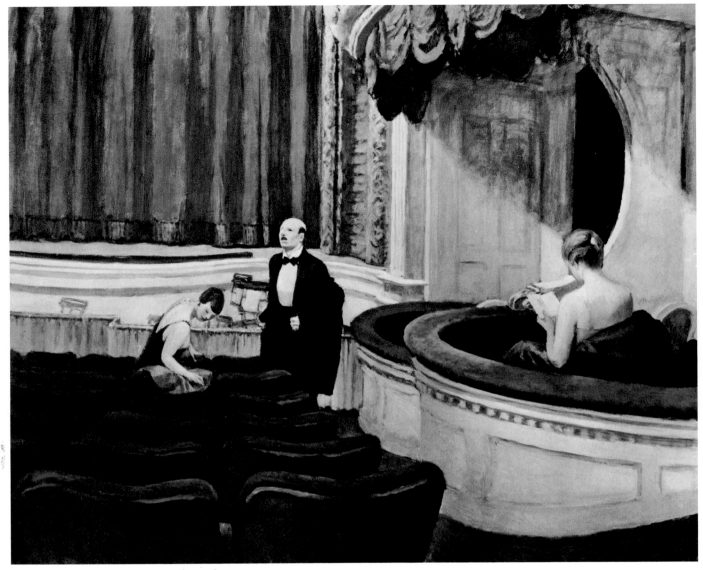

188. Edward Hopper, *Two on the Aisle*, 1927

189. Georgia O'Keeffe, *Brown Sail, Wing and Wing, Nassau*, 1940

190. Lyonel Charles Adrian Feininger, *Baltic, A Recollection*, 1947

191. Lyonel Charles Adrian Feininger, *Gothic Church I*, 1942

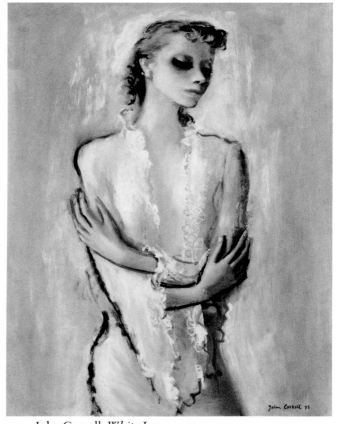

192. John Carroll, *White Lace*, 1935

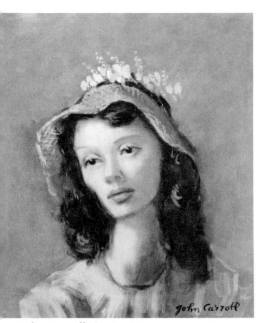

3. John Carroll, *Spring Bonnet*, ca. 1948

194. Jon Corbino, *Stampeding Bulls*, 1937

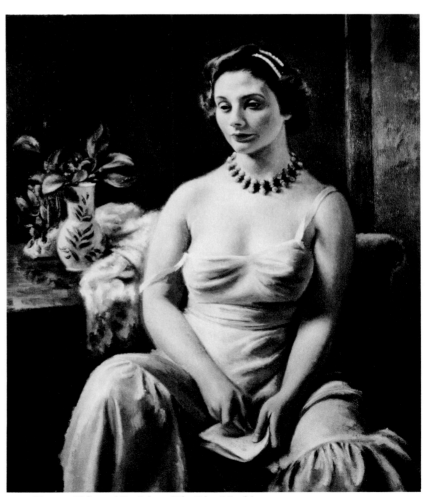

5. Gordon Samstag, *Proletarian*, 1934

196. Eugene Edward Speicher, *The Blue Necklace*, ca. 1937

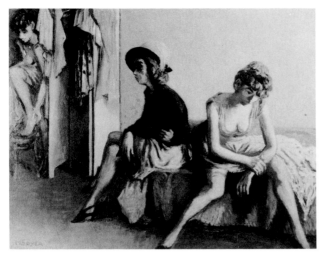

197. Moses Soyer, *Dancer Resting*, 1939

198. Vaughn Flannery, *Swan Island*, 1942

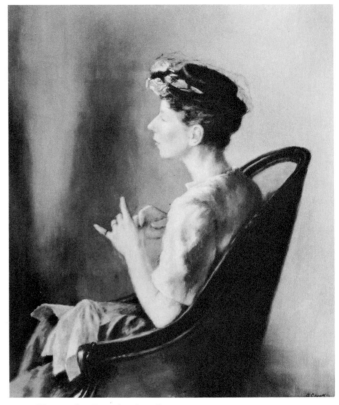

199. Alexander Brook, *Amalia*, 1942

200. John Whorf, *New England Winter*, 1925

201. John Whorf, *Wet Snow*, ca. 1938

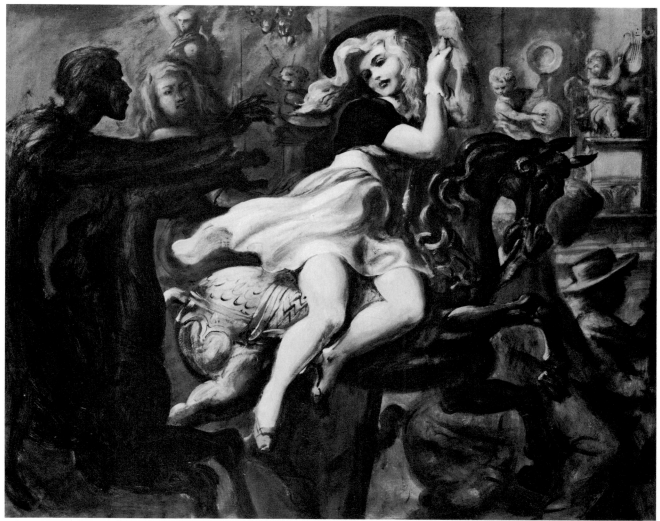

202. Reginald Marsh, *Pursuit*, 1941–42

203. John Whorf, *West Indies Scene*, ca. 1938

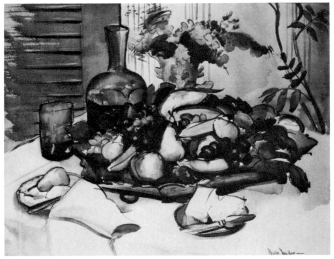

204. Barse Miller, *Table in the Shade*, 1934

205. Hugh F. McKean, *Early Morning Fishing Party*, 1934

206. Barse Miller, *Factory Town*, 1946

207. Dean Fausett, *Vermont Landscape*, 1941

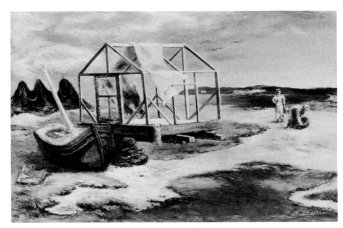

208. Julian Edwin Levi, *Driftwood*, ca. 1939

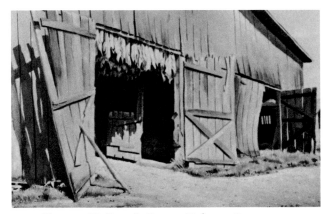

209. Clarence Holbrook Carter, *Tobacco Barn, Adams County, Ohio*, 1936

210. Joseph Floch, *Seated Figure*, ca. 1936

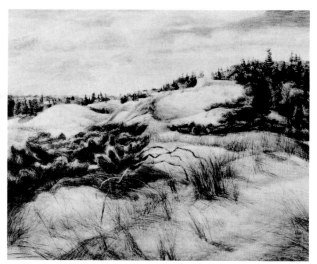

211. Zoltan Sepeshy, *Sandscape*, ca. 1938

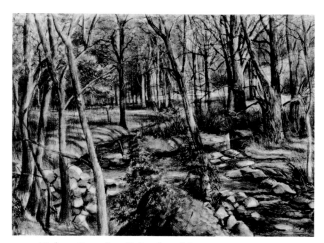

212. Zoltan Sepeshy, *Faint Sunshine*, 1940

213. Clarence Holbrook Carter, *Stew*, 1939

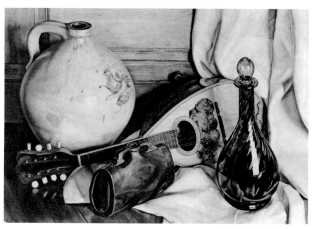

214. Luigi Lucioni, *Design for Color*, 1944

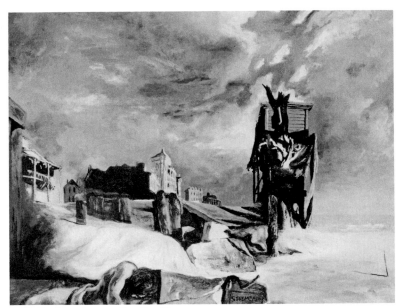

215. Walter Stuempfig, Jr., *Tempest*, 1944

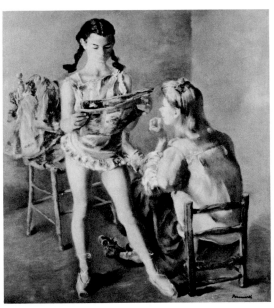

216. Jerry Farnsworth, *The Amateur*, 1943

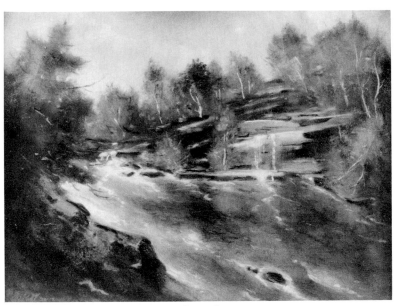

217. Henry Elis Mattson, *Big Rock Pool*, ca. 1942

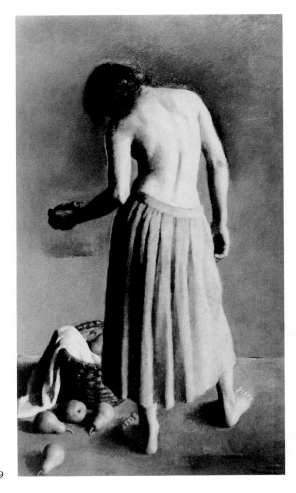

218. Robert Brackman, *In a Mid-day Light*, 1949

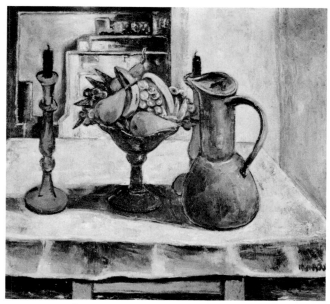

219. Bror Julius Olsson Nordfeldt, *Yellow Tablecloth*, 1945

220. Stephen Morgan Etnier, *Vieux Carré*, 1946

221. Arthur Osver, *The Steam Jet*, 1946

222. Hobson Pittman, *The Buffet*, ca. 1948

223. Zsissly, *Incoming Tide, Maine*, 1939

224. Andrew Newell Wyeth, *The Hunter*, 1943

225. Jacob Lawrence, *Barber Shop*, 1946

226. Stuart Carson Edie, *Red, White, Blue*, 1946

203

227. Irene Rice Pereira, *Projecting Planes*, 1947

228. Charles Sheeler, *Variations in Red*, 1949

229. Eugene Berman, *La Puerta de los Milagros,*
1948

230. Randall Morgan, *Ponte Vecchio, Florence,* ca. 1949

231. William Thon, *The Baptistry, Florence,* ca. 1949

232. Leonid, *Portuguese Sun,* 1948

233. Joseph Lindon Smith, *Offering
Bearers in the Tomb of Kagemni,
Sakkara,* 1948–49

234. Ogden Minton Pleissner, *The Arno, Florence*, 1949

235. William Congdon, *The Church of the Redeemer, Venice*, 1952

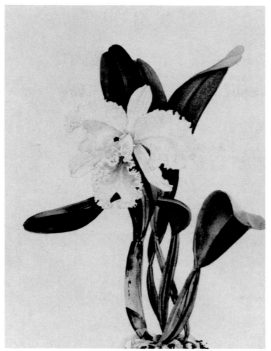

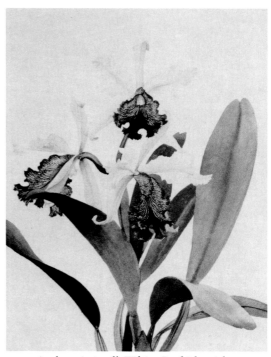

236. Andrey Avinoff, *White Orchid with Pale Yellow Throat*, ca. 1947–49

237. Andrey Avinoff, *White Orchids with Pale-Green Yellow Throats*, ca. 1947–49

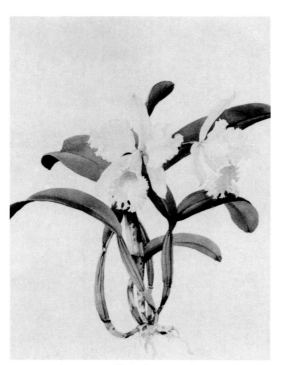

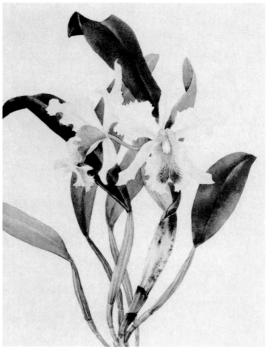

238. Andrey Avinoff, *Yellow Orchids with Red-Orange Throats*, ca. 1947–49

239. Andrey Avinoff, *Pale Yellow Orchids with Magenta Throats*, ca. 1947–49

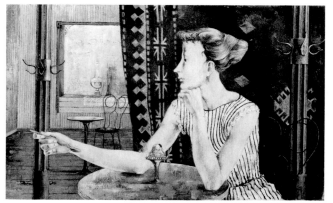

240. Stephen Hopkins Hensel, *Ice-cream Parlor*, 1949

241. William Austin Kienbusch, *Barns and Fences, No. 2*, 1949

242. Joe Jones, *Island in the River*, ca. 1949

243. Joe Jones, *Regatta, Barnegat Bay, New Jersey*, 1951

244. Carl Frederick Gaertner, *Covert's Old Pasture*, 1947

245. Carl Frederick Gaertner, *Landscape*, 1948

246. Karl Knaths, *The Clock*, 1951

247. Carl Frederick Gaertner, *Collision Bend*, 1952

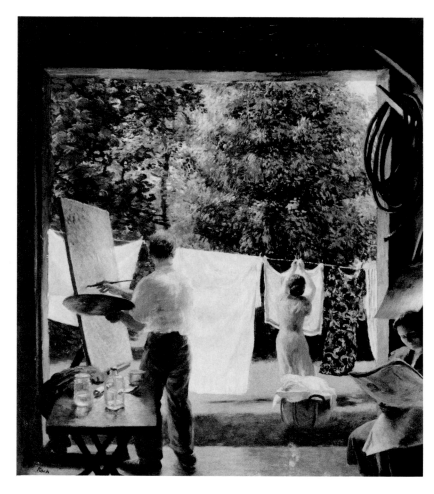

248. John Koch, *Hanging Clothes*, 1950

249. Ralston Crawford,
Mountain Bird Maru, 1947–49

250. Walter Tandy Murch,
 Taking-Off, ca. 1952

252. Dong Kingman, *East River*, 1953

251. Mark Tobey, *Quiet One*, 1950

253. Ad Reinhardt, *Number 1, 1951,* 1951

254. Hedda Sterne, *New York, No. 1,* 1954

255. William Baziotes, *Scorpion*, 1952

256. Fairfield Porter, *Frank O'Hara*, 1957

257. Kyle Randolph Morris, *Number 10, 1956*, 1956

258. R. B. Kitaj, *Notes Towards a Definition of Nobody—A Reverie*, 1961

259. Jimmy Ernst, *Cirque d'Hiver*, 1952

260. Philip Evergood, *The Enigma of the Collective American Soul*, 1959

261. Robert Rauschenberg, *Round Sum*, 1964

262. Willem de Kooning, *Lily Pond*, 1959

263. Adolph Gottlieb, *Summer*, 1964

264. Helen Frankenthaler,
Blue Jay, 1963

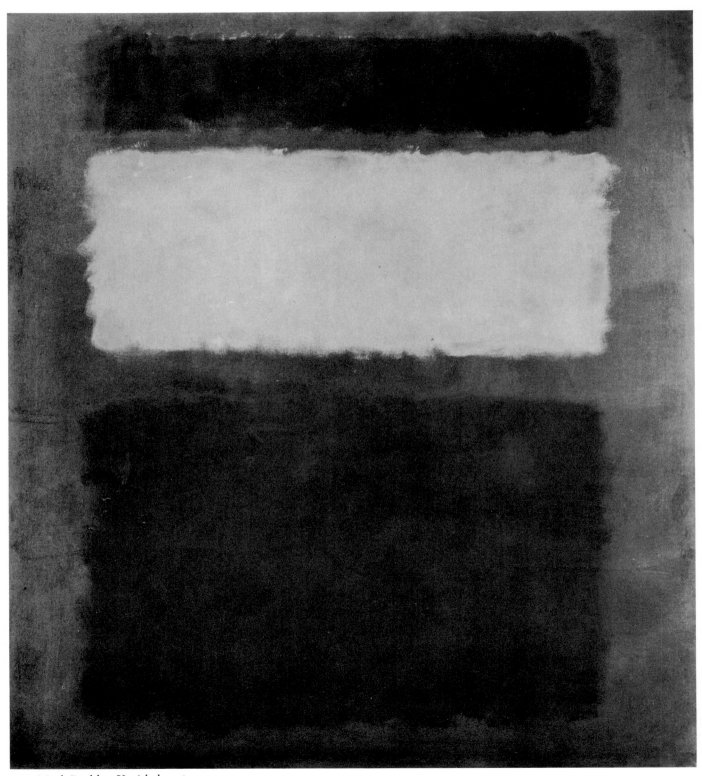

265. Mark Rothko, *Untitled,* 1960

266. Hans Hofmann, *Night Spell*, 1965

267. Frank Stella, *Lac Laronge IV*, 1969

268. Kenzo Okada, *Tanabata*, 1955

269. Sam Gilliam, *Untitled*, 1968

270. Ilya Bolotowsky, *Blue Ellipse*, 1976

271. Walter Darby Bannard, *Summer Joys #2*, 1970

272. Joseph Raffael, *Water Painting No. 1*, 1972

273. John Seery, *Letter to a Poet,*
1973

274. Alvin Loving,
Dan, 1973

223

275. Richard Estes, *Helene's Florist*, 1971

276. Don Eddy, *Jewelry*, 1974

277. Deborah Remington, *Chatham*, 1973

278. Jack Beal, *Still Life Painter*, 1978–79